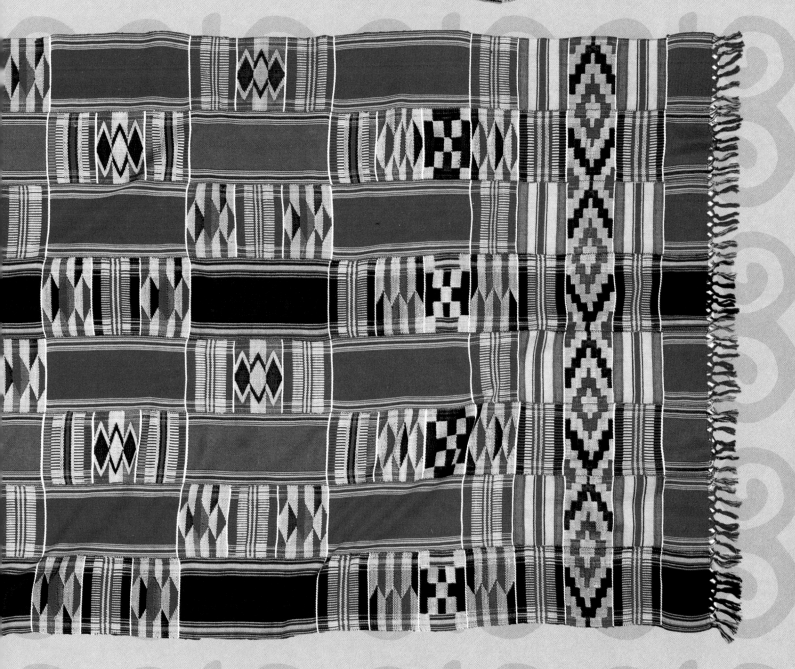

THE VOICES OF TRIUMPH KENTE CLOTH

Textiles, perhaps more than any other art form, reflect the cultures from which they come. They are at once personal, societal, religious, and political—invaluable vehicles for the spread of ideas from one culture to another. In Africa, woven cloths have served these functions for more than two thousand years, conveying the vibrant essence of an African aesthetic.

Kente, the type of cloth seen on the cover, is the primary woven fabric produced by the people of the old Ashanti Kingdom of Ghana. This particular cloth was specially designed and woven in Ghana to convey the theme "African Americans: Voices of Triumph."

Although the Ashanti tend to favor strips of uniform color, the varying colors in this kente cloth express the many paths taken by all our people—and especially the multiple destinations of black slaves who were removed from the shores of Africa.

The traditional red, gold, and green repeated in the middle of the design is one of the several variations of the "liberation colors" recognized by children of African descent all over the world: red for the blood (shed by millions in captivity), gold for the mineral wealth (prosperity), and green for the vegetation of the land of Africa (home).

The weavers of Ghana and other countries throughout West Africa have long adapted foreign elements to suit their own needs, creating unique motifs to express cultural values. Among the motifs incorporated in the design for this cloth is *abusua foa* (the council of elders) represented by the boxes arranged in an X ("all ideas coming together at one point") to symbolize leadership, consensus, and the voice of the people.

The stepped border motif, which seems to connect all the strips, symbolizes unity, interdependence, and cooperation as prerequisites for the advancement of the people.

The "shield" motif symbolizes defense against the countless assaults and obstacles encountered in the course of our lifetime.

Finally, the diamond, rarest, hardest, and most precious of all the minerals of Africa, represents the many-faceted soul of the children of Africa in America and reflects both their power to endure and their growing triumph in the struggle for freedom and equality.

AFRICAN AMERICANS

VOICES OF TRIUMPH™

CREATIVE FIRE

BY THE EDITORS OF TIME-LIFE BOOKS
ALEXANDRIA, VIRGINIA

TIME LIFE

Time-Life Books is a division of TIME LIFE INC.

PRESIDENT and CEO, TIME LIFE INC.: John M. Fahey, Jr.

TIME-LIFE EDUCATION
PRESIDENT: Robert H. Smith
Vice President, Marketing: Rosalyn McPherson Andrews
Vice President, Operations: Lisa H. Peterson
Vice President, Business Development: Joan D. Mayor
Direct Response Marketing Manager: Amy Haworth
Project Coordinator: Theresa Mixon
Executive Assistant: Barbara A. Jones

TIME-LIFE BOOKS
PRESIDENT: John D. Hall
EDITOR-IN-CHIEF: John Papanek
MANAGING EDITOR: Roberta Conlan
Executive Art Director: Ellen Robling
Director of Photography and Research: John Conrad Weiser
Director of Editorial Operations: Prudence G. Harris
Director of Publishing Technology: Eileen Bradley

TIME-LIFE CUSTOM PUBLISHING
Promotions Manager: Gary Stoiber

The Voices of Triumph™ Development Team gives special thanks to Quincy Jones, who joined hands with us early in the project, supported our vision, and believed in our goal.

AFRICAN AMERICANS: VOICES OF TRIUMPH™
Series Directors: Roxie France-Nuriddin, Myrna Traylor-Herndon
Series Design Director: Cynthia Richardson

Editorial Staff for **CREATIVE FIRE**
Administrative Editor: Loretta Y. Britten
Picture Editor: Sally Collins
Text Editors: Esther Ferington, Paul Mathless
Art Directors: Alan Pitts, Kathleen Mallow
Associate Editor/Research: Sharon Kurtz
Writer: Darcie Conner Johnston
Assistant Editors/Research: Michael E. Howard, Dionne Scott
Senior Copyeditors: Anne Farr, Colette Stockum
Picture Coordinator: Jennifer Iker

Editorial Operations
Production: Celia Beattie
Library: Louise D. Forstall
Computer Composition: Deborah G. Tait (Manager), Monika D. Thayer, Janet Barnes Syring, Lillian Daniels

Special Contributors: Sarah Brash, George Daniels (editors); Regina Barboza, Steven Barboza, Karen Grigsby Bates, Donald Bogle, Tonya Bolden, Elza Boyd, Herb Boyd, Khephra Burns, William Clark, Thomas J. Craughwell, Marfé Ferguson Delano, Sarah Labouisse, Frank McCoy, Glenn McNatt, Brenda Lane Richardson, Dariek Scott, Judy Simmons, Elizabeth Thompson, Martin Weston (writers); Ellen C. Gross, Catherine B. Hackett, Maurice Hall, Greg S. Johnson, Jane Martin, Erika Dalya Muhammad, Stephen Ostrander, Catherine Harper Parrott, Patricia A. Paterno, Elizabeth Schleichert, Marilyn Terrell, Janet Sims-Wood (researchers); John Drummond (designer); Mel J. Ingber (indexer)

Resource Consultant: Dr. Dolly McPherson

Correspondents: Christina Lieberman, New York; Maria Vincenza Aloisi, Paris. Valuable assistance was also provided by Elizabeth Brown, Katheryn White, Daniel Donnelly, New York.

First printing. Printed in U.S.A.

TIME-LIFE is a registered trademark of Time Warner Inc. U.S.A.
VOICES OF TRIUMPH and
AFRICAN AMERICANS:
VOICES OF TRIUMPH
are trademarks of Time Life Inc.

Library of Congress Cataloging in Publication Data
African Americans: voices of triumph.
Creative fire / by the editors of Time-Life Books.
p. cm.
Includes bibliographical references and index.
ISBN 0-7835-2258-4
ISBN 0-7835-2259-2 (lib. bdg.)
1. Afro-American arts. 2. Arts, Modern—20th century—United States. I. Time-Life Books.
NX512.3.A35A37 1994
700'.89'96073—dc20
93-31616
CIP

AFRICAN AMERICANS: VOICES OF TRIUMPH™
consists of three volumes: *Perseverance*, *Leadership*, and *Creative Fire*.
For more information about the VOICES OF TRIUMPH™ volumes and
accompanying educational materials call or write 1-800-892-0316,
Time-Life Customer Service, P.O. Box C-32068, Richmond, Va. 23261-2068,
or ask for VOICES OF TRIUMPH™ wherever books are sold.

From African-influenced sculptures of the 1920s to rap and hip-hop, from all-black 1930s cowboy movies to award-winning modern novels, nothing could be more diverse than the contributions that African Americans have made to American culture. What unifies these artists is a creative fire—a compulsion to produce art that infuses their poetry and painting, their film and song, with a vision shaped by the African American experience.

Even the oppression of slavery never extinguished that fire. African traditions of storytelling and oral history endured under the yoke of enslavement. Slave carpenters and quilters, metalworkers and weavers, potters and basket makers created objects that were beautiful as well as useful. And in the unrelenting labor of the fields, African Americans sang out with hollers, work chants, and spirituals to begin a heritage of creativity that has defined American music to this day.

Before emancipation, some black Americans, free as well as slave, managed to make a name for themselves as talented poets, musicians, and portrait painters, and their stories are among those told and illustrated in the pages that follow. Black writers rose to prominence in the 1800s as literary warriors in the battle against the brutal institution of slavery and as advocates of the rights of all men and women. Some, like Frederick Douglass and William Wells Brown, were escaped slaves themselves. Other black artists pursued different visions. Landscape painter Robert Duncanson, for example, sold his works to European as well as American connoisseurs during the Civil War and postwar era, becoming the first internationally known black American artist.

The creative fire burned even brighter in the period between the First World War and the Great Depression when many blacks left the rural South for the questionable comforts of northern cities. In sculpture, painting, photography, poetry, literature, and other arts, black America flourished during the New Negro Movement, the period that later came to be known as the Harlem Renaissance. This era also saw the emergence of the uniquely African American form of music: jazz.

By then, black Americans had become involved in the new art of filmmaking. In the 1930s and 1940s some former vaudeville performers found limited work in the mainstream movie industry. However, African American entrepreneurs also labored outside of Hollywood to produce movies that depicted black middle-class families as well as black detectives, cowboys, businessmen, and pilots. In the late 1960s, director Melvin Van Peebles's independent film inspired a wave of Hollywood "blaxploitation" movies. Later, a new generation of black film directors produced a wide variety of films, from the powerful, Oscar-nominated *Boyz 'N the Hood*, a story of south central Los Angeles in the 1980s, to the dreamlike drama *Daughters of the Dust*, a study of black family life in the Georgia Sea Islands at the turn of the century.

Today, internationally known African American musicians, filmmakers, painters, sculptors, poets, playwrights, and novelists help shape the culture not only of the United States but of the world. Millions know their stories of struggle and triumph, which are recounted with pride in these pages. But this volume of African Americans: Voices of Triumph also includes many of the lesser-known stories as well—about the lives of hundreds of black American artists who were left out of the history books, each life aglow with creative fire, each with a vision to share and the talent to express it.

Roxie France-Nuriddin,
Series Co-Director

Myrna Traylor-Herndon,
Series Co-Director

Cynthia T. Richardson,
Series Design Director

EDITORIAL ADVISORY BOARD

BOARD OF CONSULTANTS

CREATIVE FIRE

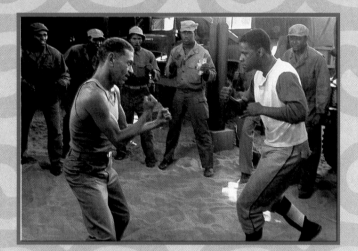

THREE
WITH PEN IN HAND...126

FOUR
THE VISUAL ARTS: BOUNTY FROM GIFTED HANDS...180

ANCIENT FIRES: STILL LIGHTING THE WAY

In Africa—a land burning with the creative fire of artistic expression—the individual artist is, in a sense, invisible. Whether rendered for the eye or performed for all the senses, traditional African art reflects instead the ways of the community. Vivid tales of times gone by, passed from generation to generation by gifted storytellers, define a community's history, philosophy, and beliefs. Skilled artisans, working in gold, bronze, wood, ivory, and beads, create strikingly beautiful sacred objects to help the community practice its rituals and religion. Music works its way into most aspects of African daily life—from songs sung during planting and harvesting to fanfares for kings and visiting dignitaries. Performance—primarily dance—plays a vital part in nearly all communal ceremonies and serves as a bond between members of the society.

The lines defining these varied forms of artistic expression are usually blurred. A single ceremony might include dance, music, and storytelling, all aided by the use of elaborately decorated masks and costumes. For generations, such ceremonies have stoked the creative fires of African artists to their brightest flame. For artists of today, the glow of those fires continues to light the way.

PERFORMANCE: MASKS, DANCES, AND UNITY

As the drama of a performance unfolds, intricate dances, synchronized movements, fantastically embellished masks, and symbolic gestures turn everyday life into ritual. The miracle of birth, the mystery of death, the valor of battle, and even various comical situations are played out in the village square. As people crowd around to watch, some dance with the performers, who, for their part, often carry their performance out of the circle and into the crowd.

Dance is vital to nearly all African ritual. In Burkina Faso, a dancer flutters his oblong mask back and forth; he is a butterfly swooping through the air after the first downpours of the rainy season. In Gabon, a performer cavorts on high stilts, expressing a far more ominous idea: The beautiful white mask he wears represents a figure called the Girl from the Land of the Dead. After young men of the Ivory Coast pass the final stage of their initiation into manhood, the ritualized celebration carries dance, music, and song well into the night. Many performances mark festivals put on by various secret societies within the community. Their ceremonies promote a sense of unity and commonality of values within the group. This is the power and purpose of much traditional African drama. Life becomes ritual, and the stylized masks used in the performance either are terrifying or are as familiar to the audience as the faces of neighbors.

SINGING STRINGS, TALKING DRUMS

The soul of Africa abides in its music, which educates children, honors its rulers, carries hopes of bountiful harvests. Across the broad breast of the continent the sound of the drum reverberates, giving rhythmic interpretation to the emotions of everyday life—to joy, to sorrow, to news from afar of exciting events. Beyond the drum comes music plucked from the strings of the *corah*, the *kissar*, the *icbacarre*. And to them are added the chants of a multitude of human voices.

In the deft hands of craftsmen and craftswomen, musical instruments take shape from tree trunks, hides, gourds, tin cans—carved, stretched, rubbed, and tuned to produce the complex sounds and rhythms that pulse through Africa's varied lands.

In the fields, a Masai boy serenades his cattle with a flute. In the forest, a tribe of Pygmies chant songs of praise to their wooded home. In the desert, Sudanese camel drivers sing to persuade their animals to drink more water. Almost anyplace where hard toil goes on, songs fill the air to help make the job a little easier and the time pass a little faster.

In Nigeria, entire orchestras of Yoruba drummers beat out great waves of thunderous rhythms with their *dundun*—"talking drums." The dundun players tighten and slacken the cords binding their drumheads to change pitch as they play, thus imitating the tonal speech patterns—literally, the talk—of the Yoruba people. If no drums are at hand, Africans use their bodies to keep time, making percussive sounds with their mouths, clapping their hands, stomping their feet, slapping their torsos and legs to make music.

To listen is to hear the power of music everywhere—the haunting wail of distant voices, the beat of distant drums.

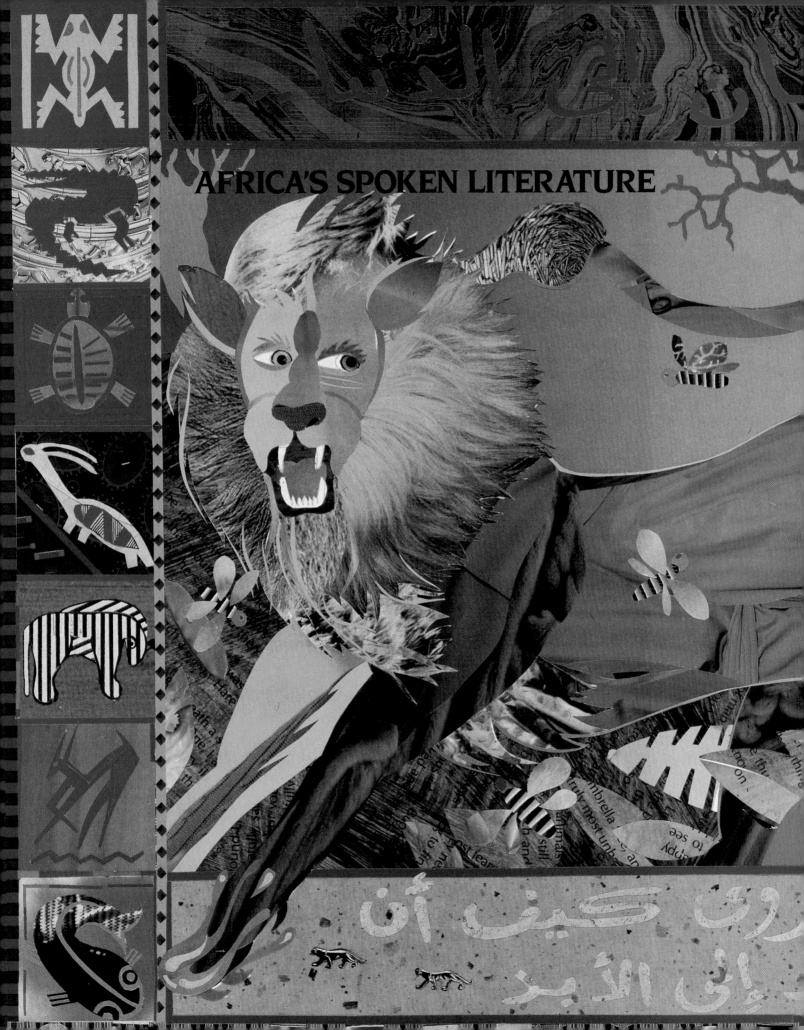

AFRICA'S SPOKEN LITERATURE

For millennia, until the coming of Islam and Arabic script, the words of Africa, both fact and fable, were passed on in oral form. Accounts of mighty empires, fearsome battles, great scholars—the whole panoply of African thought—were handed down by raconteurs called *griots* by the French or *balute* in the Luban language of central Africa. These tale spinners still tell of the ancestors who constitute a community's history, offering proverbs containing time-honored wisdom, and relating myths about how the world and all in it came to be.

The myths help give the people a sense of the world and their place in it. One favorite is the story of how Lion got his roar. "After the coming of man into the world," it begins, soft-voiced Lion became a great predator. This was dangerous for the other animals, who needed to know when Lion was coming. Rabbit had an idea.

Rabbit led Lion far into the woods until Lion tired and fell asleep. Then Rabbit robbed a beehive and smeared honey over Lion's paws and head. When the bees saw their honey on the sleeping Lion, they stung him so much that his soft cries of pain changed to great roars. That—as written in Arabic below— is how Lion's voice was changed forever. As they have been through the ages, such stories are touchstones of wisdom for the storytellers of today.

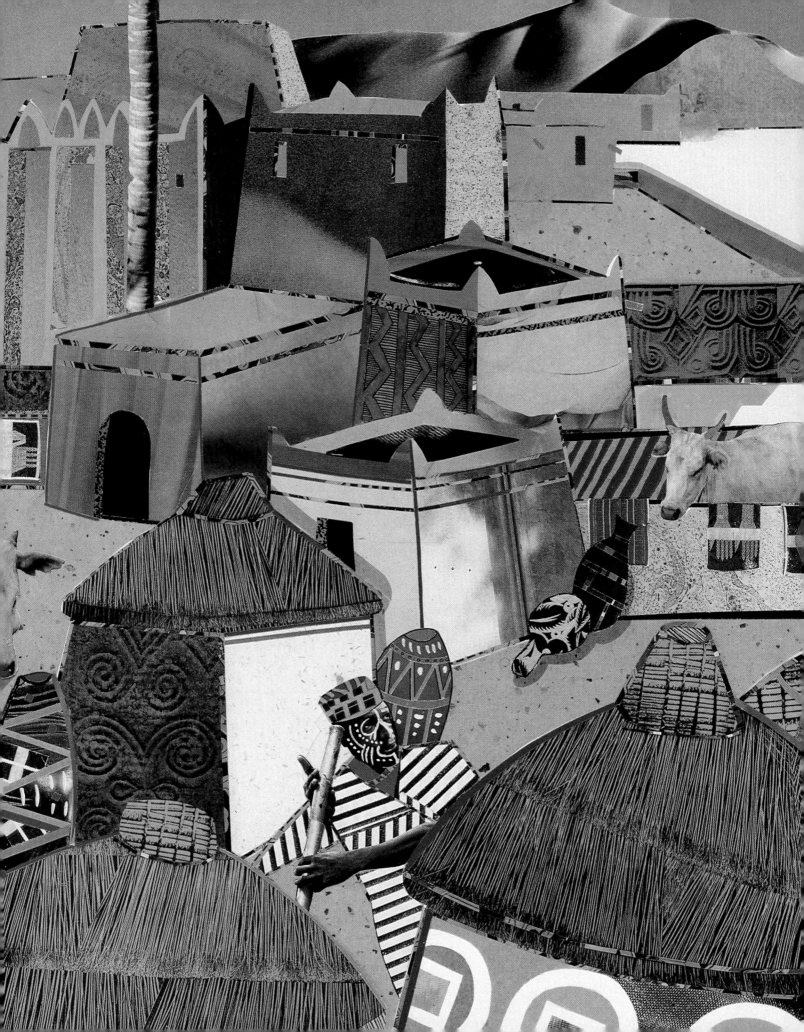

IN PRAISE OF BEAUTIFUL THINGS

African art greets the eye as well as the ear, but attempts no design for its own sake. Instead, it embellishes the appearance of life's everyday objects—the thatched roofs and painted walls of huts, the geometric mud-brick walls of mosques, the gourds that hold water and grain, the garb of the villagers.

Everywhere in an African village there is beauty. The sunbaked sides of the houses create an angular street mosaic. Mosques and palaces rise skyward with bronze-capped turrets gleaming; inside, sacred objects of gold, bronze, and ivory capture the eye.

Even items used for cooking and storing food are pleasing to behold: brightly decorated gourds; sturdy baskets intricately woven from grasses, reeds, bamboo, canes; elegantly shaped, inscribed, and colored clay pots. And the fabrics are no less appealing: garments of rich cottons and silks, elaborately designed kente cloths, tie-dyed dresses, embroidered hats. Adding to the beauty of the fabrics and sometimes defining a person's place in society is finely crafted jewelry—gold earrings, brass anklets, beaded bracelets, bone rings, and belts made from cowrie shells.

Certainly, it is true that some of these items could be made in a plainer fashion. But, as a wise man once said, "One does not want to live without pretty things."

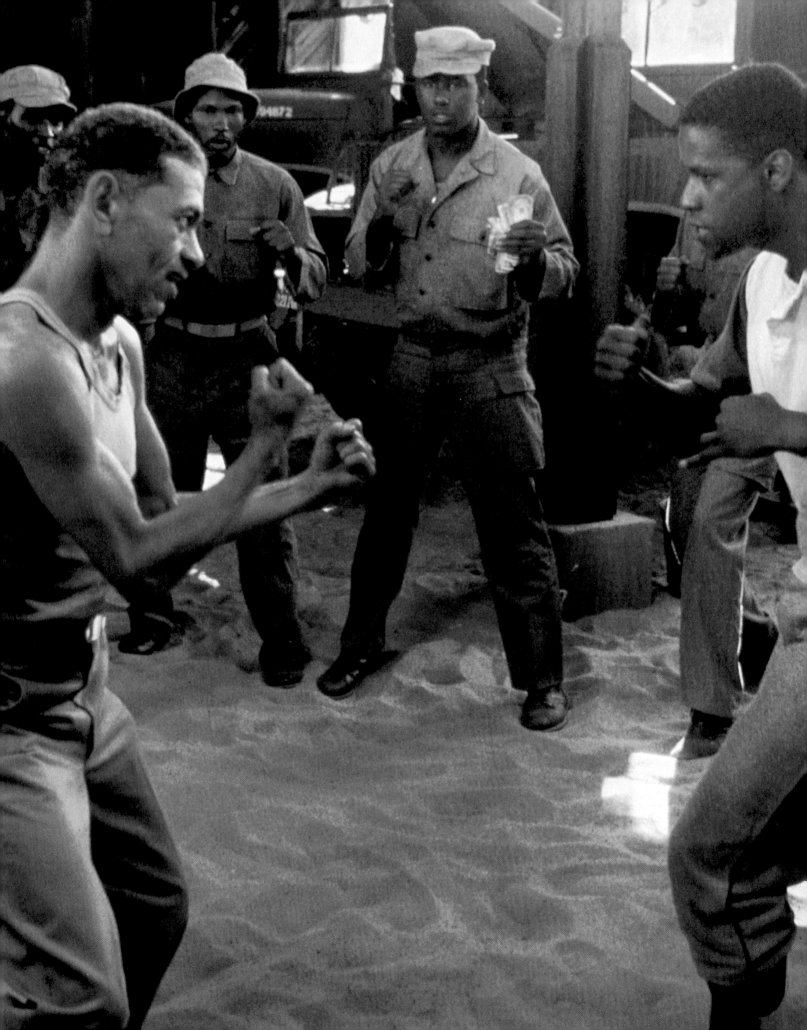

TO CAPTURE THE FLICKERING IMAGE

Actor Denzel Washington (near left) squares off against a feisty Adolph Caesar in a scene from the 1984 film A Soldier's Story, based on black playwright Charles Fuller's Pulitzer Prize-winning play.

uring the spring of 1918, a confident, energetic African American novelist named Oscar Micheaux took a business trip to Omaha, Nebraska. He was there to visit George Johnson, the general booking manager of the Lincoln Motion Picture Company, a black-owned movie production firm based in Los Angeles (*pages* 42-45). Johnson and his other partners at Lincoln were excited by the prospect of filming an adaptation of Micheaux's self-published novel *The Homesteader*, a drama about black ranchers. For two days, Micheaux and Johnson negotiated, trying to hammer out an agreement.

Eventually, a contract was drawn up. But then Micheaux made a startling request: He wanted to go to Los Angeles to supervise the making of the film himself. For Lincoln Motion Pictures, that was out of the question. How could an upstart with no real film experience imagine he'd be given control of a movie? The company dropped its plans for an adaptation. But Micheaux did not.

Within a matter of months, Micheaux established the Micheaux Book and Film Company, with offices in Sioux City, Iowa, and Chicago, to produce *The Homesteader*. Scrambling to raise money, he sold stock in his new company at $75 to $100 a share to a group of white Sioux City farmers. He hired black actors and actresses, and began production at Chicago's Selig studio. In 1919, his eight-reel version of *The Homesteader* opened in New York City. The film marked the beginning of a career that spanned some 30 years, during which Oscar Micheaux produced, by varying accounts, between 30 and 40 motion pictures with black casts. A remarkable output by any standard, it was all the more so considering the obstacles he confronted. He had no training in movies, no studio to finance him, no publicity or distribution. About all he had was his unabashed drive—and his love of moviemaking.

Born to former slaves in 1884 in Metropolis, Illinois, Micheaux became a Pullman porter as a teenager. In 1904 he moved to South Dakota, where he purchased a 160-acre homestead with his savings. There he began writing novels about the people and places he knew, undaunted by the fact that American publishing houses were hardly flocking to buy stories of African American life. In 1913 he published, at his own expense, his first novel, *The Conquest: The Story of a Negro Pioneer*. He then traveled through the countryside persuading white farmers and businessmen that the very thing they needed to buy was a copy of his book. Two years later, he published *The Forged Note: A Romance of the Darker Races*, followed in 1917 by *The Homesteader*. The rest, as they say, is history.

Indeed, although Oscar Micheaux was not the first black American filmmaker, he

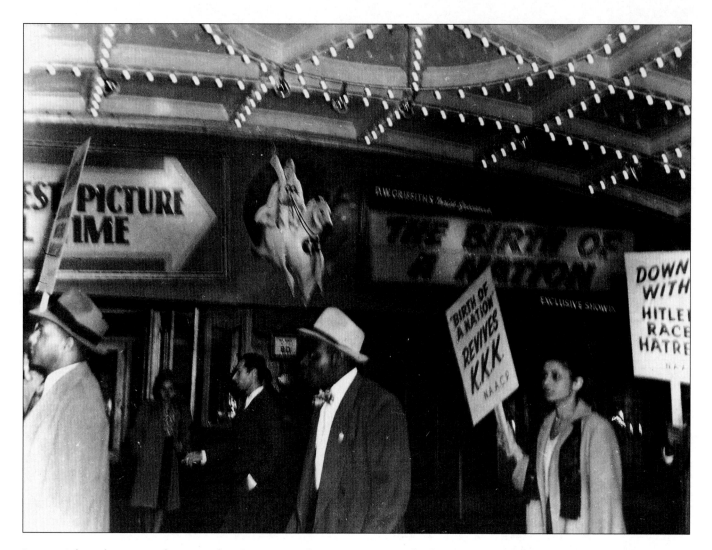

is certainly to be counted among the pioneering African Americans who have contributed to a motion-picture history rich in personalities, struggles, and accomplishments. That history can be divided into two distinct parts. During the first half of the century, early filmmakers like Micheaux worked outside Hollywood and produced black-cast films, sometimes called race movies, for African American audiences. These films showed a wide variety of black characters, from black cowboys and detectives to glamorous heroines and stalwart members of the middle class. The other history—and by far the better known—consists of the images emerging from mainstream, Hollywood studios. More often than not these films told the story of black America in the most stereotyped terms; just as black Americans were sitting at the back of segregated buses up through the 1950s, black performers in Hollywood were confined, for the most part, to servile roles. Yet on occasion, Hollywood has been capable of surprising achievements, thanks mainly to ingenious performances by black actors and actresses as well as—in more recent years—the expertise of black directors, cinematographers, and other film professionals.

The earliest images of African Americans on film, and surely among the most stereotyped, came from small mainstream companies. As early as 1894, peep-show viewers could watch a short movie like *The Pickaninnies Doing a Dance*, which presented African

Above, NAACP picketers protest the racist imagery and pro-Ku Klux Klan message of D. W. Griffith's film *The Birth of a Nation* at a New York revival decades after the movie's premiere. Similar protests in several cities accompanied the film's first run in 1915.

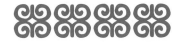

Americans as little more than figures of derision and curiosity. Between 1905 and 1914, other shorts with titles like *Wooing and Wedding of a Coon*, *For Massa's Sake*, and *The Loyalty of Jumbo* depicted a shocking series of dimwitted black characters: loyal, self-sacrificing servants; comic buffoons with broad grins performing deplorable antics; hefty, dowdy mammies; and savage Africans ready to attack. Worse still, white actors and actresses in blackface usually played these roles, making the characters all the more grotesque and unrealistic.

No film of these early years offered a more disturbing portrait of African Americans than David Wark Griffith's 1915 classic, the racist masterpiece *The Birth of a Nation*, which took as its subject the years during and after the Civil War. A genuine technical triumph in which Griffith mastered the use of the closeup, rapid-fire editing, and both realistic and impressionistic lighting, *The Birth of a Nation* also presented images of marauding black troops, power-hungry mulattoes, and renegade black males lusting for power and for southern white women. Like other films of the silent era, the movie used written title cards to clarify the plot. "The Ku Klux Klan," one read, "the organization that saved the South from the anarchy of black rule."

The Birth of a Nation sent shock waves through the black American community, stirring African American leaders to debate and action. Protests against the film were launched in New York, Boston, Los Angeles, and San Francisco by the NAACP, the civil rights organization that had been founded just a few years earlier. The film was refused licenses for exhibition in Kansas and Ohio; ultimately, it was banned in five states and 19 cities. Protests and criticism continued in the following years. Decades later, novelist Ralph Ellison deplored its horrific imagery. *The Birth of a Nation*, he wrote, established that "the Negro as scapegoat could be sold as entertainment, could even be exported. If the film became the main manipulator of the American dream, for Negroes that dream contained a strong dose of such stuff as nightmares are made of."

The movie also served as a stimulus for black Americans to make films of their own outside the established film colony. Even before *The Birth of a Nation*, an enterprising African American named William Foster had written and directed a series of black shorts, with titles like *The Railroad Porter*, *The Butler*, and *The Grafter and the Maid*. Now other African Americans plunged into action to make movies about black America's accomplishments and aspirations. Among the first was Emmett J. Scott, the serious-minded secretary of educator Booker T. Washington. Scott raised funds for *The Birth of a Race*, intended as an African American response to *The Birth of a Nation*, but lost editorial control of the film, which was poorly received when it was released in 1918. The Lincoln Motion Picture Company, which would later play its indirect role in launching Oscar Micheaux's career, did somewhat better with black-cast movies that saluted black middle-class fortitude and achievement.

Lincoln was just one of many small companies to make race movies. During that era, similar film production companies—some black-owned like

Emmett J. Scott (*below*), Booker T. Washington's secretary, became a movie producer for the film *The Birth of a Race*, meant as a reply to *The Birth of a Nation*. The project began with backing from Universal Pictures and the NAACP, but both eventually withdrew their support. Released in 1918, the movie was a critical failure.

Lincoln, others white-controlled—sprang up in cities as diverse as Jacksonville, Chicago, Philadelphia, Saint Louis, and New York. Approximately 150 came into existence at one time or another, often only long enough to make a film or two. By the late 1940s, several hundred race movies had been produced.

Created on shoestring budgets, the films were of uneven technical quality—sometimes plodding or disjointed, sometimes deliriously and enjoyably dopey. But they met a need that Hollywood ignored, providing black America with an alternative cinema complete with black doctors, lawyers, teachers, detectives, gangsters, and sultry sirens, as well as details of daily life with which an African American audience could immediately connect.

Gathered at a segregated theater or perhaps a black church or school, audiences enjoyed *The Bull-Dogger*—produced by the Norman Film Manufacturing Company in Jacksonville, Florida, in 1923—in which real-life black rodeo hero Bill Pickett joined other black cowboys and cowgirls in feats of western derring-do. They watched in delighted disbelief as a dashing black aviator made a midair rescue of a black damsel in distress in a 1926 Norman production, *The Flying Ace*. Viewing other race movies, they could ponder more serious issues of specific interest to African Americans. In *Scar of Shame*, a 1927 effort by the Colored Players Corporation, black American attitudes toward class and color were given full treatment in a tale of a young woman whose marriage to a middle-class black pianist suffers because of her lower-class origins.

Of all the early African American filmmakers, the most significant and by far the most prolific was the indefatigable Oscar Micheaux. After his directorial debut with *The Homesteader*, Micheaux never looked back, directing and producing race movies at a steady—and sometimes frantic—pace. Over the years, he also created his own studio system with a stable of stars, including romantic lead Lorenzo Tucker, glamorous Ethel Moses, and sexy Bee Freeman. Ever the salesman, Micheaux toured the country in search of financing and theater bookings, "stepping out of cars and into meetings as if he were God about to deliver a sermon," according to Lorenzo Tucker. "He was so impressive and so charming that he could talk the shirt off your back."

Micheaux's limited funds meant he often could not afford to reshoot scenes or to film from multiple angles, and so the result was often technically inferior, with awkward shots, uneven lighting, and rambling, underdeveloped story lines. Yet the films offered a fascinating and popular mix of social message and entertainment. *Within Our Gates*, an early Micheaux effort from 1920, was a melodrama with a controversial southern lynching sequence. His film *Birthright*, made in 1924, was the tale of a young black Harvard graduate who returns to the South bent upon founding a colored school to "uplift the race." Many of Micheaux's films also included black actresses in vivid, important roles.

In 1927, Micheaux and other early silent-film makers on tight budgets were affected by a new technology that challenged their very existence. That year Warner Brothers released *The Jazz Singer*, in which an ersatz black man, white entertainer Al Jolson made up in blackface, sang his trademark song, "Mammy," and launched the era of sound. Unable to afford the new sound equipment, most race-movie companies folded. Micheaux himself filed for bankruptcy in 1928. But he quickly rebounded, se-

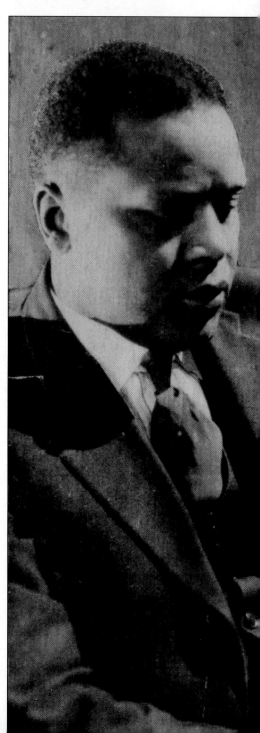

Prolific black filmmaker Oscar Micheaux, captured below in a reflective moment, directed the all-black 1937 film *Underworld* (*poster, right*), in which an innocent young southerner is drawn into the Chicago crime world.

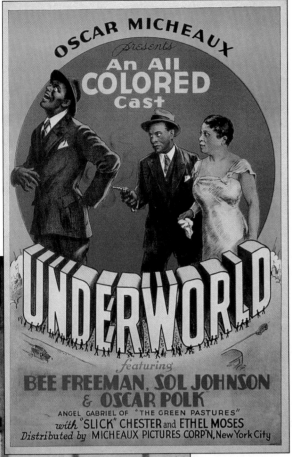

curing backing from white investors. By the early 1930s, his firm and a number of newly formed race-movie companies produced movies with sound. Micheaux made a number of films in the 1930s and 1940s; he even remade *Birthright* as a talking picture in 1939.

In Hollywood, the addition of sound led to some new opportunities for African Americans. Black performers found work in two "colored" musicals of 1929, 20th Century Fox's *Hearts in Dixie* and MGM's *Hallelujah*. Avoiding the issue of American race relations, both movies presented docile black characters isolated in rural, all-Negro worlds. Even so, they showcased a number of impressive black performers, from Nina Mae McKinney, touted as Hollywood's first black love goddess, to blues singer Victoria Spivey, actor Clarence Muse, and comedian Stepin Fetchit. "In the Negro, the sound-picture has found its ideal protagonist," white film critic Robert Benchley wrote enthusiastically in the April 1929 issue of the National Urban League publication *Opportunity*. But when neither of the year's black musicals was successful at the box office, Hollywood quickly dropped the idea of making black movies. The next such film, *Green Pastures*, did not appear for another seven years.

In the meantime, Hollywood's black performers were left to make what they could of limited roles, for the most part as servant characters. Perhaps none did so with as much impact as Stepin Fetchit. Originally named Lincoln Theodore Monroe Andrew Perry, he was the son of a Key West, Florida, cigarmaker. Perry ran away at age 14 to become a singer and tap-dancer in carnivals and minstrel shows. He got the idea for a new name, he later said, after he won a $30 bet on a racehorse called Stepin Fetchit. First he used the phrase "Step 'n' Fetchit" for an act featuring himself and a stage partner, Ed Lee. Then he took the whole name for himself. By the time he arrived in Hollywood, Fetchit had been an entertainer for about 10 years.

The roles for which Fetchit became famous were the worst kind of African American stereotype. In film after film, he played essentially the same character: a lanky, slow-moving, slow-talking whiner. In the 1934 comedy-melodrama *Judge Priest*, he was almost impossible to understand. In *Charlie Chan in Egypt*, a mystery from 1935, he was ludicrously terrified of ghosts. His very name conjured up the image of a servile figure who must "step and fetch" at someone else's orders. Yet even while playing one feckless lackey after another, Fetchit's comedic talents shone through. Like other black performers who followed him, Fetchit conveyed an ironic detachment from the degrading roles in which he was cast. By performing at his chosen pace, he also seized the attention of the audience. And the studio recognized it: At one point, he reportedly earned $160,000 a year. Behind the scenes, he was as demanding as any other Hollywood star. "He insisted on directing any scene in which he played," the *New York Evening Post* reported in 1934.

A very busy actor who appeared in some 26 films between 1929 and 1935, Fetchit still had time for a much-publicized, lavish lifestyle offscreen. Stories circulated

about his imported thousand-dollar cashmere suits and his 12 cars, one a Phaeton town car with his name emblazoned in neon lights along the sides. By the late 1930s, however, as Fetchit gradually declined in popularity, his Hollywood heyday came to an end. Left with debts of $4 million and assets of $144, he sank into obscurity, reappearing occasionally in bit parts and race movies.

Fetchit led the way for a host of other talented African American performers who became nationally known during the Great Depression—almost always, like Fetchit, playing servant roles. In the 1934 film *Imitation of Life*, Louise Beavers was cast as the submissive, self-sacrificing maid Delilah, whose pancake recipe helps her white "friend" build a financial empire. Dancer Bill "Bojangles" Robinson appeared in several movies, most notably as the enthusiastic servant who taught Shirley Temple how to tap-dance up a staircase in *The Little Colonel*, released in 1935. Like Fetchit, such black performers found it necessary to "wear the mask," in the words of black poet Paul Laurence Dunbar, in order to achieve some measure of Hollywood success.

Those who did not fit into Hollywood's rigid stereotyping system faced more problems. Savannah-born beauty Fredi Washington did well in her first Hollywood role in *Imitation of Life* as Peola, a young woman who passes for white in one of Hollywood's rare treatments of race themes. Washington might have been expected to go on to other important roles. But her light-colored skin, blue-green eyes, and fine fea-

Known for his offscreen life of luxury, Depression-era movie comedian Stepin Fetchit (*below, right*) lavishly entertains a group of guests atop his Los Angeles apartment house in 1936. Fetchit was criticized by some African Americans for playing only dimwitted servants but was limited to such roles by the Hollywood stereotypes of the day.

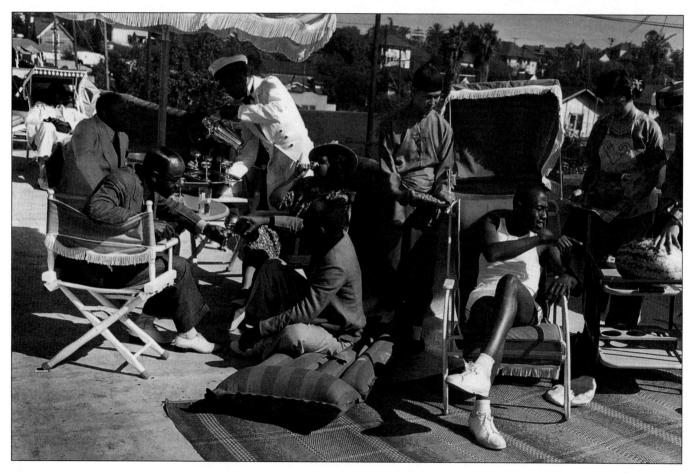

tures made her hard to cast; Hollywood considered her far too light and too serious to play comic black maids. Washington later returned to New York, where she helped found the Negro Actors Guild.

Another black actor-activist of the 1930s was Clarence Muse, who turned away from a law career to become an actor. His first film part in *Hearts in Dixie* was followed by some 200 other roles. In 1932 Muse wrote and published a pamphlet, *The Dilemma of the Negro Actor*, in which he addressed problems that were to exist for black film performers for years to come. Muse wrote that the African American actor always had to struggle with roles that did not reflect his or her own experience. Yet if the performer refused to do such parts, there might be no work available at all. (Decades later, essentially the same dilemma would be explored by black independent filmmaker Robert Townsend in his 1987 satire *Hollywood Shuffle*.) Muse was also one of Hollywood's first black screenwriters, joining with poet Langston Hughes to write *Way Down South*, a drama released in 1939.

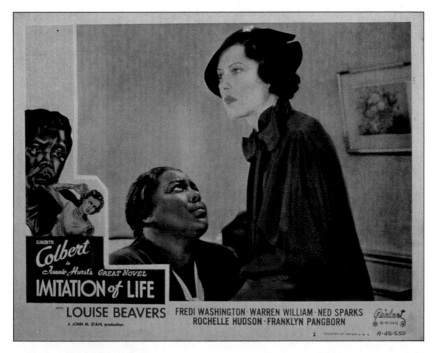

In a poster for the 1934 film *Imitation of Life*, a pioneering Hollywood examination of race, actress Louise Beavers as Aunt Delilah implores her light-skinned daughter, played by Fredi Washington, not to deny her racial identity by passing for white.

Another movie released that year gave 44-year-old black actress Hattie McDaniel a part that led to her becoming the first African American to win an Academy Award. McDaniel was voted Best Supporting Actress for her performance as Mammy in the David O. Selznick epic *Gone with the Wind*.

It was a typically ambiguous moment in black movie history. The role for which McDaniel won her award was a classic Hollywood stereotype, as was the hysterical slave played by Butterfly McQueen in the same film. Even before the movie began production, the project had stirred protests from the black press, the NAACP, and other sources that led producer Selznick to omit the word *nigger* from the script and to drop the novel's references to the Ku Klux Klan. In the end, the completed film still painted such an unrealistic portrait of slavery that the National Negro Congress picketed the movie in New York.

But all the problems of the film itself could not detract from McDaniel's performance. In her portrayal of Mammy she brought to the screen the comic assertiveness she had honed in a lifetime of performing experience. McDaniel was a trouper from way back, having toured with her father Henry Mitchell's minstrel group. She went on to be a singer and songwriter, working as a domestic whenever her bookings fell off. In 1931 at the age of 36, she joined her brother Sam and sister Etta in Los Angeles, where she hoped to break into films. In a few years, McDaniel went from working as an extra to playing unbilled parts and then important supporting roles.

Her characters were mammy figures, large, robust black women whose primary function was to nurture and nourish a film's white characters. McDaniel herself rec-

ognized she had little choice but to play such servant roles. "Why should I complain about making seven thousand dollars a week playing a maid?" she once said of her film career. "If I didn't, I'd be making seven dollars a week actually being one!" But while the parts were predictable and the scripts one-dimensional, McDaniel managed to invest her characters with distinctive qualities. With her massive build and booming voice, she appeared to be a woman born to give orders, not to take them.

As was typically the case for black characters in Hollywood films, McDaniel's Mammy existed in a kind of vacuum. Viewers neither knew where the character lived nor where she came from, and Mammy never even ventured an opinion about the effects of the Civil War on her destiny. But through her formidable talents McDaniel created a character of enormous vitality and resilience. Looking Vivien Leigh's Scarlett dead in the eye, McDaniel's character rarely hesitated to speak up; her lines were often laced with anger and an edge of hostility that the movie's script does not explain.

When the film held its gala opening in Atlanta, the rules of segregation—written and unwritten—precluded McDaniel and the film's other major black performers from being invited. Belated recognition came when McDaniel attended the Academy Awards ceremony—the first black performer to do so. However, she and her escort, black actor Wonderful Smith, were seated separately from the other celebrities for most of the evening. McDaniel nonetheless accepted the history-making Oscar with simple dignity. "I shall always hold it as a beacon for anything that I may be able to do in the future," she told the audience. "I sincerely hope that I shall always be a credit to my race, and to the motion-picture industry."

That graceful acceptance of the Hollywood system was diametrically opposed to the more critical stance of one of McDaniel's contemporaries, Paul Robeson. An All-American football star and valedictorian of his class at Rutgers, Robeson went on to earn a law degree from Columbia and then to a stage career as a classical actor and a concert singer. He got his start in film when Oscar Micheaux cast him in *Body and Soul,* a silent 1925 melodrama in which Robeson played a shifty black minister. A variety of other movies followed, including the British film *Sanders of the River* and a powerful version of Eugene O'Neill's *Emperor Jones*, with Robeson in the title role. Then came *Show Boat*, a 1936 Hollywood musical in which he played the lazy, no-account servant Joe, who would rather whittle than work—clearly a stereotype. But when he sang "Ol' Man River" in his rich, deep voice, Robeson transcended the film's racial characterization, creating what has since become a classic scene in American movie musicals.

Despite playing stereotypical parts in such

Bedecked with flowers for the occasion, actress Hattie McDaniel (*below, left*) accepts the Academy Award for her supporting role in the 1939 epic *Gone with the Wind* from actress Fay Bainter at the 12th annual Academy Awards ceremony in Los Angeles.

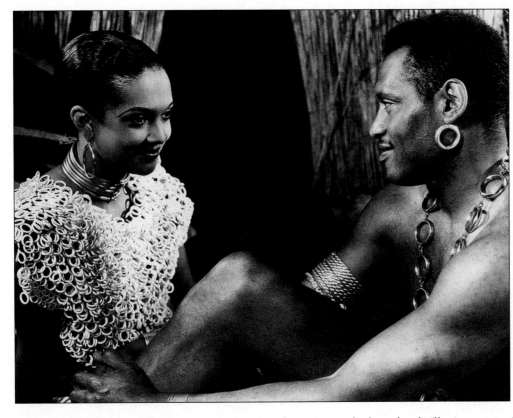

In the 1935 British production *Sanders of the River*, Paul Robeson, shown here with costar Nina Mae McKinney, played the African chieftain Bosambo. Robeson had hoped the film would portray African culture with dignity but instead found the final edit strongly slanted in favor of British imperialism.

British films as *King Solomon's Mines* and *Jericho*, both released in 1937, Robeson invariably exuded intelligence, confidence, and control. Yet with the exception of his part as a noble coal miner in 1940's *The Proud Valley*, he was disappointed with his films.

More than most black actors of his time, Robeson understood the power of images in shaping an audience's opinions. As early as 1935, he spoke out against the British imperialist theme of *Sanders of the River*, which he said had been "placed in the plot during the last five days of shooting." He tried unsuccessfully to buy the film back to stop its release. In a 1937 London interview, he expressed a broader disillusionment with his film roles up to that time. "I thought I could do something for the Negro race in the films: show the truth about them—and about other people too. I used to do my part and go away feeling satisfied. Thought everything was okay," he said. "Well, it wasn't. Things were twisted and changed—distorted. They didn't mean the same."

The last straw proved to be his 1942 Hollywood movie *Tales of Manhattan*, which presented blacks as naive, overreligious, singing dolts. Robeson said he would join any protests at its New York opening and announced he would not appear in another film. He kept his word. Although Robeson did supply the narration for a 1942 documentary, *Native Land*, he never played another film character.

Meanwhile, other black performers continued to find a far wider range of roles in race movies. As more white filmmakers moved into the market—and eventually controlled it—race movies came to resemble more typical Hollywood fare, from black westerns like the 1938 film *Bronze Buckaroo*, in which Herb Jeffries played a dashing singing cowboy, to black melodramas like 1940's *Am I Guilty?*, starring matinee idol Ralph Cooper as a smooth-as-silk hero. Still, with their black casts, the movies gave moonlighting Hollywood performers a chance at starring roles. Louise Beavers put aside her cheery domestics to portray first a widowed mother raising two sons in the 1938 movie *Life Goes On* and then a probation officer in *Reform School*, released the following year. Nina Mae McKinney, a singing star in the 1929 musical *Hallelujah*, reemerged as a sexy, vibrant leading lady in the late 1930s in such race films as *The Gang Smashers* and *The Devil's Daughter*. Character actor Clarence Muse co-wrote and

starred in a 1940 race movie, *Broken Strings*. And comic Mantan Moreland, known for his role as Birmingham Brown in the Charlie Chan movie series, took center stage in such race movies as *Mantan Messes Up* and *Mantan Runs for Mayor*, both released in 1946.

Newcomers like Lena Horne, Dorothy Dandridge, and Ruby Dee appeared in race movies before their Hollywood careers took off. So did a host of unabashed "chitlin circuit" stars who had no intention of toning down their acts to please a large white audience, from comic Jackie "Moms" Mabley to the great rhythm-and-blues star Louis Jordan. Oscar Micheaux remained one of the most active black filmmakers, but there were a number of others, among them a longtime film veteran named Spencer Williams.

It is ironic that Williams is remembered today for his role as Andy on the 1950s television series *Amos 'n' Andy*, for by the time he played that part Williams had already had a lengthy career in film. Brought up in Louisiana, he migrated west in the late 1920s, landing a job at Christie Studios in Hollywood as a sound technician. The studio was then producing a series of black comedy shorts, so owner Al Christie decided to use Williams as a writer instead.

In the 1930s, Williams earned his spurs by writing and acting in such race movies as *Harlem Rides the Range* and the black horror film *Son of Ingagi*. Then, in the next decade, he directed a series of diverse black films, including *Dirty Gertie from Harlem USA*, a 1946 drama inspired by W. Somerset Maugham's short story *Rain*. In two folk dramas, the 1941 film *The Blood of Jesus* and 1944's *Go Down Death*, Williams explored the African American religious experience. Both films offered a rare glimpse of an African American filmmaker working with material Hollywood would never have understood.

With the advent of World War II, Hollywood began to modify its depiction of black Americans as the film colony became acutely aware of its role in promoting homefront morale and America's image abroad. The Bureau of Motion Pictures, a part of the government's Office of War Information, monitored Hollywood's scripts and productions to ensure that all elements of a movie, including the portrayal of blacks, presented a positive picture of America. The bureau joined a group of blacks led by NAACP executive secretary Walter White to press for a more sensitive depiction of black characters and themes.

White also saw the importance of the career of Lena Horne. A young New York singer, Horne had appeared in the 1938 race movie *The Duke Is Tops* before signing a contract with MGM, Hollywood's most powerful studio. White believed that Horne could do much to alter the image of African American women in films, and he did not want her to end up playing maids. That did not happen, but Horne's early days at MGM were still frustrating. The studio didn't seem to know what to do with a glamorous black movie star. On a trip back east, Horne later said, she considered not returning to the West Coast. But bandleader Count Basie persuaded her to do other-

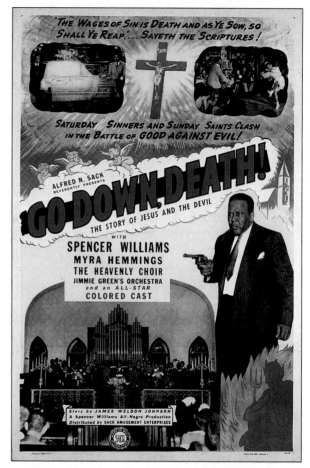

African American film veteran Spencer Williams wrote, directed, and starred in the 1944 race movie *Go Down Death* (*poster, above*), a southern tale of sin and redemption that offered one of the first serious film depictions of the black religious experience.

Actress Lena Horne (*right*) starred opposite Bill "Bojangles" Robinson in the 1943 all-black Hollywood musical *Stormy Weather*. The movie's title song became a signature tune for the glamorous—and enduring—singer and film star, who had her own show on Broadway in the early 1980s.

wise. "You've got to go back. They've never had anyone like you," she recalled Basie telling her. "They have never been given the chance to see a Negro woman as a woman. You've got to give them that chance."

Returning to Hollywood, Horne appeared in such films as *Swing Fever* and *Ziegfeld Follies*, both of which featured white stars. Horne typically would perform a song or two, usually in a special musical sequence, then disappear from the story. Should the studio feel white southern audiences might object to seeing her, the scenes could easily be cut. Still, Basie had given her solid advice. Horne became the first African American woman to be fully glamorized and publicized by her studio. For black GIs around the world, she became a pinup girl, the embodiment of the fresh-faced, wholesome young woman back home. Moreover, by appearing simply as herself rather than as a Hollywood character, Horne presented an image of a composed, sophisticated African American woman.

Horne also starred in Hollywood's two big all-black musicals of 1943, *Cabin in the Sky* and *Stormy Weather*. Neither offered a serious examination of African American life and neither was completely free of stereotypes, but both films softened and humanized the old images. Today the musicals have become classics because of their casts of legendary black entertainers: actress Ethel Waters in the singing role of Petunia, comic Eddie "Rochester" Anderson, musicians like Duke Ellington, Louis Armstrong, Cab Calloway, and Fats Waller, and dancers including Bill "Bojangles" Robinson, the Katherine Dunham dance company, and the tap-dancing Nicholas Brothers. As Horne later recalled, both films were "shown time and time again at the army camps" and to enthusiastic black audiences in the South.

A few Hollywood films treated the subject of race with a new seriousness. In John Huston's 1942 movie *In This Our Life*, a young black man is falsely accused of a hit-and-run accident; the next year sympathetic black characters appeared in *Bataan* and *Sahara*. The stereotypes of the past certainly had not vanished; black actor James Baskette, for example, won a Special Oscar for his performance as the kindly, servile Uncle Remus in the 1946 Disney film *Song of the South*. But in 1949, race relations became a hot topic for Hollywood with the release of four "problem pictures": *Home of the Brave*, *Lost Boundaries*, *Pinky*, and *Intruder in the Dust*. Although none was free of compromises or flaws, at last race had moved front and center as a movie theme. In these films, black characters no longer simply carried a tray or sang a happy tune. Instead they were presented as intelligent, sensitive, and troubled figures in movies that touched on "deep centers of American emotion," as Ralph Ellison later wrote of this period in film. Arriving on the eve of the civil rights movement, the problem pictures helped move the image of blacks in film into the modern age.

For Hollywood, the new approach took some adjusting. Ethel Waters, for example, was eager to play the part of the strong-willed and sensitive grandmother in *Pinky*. But she clashed with director John Ford, who seemed uncertain how to direct a black performer. Then studio executive Darryl F. Zanuck replaced Ford with Elia Kazan. He made the change, Zanuck once said, because "Ford's Negroes were like Aunt Jemima. Caricatures." Kazan himself recalled that John Ford "didn't know what to

do with her." Under Kazan's more supportive direction, Waters infused her character with a warmth and a compelling moral conviction. She won an Oscar nomination as Best Supporting Actress.

The emergence of Hollywood problem pictures like *Pinky* coincided with the death of race movies, which fell victim to a changing market. Now black audiences could watch African American performers in major roles in well-crafted, polished Hollywood dramas that focused on race dynamics in America. The later race movies, which for the most part portrayed insulated, all-black worlds without tensions between black and white, seemed passé.

As the long struggle for civil rights finally burst into the national headlines in the 1950s and 1960s, race relations became a still more common Hollywood theme. During this era, one African American film actor more than any other expressed the nation's growing anxieties about its racial divisions. For many, he also represented black America's aspirations for itself in a future, more open society. That actor was Sidney Poitier. Almost singlehandedly, he ushered in a new Hollywood image of the black male as a hero with a fundamental code of decency, honesty, and intelligence.

Perhaps Poitier represented postwar attitudes so well because he himself was a product of the era's belief in social progress and racial mobility. Born in Miami, Florida, the youngest of his Bahamian parents' seven children, Poitier grew up in great poverty on Cat Island in the Bahamas. As a gangly, uneducated 16-year-old, he made his way to New York with only $27 and enough money to pay for a return ticket to Miami. Living a hand-to-mouth existence, the teenager worked at an assortment of jobs—dishwasher, chicken plucker, dockhand, busboy—and served a stint in the army. One day when he scanned New York's *Amsterdam News* in search of better work, he read what he thought was a want ad: "Actors Wanted by Little Theatre Group." It was actually a news article, but when Poitier showed up unexpectedly at the American Negro Theatre on West 135th Street, director Frederick O'Neal gave him a chance to audition. Poitier gave it a try. "You're no actor," O'Neal said, as Poitier remembered the moment. "Just go on and get out of here."

Somehow, the rejection only spurred him on. "First and foremost," he later recalled thinking, "I have got to prove to him that I can become an actor. Then I'll walk away from it and go on to other things." What held him back most, Poitier knew, was his West Indian accent—so thick that people often laughed when they heard him speak. To rid himself of the accent, he bought a $13 radio. "For the next six months, except when I was working or sleeping," he later wrote, "I listened to that radio morning, noon, and night. Everything I heard, I would repeat, it didn't matter what it was."

Poitier lost the accent. Returning to the American Negro Theatre, he had a far more successful audition, becoming part of a group of postwar black actors and actresses that included Harry Belafonte, Ossie Davis, and Ruby Dee, all of whom would later take up movie careers as well. After winning some small theater roles, Poitier went to Hollywood at the age of 22 to play a plum part in the 20th Century Fox movie *No Way Out*, released in 1950. He was cast in what came to be a typical Poitier role: an educated, bright, and dedicated young man—a doctor, in this case—caught up in a heated racial situation.

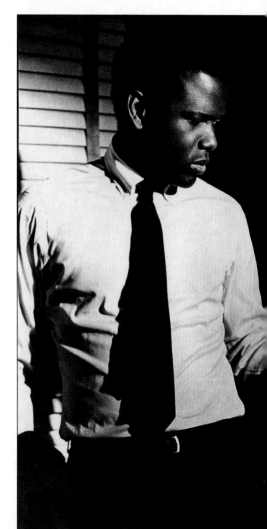

In the 1967 film **In** *the* **Heat of the** **Night**, one of the earliest to pair a black actor and a white actor as unlikely friends, Sidney Poitier played northern detective Virgil Tibbs opposite Rod Steiger as a bigoted southern sheriff. The film won an Oscar for Best Picture.

Poitier went on to a lineup of films that had an extraordinary impact on audiences, black and white. In the 1952 drama *Cry the Beloved Country*, set in South Africa, he played a young priest. When the production moved to film on location, Poitier and veteran black actor Canada Lee were only allowed to enter South Africa as "indentured laborers." Three years later, in *Blackboard Jungle*, Poitier was a pressured, but bright, inner-city student, and in *Edge of the City*, a 1957 release, he played a working man who befriends a confused white army deserter. He was a convict on the run in 1958's *The Defiant Ones*; a psychiatrist in *Pressure Point*, a 1962 release; and a polished, educated police detective in the 1967 film *In the Heat of the Night*.

Usually, he worked with largely white casts. "I made films when the only other black on the lot was the shoeshine boy," he later recalled. One of the few exceptions was *A Raisin in the Sun*, a 1961 adaptation of black playwright Lorraine Hansberry's award-winning family drama. For that film, in which he played a chauffeur, Poitier had the chance to work with a number of top black performers, including Diana Sands, Claudia McNeil, and his one-time theater colleague Ruby Dee, who played his character's wife. The film presented sensitive, groundbreaking portrayals of African American women grappling with problems such as a splintered family, a distant husband, and a quest for cultural roots and personal identity.

In the great majority of his movies, Poitier appeared to be a model integrationist hero, a paragon of middle-class values. Later, during a period when many African

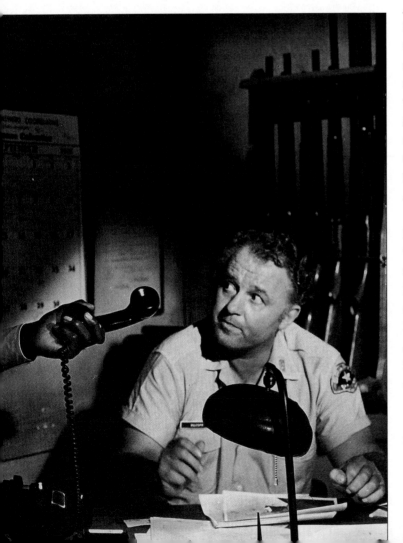

Americans took a more militant stance, complaints arose that Poitier's heroes, especially in such 1967 movies as *Guess Who's Coming to Dinner* and *To Sir, with Love*, were idealized liberal conceptions of the manageable "good Negro," a figure that accommodates to, rather than challenges, the social system. And yet, whatever the part, Poitier was also a striking dramatic force, an actor who spoke with conviction and projected intelligence and strength. Moreover, Poitier's unprecedented success openly affected the cultural mainstream. In 1963 he became the first African American to win the Academy Award for Best Actor for his performance in *Lilies of the Field*.

Even as Poitier became the dominant black presence in films of the 1950s and early 1960s, other African Americans were also making their mark. Ruby Dee gave sterling performances in such films as 1951's *Tall Target* and opposite Poitier in *Edge of the City*. Dorothy Dandridge (*pages 50-53*) became a dazzling cultural icon for her roles in the 1950s, and singer Eartha Kitt played sultry heroines in such late 1950s movies as *Anna Lucasta*, *St. Louis Blues*, and *Mark of the Hawk*. Diahann Carroll, who would later make television history as the lead character in the situation comedy *Julia* in 1968, appeared in the 1961 film *Paris Blues* and in *Hurry Sundown* in 1967.

Leading man and singer Harry Belafonte, however, suffered a curious image change on his way from the stage to the

screen. In his concert appearances, Belafonte wore tight pants and open shirts and was considered a sex symbol. But when he was cast opposite white actresses in such films as the 1957 movie *Island in the Sun* and the 1959 drama *The World, the Flesh, and the Devil*, that aspect of his onstage persona was kept under wraps. Moviegoers were titillated with the idea of interracial romance in Belafonte's films, but his characters were not developed as full-fledged romantic heroes and there were no explicit love scenes between his characters and those played by white actresses.

Outside Hollywood, a pair of independent white filmmakers directed unusual dramas, both released in 1964. Larry Peerce's *One Potato, Two Potato* homed in on the subject of interracial marriage, and Michael Roemer's *Nothing but a Man* studied the plight of an independent black man in the South who refuses to kowtow. It was not until 1968, however, that a major studio took the unprecedented step of hiring a black director, when Warner Brothers tapped Gordon Parks to direct *The Learning Tree*, a 1969 release based on his own semiautobiographical novel. Such milestones were not new to Parks, who had become *Life* magazine's first black staff photographer in 1948. In *The Learning Tree*, he movingly evoked a period and place—Kansas in the 1920s—seemingly remote in the America of 1969. The world of the film is in some ways idyllic; the young hero does cartwheels in a field of flowers. But it is also violent. In another scene, the blood of a black man shot by a white sheriff turns a creek red.

The next year, Ossie Davis directed the film *Cotton Comes to Harlem*, an adaptation of the novel by African American author Chester Himes. Afterward, a trio of dramatically different new films by black directors appeared: the 1971 movie *Sweet Sweetback's Baadasssss Song*, independently produced by Melvin Van Peebles (*pages 54-55*); *Shaft*, also released in 1971, and directed by Gordon Parks; and 1972's *Super Fly*, directed by Parks's son, Gordon Parks, Jr. These controversial black-directed films introduced new black movie icons for an age of cultural separatism and Black Nationalism: outspoken, defiant, highly sexual protagonists, able to survive on America's mean streets and in its tangled world of urban decay and crime.

The box-office success of all three films led the way to a slew of black action pictures, usually heady urban male fantasies: *The Legend of Nigger Charley* and *Slaughter* in 1972, *Black Caesar* and *Hell Up in Harlem* in 1973, and *Three the Hard Way* and *Truck Turner* in 1974. Often cheaply made—and frequently directed, written, and produced by whites—the films became known as blaxploitation movies. Criticized for their violence and their glamorization of morally ambivalent heroes, these films nevertheless touched on a basic sense of alienation in black audiences of the time by celebrating black triumphs over a corrupt system created by white America.

The popularity of blaxploitation movies hardly ruled out other dramatic roles for black performers. In 1972, the same year that some flocked to *The Legend of Nigger Charley*, Diana Ross played a troubled Billie Holiday in the romanticized *Lady Sings the Blues*, and Cicely Tyson took on the role of a sharecropper's resilient wife in the black family drama *Sounder*. Ross and Tyson both won Oscar nominations for Best Actress. So did Diahann Carroll, two years later, for *Claudine*, in which she played a welfare mother and domestic servant trying to raise six children.

Offscreen, Hollywood employed a small but growing number of black talents in

Actress Cicely Tyson was nominated for an Oscar for her performance as Rebecca (*above*), the strong and determined wife of a Louisiana Depression-era sharecropper, in the 1972 film *Sounder*. The highly acclaimed family drama was something of an anomaly during the blaxploitation period of the early 1970s.

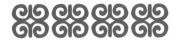

the 1970s. Another Oscar nomination for *Sounder* went to screenwriter Lonne Elder III, while poet and author Maya Angelou wrote the script for the 1972 release *Georgia, Georgia*. Black playwright Richard Wesley wrote the script for 1974's *Uptown Saturday Night*, which was directed by Sidney Poitier. Other black directors included Hugh Robertson, who had earlier won an Oscar nomination for his film editing on *Midnight Cowboy* (*page 56*), and Michael Schultz, who directed such black-oriented features as 1975's *Cooley High* and the 1976 film *Car Wash*, as well as a 1978 film based on a Beatles album, *Sgt. Pepper's Lonely Hearts Club Band*.

In the 1980s, however, black filmmakers directed fewer feature films; with the end of the blaxploitation era, motion pictures with racial themes seemed to lose their appeal for the studios. But even in this era of apparent retreat, two African American men—Richard Pryor and Eddie Murphy—emerged as major box-office superstars.

Pryor came first, with a screen success that represented the culmination of a roller-coaster career and a tumultuous private life. A high-school dropout, Pryor was an army veteran still in his twenties when he went on the stage, performing comedy in clubs and bars in the early 1960s. A slim, clean-cut, gifted storyteller with a talent for mimicry and mime, Pryor also appeared in a string of largely forgettable movies late in the 1960s.

Despite this early success, Pryor was restless and unhappy. During a performance in 1970 at the Aladdin Hotel in Las Vegas, his self-disgust suddenly surfaced, and with an angry exclamation he walked offstage. For two years he dropped out of sight, living in a room in Berkeley, California. "I read a book," he later told *Newsweek*, "called *Malcolm X Speaks*. And I knew I wasn't crazy. Someone else thought what I thought. And it freed me. I wasn't gonna stand up there and wear a tuxedo anymore. There was something better to do. I got my head out of the white man's dream."

When he returned to performing, a comic metamorphosis took place. Pryor perfected a vivid collection of characters that included numbers runners, junkies, winos, and convicts. Most spoke in earthy metaphors and in the uninhibited, profane language of the streets, and through them Pryor expressed with insightful humor the attitudes, expressions, and disillusionment of an underclass.

Pryor's movie work also took a new direction. In a series of supporting roles, Pryor gave inventive and original performances in *Lady Sings the Blues*, *Uptown Saturday Night*, *The Bingo Long Traveling All Stars and Motor Kings*, and *Car Wash*. In the late 1970s, he starred in such movies as *Which Way Is Up?*, *Greased Lightning*, and *Blue Collar*.

The film that lifted Richard Pryor into superstar status, however, was the 1976 comedy *Silver Streak*, in which he did not appear until fairly late in the action. In one now-classic comic scene, he taught Gene Wilder's character how to act black. Pryor's unique black style and attitude enlivened an otherwise lackluster film and helped launch what came to

A storyteller as much as a comedian, Richard Pryor makes a dramatic point in a scene from his 1983 concert movie *Richard Pryor . . . Here and Now*, produced three years after a near-fatal drug-related accident in which he suffered burns over half of his body.

be known as the crossover film: a movie with a black star that is made to appeal to a large, general audience rather than a predominantly African American one.

In concert films released in 1979, 1982, and 1983, Pryor remained in control of his material and image, building skits out of such painful private experiences as his heart attack, his testy romantic relationships, and the freebasing accident that nearly killed him. But he also continued to star in more limited parts in crossover films such as *Stir Crazy*, once again costarring Gene Wilder; *The Toy*; and *Superman 3*.

Throughout the 1980s, many Hollywood films cast black men with white male partners in buddy movies similar in essence to the Pryor-Wilder pairing. Interracial male bonding became a popular theme for general audiences who very much wished to believe that divisions between black and white no longer existed. Characters like the heroes of *Super Fly* and *Shaft*, operating in black worlds in which whites were viewed suspiciously, abruptly vanished from Hollywood's silver screens. It was a buddy movie, the 1982 release *48 HRS.*, with comedian Eddie Murphy and white actor Nick Nolte, that launched Murphy on a hugely successful film career.

In many ways, Eddie Murphy had much the same appeal as Richard Pryor, but he came from a very different background. The product of a middle-class, predominantly black Long Island community, Murphy grew up entertaining family and friends with impersonations and comic routines. As a teenager, he worked up a comedy act that earned him from $25 to $50 a night in Long Island clubs. By the age of 20, he had become a regular on TV's *Saturday Night Live*. The job won him a large following—and the part in *48 HRS*. The film catapulted young Murphy to superstar status. Afterward, he looked as if he could do no wrong at the box office as he dashed from one movie hit to another: the 1983 comedy *Trading Places*, 1984's *Beverly Hills Cop*, and a 1987 sequel, *Beverly Hills Cop* II.

Murphy drew audiences to him with irreverent charm, rapid-fire delivery, and unpretentious working-class attitudes and outlook. For black viewers, there was the pleasure of seeing characters that neither feared whites nor answered to them. In each film, however, Murphy's character remained an isolated black figure in a largely white context. In the *Beverly Hills Cop* movies his character has no leading lady, a lack of romantic interest that rendered the hero neutralized.

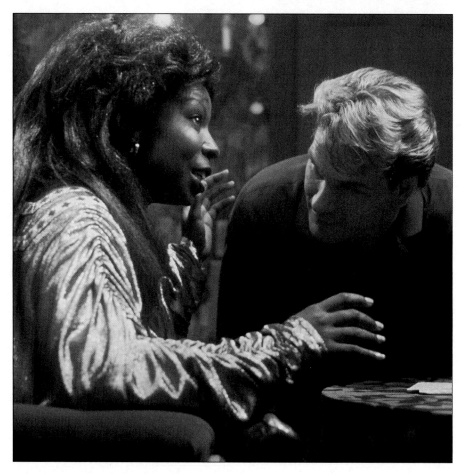

Whoopi Goldberg, playing the part of a fraudulent psychic in the 1990 hit *Ghost*, reacts as an apparition played by Patrick Swayze makes his presence known during a seance in her parlor. Goldberg won the Oscar for Best Supporting Actress for her performance.

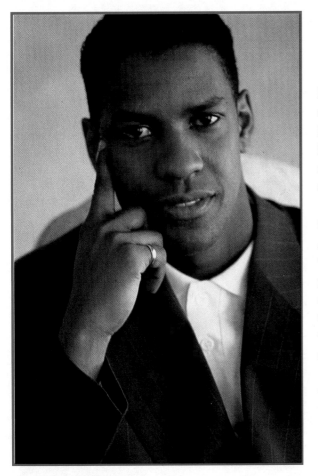

Academy Award winner Denzel Washington, who is known for the diversity of his roles, often selects parts that reflect his social consciousness, including film portraits of South African activist Stephen Biko and African American leader Malcolm X.

This changed, starting with the 1988 film *Coming to America*, followed by *Harlem Nights* (for which he was also writer, director, and executive producer) and the 1992 comedy *Boomerang*. In all of these Murphy played romantic leading men who were depicted interacting with other African Americans. Although the films themselves, much like race movies of old, seemed directed toward a black audience, white audiences enjoyed them as well.

While Murphy and Richard Pryor played major comic roles during the 1980s, only a few serious parts were available for African American actors, and these attracted top talent. Louis Gossett, Jr., won an Academy Award as Best Supporting Actor of 1982 for his portrayal of the tough drill sergeant in *An Officer and a Gentleman*, and a group of black actors—including Howard Rollins, Jr., Adolph Caesar, and the relative newcomer Denzel Washington—excelled in the 1984 film *A Soldier's Story*, which examined frictions among black soldiers on a southern army base during World War II. Beginning in 1987, veteran African American actor Danny Glover also costarred with Mel Gibson in the *Lethal Weapon* series, enormously popular buddy movies that offered considerable action and humor but less in the way of realistic drama.

The 1989 Civil War film *Glory* once again showcased an ensemble of skilled black actors, from Denzel Washington to film veteran Morgan Freeman, who has been acclaimed in some quarters as perhaps the finest actor, black or white, in America. The same year, Freeman performed memorably in *Driving Miss Daisy*, earning an Oscar nomination as Best Actor. Among his numerous other film credits, Freeman also directed the South African drama *Bopha!*, a 1993 project for which black television host Arsenio Hall was the executive producer.

Pickings were slim for black actresses in the 1980s as well. Alfre Woodard did win a Best Supporting Actress nomination for her work in the 1983 film *Cross Creek*, but her part was the familiar one of a domestic. Steven Spielberg's 1985 adaptation of black novelist Alice Walker's *The Color Purple*, however, gave African American comedienne Whoopi Goldberg her first major film role. The part was an unusually serious one, a rare attempt by Hollywood to uncover the tensions and inner conflicts of African American women. Primarily because of the way it depicted black males, the film was enmeshed in controversy. Yet Goldberg's performance won her an Oscar nomination.

Goldberg went on to become the most prominent black woman in American movies in the late 1980s and early 1990s—an outcome few could have predicted. Born Caryn Johnson in New York City, the actress grew up in housing projects, dropped out of high school, was briefly married, and had a daughter. She was determined to be an actress, however. For years she skittered about, mostly on the West Coast, in search of roles, often living on welfare and taking odd jobs. She changed her name, too. "The name came out of the blue," she later said. "It was a joke. It's like Rip Torn, you know?" In time, Goldberg became a polished solo performer, and in 1985, she triumphed on Broadway and starred in *The Color Purple*.

Once again, however, Hollywood did not seem to know what to do with the latest black actress. Goldberg floundered repeatedly in such undistinguished comedies as the 1987 film *Jumpin' Jack Flash*. Often she played odd characters without any connection to an African American community or much of a romantic life. Then, in 1990, she played a medium in *Ghost*. Her character, who helps a young white couple reunite, could easily have been the familiar black woman as nurturer, an updated mammy figure. But Goldberg's high comic voltage saved her and the picture, winning rave reviews and restarting an all-but-moribund career. For her role, Goldberg won an Oscar as Best Supporting Actress. She went on to play leading parts in major comedies.

At about the time Goldberg was resurrecting her career with *Ghost*, the leading black male on screen was unquestionably versatile actor Denzel Washington. One of three children of a Pentecostal minister and a mother who owned beauty shops, Washington grew up in Mount Vernon, New York. A graduate of Fordham, he studied theater for a year in San Francisco and later acted off-Broadway. His 1981 movie debut in the comedy *Carbon Copy* gave no hint of the skilled actor to come, but his role as Dr. Phillip Chandler on the television series *St. Elsewhere* brought him to the attention of a large viewing audience. When he appeared as a coolly militant character in *A Soldier's Story*, Washington revealed himself as an actor of unusual intensity and power.

Director Richard Attenborough then cast Washington as South African activist Stephen Biko in the 1987 film *Cry Freedom*. Washington went on to win an Academy Award as Best Supporting Actor for his role as a cynical soldier and former slave in *Glory*. He played a highly educated Jamaican detective in the 1989 film *The Mighty Quinn*, a jazz artist in 1990's *Mo' Better Blues*, and an ambitious police officer in *Ricochet*, released in 1991. In 1992 Washington triumphed again in the title role of the film epic *Malcolm X*, in which he gave an intelligently crafted performance. With the possible exception of Sidney Poitier, Washington was playing a wider range of leading roles than any other African American actor in screen history.

In both *Malcolm X* and *Mo' Better Blues*, Washington worked with another of the era's leading black movie talents, director Spike Lee. Lee, who burst onto the scene in the mid-1980s, was a product of Brooklyn. Like a variety of other African American filmmakers, some of whom are profiled on pages 62-69, Lee worked at first as an independent, raising his own money outside the studio system and retaining full artistic control. After a few student films, he hit pay dirt in 1986 with *She's Gotta Have It*, which he had filmed in Brooklyn in 12 days with a cast of unknowns on $175,000 in borrowed money.

When it opened, *She's Gotta Have It* was praised as a new type of black movie comedy. Here was the story of an independent African American woman, Nola Darling, in the midst of a romantic dilemma: Nola has three very different suitors, each of whom feels she must choose one. Nola, however, doesn't see why she can't have all three. Young black moviegoers formed lines that stretched around the block in anticipation of seeing a story rich in African American cultural references. *She's Gotta Have It* made a profit of some $7 million. Just as Melvin Van Peebles had shown in 1971 with *Sweet Sweetback's Baadasssss Song*, Lee had again proved that black audiences were waiting for movies with images they could relate to.

40

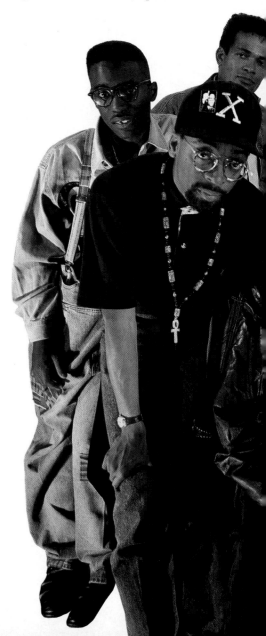

The young African American filmmakers gathered for this 1991 group photograph include (*clockwise from upper left*) Matty Rich of *Straight Out of Brooklyn* fame; *New Jack City's* Mario Van Peebles; Ernest Dickerson, who directed the 1991 film *Juice*; brothers—and partners—Reginald and Warrington Hudlin, who made the *House Party* films; Charles Lane, director of *Sidewalk Stories*; Academy Award nominee John Singleton; and, wearing a cap promoting his film *Malcolm X*, Spike Lee.

With studio backing and far more workable budgets, Lee went on to direct a series of provocative films in which he also appeared. The 1988 satire *School Daze* examined color and class attitudes on a black college campus, and the following year's *Do the Right Thing* provided a blistering exploration of inner-city racial tensions that climaxed with the very type of racial explosion that Hollywood's buddy movies had so carefully avoided. The romantic melodrama *Mo' Better Blues*, in which black actor Wesley Snipes had a supporting role, was followed by a 1991 release, *Jungle Fever*, starring Snipes in a look at interracial romance. A year later came the epic screen biography *Malcolm* X, Lee's most ambitious work yet.

By then, the Hollywood studios had opened their doors to a new wave of black filmmakers. Determined to tell their stories from their own particular points of view, these directors revitalized the American cinema with a new set of cultural references, values, and icons. The black new wave, as some called it, included tremendous diversity. New Yorker Charles Lane directed *Sidewalk Stories*, a story of a homeless street artist that won a Prix du Publique Award at the 1989 Cannes Film Festival. The same year, a woman, Martinique-born Euzhan Palcy, directed *A Dry White Season*, which examined the brutalities of South Africa's apartheid system. But it was in the next year, 1990, that the dam broke, with a flood of new and diverse releases. In that year, the critics applauded veteran director Charles Burnett's family drama *To Sleep with Anger* and Wendell Harris's *Chameleon Street*, the story of Douglas Street, a real-life impersonator who successfully posed as a surgeon and a lawyer, while director Reginald Hudlin and his producer brother Warrington made the black teen picture *House Party*, which grossed more than $26 million. The rush continued in 1991 as actor and television director Bill Duke filmed Chester Himes's novel *A Rage in Harlem*, 19-year-old Matty Rich directed *Straight Out of Brooklyn*, Melvin Van Peebles's son Mario directed the fast-moving urban drama *New Jack City*, and independent filmmaker Julie Dash directed the much-talked-about *Daughters of the Dust*.

But perhaps no film heralded the arrival of the new directors quite so movingly as yet another 1991 release, 23-year-old writer-director John Singleton's *Boyz N the Hood*. In this coming-of-age story set in south-central Los Angeles, the young hero lives in a war zone where he struggles daily to survive and to hold on to his hopes and his humanity. A success with the critics, *Boyz N the Hood* was also the highest-grossing black-genre film ever. Singleton, a graduate of the University of Southern California's film school, became the youngest person of any race to be nominated for an Academy Award as Best Director. He was also, shockingly, the first black director ever to have received an Oscar nomination.

With each decade, it seems, African American filmmakers and performers have invigorated and challenged American cinema. Starting many years ago with such filmmakers as Spencer Williams and Oscar Micheaux and such performers as Paul Robeson and Ethel Waters, the impulse to make films within a distinct cultural frame of reference has never died. Instead it is alive and well, widening the screen's range of subject matter and bringing to it a different sense of style and a particular kind of social realism that promises an even richer, fuller African American cinema to come.

EARLY BLACK MOVIEMAKING

Los Angeles's black community was thriving in the summer of 1915. The city's Central Avenue section boasted a Booker T. Washington Building, a pair of hotels, two newspapers, and so many other enterprises that the black weekly *California Eagle* headlined: "Central Avenue Assumes Gigantic Proportion as Business Section for Colored Men." The community also had its share of movie houses, but the films were largely made by whites for whites; blacks, when they appeared, were mostly portrayed as menials or dimwitted comedy characters.

That would start to change the very same year, when African American actor Noble Johnson and several partners founded the Lincoln Motion Picture Company to make films about blacks, directed and acted by blacks, for blacks. Lincoln was one of many small companies throughout the country to make films with black casts in the years that followed.

Tall, good-looking Noble Johnson was already a bit player in the movies. Brought up around horses in Colorado, the young man was working on a ranch in 1914 when a Philadelphia moviemaker on location needed someone to substitute for an injured performer. Johnson did so well—in one scene driving a runaway four-horse stagecoach—that the company signed him up for further films, usually portraying Indian or Mexican characters. As the film industry moved west, he soon was in Hollywood playing minor roles for Universal Studios.

But Johnson had stronger ambitions. With a few backers, including black actor Clarence Brooks,

A stock certificate issued in 1922 names George Johnson (*right*) as an owner of Lincoln Motion Pictures. Founded by Johnson's brother Noble and others, Lincoln was among the first black studios.

Noble Johnson, Lincoln's founder and star performer, stands with cameraman and longtime friend Harry Gant, the only white affiliated with the company.

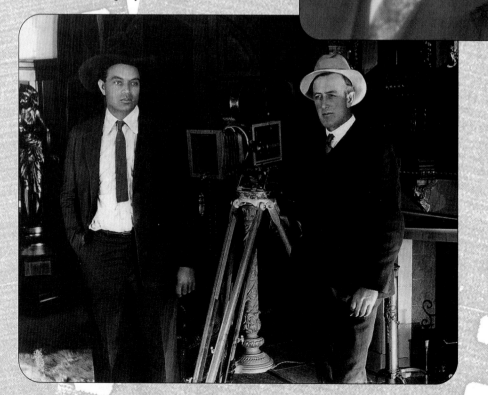

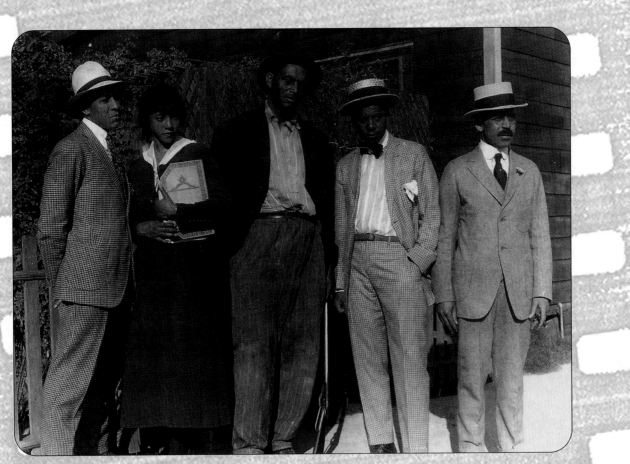

Lincoln president Noble Johnson (*holding carbine*) is joined by two of the company's stars, Clarence Brooks and Beulah Hall (*left*) and two early backers, Dudley Brooks (*second from right*) and local druggist James T. Smith (*far right*).

and a white cameraman named Harry Gant, Johnson started Lincoln Motion Pictures to create pioneering films in which blacks came across as real people.

The company's first film was ready in 1916. A short two-reeler entitled *The Realization of a Negro's Ambition*, it cast Noble Johnson in the role of a Tuskegee graduate, a civil engineer, who overcomes prejudice by saving the life of a wealthy white oilman's daughter. Rewarded with a job, he strikes oil in California, then, realizing that the same oil-rich conditions exist on his father's Alabama farm, brings in a gusher there, marries his childhood sweetheart,

and lives happily ever after.

Trite and simplistic by modern standards, *Ambition* nonetheless spoke strongly to black yearnings for acceptance and offered a new type of protagonist, a middle-class hero who believed as strongly as anybody else in the American work ethic. Produced on a shoestring budget and distributed to black theaters via friendly black newspaper editors who served as booking agents, *Ambition* struck a responsive chord with audiences. "Our patrons were surprised and delighted," declared a Chicago theater owner.

Lincoln's second film was in the same genre, but with an added dimension. For its hero, *The Trooper of Troop* K presented an undisciplined character who finds courage and purpose in the army, wins combat honors by rescuing his wounded white captain, and returns home to marry the girl

who previously thought him unsuitable. What lifted *Trooper* to another level was the all-too-real ordeal of the African American 10th Cavalry Regiment—the famed "buffalo soldiers" who had helped fight the Plains Indians after the Civil War—campaigning through northern Mexico earlier in 1916. Seeking to corral the bandit and revolutionary leader Pancho Villa, Troops C and K of the 10th Cavalry had been ambushed by Mexican forces at the battle of Carrizal; only a valiant stand staved off disaster.

Lincoln Pictures scoured the Los Angeles area for black cavalry veterans, hired enough Mexicans to make up a rival army, and staged a sensational battle scene. By now, Noble Johnson's older brother George, an Omaha postal worker, had joined Lincoln at the business end of things, expanding the distribution setup into some-

At left, Boyd's Theater in Omaha, Nebraska, advertises *A Man's Full Duty* in 1919. George Johnson, who lived in Omaha at the time, made the breakthrough that first brought Lincoln films to theaters outside of California.

Rescuing his captain in this poster for Lincoln's second film, Johnson evokes the valor of black cavalrymen who fought in northern Mexico in 1916.

THE TROOPER OF TROOP K
IN 3 PARTS

Featuring
NOBLE M. JOHNSON
SUPPORTED BY
BEULAH HALL AND JIMMIE SMITH
A THRILLING PICTURIZATION OF THE LATE
CARRIZAL, MEXICO BATTLE, BETWEEN THE FIGHTING
U.S. TENTH CAVALRY AND THE CARRANZISTA'S SOLDIERS
produced by LINCOLN MOTION PICTURE COMPANY
LOS ANGELES, CALIF.

thing like a nationwide network.

Trooper played to enthusiastic audiences. At Tuskegee, 1,600 students cheered the high quality of its production and its black theme. In New Orleans, the movie played in both black and white theaters to what was described as record-breaking crowds. In Omaha, George Johnson produced the first of a number of spectacular premieres, involving black bands and fraternal lodges and a turnout by the city's increasingly affluent black middle class.

Yet for all the success, there was little profit. Black businessmen were reluctant to pump their capital into something as risky as the movies. And with costs averaging $8,000 for each release print sent out, there never was enough film circulating to put the company on a sound footing.

Even if there had been capital for more prints, the economics of the business were borderline. Theater owners typically charged around 20 cents per seat, with 60 percent going to the movie company. Most of the houses catering to African Americans were small and the runs limited to a few

days. Thus, with a maximum of five prints per movie in circulation, every film would have to be a sellout for eight months or more just to break even.

But the Johnsons pressed ahead. *The Law of Nature*, released in 1918, continued the theme of true values in relating the tragedy of a girl who marries a ranch foreman and persuades him to move east, where she abandons him and their child for the glitter of the big city. She repents in time, and weakened by dissipation, returns to receive his blessing and die with her child in her arms.

Nature was a strong success among black audiences. But it was Noble Johnson's last movie for Lincoln. All along, he had continued working for Universal and had risen to feature billing in two of their adventure serials. Now Universal demanded that he choose between it and Lincoln Pictures; the company argued that his success in Lincoln's films was a result of the exposure he had gained in their features and serials. Johnson opted for his hard-won security at Universal. He resigned as president of Lincoln and took no further part in its affairs. George Johnson wrote and produced two more movies: *A Man's Full Duty*, released in 1919, and *By Right of Birth*, completed in 1921. Both were paeans to black rectitude, and as before, both were greeted favorably but did not make much money.

Struggling to survive, George Johnson staged gala Los Angeles premieres with all the trappings he could muster. He even charged up to two dollars a seat. But the arithmetic still did not work out, and Lincoln Motion Pictures shut down for good in 1923. Noble Johnson continued in films until 1950, then retired to travel and raise dogs. George, for his part, devoted his later years to collecting a fabulous trove of information about black filmmaking.

A son looks at his father adoringly as all ends well in this still from the company's first film, *The Realization of a Negro's Ambition*.

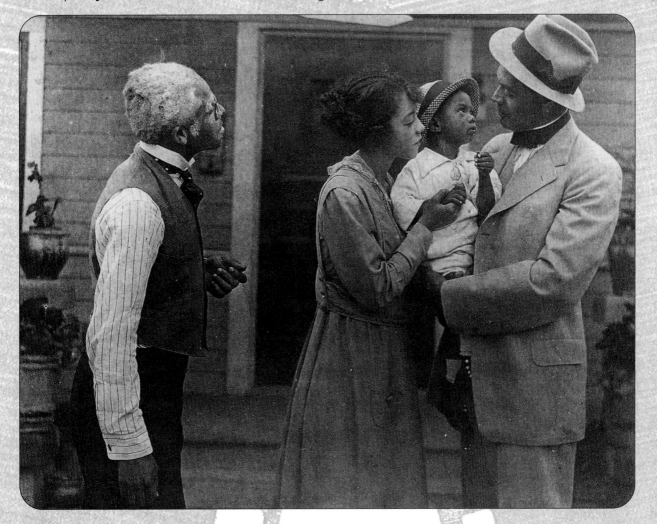

A VERSATILE FILM PIONEER

As most of Africa moved toward independence in the 1950s and 1960s, the leaders of Ethiopia and Liberia decided to hire a black American film producer, William Alexander, to record events of interest to their regimes. Alexander was known then for taking on demanding black-oriented assignments. But the movies that he made for Ethiopian emperor Haile Selassie and Liberian president William Tubman—like many of his other films—are now so hard to find that a number of them may be gone forever. And Alexander himself, whose career spanned several decades and three continents, is something of a forgotten pioneer.

Born in Missouri in 1916, Alexander grew up in Colorado. He was an enthusiastic athlete, a football player at Greeley High School, and a gymnast at Colorado State College of Education, now known as the University of Northern Colorado. Jobs were scarce when Alexander left school in 1935, but he managed to secure work in Colorado as an employee of the Depression-era National Youth Administration, a federal agency whose division for black youth was headed by Mary McLeod Bethune. The ambitious young man later found work in Washington, D.C., and moved there in 1941.

In the 1940s, William Alexander, who is shown below, right, with screenwriter-director Powell Lindsay and production manager Harryette Miller, helped create All-American News, newsreels with an African American perspective, whose opening credits featured a wide-open eye with a globe for the iris (*left*).

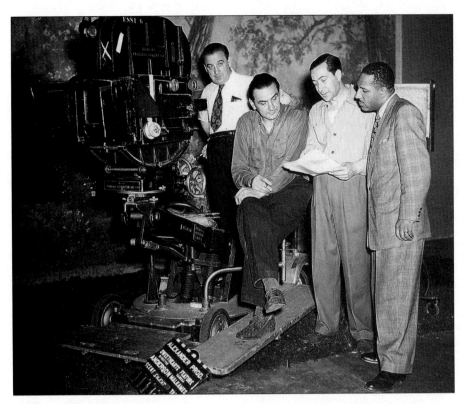

That December, the United States entered World War II, and Alexander found himself at the heart of the home-front morale effort in the Office of War Information, where he landed a job making movies related to "Negro affairs." Learning his craft as he went along, Alexander had the opportunity to work with Hollywood veteran Emmanuel Glucksman and with Claude Barnett, another young black producer, to create a series of newsreels that were intended for black viewers and distributed under the title All-American News.

Newsreels—very short films composed of several news stories—often preceded feature films in movie theaters. Most newsreels included African Americans only as comic relief. But the 45 or so produced under the All-American News title showed black Americans leading respectable, patriotic lives—Joe Louis's daughter playing the piano, for example, or author Anne Petry receiving a $2,400 prize for her novel *The Street*. Alexander himself was often seen on-screen as an interviewer or a reporter. Most All-American News pieces also included at least one war story, such as footage of the all-black 92d Infantry Division fighting at the Italian front. Decades later, Alexander estimated that All-American News reached as many as 900 black theaters across the United States.

At war's end in 1945, Alexander founded the Associated Producers of Negro Motion Pictures and then moved to New York, where he established his own company, Alexander Productions. One of his few employees was Harryette Miller, a black woman who eventually became his production manager. "The one thing about him that really stood out was his business awareness, his ability to raise money and to fund these productions—the feature films and shorts," Miller recalled in 1993. "It was this inside knowl-

edge, knowing the inner workings of the financial side and how to sell his product and ideas, that gave him an edge."

Alexander combined that fund-raising knack with what he had learned about moviemaking during the Second World War to produce an extraordinary burst of films. In 1946 alone he made *The Highest Tradition* and *The Call of Duty*, both about black soldiers, as well as two musical shorts, *Vanities* and *Rhythm in a Riff* (also known as *Flicker Up*).

In 1947 Alexander put much of his own money into his first full-length feature film, *The Fight Never Ends*, starring Joe Louis and Ruby Dee. But the film was not a success with black audiences. "Man, we lost our shirts, our underwear and our shoestrings," Alexander reminisced in a 1975 interview in *Sepia* magazine. "Joe was still heavyweight champion in those days, but we couldn't give that picture away. The brothers weren't ready because they were too busy hollering 'integration.'"

The defeat registered only briefly with the ambitious producer, however. Before the decade was out, Alexander had completed *Jivin' in Bebop*, *Love in Syncopation*, *That Man of Mine* (a musical starring Ruby Dee), and the black drama *Souls of Sin*. The cast of *Souls of Sin* included a handsome young actor by the name of William Greaves, who would later become an influential black filmmaker himself (*page 62*).

Ever on the lookout for opportunity, Alexander moved to Baltimore in the 1950s, where he had his own radio show, a rare achievement for an African Ameri-

the United States, Alexander began to look for opportunities abroad. He moved to London, formed a company named Blue Nile Productions, and became the official state producer for Liberia and Ethiopia. Over the next several years Alexander made scores of documentaries—most of which no longer exist—in both Africa and Europe.

In the early 1960s, he filmed a 12-part series for ABC TV on several newly independent African nations. He won the 1964 "short subjects" prize at the Cannes International Film Festival for *Village of Hope*, a look at a Liberian lepers' village; another prize the next year at the Venice Film Festival for *Portrait of Ethiopia*; and the 1967 United Nations Award for another documentary, titled *Wealth in the Woods*. The producer also filmed at least two European features: *The Evil Eye* in France and *River of Death* in England.

Even for the tireless Alexander, it was a busy time. He later recalled having offices in Rome and London, as well as in Addis Ababa and Monrovia, and "shuttling between them and places all over Africa" to cover, among other events, the Organization of African Unity's deliberations on the Biafran civil war. "Every time there was a meeting I was there," he remembered.

After the death of Liberia's William Tubman in 1971, Alexander returned to the United States, where he raised five million dollars to film William Bradford Huie's novel *The Klansman*, a southern melodrama on racial themes. Raising the money, said at the time to be the largest sum

can in those days. In Baltimore he met another black film enthusiast, Biddy Woods. "A man like Bill was always thinking. He always had a scheme somewhere," Woods recalled in 1993. "He spent a lot of his time thinking about what he could do next."

Alexander's next plan, as it turned out, was to join with Woods in 1951 to produce a new set of black newsreels. This time the films were made under the name Byline Newsreels and were funded in part by the Republican party; the content ranged from nonpartisan features to profiles of leading black Republicans.

Alexander also shot commercials for Ballantine Beer, Pepsi-Cola, and other companies. "I guess I filmed more commercials than anybody in America, particularly for various brands of beer," he later recalled. "But the cats didn't dig them, they wanted white people up there on the screen." The irony, Alexander noted, was that "those same commercials would be 'in' today. So I was ahead of my time."

Frustrated with his prospects in

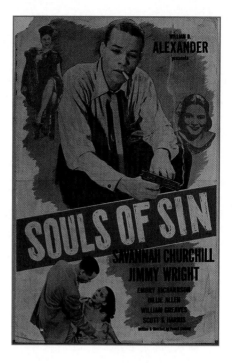

A movie poster (*left*) announces the release of Alexander's 1949 film *Souls of Sin*, a story of three black men living in Harlem. The feature was among the last in the "race movie" tradition of independently produced, black-cast films.

Alexander takes a break with director Terence Young during the filming of the 1974 film *The Klansman*, in which a young woman steps into a highly charged political situation on a trip home to backwoods Alabama.

ever put together by an independent black filmmaker, may have been Alexander's greatest success with the disastrous 1974 movie, which starred Richard Burton, Lee Marvin, Lola Falana, and O. J. Simpson. Alexander approached—and was turned down by—27 directors before Terence Young, known for directing James Bond movies, finally accepted the job. The production went way over budget, critics panned the finished film, and the box office returns were bad.

The year after the *Klansman* fiasco Alexander went to Europe to plan another collaboration with Burton and Young. The feature, called *Jackpot*, never materialized. By then Alexander was nearing 60. For the next 16 years, his friends later said, he spent much

of his energy raising funds, both for small businesses and for a proposed feature film. He died of cancer in November 1991 and was inducted into the Black Filmmakers Hall of Fame.

In the 1975 *Sepia* interview, Alexander suggested that the black-oriented action films of the era were probably a passing fad, but that the slowly expanding role of blacks in the film industry was not. "I think the black film thing—like all fads, like all sequels—will have a certain phasing out," he said. "This is my feeling. And I think there are other areas just as lucrative that can be turned to where we can prove our skills. Not only in front of the camera, but way back at the check-signing stage, gathering of financing and ownership of movies."

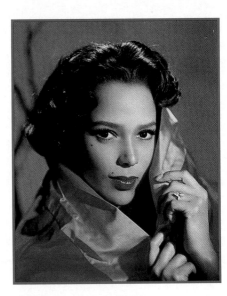

A silken cowl sets off the glowing beauty of Dorothy Dandridge in this portrait from the early 1950s made for her mother, Ruby. At right, the teenage Dorothy (*second from left*) and the other two Dandridge Sisters perform "A Tisket, a Tasket" with Cab Calloway at Harlem's Cotton Club in 1938.

A SHINING IMAGE OF BLACK WOMANHOOD

At the height of her career in the mid-1950s, actress and singer Dorothy Dandridge reigned as a symbol of cultural success for African America—one of the first black women to become a movie star, to soar at the box office, and to win an Oscar nomination in a leading role. *Life* magazine honored her with a cover; a *Time* reviewer raved: "She holds the eye like a match burning steadily in a tornado." Yet, ultimately, Hollywood was unready for such a luminous image of black womanhood. And when Dandridge died at the age of 42, her friends could say with considerable justice that she was a victim of racism.

Born in Cleveland in 1922, Dandridge grew up without knowing her father; her parents divorced when she was small. But her mother, Ruby Dandridge, devoted herself to Dorothy and her older sister, Vivian. Her fervent goal was for them to escape the drudgery that had blighted her own life. Dorothy remembered her mother saying, "You ain't going to work in Mr. Charley's kitchen like me. You not going to be a scullery maid." As a girl, Ruby Dandridge had taken part in local musical productions, and she had theatrical hopes for her daughters. One day when Dorothy was still very young, Ruby entered the two children in a recitation at a church social. The little girls brought down the house.

That was enough for mother Dandridge. She took Dorothy and Vivian, now called the Wonder Kids, on tour in Ohio and Tennessee, then moved to Chicago and on to Los Angeles. By this time the children were singing and dancing. A scout from the MGM studio signed them up for occasional movie work in such films as the Marx Brothers' 1937 comedy *A Day at the Races*. The "kids," joined by a girl named Etta Jones, now became known as the Dandridge Sisters. (Jones later went on to a successful solo

Dorothy Dandridge joins her daughter, Harolyn, in blowing soap bubbles (*above*). Tragically, the child, born to Dorothy and her first husband, Harold Nicholas (*left*), was seriously retarded from birth.

singing career.) There followed a 1938 gig at Harlem's famed Cotton Club. Also on the bill were the Nicholas Brothers, Harold and Fayard, well-known tap-dancers; Dorothy was impressed with Harold, who became her boyfriend.

The Dandridge Sisters later traveled to wartime London. Between bookings, Dorothy broke into movies—sometimes playing maid roles. In 1941, she won a small part as the girl singing and dancing "Chattanooga Choo-Choo" in *Sun Valley Serenade* with

her old colleagues the Nicholas Brothers. Harold and Dorothy, who had never lost touch, decided to get married.

Despite Dorothy's high hopes, the marriage was a disaster: Harold was unfaithful. Then came a second calamity. Dorothy gave birth to a brain-damaged daughter, whom she named Harolyn and loved enormously. But Harolyn never uttered a word, not even "Mama," and in the end, Dandridge accepted medical advice to institutionalize her child.

A top torch singer though not yet a movie queen in 1953, Dandridge shares a piano bench with composer and musical arranger Roger Edens at a Hollywood party.

The young woman was desolated—a failure, she felt, at both marriage and motherhood. "I had to prove to myself there was something I could do and do well," she said. Hurling herself into her career, she spent her days in the rehearsal hall. Black composer and music coach Phil Moore became her mentor—and lover—helping her perfect a sexy, almost whispery singing style.

But the first big opening at Los Angeles's Club Gala was another debacle. So nervous that she could not stand, Dandridge had to sing sitting down and performed feebly. The stage fright never completely vanished, but she learned to control it. A few nights later she conquered the Club Gala, becoming a huge hit. Then it was on to Hollywood's

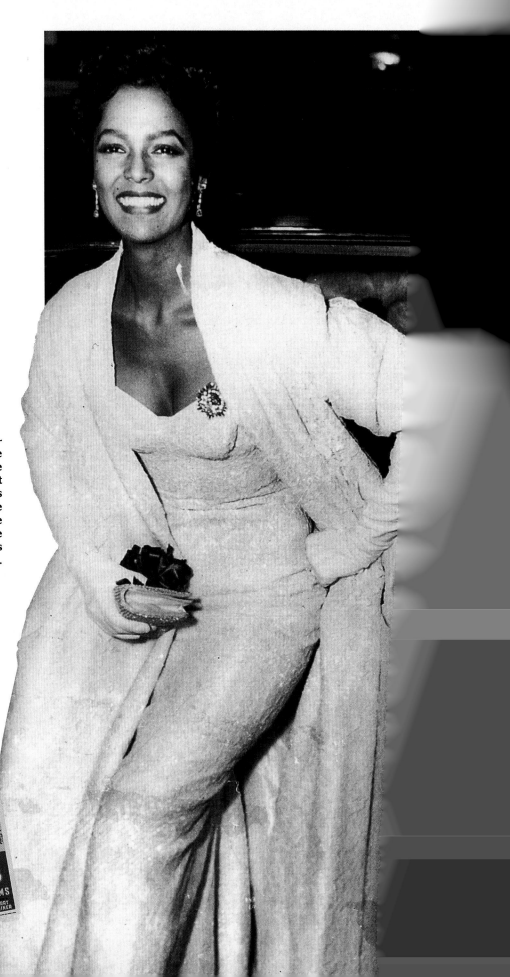

Sheathed in white, Dorothy flashes her gorgeous smile as she arrives for the New York premiere of *Carmen Jones*, the 1954 film that rocketed her to Hollywood's heights. Costar Harry Belafonte draws torrid Carmen to him in the Italian poster (*below*) to advertise the modern reworking of Georges Bizet's 19th-century opera.

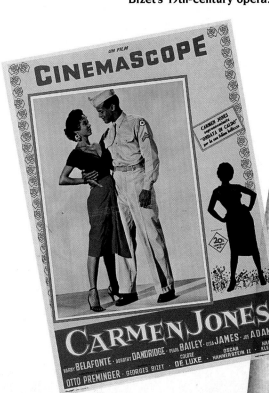

Mocambo and New York's La Vie En Rose, where she stayed for months and broke all records.

For all this success, Dandridge's real ambition was the screen, not the musical stage. "I adore singing, but I am essentially a dramatic actress," she once told *Ebony* magazine. Up to 1951, Dandridge had appeared in about 15 feature films and shorts, though never as a leading lady in a Hollywood production. That chance came—after a fashion—when she played an African princess in *Tarzan's Peril*. "Not much for someone who wanted to be Ethel Barrymore," she would later remark. She then appeared in three other films that slowly advanced her career. Finally, perseverance won her the grand prize—as Carmen in the stunning all-black 1954 musical *Carmen Jones*, based on the opera by Georges Bizet.

When Dandridge first read for director Otto Preminger, he rejected her as too classy to play the seductress who lures a nice young soldier away from duty and true love. But then she arrived heavily made-up and wearing a skintight skirt and low-cut blouse. "It's Carmen!" exclaimed Preminger, and the role was hers.

Playing opposite Harry Belafonte, Dandridge turned *Carmen* into the surprise smash of the year. "One of the outstanding dramatic actresses," applauded *Newsweek*. Wrote *Life*: "Of all the divas of grand opera none was ever so decorative or will reach nationwide fame so quickly as this sultry young lady." *Film Daily* named her one of the year's top five performers, but her real triumph came with her nomination for the Academy Award as Best Actress—the first nomination in that category for an African American.

If Dandridge thought the nomination would open Hollywood's arms to a black leading lady, she was sadly mistaken. After her great success in *Carmen Jones*, it was three years before she appeared in another film. She made five more movies between 1957 and 1962, but with the exception of her triumph in 1959's *Porgy and Bess*, all typecast her in the role of a "tragic mulatto," seemingly doomed because of her black blood. Dandridge, who in real life involved herself with both black and white lovers, was the first black actress to find herself in the arms of white heroes on-screen; however, the movies nearly always avoided kisses.

Dandridge returned to night-clubs, but, detesting the work, started to drink heavily. In 1959, hoping again for domestic happiness, she married a white man, a onetime maître d' named Jack Denison, who owned a club on Hollywood's Sunset Strip. As it turned out, Denison wanted her to sing for her supper, which she did at first; then she divorced him in 1962. The marriage had drained her financially as well as emotionally, and she filed for bankruptcy.

Her last years were spent in a haze of alcohol and hassles with the Internal Revenue Service and various creditors. She died of an overdose of an antidepressant on September 8, 1965, only two months short of her 43d birthday. Whether the overdose was an accident or suicide is debatable. In a broader sense, her death might be attributed to a number of forces: Racism as well as her own personal demons brought an end to the life of a woman whom at least one critic has called Hollywood's first authentic black woman movie star.

Still lovely at 42, although burdened by years of sorrow, Dandridge applies a little makeup on a September morning in 1965, before returning home from the hacienda of a movie producer in Mexico. She seemed in fine spirits as a photographer portrayed her by a sunny window. Within days, she was dead.

DEFYING EXPECTATIONS

In the fall of 1971, director Melvin Van Peebles redefined Hollywood's approach to black audiences with a single film, *Sweet Sweetback's Baadasssss Song*. No studio had been willing to back the project, so Van Peebles shot it independently for $500,000, with himself in the title role of a black man standing up to the system. But when his graphic tale grossed more than $11 million, the studios thought again.

That professional triumph had been hard won. The Chicago-born Van Peebles, who graduated from Ohio Wesleyan in 1953, spent a few years as an air force navigator with the Strategic Air Command. By the time he left the service in 1956, he had married and had two children. Unable to find a civilian aviation job, the 24-year-old black veteran became a cable-car operator in San Francisco.

Van Peebles's interest in the visual arts—and specifically movie-making—was sparked when he and a photographer friend developed a book about cable cars. He went on to make a few film shorts that earned the respect of connoisseurs, but when Hollywood was unreceptive, he moved his family to Holland in 1959. For a while, he acted with the Dutch National Theater. Then he and his wife separated and Van Peebles moved to Paris to try to launch a directing career.

Because the French automatically granted a film director's union card to authors who wanted to film their own books, Van Peebles, shown at right during this period, spent years grinding out five novels in French, panhandling, and performing in cafés to survive. In 1967, a film treatment of his book *Story of a Three Day*

Pass finally earned him a director's license and a grant. The movie, a bittersweet tale of a black GI's weekend with a white French girl, won a San Francisco International Film Festival award.

By now, Hollywood was interested in black directors. Columbia Pictures hired Van Peebles to direct the 1970 film *Watermelon Man*, the tale of a white bigot who awakens one morning to discover he's become black and gains a new perspective. Van Peebles later said he made that movie "in order to do the films I really wanted to do." He was referring to *Sweetback*. "All the films about black people up to now have been told through the eyes of the Anglo-Saxon majority—in their rhythms and speech and pace. They've been diluted to suit the white majority, just like Chinese restaurants tone down the spices to suit American tastes," Van Peebles said in a 1971 interview. "In my film, the black audience finally gets a

chance to see some of their own fantasies acted out."

In the film, Sweetback—a quiet man who lives and works in a brothel—sees two white policemen beating another black man one night. Stirred to action, he attacks the officers with their own

54

At left, Melvin Van Peebles in the role of Sweetback runs from the white man's justice; unlike black outlaws in other films, Sweetback gets away.

Two generations of filmmakers, Mario (*below left*) and father Melvin Van Peebles sit side by side in front of posters advertising Mario's 1991 film *New Jack City* and Melvin's *Sweet Sweetback's Baadasssss Song.*

handcuffs. Sweetback goes on the run, with plenty of fights and sexual encounters along the way. Then comes the plot development that defied all audience expectations: Instead of being killed or captured, the black rebel gets away. Van Peebles had created a mythological street-culture hero, as he once said, "for those dudes in the chartreuse suits."

The film had a gritty, unconventional feel. Van Peebles, who also wrote the script, shot it in 19 days, with nonunion actors in many roles, including his son Mario as the 12-year-old Sweetback. When the film was first released in March 1971, only two major theaters would show it. But Van Peebles launched his own publicity campaign, and by the fall it was available nationwide.

Not everyone liked the movie. Many middle-class blacks attacked Van Peebles for depicting tawdry black street life without explaining the forces that create it. White and black movie critics

condemned *Sweetback* for its raunchy tone and violence. Yet black audiences flocked to see the film in record numbers, and Hollywood, hungry for a share of that audience, began churning out new black action films and launched the "blaxploitation" era.

Van Peebles himself was on to other things. In the early 1970s, he produced two Broadway shows—*Ain't Supposed to Die a Natural Death* and *Don't Play Us Cheap*—that won him 11 Tony award nominations. He also took on a number of television and record projects, and off-Broadway directed 1981's *Bodybags* and his

own 1982 play *Waltz of the Stork*, in which he starred with his son.

All his life, Van Peebles has remained hard to pin an occupational label on. In the early 1980s, for example, he became the only black trader on the floor of the New York Stock Exchange. He has also taken up painting and running marathons while continuing to participate in films and plays that have sometimes paired him with Mario, who in 1991 became the family's second film director with the critically acclaimed urban drama *New Jack City.* Mario directed his father two years later, in the 1993 release *Posse.*

STELLAR ACHIEVERS BEHIND THE SCENES

"There are very few Negroes working on the technical and production sides of film-making," wrote the NAACP magazine the *Crisis* in 1946. "There have been one or two Negro writers, a few musicians and a handful of dance directors." Barred by segregated unions, black Americans found it all but impossible to land Hollywood jobs.

The number of black craftspersons began growing after the civil rights movement, partly due to support by black directors, but there is still a long way to go. In 1991, black filmmaker William Greaves wrote that behind the scenes, "the employment of people of color" like the award-winning specialists shown here and on pages 58-61 "is woefully less than it could be."

Hugh Robertson—Film Editor

Actors, scriptwriters, and even some directors grouse about how much of their work winds up as scrap "on the cutting room floor." The person who consigns it there is the film editor—the specialist charged with meshing the various takes into an artistic whole, working the creative magic that transforms rough cuts into finished film.

Hugh Robertson was one of the first blacks to make it big in film editing, entering the industry when he was 17 years old. He went on to study at New York's New Institute for Motion Pictures and Television, and honed his skills at the Sorbonne in Paris and the Negro Actors Guild in New York.

Because of his race, however, it took Robertson 11 years to get his union card. He applied to New York's Motion Picture Editors Local 771 in 1949 and was turned down cold. Undaunted, he assisted white film editors with such movies as *Twelve Angry Men*, *The Fugitive Kind*, *Middle of the Night*, and *Odds against Tomorrow*. At last, in 1960, he received his union card. "The old regime finally got voted out and I got in," he said.

Robertson quickly was hired as associate editor for *The Miracle Worker* and *Lilith*. Then came a real break when director John Schlesinger asked him to edit the 1968 movie *Midnight Cowboy*. So outstanding was Robertson's work that both the U.S. and the British motion-picture academies nominated him for awards; he won the British Film Academy Award, but not the American Oscar. He next was responsible for editing Gordon Parks, Sr.'s riveting 1971 film *Shaft*, a classic of the black action genre.

Considering all the fundamental decisions a film editor has to make, it was only a short step to directing his own films. Robertson made three: *Melinda*, for MGM in Hollywood, and *Bim* and *Obeah* for his own production company in Trinidad, to which he moved in 1974, seeking greater artistic freedom. All three were well-received dramas, with blacks in charge at every level.

The Black Filmmakers Hall of Fame welcomed Hugh Robertson to their ranks in 1982. Six years later, he succumbed to cancer at the age of 55.

Floyd Norman—Animator

"I used to draw on the walls," animator Floyd Norman once recalled. "Since the drawings seem to start near the floor, I have to assume I started pretty young." Judging from the quality of his later achievements, Norman must also have started pretty good. He went on to a distinguished career as a cartoon animator and, like Hugh Robertson, an honoree of the Black Filmmakers Hall of Fame.

Born in Santa Barbara, California, in 1935, Norman was starting his third year of college and working for a cartoonist when, as he remembers it: "I received a terrific offer to come work at Disney for 40 bucks a week. How could you pass that up? I even got the call while watching *The Mickey Mouse Club*. Talk about destiny." He began working for Disney in 1956.

Norman soon found he adored the work: drawing Tinkerbell for the televised *Mickey Mouse Club* and Jiminy Cricket for the *Disneyland* television show, working on *Sleeping Beauty*, *101 Dalmatians*, *The Sword in the Stone*, *Mary Poppins*, and doing the tiger Shere Khan and the python Kaa for *The Jungle Book* (right).

In 1966, after 10 years with the company, Norman and black artist Leo D. Sullivan started Vignette Films to produce educational films about such famous African Americans as poet Paul Laurence Dunbar and composer W. C. Handy. They succeeded for a decade, but then hard times put the company under. Norman went on to Hanna-Barbera, drawing Saturday-morning television cartoons on *The Flintstones*, *The Smurfs*, and *Scooby-Doo*. He also did animations for just about everything else: *Sesame Street*, *Laugh In*, Bill Cosby's *Fat Albert Show*.

Then, in the early 1980s, Norman returned to the Walt Disney Company, this time designing and writing comic strips and children's books. He sometimes wonders where the time went. "I remember hearing people say, 'Oh, that's one of the new young kids.' Then there's a quick cross-dissolve and I hear a couple of young artists saying, 'Oh, that's one of the old-timers.' I went from being the young kid to an old-timer. Zip!"

Russell Williams—Sound Mixer

Among the honors on the table before Russell Williams in the photo below stand an Emmy and two Academy Awards. Williams is the first African American to win two Oscars. Even more impressive, he managed to achieve the feat in successive years—for the 1989 Civil War epic *Glory*, and for the 1990 release *Dances with Wolves*.

Raised in Washington, D.C., and educated at American University, where he earned a BA in film production, Williams spent six years around the capital before heading west to set up the Sound Is Ready Company. Specializing in live sound, he offered producers the know-how and the complex equipment needed to capture it flawlessly.

The task can be extraordinarily difficult, especially on location. Doing *Wolves* in South Dakota, Williams's sensitive equipment was subjected to pervasive dust and temperatures that ranged from 100 degrees plus to a bitter 15 below. Worse, the whistling prairie wind threatened to overlie every scene.

Defeating the elements in *Wolves* was no mean triumph, but according to Williams, doing *Glory* was "my most exciting time as a filmmaker." He had read about Massachusetts's heroic all-black 54th Infantry Regiment in history books. "But to actually be a part of the filming," the sound mixer later recalled, "to show folks that whites didn't give us anything here, that we'd been part of the process"—that spoke to Williams directly.

The problems of recording dialogue aside, the task was to re-create an 1863 auditory effect while filming in the late 1980s in Savannah, Georgia. At every level, the modern cacophony had to be blocked out of the track by sounds that were appropriate to the period: the rumble of wagon wheels, a blacksmith's clanging hammer, marching men, distant commands. Some of this could be found in sound libraries, but much of it had to be recorded afresh. And sometimes, the overlays were not enough. "You can't do Gettysburg with a DC-10 overhead," Williams recalled. "I insisted on rerouting bus and airplane lines."

In his first 14 years in Hollywood, the master sound man brought his expertise to seven major films, five television movies, and four documentaries. Williams gets a great deal of satisfaction out of the fact that directors now send him scripts—"just like I was an actor."

Ruth Carter—Costume Designer

"I'm strictly on the realism side," says costume designer Ruth Carter. "I like re-creating your grandmother, your aunt, your uncle, that alcoholic on the corner."

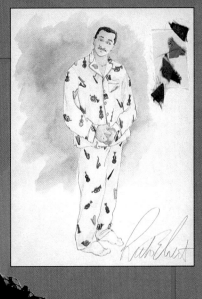

Ruth Carter's dedication to realistic detail brought her an Academy Award nomination for Best Costume Design for her work on the 1992 film *Malcolm X*, making her the first African American costume designer to be so honored. That same year, at age 33, she became a full voting member of the Academy of Motion Picture Arts and Sciences itself.

Carter had come a long way from a childhood in near poverty in Springfield, Massachusetts. Life for her divorced mother was a never-ending struggle just to keep a roof over the heads of her eight children. Mother's old sewing machine was teenage Ruth's only ticket to the trendy fashions of the 1970s. "If I wanted that patchwork jeans jacket, I had to make it," she recalled. By the time she was in college at Virginia's Hampton Institute, she was enough of a seamstress to produce the costumes for a school play. "Once I did the costumes, I just kept doing it for everybody," she said. Carter became the first student in Hampton history to pursue a formal course in costume design; the program she pioneered was later integrated into the university's Theater Arts curriculum.

Carter was working as assistant resident designer for the Los Angeles Theater Center when Spike Lee offered her a chance to costume his 1988 film *School Daze*. She put her touch on each of Lee's next four films, and she also did costumes for the 1993 action comedy *Meteor Man* (*inset, far right*) and Tina Turner's sizzling miniskirts for *What's Love Got to Do with It* (*inset, near right*), released the same year. Designing clothes to fit Turner's larger-than-life personality was a challenge, but Carter's best assignment was creating outfits for Lee's *Malcolm X* (*below*). "It was my favorite because of the adventure, because of the research," the costume designer later recalled. "I went to the Department of Corrections and got Malcolm X's file—his life for eight years while he was in prison was handed to me. And the top thing in the file was his booking picture when he was 17. Those memories I will cherish for the rest of my life."

Ernest Dickerson—Cinematographer

Even as a child, Dickerson was fascinated as much by the overall look of a film as by its performers and story line. When he discovered that cinematography is responsible for setting a movie's mood, he knew what he wanted for a career. "It seems like all the arts come together in film," he would observe later. "Photography, painting, design, construction, architecture. They all come together in film."

As director of photography, the cinematographer needs a vast knowledge of lighting, optical principles, and camera equipment to put the story on film with exactly the right effects of color, composition, and movement. A cinematographer plots every camera move and every sequence, and then carries it all out with the camera crew. On a Hollywood set, this specialized craftsman is second in command only to the director, and he is the first person the director and producer choose when they are putting together their team.

The first requisite for successful cinematography, Dickerson has said, is to have a vision of how scenes should come out on film. "You have to train yourself to *see* first. All the camera does is record what you're looking at," he points out. "But you have to see it first. It's not a shot in the dark."

Dickerson is noted for his brilliant use of the palette to define a movie's ambience. "I always like to use color to tell the story, or support the story," the cinematographer says. "Not just taking color like it is, but manipulating it and controlling it so it really becomes a part of the story."

Dickerson started learning his craft as an undergraduate at Howard University. He majored in architecture—"that prepared me for anything"—while keeping a minor in photography. Next came New York University's graduate film program, and in 1982 an MSA in cinematography.

His academic credentials notwithstanding, Dickerson strongly believes that "the only way you can learn cinematography is to do it." Like a number of skilled African American movie talents, he got much of his on-the-job training with Spike Lee. Dickerson signed on to do the camera work for the 1988 film *School Daze* and was with Lee on every movie through *Malcolm X.* Like Ruth Carter, he regarded that film as "the fulfillment of a dream."

Colleagues acknowledge Ernest Dickerson as one of the best, and when he was invited to join the American Society of Cinematographers in 1990 at the age of 39, he was the youngest person ever to enter their ranks. By then, however, he had set his sights on a more visible leadership role. "Directing is the ultimate," Dickerson says. In 1991 he made his directing debut with the urban drama *Juice.*

Wynn Thomas—Production Designer

The union exam given by United Scenic Artists Local 829 in New York was daunting. "You had to be able to draw pictures," said Wynn Thomas, remembering the test in 1981. "You had to be able to do architectural drawings. You had to be able to paint. You had to be able to build models. All those skills were tested."

Thomas, a 28-year-old African American with a BFA in theater design from Boston University, did not make it the first time, nor the second. But make it he did. "I think I was the first black in 25 years to pass that exam," he recalled. But there was one benefit to being the only black at union meetings: People remembered him.

That was how he got his chance. He once saw the production designer for Francis Ford Coppola's 1984 film *Cotton Club* at a union meeting, phoned him the next day, and said, "Hi. My name is Wynn Thomas. Remember the black guy at the meeting yesterday?" The designer did. He agreed to look at Thomas's portfolio and was impressed. He also happened to have an emergency job building set models for the *Cotton Club* production.

Thomas took it from there, and by 1993 had served as production designer or art director on at least 14 films, from Spike Lee's *School Daze* and *Malcolm X* to Andrew Davis's *Package* and Robert De Niro's *Bronx Tale*. (Thomas is shown with De Niro below.)

As a critical member of the creative team, Thomas has ultimate responsibility for translating the director's ideas into a physical environment. He draws and makes models of the design and builds the sets. He often finds and decorates the locations, and because he supervises a large staff, he plays a crucial role in every budget.

Thomas relishes the enormous challenge. Take, for example, the problems of re-creating the 1940s-era streets of Boston for *Malcolm X* (*below*). "Not only do you need to be concerned about what items are going to be in the storefront," Thomas later recalled, "but also what do the bell bottoms look like? What do the streetlights look like? How were the cars different? You have to be concerned with the very broad details as well as the more minute ones." That sort of re-creation, Thomas has said, "giving definition to different characters in different times and places, makes for a very satisfying livelihood."

A DIFFERENT VIEWPOINT

Michelle Parkerson (*page* 65) was an undergraduate film major at Temple University when she won a major student award for her movie *Sojourn*—and gained a powerful sense of affirmation. "You can do this," she recalls saying to herself. "You can make your own version of a history that has been manipulated and mutilated and stereotyped since films began." The same words apply to the work of a number of black directors and producers who have been making movies outside the Hollywood mainstream—and without studio backing—since the 1960s.

Although these independent filmmakers continue the tradition of race-movie directors like Oscar Micheaux and Spencer Williams, they offer a distinctly modern vision. The accepted dean of the movement, William Greaves (*below*), got his start behind the camera in the 1950s, while some of those profiled here and on the following pages made their first cinematic statements in the 1980s. Independence means a constant quest for grants and other sources of financial support, but for these artists it also means freedom to "retell history," as Parkerson put it, in words and creative images that reflect their personal visions.

WILLIAM GREAVES

William Greaves's surrealistic feature film *Symbiopsychotaxiplasm: Take One* premiered in 1991. A multilayered experiment centering on two actors playing a married couple, the innovative film also shows the crew that is filming the actors on location and includes abrupt appearances by police and even a homeless drunk. The movie has been shown at film festivals around the world, but for Greaves, its release was bittersweet: Completed in 1968, it had gone undistributed and thus unseen for 23 years.

That long limbo is only an extreme example of the obstacles Greaves faced on the way to completing more than 200 films, many of them documentaries. An actor in some of the last race movies, Greaves was frustrated by the lack of other film opportunities and went to Canada in 1952 to work for the National Film Board. While there he served in various roles—including director and editor—on more than 80 films. He returned to the United States eight years later to make films for the United Nations, and in 1964 he formed William Greaves Productions to make movies on his own.

Greaves took a detour into the world of television in 1968 when Boston public television station WNET decided to develop *Black Journal*, a black-oriented news show with Greaves as cohost and executive producer. He later proudly recalled its influence on a rising generation of black film professionals. Under Greaves's stewardship, *Black Journal* was awarded an Emmy in 1969.

Greaves left *Black Journal* in 1970 to pursue independent filmmaking full-time. In the years that followed, he filmed dozens of black-oriented documentaries on such subjects as Frederick Doug-

lass, Booker T. Washington, and pioneering journalist Ida B. Wells. He also made documentaries on the Harlem Renaissance, the first Ali-Frazier fight, the first National Black Political Convention in 1972, and even the First World Festival of Negro Arts in Dakar, Senegal. In a rare Hollywood foray, Greaves also served as executive producer of the 1981 film *Bustin' Loose.*

A member of the Black Filmmakers Hall of Fame, Greaves was further honored in 1991 with a retrospective of his work at the Brooklyn Museum under the title "Chronicler of the African-American Experience." In noting that he planned to continue chronicling, he pointed out that recording history was "one of the major reasons I went into film production in the first place."

KATHLEEN COLLINS

By the time Kathleen Collins died of cancer in 1988 at the age of 46, she had already inspired a generation of black American women filmmakers. Born in Jersey City, New Jersey, Collins majored in religion and philosophy at Skidmore College in Saratoga Springs, New York. She then began her lifelong involvement with film, earning a master's degree in French cinema and literature at the Sorbonne in Paris in 1965.

Collins then found work as a member of the production staff of a New York public television station, but she wanted to branch out on her own. In 1971 she wrote her first film script for an inde-

pendent feature. Collins knocked on doors for a year, but as she later recalled, "Nobody would give any money to a black woman to direct a film." She remembered this period as "probably the most discouraging time of my life."

In 1974 she left public television to teach film history and screenwriting at the City College of the City University of New York. Six years later, with renewed enthusiasm and $5,000 in loans from friends, Collins completed her first feature, the 1980 film *The Cruz Brothers and Mrs. Malloy.* An adaptation of a novel by Henry Roth, the film tells the story of three Puerto Rican brothers, their late father—who appears to them

as a ghost—and an elderly woman who hires the brothers to fix up her home.

Two years later came a second film, *Losing Ground,* which portrayed an African-American college professor seeking her own identity apart from being the wife of a painter and the daughter of an actress. *Losing Ground* was awarded first prize at Portugal's Figueroa Da Foz International Film Festival in 1982. Collins, who also wrote a number of plays, once said that her work was based on a "belief that what I see personally, if I can be very faithful to that, and manage to find a way to say it, will mean something to other people."

When he started making films in the late 1960s, St. Clair Bourne had already lived through some real-life drama of his own. Bourne, who grew up in Harlem, was a junior at Georgetown University in Washington, D.C., when he was expelled for participating in an Arlington, Virginia, sit-in. He promptly joined the Peace Corps and spent two years in Peru, becoming something of a celebrity within the agency when he was profiled in a 10-page *Ebony* magazine feature. Afterward, he completed his college degree at Syracuse University. It was not until 1967 that he began studying filmmaking full-time as a Columbia University graduate student. A year later, at the age of 25, Bourne became the youngest associate producer hired to work with William Greaves on the public television news show, *Black Journal*.

In five months, Bourne was promoted to producer. He stayed at *Black Journal* for three years, then left in 1971 to form his own film production company, the Chamba Organization, founding the *Chamba Notes* newsletter for black independent filmmakers shortly thereafter. His first independent film, *Let the Church Say Amen!*, told the story of a young black minister just starting out in his career. It became the first film by a black director to be included in the Whitney Museum's New American Filmmakers Series—a major showcase for independent filmmakers.

In the next two decades, Bourne filmed more than 30 documentaries, including *In Motion: Amiri Baraka*; a biography of Langston Hughes; and *The Black and the Green*, an account of African American civil rights workers on a trip to Northern Ireland. "I think that the struggle to have a group's story told by a member of that group has really been won," he told an interviewer in 1989. "Now I think it's time for 'minorities'—which is a word I hate—or 'people of color'—which is the term I prefer—to tell a 'totality' story, and that includes telling the story of what's happened to white people." Bourne went on: "I've got a couple of film projects where there are black characters, but which are really stories about white people—but from a black filmmaker's understanding of who these people are. That's the new battlefield, and that's where I'm headed."

ST. CLAIR BOURNE

MICHELLE PARKERSON

My mother was the first person who turned me on to really scrutinizing film," director Michelle Parkerson recalled in 1991. "I learned a lot about the awesome power of film over the spectator from her and to associate names with what I was looking at in terms of craft." After graduating from Temple University, Parkerson spent several years as a television producer before releasing her first independent film, *But Then, She's Betty Carter*, a 1980 tribute to the jazz vocalist. In the movies that followed, she continued to provide compelling portraits of performers, most of them women.

Parkerson's 1983 documentary *Gotta Make This Journey*, for example, captured the beauty and political harmony of the female a cappella singing group Sweet Honey in the Rock (*pages* 124-125), while 1987's *Storme: The Lady of the Jewel Box*, offered the surprising story of a black male impersonator. In *A Litany of Survival*, Parkerson paid tribute to a personal hero, African American poet and essayist Audre Lorde. At the time the film was being made, Lorde was battling cancer; the poet died in November 1992, before the film's release.

No matter what the subject is, Parkerson strives "to get people to be very candid," as she once put it, describing her working methods. "That's the meat of the documentary, when people open up and you see what really makes them tick, or what really has destroyed them or what really has elevated them or made them angry or inspired them."

Parkerson is also a poet and a playwright and has taught at colleges. Still, her greatest interest is film. "*Moving* pictures, that's what I'm after," she explains. "Stuff that disturbs people or makes them explore something different or makes them do something to support a particular cause or group or go out and buy the records of an unsung heroine. You've done your job when people respond in that kind of way."

Haile Gerima translates the word *Sankofa*, the Akan-language title of his evocative 1993 film on slavery, as meaning "returning to your roots, recuperating what you've lost and moving forward." It is also an apt summary of the philosophy he has adopted as a black filmmaker.

Born in the small Ethiopian village of Gondar in 1946, Gerima emigrated to the United States in 1967 to study drama in Chicago, but found himself frustrated by a limited, white-oriented curriculum. He enrolled at the University of California at Los Angeles two years later, but the young drama student was still unhappy. "As an actor I didn't have much power," Gerima later explained of his stage work. Film "reaches more people," he has also

said. "Images are the simplest way to communicate." To achieve his professional aims, Gerima decided to become a film director.

In 1974, while on a summer vacation in Ethiopia, he and a small group of friends and amateur actors put together Gerima's first major independent production, a docudrama about Ethiopian rural life entitled *Harvest: 3000 Years*. The film was shot in two weeks, but Gerima spent more than a year editing it. *Harvest: 3000 Years*, which premiered in 1976 at the New Directors/New Films series at the Museum of Modern Art in New York, received the Oscar Micheaux Award for Best Feature Film from the Black Filmmakers Hall of Fame as well as several international awards.

By then, Gerima had begun teaching filmmaking at Howard

University in Washington, D.C. In the years that followed, he made such documentaries as the 1978 film *Wilmington 10—USA 10,000*, a two-hour account of jailed Americans whom he sees as political prisoners, as well as more dramas, like the compelling *Ashes and Embers*, a 1982 film about a black Vietnam veteran.

For Gerima, independent filmmaking remains an essential source of African American images and ideas. "We must understand that Hollywood cinema has always been escapist," he wrote in 1982. "In the pursuit of this escape and entertainment, black and other oppressed social groups have been victimized." It is the role of black directors, he added, "to deal with our reality and not help to perpetuate the misery of black people."

HAILE
GERIMA

AYOKA CHENZIRA

Whether she is producing animation, live-action drama, or documentary footage, says African American filmmaker Ayoka Chenzira, her goals are the same: "to entertain, to encourage, to wrestle with ideas, and to make dreams visible."

She did all four in her first well-known film, the 1984 short *Hairpiece: A Film for Nappy-Headed People*, a lively bit of animation on the tender subject of black women's self-image and hair styles: "The reshaping of ourselves to try to fit in," as Chenzira later said. The year that *Hairpiece* appeared, Chenzira became one of seven writers and directors

chosen from a field of 500 to attend the prestigious Sundance Institute. After 10 years of work in the New York film industry, the Columbia University graduate was on her way.

Chenzira's later projects can only be described as varied. Her 1985 docudrama *Secret Sounds Screaming*, for example, explored the sexual abuse of young Americans. Three years later, *Boa Morte*, literally "good death," examined a Brazilian mutual aid society that is among the oldest women's organizations in the Americas. *Zajota and the Boogie Spirit*, released in 1990, combined film, video, and computer graphics to depict the

transatlantic slave-ship passage. Chenzira's technical flair, creative vision, and eye for beauty won her an Innovator's Award from the Sony Corporation the following year. An assistant professor at the City College of New York, Chenzira also took time at one point to organize a festival of African American cinema that toured 14 countries in Africa.

"To me it's real simple," Chenzira says of the inspiration that animates her many activities in the film world. "I'm a person here on the planet who's here working out some stuff. I come to film thinking of it as an art form. My work comes from a very private place."

CHARLES BURNETT

Not everybody has fantasies about judo-chopping someone to death," filmmaker Charles Burnett said in 1991, referring to Hollywood's hugely profitable action films. Instead, "we need stories dealing with emotions, with real problems like growing up and coming to grips with who you are."

Born in Vicksburg, Mississippi, in 1944, Burnett moved with his family to southern California three years later and spent the rest of his childhood in the Watts section of south-central Los Angeles. "You grew up seeing a lot of your friends getting into trouble," Burnett has recalled of his youth. "I really liked a lot of the kids I grew up with. I felt an obligation to write something about them, to explain what went wrong with them. I think that's the reason I started to make these movies."

Burnett studied film as an undergraduate at the University of California at Los Angeles. He went on to become one of the first wave of African Americans to complete UCLA's graduate film program, receiving his Master of Fine Arts in 1973 and completing his first feature film, *Killer of Sheep*, the same year. (It was released four years later.) Supported by a Louis B. Mayer grant, *Killer of Sheep*—the poignant story of a black slaughterhouse worker living in south-central Los Angeles—still had a tight budget; but despite being shot on weekends with amateur actors and crew, the film won several major awards and in 1990 was chosen for inclusion in the National Film Registry at the Library of Congress, taking its place on a list of the most historically and culturally signifi-

cant American films.

Burnett won a Guggenheim Fellowship to develop his next feature, 1984's *My Brother's Wedding*, which explored class conflicts within the black community. It proved a critical success but a commercial disappointment, and Burnett found it hard to get the money to shoot his next feature. Then, in 1988, Burnett received one of the MacArthur Foundation's "genius" awards, which provide money to be used by the winners however they wish. The stipend helped Burnett get started on *To Sleep with Anger*. Released in 1990, the film, which starred Danny Glover, earned special recognition at the United States Film Festival.

For Burnett, as for other independent filmmakers, moviemaking remains a highly individual enterprise. "What has to be developed in filmmakers," he says, "is a sense of who you are, what you want to say, and how you want to say it—a world-view or a perspective that you can express in your own terms."

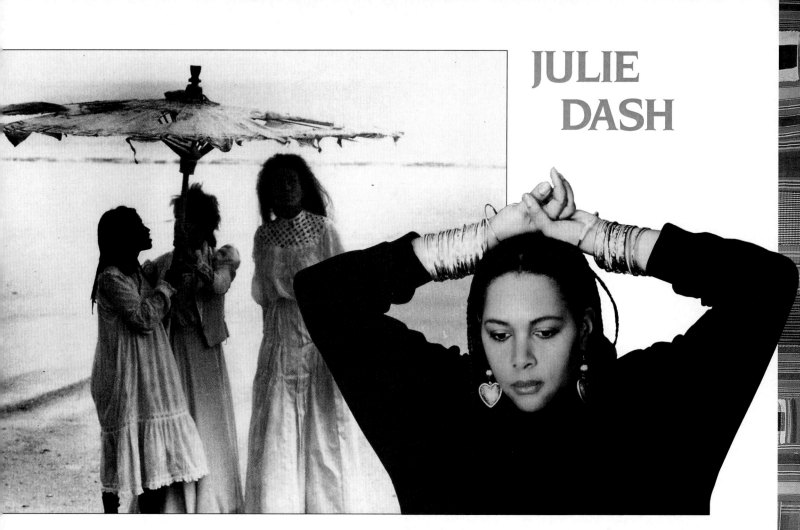

JULIE DASH

When *Daughters of the Dust* opened at the Film Forum in New York City in January 1992, "it was sold out every show," recalled the film's writer, producer, and director Julie Dash. "I was overwhelmed. People were asking me how it felt to be the first African American woman filmmaker with a feature film in theatrical release. It was a thought that had never crossed my mind."

Set in the Georgia Sea Islands in the early 1900s, the film offers a richly visual treatment of the many women of the Peazant family as some prepare to leave for the economic opportunities of the North. For Dash, whose father's family came from the Sea Islands, the plot is about "the fear of going away from home and not being able to come back, the fear of abandoning one's culture." The movie's sometimes dreamlike scenes are meant, as she has put it, "to evoke ancient sensibilities, to challenge the conventional formats of representing Black women in the genre of historical drama." The film received rave reviews and several awards.

Born in New York City, Dash first studied filmmaking at the Studio Museum of Harlem and earned a bachelor's degree in 1974 at the City College of New York. Graduate study at the University of California at Los Angeles culminated in *Diary of an African Nun*, a 1977 student film which won her a Director's Guild Award. By then Dash had begun working on the idea for *Daughters*, but finding the money for such an ambitious project proved difficult, and the bulk of the shooting did not begin until 1989.

In the meantime, Dash received research grants from both the Guggenheim and Rockefeller foundations, created a trailer for the film, and produced a number of other pieces. Her 1983 short film *Illusions*, set in 1942 Hollywood, won the Black Filmmakers Foundation Best Film of the Decade award in 1989. Support for the more ambitious *Daughters* project finally came from the PBS American Playhouse series.

For Dash, the success of that project was all the sweeter because she made the film, as she put it, "from a black aesthetic and from an African American woman's reality." In other words, she once said, "I make the kinds of films I've always wanted to see."

THE ROOTS OF AMERICAN MUSIC

The soul singing of Ray Charles epitomizes a uniquely American sound—built upon the many forms of music that were born of the African American experience from the time of slavery to the present .

he year was 1959. The scene, a dance hall just outside of Pittsburgh, where, in the wee hours, rhythm-and-blues singer-piano man Ray Charles was performing. With almost 15 minutes to go before his last set closed, the 29-year-old Charles had run out of tunes. After pondering a moment, he said to the band and his backup singers, the Raeletts, "Listen, I'm going to fool around and y'all just follow me."

Charles began noodling at the piano, and a little riff took shape. One thing led to another, and suddenly he was singing and waiting for the right moment to cue his backup. At a break in the rhythm he called out "Now!" The Raeletts and the band came in right on the beat.

"I could feel the whole room bouncing and shaking and carrying on something fierce," Charles recalled in his autobiography, *Brother Ray.* "So I kept the thing going, tightening it up a little here, adding a dash of Latin rhythm there. When I got through, folk came up and asked where they could buy the record. 'Ain't no record,' I said, 'just something I made up to kill a little time.' " That is how "What'd I Say" came into being. It later became Charles's first million-selling record.

Like many Ray Charles compositions, "What'd I Say" was a blend of gospel feeling, rhythmic changes reminiscent of African music, voicings like the responses to a preacher's call, and bluesy passages straight out of the Mississippi Delta. The Genius, as Charles is fondly nicknamed, has recapitulated in his person the long history of African American music, a history that includes work songs, field hollers, spirituals, and the blues—forms that set the stage for the emergence of ragtime, jazz, gospel, R&B, rock 'n' roll, soul, and rap. Since slavery times, black musical modes have evolved to create the phenomenon recognized and appreciated the world over as American music.

Although African slaves were stripped of their freedom and cut off from their culture, they somehow held on to the rich musical traditions so vital to everyday African life. In the varied societies of western Africa, music exists for every occasion from birth to beyond the grave. Of prime importance is the work song, which resonates among laborers from Senegal to Angola. And because Africans were brought to America to serve as slave laborers, the work song is a reasonable starting point for tracing the impact of African musical characteristics on American music.

Work songs were common among black slaves. The rhythmic cadences helped set the pace for repetitious tasks, easing the drudgery of labor and making the time

go faster. Closely related to work songs were field hollers, in which a slave might suddenly call out a long, clear, rising note, perhaps ending in a falsetto and often evoking a response from other toilers. The field holler served a number of purposes, erupting simply to provide a kind of emotional release, perhaps, or to warn fellow slaves of the approach of the overseer.

After slaves began to be Christianized in large numbers around the mid-18th century, they would gather secretly, far from the ears of owners and overseers, to release their pent-up emotions in song. Their heartfelt music took the form of spirituals—folk songs that cried out against the painful cruelty of slavery, expressed faith in the hope of freedom in the next life if not in this one, and appealed to God for succor. Linked to the spiritual was the ring shout, a ritual dance common among Africans to honor their ancestors. In the American incarnation of the ring shout, after the worshipers began singing a spiritual, some would form a circle and shuffle around—technically conforming to preachers' strictures against dance by not lifting their feet—as they gave voice to the music.

Over several hundred years, black Americans' field hollers and work songs, ring shouts and spirituals gradually came together with street vendors' cries and prison songs to form, in the late 19th century, a new musical style called the blues. Early blues singers were often lonely wanderers, men who had seen their share of hard times, who had had plenty of experience with lost love. Their songs captured the feelings of a people.

No uniform definition of the blues exists. They may denote a downhearted state of mind or the music that expresses that state of mind. But blues are not solely sad or painful; irony and wry humor can be found among the music's many moods. The blues singer expresses his or her misery, achieving a kind of catharsis with the listener that helps make life bearable again. Resiliency, not despair, is the message.

Whatever the content or style of a blues song, the common denominator is the classic blues structure, in which a song's bar lines are ignored; blue, or bent, notes—usually, flatted third or seventh notes and sometimes flatted fifths—are stressed; and the music adheres strictly to a 12-bar form. The lyrics of classic blues fit into a three-line structure, a form much more closely related to African than to European music. Often the first line declares an unhappy situation, the second line repeats it, and the third line answers with some sort of conclusion, as in: "When a woman gets the blues, she hangs her head and cries / When a woman gets the blues, she hangs her head and cries / But when a man gets the blues, he grabs a train and flies."

The blues were largely an unwritten, folk style of music until 1912, when an African American musician in Memphis, Tennessee, William Christopher "W. C." Handy, printed sheet music for a campaign song he had composed three years earlier for Ed "Boss" Crump, who was running for mayor. The song had created a sensation, so Handy finally published it as the "Memphis Blues." Handy subsequently published many other of his own compositions, including his best-known "St. Louis Blues," and soon blues numbers were being sung professionally by black entertainers.

Concurrent with the growth of the blues was the emergence of ragtime. The name comes from "ragged time," the idiomatic syncopation characteristic of a popular style of piano music. Ragtime was essentially an attempt by black Americans to reproduce in their music something of the cross-rhythms—the almost infinite variations on regular time—that lie at the heart of African music.

Ragtime is a melodically inventive and rhythmically lively music, in which strong tonal progressions play over a bright, steady double beat in the bass line. The form was fundamental in shaping the solo and ensemble improvisations of early jazz. Indeed, for a while in the early 20th century, the term *ragtime* was interchangeable with *jazz*, especially among performers in New Orleans.

The name of the first ragtime musician is impossible to determine, but Scott Joplin is considered the greatest. Born in 1868 in Texarkana, Texas, Joplin showed musical promise at an early age and learned both traditional African American music and European forms. In his late twenties he began writing ragtime songs. A music publisher in Kansas City accepted one of Joplin's tunes, "Original Rags," in 1899 but apparently overlooked or rejected another composition, "Maple Leaf Rag." Later the song went on to become the most famous of Joplin's many ragtime numbers.

Although he gained fame for his ragtime tunes, Joplin's real obsession was his opera, *Treemonisha*. He completed the work in 1905 but did not publish it until 1911, by which time he had left an unhappy marriage and moved from St. Louis to New York City. Sadly, the opera was given only one performance, in 1915 in Harlem, and it failed to impress the select audience. Joplin, who suffered from syphilis, an incurable disease at the time, never recovered emotionally from the shock of this rejection; he died in a mental hospital on April 1, 1917.

Even before Joplin's death, however, ragtime had given way to the growing popularity of jazz. Music historians tend to agree far more readily on what jazz is than on where or when it evolved. What seems clear is that it emerged from a fusion of African American folk idioms, ragtime, and various popular musical styles. But a number of historians and musicologists have recently challenged the conventional notion that it began in New Orleans and moved up the Mississippi River. They contend that jazz evolved all over the South and in the Southwest, particularly around the musical hub of Kansas City, Missouri.

Still, New Orleans has strong arguments for its claim. In the memories of the earliest jazz musicians, the city invariably receives the laurels. Its African American residents were generally more musically sophisticated than those living elsewhere. And a vibrant subculture of black Creoles—mixed-blood descendants of the city's early French and Spanish settlers—contributed the fruits of European training, such as music theory and notation, through bands like that of John Robichaux.

The final ingredient in this jazz gumbo was the blues,

Master of ragtime Scott Joplin, shown at left in a rare photograph, wrote his first songs in a sentimental Victorian style that reflected his classical training. He switched to ragtime when it became popular, and in 1899 his "Maple Leaf Rag" became a sheet-music hit. The publisher, a white man named John Stark, went on to become Joplin's lifelong friend and confidante.

African Americans at a turn-of-the-century ball do the Cakewalk, an intricate dance of complicated lineage. Originally a parody by slaves of white people dancing the minuet, it was popularized by white minstrels working in blackface.

which probably came to New Orleans from the surrounding rural Mississippi Delta and from the waterfronts and rail yards of the region. These elements combined to make New Orleans a musically rich and diverse city in the 1890s.

Cornet player Charles "Buddy" Bolden was probably the best known of the early black jazz musicians. "I used to hear Bolden play every chance I got," recalled Edward "Kid" Ory, the renowned trombonist. "There wouldn't be a soul around," said Ory, "but Bolden would say, 'Let's call the children home.' And he'd put his horn out the window and blow, and everyone would come running."

It was perhaps inevitable that one musician or another would come along and marry the Creole and folk styles. One who did so was the flamboyant Ferdinand La Menthe "Jelly Roll" Morton. Despite leading a colorful life as a gambler, hustler, pool shark, and entrepreneur, Morton, born in 1890, was above all an artist—an incomparable pianist-composer who unquestionably played a key role in developing jazz, even if his claim to having invented it can never be proven.

As a teenager, Morton worked the bordellos of Storyville, New Orleans's red-light district, plinking out ragtime tunes, French quadrilles, light classics, and the popular songs of the day. Sometime between 1907 and 1923, years he spent on the road, Morton fused a variety of African American musical idioms with a touch of Caribbean music to create a sound that was much like the music beginning to be called jazz.

Morton was living in Chicago when he made his first recordings in 1923. A few years later he had his own band, the Red Hot Peppers, which featured fellow New Orleans jazzmen Omar Simeon on the clarinet, trombonist Kid Ory, and banjo man Johnny St. Cyr. The recordings Morton made with this ensemble in 1926 and 1927, particularly "Black Bottom Stomp," were a triumph of composition and improvisation.

As it happens, Morton's music was not the first of any importance by an African American to be captured on wax. That distinction belongs to singer Mamie Smith, who recorded "Crazy Blues" in 1920 and touched off a boom in blues records by black women singers (*pages* 90-95). After the women enjoyed a recording monopoly for several years, black male blues singers finally broke into the recording business. Among the leading bluesmen in the 1920s and 1930s were Blind Lemon Jefferson, Huddie Ledbetter ("Leadbelly"), "Big Bill" Broonzy, Leroy Carr, Sonny Terry, and the mysterious Robert Johnson.

Johnson, who lived but 27 years, was a child of the Delta, born in 1911 in Hazlehurst, Mississippi, where ramshackle roadhouses called juke joints were plentiful. A very young Johnson would sneak out at night, find a dance—especially where two local guitar virtuosos, Son House and Willie Brown, were playing—and listen for hours. He wanted desperately to play the guitar, and as soon as House or Brown put his instrument down, Johnson would grab it and try to play. He was so awful that people hollered for him to stop.

The first jazz-band leader of note, Charles "Buddy" Bolden stands second from the left in this 1895 photograph, the only one of him in existence. So popular was Bolden's cornet playing that he once had as many as seven bands working simultaneously under his name at dances in different parts of New Orleans. He would travel from one dance to the next, playing solos to keep the goings-on lively and the crowds happy.

Louis Armstrong revolutionized jazz, playing notes no trumpeter had ever reached, doing variations on tempo and melody never previously imagined. Shown at right in the early 1930s, when he was at his improvisational peak, Armstrong was a powerful soloist. He singlehandedly changed jazz from an ensemble form of music to one showcasing solo turns by outstanding instrumentalists.

Then one day Johnson went away. According to the reminiscences of Son House, the kid was gone for about six months. He reappeared out of the blue one Saturday night with a guitar slung on his back. "Well, boy, what do you do with that thing?" House demanded. Johnson started playing and was so good, House recalled, that when he finished, "all our mouths were standing open."

From then on, Johnson was on the road with his guitar, singing the blues and absorbing musical influences from all over the country. His guitar playing reshaped the blues almost completely. He tightened the rhythm, letting the upper-register strings play a free melodic part but using the thumb for a hard beat in the lower strings that was almost like a drum part. As a singer, Johnson could imitate anybody, but it was his own style, an impassioned, plaintive sound—almost a cry—that made him a favorite. In 1938, however, his career came to an abrupt end. He became violently ill one night and died a few days later, reportedly the victim of poisoning by a jealous husband who had spiked his whiskey with strychnine.

Although blues songs, starting in 1920, were the first African American music to make it onto records in a big way, jazz was the dominant popular music of the decade, in part because of the early presence of outstanding instrumentalists in its ranks. Unquestionably the greatest of these was Louis "Satchmo" Armstrong. Born in 1900, Armstrong lived a life of utter poverty as a youth, wandering the streets of New Orleans in rags and scavenging food from garbage cans. In 1913 he was placed in the city's Colored Waifs' Home, where, though he had never played a musical instrument, he soon became the star of the orphanage's brass band. Released from the home three years later, the 16-year-old began playing around Storyville and picking up know-how from men like cornetist Joe "King" Oliver, who played in Kid Ory's band. By age 18 Armstrong had become a preeminent cornetist and was working with many of the top musicians in town.

In 1922 Oliver, now leading a band in Chicago, sent for Armstrong. Satchmo was an immediate hit. Two years later he was called to New York City to join Fletcher Henderson's band. But Armstrong soon tired of playing under someone else's direction. In 1925 he made some recordings with a studio ensemble that he dubbed the Hot Five. The cuts he recorded with this group were landmarks in jazz history for their innovative rhythms and Armstrong's endlessly creative solos.

Then followed a steady succession of Armstrong milestones: his stunning recording of "West End Blues" in 1928, when he gave up the cornet and switched to the trumpet; his mounting popularity through

brief appearances in dozens of films in the 1930s; and his evolution into "Pops," the congenial entertainer who became jazz's first figure of national, then international, fame. Not only did Satchmo revolutionize jazz, but his unique singing style and gravelly voice also profoundly influenced vocal music. The greatness of his work remains undiminished more than two decades after his death.

Although Armstrong dazzled the jazz world in the 1920s with his studio ensembles of five and, later, seven pieces, a new trend in popular music, the big band, was already waiting in the wings, and Satchmo's genius played a part in its creation. During his stint with Fletcher Henderson's outfit, Armstrong collaborated with Henderson and saxophonist Don Redman, the band's nonpareil composer and arranger, to transform the dance band into a large, swinging jazz band. Redman's technique was to divide the band into saxophone and brass sections and play them off against each other, an approach still popular today.

By 1935, however, nightclubs and dance halls were being dragged under by the Depression, forcing a number of big bands to fold for lack of work. Hard-pressed, Henderson sold his best arrangements to white clarinetist Benny Goodman, which crippled Henderson's chances ever again to develop a top band. He could take pride, nevertheless, in having started the big-band craze and having led the way for such remarkable bandleaders as Don Redman, Cab Calloway, Chick Webb, and Duke Ellington.

Edward Kennedy "Duke" Ellington did more than any of them to extend Henderson's sense of band organization and musicality. After establishing a reputation as a jazz pianist in his native Washington, D.C., Ellington moved to New York City in 1923 at the age of 23 and organized a small ensemble. By 1927 he had enlarged the band to 10 pieces and was experimenting with orchestral moods and timbres.

Ellington soon rivaled Louis Armstrong for the lead position in jazz. In 1939 he upgraded the quality of his already excellent collection of musicians by signing up Billy Strayhorn as arranger, composer, and second pianist. Among many other accomplishments, Strayhorn, known as Swee'pea, composed the band's theme song, "Take the 'A' Train."

During his long career, Ellington built a musical legacy beyond measure. Compositions and arrangements of such numbers as "Satin Doll," "Sophisticated Lady," "Caravan," and "Mood Indigo" were equaled only by the stellar assemblage of jazz musicians who performed them—among them Johnny Hodges on the alto sax, bassist Jimmy Blanton, Harry Carney on baritone sax, trumpeter Cootie Williams, and drummer Sonny Greer.

The Ellington orchestra carried top-

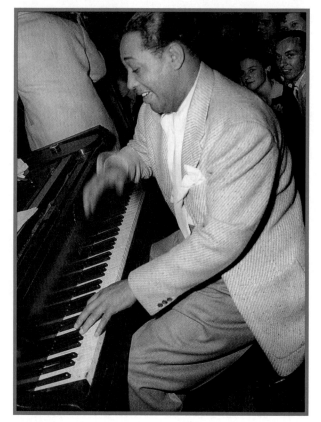

Count Basie, pictured below left with singer Joe Williams, kept his swinging big band busy even after small combos became the rage following World War II.

Duke Ellington (left), tickling the keys at a concert in Denver in 1942, led at this time one of the greatest jazz bands in history. From their years of playing behind the acts at Harlem's famed Cotton Club in the late 1920s, Ellington's ensemble experimented with daring approaches to tone, color, and texture, resulting in such later classics as "Ko-Ko," "Blue Serge," and "Cottontail."

Billie Holiday, pictured here at the microphone during a 1949 performance in New York City, was often praised for the way she used her voice like an instrument and for her musical inventiveness, which was said to rival that of Louis Armstrong.

flight jazz to fans all over the United States, as did several other big bands of nationwide renown. In addition, jazz aficionados in the Southwest flocked to hear so-called territory bands, which ranged throughout that region from their base in bustling Kansas City. One of the best was Bennie Moten's, whose roster read like a list of jazz all-stars: Oran "Hot Lips" Page (trumpet), Eddie Durham (trombone, guitar), Ben Webster (tenor sax), and Jimmy Rushing (vocalist). His most acclaimed graduate, however, was pianist William "Count" Basie.

In 1929, at the age of 24, Basie joined Moten's Kansas City Orchestra. When Moten died in 1935, Basie set out on his own, forming a band that featured drummer Jo Jones and, later, tenor saxophonist Lester Young. By the end of the 1930s the band was famous around the world, mostly through hit tunes such as "One O'Clock Jump" and "Jumpin' at the Woodside."

If Basie and others made Kansas City the big draw for jazz buffs west of the Mississippi in the 1930s, back east during that time the focus was not on a city but on a short stretch of a single street that became the symbolic world headquarters of jazz. Given the limited space in the brownstones that lined New York's 52d Street (*pages* 100-103), club owners there opted for small groups with headline acts to draw the crowds.

Whenever Art Tatum played 52d Street's 3 Deuces with his trio, there was never an empty seat in the club. Tatum, who was self-taught and partially blind, made his reputation as the all-time greatest jazz pianist primarily in after-hours joints where musicians gathered. The solo recordings he made in 1933 are ample proof of his unmatchable technical facility and masterful control of his instrument. A Tatum solo often began as a simple decorative filigree that quickly evolved into complex harmonic splashes of color, with swift arpeggios and glissandos sparkling at the top of a dense array of rhythmic shifts. It was as if the pianist had four hands.

Almost directly opposite the 3 Deuces, Billie Holiday entranced throngs of admirers with her vocal genius at the Onyx, one of her favorite spots on "The Street." With her trademark gardenia in her hair, one hand held limply at her waist, and her head cocked to the side, Holiday was the epitome of the torchy chanteuse. Although her vocal range was limited and her voice light and untrained, no singer possessed her interpretive skills, her ability to wring every ounce of emotion from a lyric. The ballad was her forte, but she could do up-tempo numbers too, which is evident from her versions of "Them There Eyes" and "What a Little Moonlight Can Do."

Billie Holiday, born Eleanora Fagan in 1915 in Baltimore, was the daughter of a guitarist with Fletcher Henderson's band. While still only 15 she moved to New York and was making the rounds as a singer, performing in Harlem clubs. In 1933 she was "discov-

77

ered" at one such place, Monette's, by white impresario and talent scout John Hammond. Hammond arranged three recording sessions for her, lining up as sidemen no less than Lester Young, Benny Goodman, and pianist Teddy Wilson. In 1937 Holiday joined Count Basie's band. A year later, she hooked up with Artie Shaw, becoming one of the first black vocalists to be featured with a white orchestra. On tour through the South, Shaw's band members tried to throw a protective mantle around Holiday, but it was not enough to shield her from the hate-filled glares and racist remarks.

Holiday left the band in 1938 and became the opening act at a club in Greenwich Village called Café Society, which broke new ground for a downtown spot by being racially integrated in its clientele as well as on the bandstand. Her appearance there coincided with her release of "Strange Fruit," a somber song about a black lynching victim hanging from a tree. This record, which brought Holiday nationwide renown, was followed by tunes in a similar melancholy vein, such as "Gloomy Sunday" (1941) and "Lover Man" (1944). The 15 years until her death in 1959 were marred by worsening drug and alcohol addiction. But even though the quality of her voice deteriorated, she could still infuse her singing with powerful emotion.

While Billie Holiday was making history downtown, a young alto saxophonist named Charlie Parker was jamming at a chili house in Harlem, on the verge of making some history himself. Parker had earned his jazz spurs as a teenager in the crucible of swing—Kansas City, Missouri, right across the river from his birthplace, Kansas City, Kansas. He had received very little formal musical training and had picked up the rudiments through practical experience in local gigs, in jam sessions, and by listening to older musicians. One night in December 1939, the 19-year-old Parker—nicknamed Yardbird, though it is unclear why, and commonly called, simply, Bird—was feeling fed up with the same old chord changes and harmonies. Sometimes he could hear different changes in his head, but he couldn't quite play them. "Well, that night," Parker later recalled, "I was working over 'Cherokee,' and, as I did, I found that by using the higher intervals of a chord as a melody line and backing them with appropriately related changes, I could play the thing I'd been hearing. I came alive."

And so, some argue, did bebop—also called bop. Whether or not he singlehandedly invented bebop, Charlie Parker was indisputably one of its key innovators. The first group experiments in the new form occurred in Harlem in the early 1940s at two popular jazz clubs, Minton's Playhouse and Clark Monroe's Uptown House. Drummers Kenny Clarke and Max Roach, guitarist Charlie Christian, pianists Thelo-

Jazz immortal Charlie Parker endured a grueling apprenticeship on the saxophone. Once, when he sat in as a 15-year-old with Count Basie's band, drummer Jo Jones became so disgusted with him that he hurled a cymbal across the room. Humiliated, Parker packed up his sax and didn't touch it for three months.

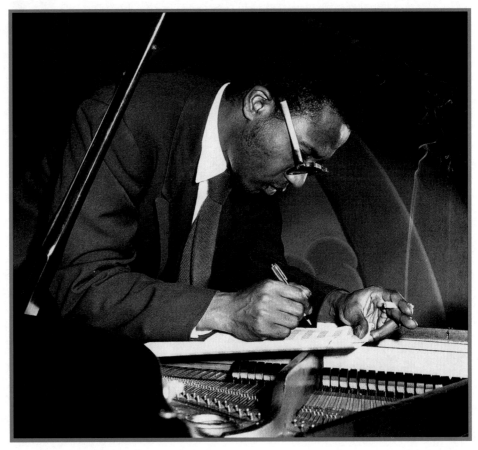

Trumpeter Dizzy Gillespie (*left*) presented himself as an artist rather than a showman, breaking with a stereotype that dated all the way back to 19th-century minstrel shows. One of the pioneers of bebop music, Gillespie composed "Night in Tunisia" and "Shaw 'Nuff."

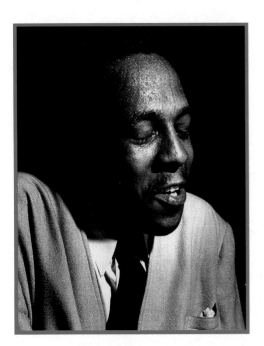

Bud Powell's energy and harmonic sense earned him recognition as a Charlie Parker of the keyboard in the 1940s, when, despite bouts of mental illness, he was the dominant figure in jazz piano.

Early in his career, pianist Thelonious Monk—shown here composing at Minton's Playhouse in Harlem, a bebop stronghold in the 1940s—was considered more eccentric than talented. He was eventually recognized as a formidable creative force, however, credited with being a major influence on the great saxophone soloist, John Coltrane.

nious Monk and Bud Powell, saxophonist Don Byas, and bassist Oscar Pettiford were among the young musicians who flocked to Harlem after their regular gigs on 52d Street or elsewhere to jam with Parker and another bebop pioneer, trumpeter John Birks "Dizzy" Gillespie. During these sessions Parker often supplied the imaginative flights and creative genius, while Gillespie codified the music and tightened up the theory behind its unprecedented approach to jazz. Bird soared with the spirit of bebop; Dizzy paid attention to the letter.

The new sound brewing in Harlem constituted a musical revolt—with social dimensions. The rebels had had their fill not only of the musical conventions imposed by the dominant swing music of the period, but also of a longstanding second-class status. In addition to being the victims of institutionalized racial discrimination, they had seen their musical experiments treated with indifference by record companies, the press, booking agents, and radio stations.

The bebop musician was turning out to be a new breed of African American jazzman, one who saw his music as art and himself as an artist and who was no longer willing to accept a role as mere entertainer. Monk's beard and hats, Bird's close-cropped, unprocessed hair—an almost shocking rarity at the time for blacks in show business—and Dizzy's beret, horn-rimmed glasses, and goatee all symbolized a new attitude of self-affirmation and defiance of convention.

When bebop went downtown to 52d Street in 1944, Charlie Parker, though still

only in his mid-twenties, found himself being hailed as a jazz legend. Despite his star status, however, his life was blighted by heroin addiction and alcoholism. During an engagement in Los Angeles in 1946, his substance abuse pushed him to the breaking point, and he had to be confined in a California mental hospital. Seven months later, after his release, he returned to New York City and put together what was to be his best quintet—Miles Davis (trumpet), Duke Jordan (piano), Max Roach (drums), and Tommy Potter (bass).

In 1951, his health deteriorating from his destructive lifestyle, Parker had his cabaret license revoked at the request of the New York City police narcotics squad. Thus barred from working in clubs where liquor was served, he knocked around for the next few years, catching a gig now and then on the sly. In 1954, depressed to the point of being suicidal, he checked himself into New York's Bellevue Hospital for a short stay. He gave his last performance on March 5, 1955, at Birdland, a Manhattan nightclub named in his honor. Seven days later, in the apartment of his good friend Baroness Pannonica de Koenigswarter at the Stanhope Hotel, Parker died—whether from lobar pneumonia or the combined effects of ulcers and cirrhosis of the liver is in dispute. He was 35 years old.

Parker bequeathed to the jazz world a huge volume of compositions, and hardly a jazz set is played anywhere that does not include one of his top songs—"Ornithology," "Parker's Mood," "Now's the Time," or "Yardbird Suite." But much of what he left behind was intangible—musical nuances of style, confidence, attitude, and virtuosity.

Those qualities served as well to describe Parker's chief disciple, Miles Davis. The product of a solid middle-class family in East St. Louis, Illinois, Miles Dewey Davis took up the trumpet at the age of 13 and by 15 was playing professionally in and around his hometown. His big break came in 1944 in St. Louis, where Billy Eckstine's band had arrived for an engagement. Davis, attending the concert with his trumpet in hand, was accosted by a man who asked if he was a trumpet player. When Davis said he was, the man, who turned out to be Dizzy Gillespie, asked if he had a union card. Davis had one. "Come on," said Diz, "we need a trumpet player." So Davis sat in for a member of the trumpet section who had become ill. On the bandstand he could hardly read the music, he was so dazzled and intent on listening to what everybody else was playing.

Davis was hooked on bebop, and within a few months he was in New York City. From 1945 to 1949 he played off and on with Charlie Parker and also performed with bands led by Eckstine and Benny Carter. Soon he was leading his own group and participating in experimental workshops led by white arranger Gil Evans. In 1949 and 1950, along with white baritone saxophonist Gerry Mulligan and others, Davis and Evans assembled a nonet and released the album *Birth of the Cool*. The "cool" school of jazz was in session.

Over the next decade or so, Davis led a quintet that featured at various times Bill Evans (piano), Julian "Cannonball" Adderley (alto sax), John Coltrane (tenor sax), Wynton Kelly (piano), Paul Chambers (bass), and Jimmy Cobb (drums), all of whom

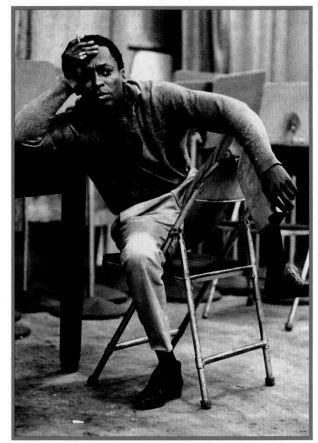

Miles Davis revolutionized jazz trumpeting when he departed in the 1950s from the bravura style of horn players like Louis Armstrong and Dizzy Gillespie. He adopted instead a thoughtful, almost hesitant approach, punctuating soft, often muted music with intervals of silence. Davis's sound has influenced almost every new jazz trumpeter since.

performed on Davis's phenomenally successful album *Kind of Blue*. So-called modal playing—the absence of frequent chord changes—was now in vogue.

In 1969, with the release of *Bitches Brew*, Davis spearheaded another style change—a fusion of jazz and rock. Right to the end of his life in 1991, Davis was an inspiring leader, a consummate stylist, and a tireless innovator.

While Davis was relentlessly pursuing new horizons, a coterie of beboppers, exemplified by drummer Art Blakey and his Jazz Messengers, was content to remain within that form while at the same time giving their music a decided rhythm-and-blues tinge. The result was an intense, hard-driving style of jazz. From this nucleus, "hard bop" groups spun off, led by pianist Horace Silver, alto saxophonist Jackie McLean, tenor saxophonist Sonny Rollins, drummer Max Roach, and trumpeters Lee Morgan, Kenny Dorham, Donald Byrd, and the incredibly gifted Clifford Brown—whose brilliant career ended tragically when he was killed at age 25 in a car accident in 1956.

Hard bop was largely an urban music emphasizing a bluesy, pulsating beat, traits it shared with still another musical form: rhythm-and-blues. For a time in the early 1950s, it was not unusual to hear jazz musicians sitting in on R&B recordings.

The actual emergence of rhythm-and-blues is hard to pinpoint. The term itself may have been coined in 1949 by a white musicologist named Jerry Wexler, a reporter on *Billboard* magazine who later recorded many R&B artists as an executive at Atlantic Records. Wexler introduced the R&B designation at *Billboard* because he was not satisfied with the magazine's label of "race records" for its black music chart.

Credit for the rise of R&B goes to such people as bandleader Louis Jordan and his Tympany Five, who helped create the sound; Dave Clark, an advance man for Decca Records, who publicized it; and black independent record producers Don Robey, Willard and Lillian McMurry, and Bobby Robinson, who first put it on wax.

Robinson, who owned a record store in Harlem, founded Red Robin Records and is best remembered for launching the era of the "doo-wop" groups, black vocal quartets that were also called bird groups for the names some of the first ones took, such as the Orioles and the Ravens. Billy Ward and his Dominoes, with lead vocalist Clyde McPhatter, also showcased the doo-wop sound. McPhatter and his successor with the Dominoes, Jackie Wilson, possessed enormous sex appeal and sweet tenor voices; all they had to do was walk onstage and the audience was theirs.

"Little Richard" Penniman, Antoine "Fats" Domino, Chuck Berry, and the Chords were other major rhythm-and-blues forces. The Chords' big score with "Sh-Boom" in 1954 marked the first time an R&B record made it to the top of the pop charts. Before the year was out, however, a white Canadian group, the Crew Cuts, made their own recording of "Sh-Boom," which outsold the original and finished among the top five popular records of 1954. This touched off a spate of "covering" (*pages* 108-111), in which established white performers made new versions of rising rhythm-and-blues records, copying the arrangements

Trumpeter Clifford Brown (*sitting*) and drummer Max Roach were on the cutting edge of jazz in the 1950s. Although Brown's genius was lost when he died at the age of 25, Roach continued going strong and won a MacArthur Foundation award in 1988.

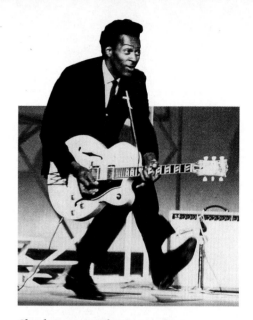

but altering the sound slightly to make it more suitable for what were believed to be white tastes—and thereby undercutting sales of the R&B originals. The appearance of these covers ushered in a new musical genre called rock 'n' roll.

While black R&B, mixed with a bit of pop and country-and-western music, was being transmuted into white-oriented rock 'n' roll, it was also changing, under the influence of Ray Charles and others, into a new kind of African American music—soul. And talented new singers were showing up to perform it.

If the career of Sam Cooke is instructive, then the proper route from rhythm-and-blues to soul required a stop in the world of gospel. Cooke was the first of the big gospel stars to cross over to secular music. He grew up in Chicago and began his gospel-singing career at the age of nine. In 1950, when he was 20 years old, he was named lead singer for the Soul Stirrers, a popular gospel ensemble.

Cooke gained a reputation as a silky-smooth vocalist with winning charm during his six and a half years with the Soul Stirrers, and the temptation to cross over and reach a larger audience finally proved irresistible. After "Lovable"—his first R&B recording—in 1957, Cooke followed with "You Send Me," and it quickly went to the top of the charts. The balladeer with the undulating "whoa-oh-oh" was now stirring souls in the secular realm. His 1964 album *Live at the Copa* finished high on the soul chart.

Cooke's mellifluous voice influenced a generation of soulsters—Solomon Burke, Joe Tex, Wilson Pickett, Al Green, Aretha Franklin (*pages* 118-119), and nearly every singer who came of age during the rise and reign of the Motown sound. Motown's climb to the corporate heights formally began in 1959 when 30-year-old Berry Gordy, Jr., borrowed $800 from his family and set out to corral some of Detroit's African American musical talent. By 1960 Motown had its first hit, "Money" by Barrett Strong. A year later, Smokey Robinson and the Miracles made "Shop Around" the company's first million-seller. The Supremes—Diana Ross, Mary Wilson, and Florence Ballard—fattened the company's coffers considerably beginning in 1964 with a string of gold records.

A company that represented a kind of flip side of Motown, putting out an earthy, southern sound as opposed to Motown's slick, urban style, was Stax Records of Memphis. Launched in 1960 by a white brother-and-sister team, Jim Stewart and Estelle Axton, Stax entered the big time with Carla Thomas's "Gee Whiz." Her success set the stage for the arrival of even bigger stars: Sam and Dave, Wilson Pickett, Booker T. and the MGs, Isaac Hayes, and the great Otis Redding. In 1962 Redding leaped from obscurity with

Chuck Berry's infectious guitar licks helped make that instrument the dominant one in rock 'n' roll. Many pop performers, from the Beach Boys to the Beatles, named Berry as their inspiration.

The first gospel star to cross over to popular music—in 1957—Sam Cooke won the hearts of millions with such hits as "Bring It on Home to Me," "Wonderful World," "Another Saturday Night," and "I Love You (for Sentimental Reasons)." Cooke died at the peak of his career, when he was just 33.

The exuberant James Brown, shown here with his Famous Flames, featured a call-and-response singing style that defined soul and a staccato delivery that anticipated rap.

Mary Wells was the first Motown soloist to make the charts. Her early hits, "The One Who Really Loves You," "You Beat Me to the Punch," and "Two Lovers," convinced Motown boss Berry Gordy, Jr., that he had struck gold with his concept of soulful but smoothly produced songs that crossed racial barriers.

"These Arms of Mine"; a year later he was in the national spotlight with "Pain in My Heart." Both records showcased the vulnerability and quavering tones so characteristic of a Redding performance.

Redding was a gifted songwriter and record producer as well as singer, and this immense talent blossomed fully on his album *Otis Blue*. But on December 10, 1967, four days after recording his greatest song and first million-seller, "(Sittin' on) The Dock of the Bay," Redding, his backup band, the Bar-Kays, and several other passengers were killed in the crash of his new twin-engine Beechcraft in poor weather near Madison, Wisconsin.

The social message of "The Dock of the Bay"—the hopelessness of black men stranded outside the country's economy—gave one slant on African American life. A contrasting perspective could be heard in another strain of soul music that sprang up in the late 1960s, which was a period of black affirmation and heightened self-esteem. No one captured the mood better than songwriter-performer Curtis Mayfield. His recordings of "We're a Winner" (1968) and "Choice of Colors" (1969) achieved both commercial and critical success.

During this same period, James Brown echoed similar sentiments about race pride, which he turned into an anthem in his 1968 top seller "Say It Loud, I'm Black and I'm Proud." This mantric tune with its infectious call-and-response beat was Brown's salute to the political cry of "Black Power!" There was nothing new in the scream and the sweat; Brown had been shouting and testifying on records since "Please, Please, Please," in 1956.

Born in Barnwell, South Carolina, in 1933, Brown was educated in the school of hard knocks. But he could make music, using his talent performing with gospel groups and pickup bands and starting his own trio at 15. A few years later he joined the Gospel Starlighters, and when they crossed over to rhythm-and-blues, Brown went along. Now called the Famous Flames, they recorded "Please, Please, Please," an adaptation of the 1952 Ori-

oles' hit "Baby, Please Don't Go." The Flames disbanded in 1957, and Brown went solo with "Try Me," which rocketed to number one on the R&B charts in 1958. From 1960 to 1977 every record released by the "Godfather of Soul" made the charts.

While James Brown and Ray Charles were leading the transition from R&B to soul in the late 1950s, jazz, too, was undergoing change, as African American demands for freedom reached beyond the civil rights movement into the cultural arena. Almost two decades earlier, bebop had been the revolutionary sound that discombobulated the reigning swing musicians of the time. Now, with a young saxophonist from Texas named Ornette Coleman (*pages* 112-113) leading the way, a radically new music called free jazz was challenging the bebop paradigm.

While Coleman was working out the new sound in the hinterlands, an early breeze of the coming change wafted through the jazz precincts of New York City from the piano pyrotechnics of another advocate of jazz freedom, Cecil Taylor. In 1956, influenced by the work of Thelonious Monk, Duke Ellington, and Horace Silver, Taylor made his first significant recording, *Jazz Advance*. For the next 10 years Taylor's furious glissandos and clusters of dissonant chords carried him far afield of conventional jazz, and he achieved cultlike status with the release of *Unit Structures* in 1966.

Taylor had banged a number of pianos out of tune by the time Coleman, toting his white plastic alto saxophone, arrived at a club called the Five Spot in November 1959 for his New York City debut. His jolting melody lines and unpredictable bursts of rhythm were a thrilling new experience for some in the audience, a noisy annoyance to others.

The free-jazz movement gained a disciple of unmatched artistry and creativity in saxophonist John Coltrane. Of all the charismatic soloists in the history of jazz—performers who dominated their age and influenced the largest number of musicians—only Coltrane in recent times has achieved the stature of jazz giants Louis Armstrong and Charlie Parker. Born in North Carolina in 1926 of musical parents, Coltrane had already learned the basics of music when at 18 he moved to Philadelphia. By 1949, after playing with a succession of R&B bands, Trane, as he came to be known, hooked up with Dizzy Gillespie's big band and switched from alto sax to tenor.

His first real recognition came in the mid-1950s as a member of Miles Davis's quintets. During this period he refined his modal style of playing, in which he nearly abandoned the use of chords. Then, a brief stint with Thelonious Monk ushered Trane along toward an innovative concept he named sheets of sound, a kind of musical stream of consciousness in which he unleashed a torrent of notes in a ceaseless but

The most important jazz figure since Charlie "Bird" Parker, saxophonist John Coltrane led the avant-garde movement of the 1960s, echoing in his music the social turbulence of that decade as well as its hope for brotherhood.

In the 39 months between his spectacular debut with his own group at the 1967 Monterey Pop Festival and his untimely death, Jimi Hendrix ruled the pop guitar world. Hendrix, shown here in London, seemed to express in his powerfully tormented music his frustrations and those of his generation: "Maybe if we play loud enough," he once said, "we can shut out the world."

seamless fashion. *Kind of Blue* and *Giant Steps*, which he recorded just two weeks apart in 1959, exemplify this breakthrough.

A year later, Coltrane, now also playing the soprano sax, won his largest popular following with *My Favorite Things*. *A Love Supreme*, cut in 1964, displayed a cosmic, otherworldly quality that gave another dimension and definition to the term *free jazz*.

Having taken the music out as far as it would go, Coltrane turned inward, finding even more space and greater complexities. Before he could sufficiently explore this inner region, however, he was stricken with a liver ailment and died in 1967.

A month before Coltrane's death, Jimi Hendrix appeared at the Monterey Pop Festival. Trane had extended the borders of free jazz; now it was Hendrix's turn to do the same with rock. In a breathtaking performance, Hendrix played his guitar in every conceivable manner—behind his neck, over his head, between his legs, even with his teeth. The crowd was as stunned by his virtuosity as it was deafened by the intense volume. Heavy metal—rock with a thick and intense sound produced by amplified guitar and bass reinforcing one another—was born.

In four years Hendrix had risen from the position of obscure sideman to the very pinnacle of rock. The Monterey conquest happened almost simultaneously with his astonishing debut album *Are You Experienced?* Hendrix introduced free-jazz improvisation into rock 'n' roll, reaffirming the African American sources of the music for his fans, most of whom were white. His rendition of the "Star Spangled Banner" at Woodstock in 1969 was his crowning achievement; he had put the blues to the acid test. But,

like many rock stars of the period, Hendrix led a troubled and tumultuous personal life, and on September 18, 1970, he died in London when he suffocated on his own vomit after inadvertently ingesting alcohol and barbiturates. He was 27.

By then, Motown was undergoing a transition of its own. Soul singer Marvin Gaye, despite the company's reservations, came out with *What's Goin' On*, an album focused on the theme of racial injustice, with three cuts—"Mercy, Mercy Me (The Ecology)," "Inner City Blues," and the title song—that hit the top on the soul and pop charts. Blind pianist-singer Stevie Wonder's 1972 work, *Music of My Mind*, followed in the same mode, assailing the status quo and crying out against injustice.

Closer to rhythm-and-blues, another development was under way. A group called Sly and the Family Stone was putting out records that resembled the work of James Brown but were laced with acid rock—music inspired by or related to a psychedelic drug experience. Simultaneously, another variation on Brown's elemental soul emerged: funk, a heavily textured soul music presented with extravagant showmanship. The Ohio Players and the Commodores made a splash with it, but the ultimate funkmeister was George Clinton. He and his group, the Parliaments, were a Motown property but had little status there, so they disengaged and became, appropriately, the Funkadelics. They mixed a special confection of updated R&B in their 1971 album *Maggot Brain*.

The mid-1970s belonged to disco and its reigning queen, Donna Summer. Dance fever ripped through the clubs of America, giving employment to singers and bands in a style of music that was more of a fad than a movement. Disco music was devoid of funk, a kind of "souped-up soul" with violins.

The biggest story of the 1980s happened in 1983, when Michael Jackson, under the guiding hand of producer Quincy Jones, proved himself the King of Pop, winning an unprecedented seven Grammys with his megahit album *Thriller*. Such acclaim was old hat for the young phenom, who had been riding a crest of popularity since his performance as lead singer on the Jackson Five's 1969 debut single, "I Want You Back."

Prince was also in contention for the pop music crown: His *Purple Rain* was a successful 1984 film as well as a smash album. Prince was a great admirer of James Brown, but, as Miles Davis noted, had "some Marvin Gaye, and Jimi Hendrix and Sly in him, also, even Little Richard." And some Duke Ellington too, Davis added.

While Michael Jackson and Prince were gaining unprecedented popularity with young Americans of all races, a new way of putting words and music together was taking shape among young African American men on the mean streets of New York City's Bronx borough. They called their new thing rap. Although its antecedents can be traced all the way back through African American music to Africa, rap began to develop as a distinct form in the late 1960s and early 1970s, when young men would adopt colorful pseudonyms and push huge loudspeakers on wheels through

Grandmaster Flash (Joseph Saddler) and his Furious Five cut the first authentic Bronx rap record in 1979. Then, in 1981, they released "Wheels of Steel," which introduced sampling and scratching. The group's "Flash to the Beat" (1982) contained the first rap singing, and "The Message" (also 1982) began the trend of rapping about social problems.

DJ Lovebug Starski (Kevin Smith) was about 15 when he began rapping in verse at parties in the early 1970s, but before long he was deejaying at discos and eventually made several records. Like many other rap pioneers, however, he knew little about business and failed to capitalize financially on the rising music form.

the streets to outdoor parties, where they would act as deejays, playing soul and disco and inserting over the music a spoken patter—the rap.

As this style developed over the next decade or so, rap became heavily rhythmic, and the pioneers of the movement, men like Kool DJ Herc, DJ Hollywood, DJ Lovebug Starski, Afrika Bambaataa, Grandmaster Flash, Kurtis Blow, and Melle Mel, began using a technique they called sampling—intermixing bits of music from different records spinning on several turntables at once. Soon turntable acrobatics added to the sound; moves such as scratching and backspinning were done with such precise rhythm that they became music. And to gain more control over the sound, the rappers experimented with electronics, inventing such devices as the mixing switch and the beat box.

These early rappers did their thing for the love of the music and the adulation of the crowds; they had no thought of taking rap outside of the Bronx. Some even turned down recording opportunities. Then, in 1979, a New Jersey group called the Sugar Hill Gang stole a march on the Bronx rappers by releasing the first all-out rap record, "Rapper's Delight." The record exploded onto the music scene with its irresistible vocal syncopation—"A hip-hop / The hi-be / To the hi-be / The hip-hip-hop / You don't stop rockin' / To the bang bang the boogie / Say up jump the boogie / To the rhythm / Of the boogie / The beat"—and sold more than 10 million copies around the world. It also popularized the phrase "hip-hop," which has come to serve as a label not only for rap but for the entire culture of music, dances, clothes, publications, language, and attitudes that has grown up around it. The "Hip-Hop Generation" began growing and evolving at a dizzying pace.

Before 1979 was out, Grandmaster Flash and the Furious Five released "Super Rappin' " on the local, black-owned Enjoy label, the first record by a genuine Bronx crew. The following year, Kurtis Blow recorded "The Breaks" on Mercury, the first rap release by a major label. By the time producers Russell Simmons and Rick Rubin launched their Def Jam label in the early 1980s, rap was making a profit, and groups and solo performers mushroomed overnight—Run-D.M.C., Public Enemy, LL Cool J, Queen Latifah, Whodini, Doug E. Fresh, M C Lyte, Ice Cube, Kris Kross, and more.

Among the emerging styles was "gangsta rap," with its incessant profanity and denigration of women. Gangsta rap groups released discs extolling street violence, drugs, and promiscuity. At the same time, other groups countered these negative influences by rapping about the dangers of crack cocaine, gang warfare, AIDS, teen pregnancy, dropping out of school, and similar hazards of urban life.

Like the blues, jazz, and other black music forms, rap started as a kind of folk music, caught on, grew like wildfire, and became broadly popular. In this fashion, the musical dynamism and creativity of African Americans continues to endow American music and culture with one new form after another, bringing enjoyment to people all over the world. The voice of African American music remains a voice of triumph.

BLACK MINSTRELSY: A TAINTED LEGACY

Of all forms of American entertainment in the latter half of the 19th century, the most popular by far was the minstrel show, a program of lively music, dance, and jokes in large part purporting to represent the life of southern blacks.

Minstrelsy began in the 1830s and rocketed to popularity after a white minstrel named Thomas "Daddy" Rice put together an act imitating a song and dance he had once seen performed by a deformed black stable hand. Blackening his face with burnt cork and wearing rags as a costume, Rice gamboled and jigged through a song called "Jump Jim Crow." His routine earned him great fame and the nickname "Jim Crow" Rice—and later gave the nation a term for the racially oppressive social system of the post-Reconstruction South.

It wasn't long before other white entertainers were "blacking up," and soon groups of these self-described "Ethiopian" performers got together to stage the first minstrel shows—*minstrel* being a medieval English word for musical entertainer. According to Edwin P. Christy, an early showman, white minstrels attempted "to reproduce the life of the plantation darky." What they reproduced instead was a distorted and damaging portrait of African American life and culture. "Black-faced white comedians used to make themselves look as ridiculous as they could," black entertainer George Walker recalled in 1906. "In their 'make-up' they always had tremendously big red lips, and their costumes were frightfully exaggerated."

Yet white minstrels were getting rich off these degrading renditions of black songs and dances. So when stage doors first swung open to large numbers of black performers after the Civil War, many jumped at what was a rare chance to make a good living—perhaps not fully aware of the cost to their own dignity and to the image of African Americans in general.

As James Weldon Johnson put it in *Black Manhattan*, minstrelsy "fixed the tradition of the Negro as only an irresponsible, happy-go-lucky, wide grinning, loud laughing, shuffling, banjo-playing, singing, dancing sort of being." Nevertheless, Johnson conceded, for black newcomers to show business "the companies did provide stage training and theatrical experience."

Soon after the Civil War, Brooker and Clayton's Georgia Minstrels, billed as "The Only Simon Pure Negro Troupe in the World," began touring the Northeast, to great acclaim. Other black troupes sprang up, each stressing in its own way that, in the brutal phrasing of one newspaper, it was made up of "real nigs," not white imitators.

James Bland, a college-educated minstrel, enjoyed a far more dignified portrayal on the sheet music of his songs (*above*) than most African American performers could expect.

Authenticity was a draw for northern whites who were curious about plantation life and the recently freed slaves. But those who attended performances by the earliest black troupes were surprised by the varying skin colors they saw on stage. Even though they encountered real black people in their everyday lives, these whites had accepted the uniform coloring of blacked-up white minstrels as a true representation of how slaves had looked. Black companies soon perceived that audiences laughed loudest at comedy sketches where even "real nigs" worked in grotesquely exaggerated blackface.

Another perverse reason the black minstrels drew full houses was the widely held belief that their performances were not acts. White patrons, who viewed black America through a screen of racist attitudes, allowed themselves to believe that the outlandish and

unrestrained stage doings were not just entertainment but an exhibition of natural behavior.

In the end, the financial success of the black minstrel troupes had two profound—and contrasting—effects. First, black entrepreneurs such as Lew Johnson and Charles Hicks, who organized and managed several of the companies, were bought out or pushed aside by white managers. Second, black minstrels, being the "genuine article," lowered the appeal of white minstrels. Audiences tended to agree with a reviewer for the New York *Clipper* that black minstrels showed plantation life with "greater fidelity than any 'poor white trash' with corked faces" ever could.

Largely as a result of this kind of audience reaction, black stars emerged from minstrelsy. The biggest may have been comedian-dancer-singer Billy Kersands, who popularized dances such as the soft shoe and the buck and wing. Performer and songwriter James A. Bland, who composed some 700 songs, gained his renown from such numbers as "Carry Me Back to Old Virginny" and "Oh, Dem Golden Slippers."

Given the times, however, life as a black minstrel was not easy. In the South, black entertainers were shot at, even lynched. Lodging on the road was often impossible to come by; the more successful minstrel companies purchased their own train cars just to provide the members with a place to sleep.

Although the idea that black performers could ever rise above the minstrel show seemed far-fetched, some aspired to do just that. George Walker, for example, along with his esteemed comic partner, Bert Williams, were among the first African American entertainers to try to move black show business away from minstrelsy and into vaudeville and musical comedy.

But even as minstrelsy began to fade in the 1890s, many of its conventions, such as performing in blackface, followed African American showfolk into the newer forms of entertainment. Indeed, the grinning visage of the minstrel continues even today to haunt the way African Americans are perceived and presented in popular entertainment. Each generation of black talent since the Civil War has struggled against it, and although racial caricatures have generally become taboo in recent decades, at least in public, the twisted legacy of the minstrel show unfortunately lives on in the subconscious assumptions of many people.

Billy Kersands, shown above from a poster advertising Callender's Georgia Minstrels, was popular with audiences both black and white for comic routines featuring his capacious mouth.

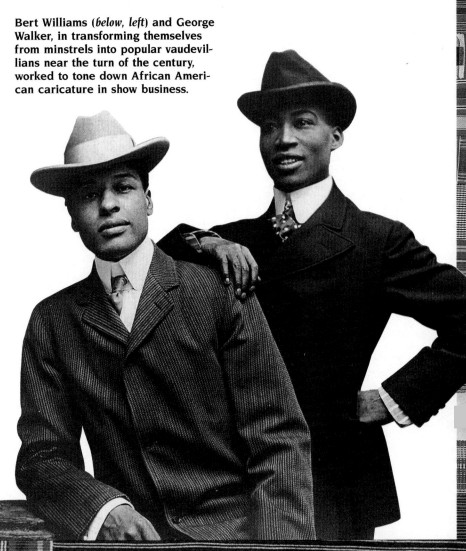

Bert Williams (*below, left*) and George Walker, in transforming themselves from minstrels into popular vaudevillians near the turn of the century, worked to tone down African American caricature in show business.

LADIES SING THE BLUES

When Mamie Smith walked into New York's Okeh studios in August 1920 and recorded "Crazy Blues," she triggered a dramatic change in the record industry. Until her release became a surprise hit, white recording executives thought that blacks lacked the money to buy records and that whites would scorn African American singers. But white-owned Okeh proved them wrong: "Crazy Blues" sold a million copies in six months, the wax discs being snapped up so eagerly that Okeh could not press them fast enough.

Suddenly all the formerly white-oriented companies jumped headlong into "race records," as discs aimed at black consumers came to be called; suddenly black entrepreneurs started their own labels; and suddenly everybody launched an intensive search for more blues singers. Scrambling to catch up, Brunswick, Columbia, Paramount, Vocalion, and Victor issued more than 100 blues records in the next two years; even these did not satisfy the demand.

In New York, black music publisher Harry Pace added blues records to a thriving sheet-music business. At first, his Black Swan label proved a formidable competitor, but in the long run it lost out to the large, white-owned companies and, in 1924, went bankrupt. Half a dozen other black record companies also arose during the 1920s but failed to survive.

Black women were the premier blues recording artists of the era, and every label had at least two African American divas on its roster. Where once these women had performed in relative obscurity, they now achieved a stardom that would carry them into musical history.

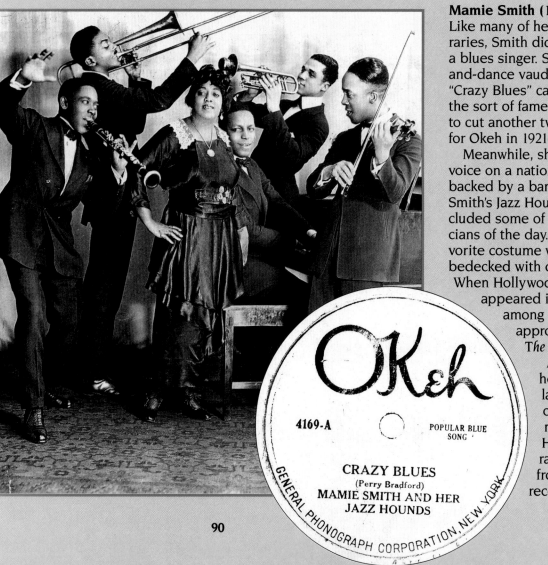

Mamie Smith (1883-1946)

Like many of her contemporaries, Smith did not start out as a blues singer. She was a song-and-dance vaudevillian when "Crazy Blues" catapulted her to the sort of fame that enabled her to cut another two dozen sides for Okeh in 1921-22 alone.

Meanwhile, she took her lusty voice on a nationwide tour, backed by a band called Mamie Smith's Jazz Hounds, which included some of the best musicians of the day. Onstage, her favorite costume was a $3,000 cape bedecked with ostrich plumes.

When Hollywood beckoned, she appeared in six films, among them one called, appropriately enough, *The Blues Singer*.

At the peak of her career in the late 1920s, she owned two apartment houses in Harlem and was raking in royalties from more than 100 recordings.

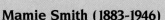

OKeh

4169-A POPULAR BLUE SONG

CRAZY BLUES
(Perry Bradford)
MAMIE SMITH AND HER
JAZZ HOUNDS

GENERAL PHONOGRAPH CORPORATION, NEW YORK

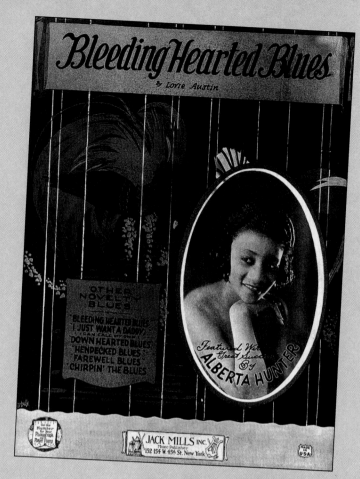

Bleeding Hearted Blues
by Lovie Austin

OTHER NOVELTY BLUES
"BLEEDING HEARTED BLUES"
"I JUST WANT A DADDY"
"I CAN CALL MY OWN"
"DOWN HEARTED BLUES"
"HENPECKED BLUES"
"FAREWELL BLUES"
"CHIRPIN' THE BLUES"

Featured With Great Success By
ALBERTA HUNTER

JACK MILLS INC.
Music Publisher
152 154 W. 45th St. New York

MADE IN USA

Victoria Spivey (1906-1976)

"Queen Victoria," as admiring fans called her, was more of an accomplished musician than most blues singers. At age 11, she was playing the piano in Houston theaters. And the first song she recorded for Okeh, in 1926, was her own composition, "Black Snake Blues." She accompanied herself on the piano as she rendered the song in a lean, nasal voice with inflections that were almost moans.

Spivey broke into movies in 1929 with *Hallelujah*. But she was a singer and composer first and foremost. One of her biggest hits, this time on the Victor label, was 1929's "Moaning Blues." Eventually she formed her own record company, and performed with gusto into the 1970s.

Alberta Hunter (1895-1984)

Another singer who wrote her own songs, Hunter started out performing in Chicago cafés as a teenage runaway from Memphis. Her mellow voice might not have fit the gutsy blues style then popular, but the rest of her did. "When I sing," she said, "what I'm doing is letting my soul out."

Her "Downhearted Blues," which both she and Bessie Smith (*page 93*) recorded, sold 780,000 copies in six months. She wowed audiences in London doing *Showboat* opposite Paul Robeson, then sang the blues at Paris's Folies Bergères. Hunter quit performing at age 59 and enrolled in a practical nursing course. After working as a nurse for over 20 years, she made a musical comeback in 1977, when she was 81.

Ma Rainey (1886-1939)

When Gertrude Malissa Nix Pridgett Rainey started traveling the tent-show circuit in 1904, she billed her act as "Assassinators of the Blues." Purists tended to agree with that. For "Ma" Rainey's style drew on both the field hollers and work songs originated by slaves and the urban blues of the late 19th century. Sometimes the two were incompatible. Yet those who loved Rainey, especially down south, called her the Mother of the Blues.

Short and squat, with a great moon face and gleaming gold teeth, Rainey had looks that once moved a friend to remark, "Ma, there are two things I've never seen—an ugly woman and a pretty monkey." "Bless you, darlin'," replied Ma.

She would sweep onstage in silks, sequins, and gold chains, wafting kisses to the crowd and waving a huge feather fan. And when she opened her mouth to sing, she could rattle the tent poles with her big, rough voice or make it coo like a turtledove.

She didn't start recording until 1923 but then cut 100 sides for Paramount in five years, scoring big with such songs as "See See Rider," "Lost Wandering Blues," and "Hear Me Talkin' to Ya." That gave her the money to retire in 1935 and enjoy running two theaters she had bought in her home state of Georgia.

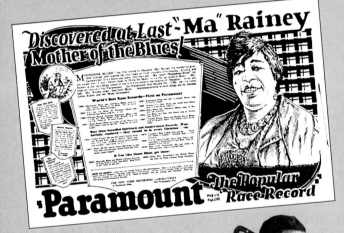

Ma Rainey belts out the blues with her Wildcat Jazz Band in 1923. Ma had been around for 20 years when Paramount proclaimed her discovery in a 1924 ad (*left*). In "Dream Blues" (*right*), Ma pursues the theme of a woman troubled by an unfaithful man.

Bessie Smith (1894-1937)

If Ma Rainey was the Mother of the Blues, Bessie Smith was the Empress, the best-loved, highest-paid, and most critically acclaimed black singer of the day.

Her genius lay in fusing country blues with elements of vaudeville and jazz to produce an intensely emotional and personal sound. Yet she was rejected by two labels before Columbia gave her a chance to do a remake of Alberta Hunter's "Downhearted Blues" in 1923. The release made Smith a star, and she cut close to 200 records for Columbia over the next decade, becoming its top-selling artist with such classics as "St. Louis Blues," "After You've Gone," "Send Me to the 'Lectric Chair," and "Empty Bed Blues." Sadly, she never had a royalty deal, and she wound up with only $28,575 from all the millions she brought in for Columbia.

Smith's big money came from her $2,500-a-week tours, mainly in the South, where she would fill every recess of a theater with her huge voice. Big and tough at 200 pounds, hard-drinking and hard-loving, she once faced down a gang of Ku Klux Klansmen who had come to disrupt her show—and another time performed despite a stab wound suffered after an argument at a party.

Bad times arrived with the Depression. Smith's recording fees in the 1930s fell to $50 a side, her tours to $140 a week. But she broadened her style, and was making a comeback in 1937 when an auto accident near Clarksdale, Mississippi, took her life.

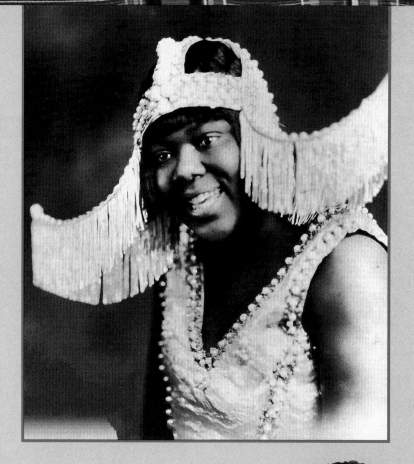

Ida Cox (1889-1967)

Like Alberta Hunter, Ida Cox ran away from her Tennessee home and was singing in theaters by the time she reached the age of 14. But although she grew up in vaudeville, her blues were earthier and more traditionally rural than those of her sister singers.

Record buyers first heard Cox's resonant, slightly nasal voice in June 1923, when she made "Any Woman's Blues" for Paramount. She skyrocketed to popularity as the company's first blues queen, with hits that ran the gamut from a grim "Coffin Blues" to the more rambunctious "Wild Women Don't Have the Blues."

Aloof and self-contained, Cox composed much of her own material, and she had few imitators. As a friend said, "She had her own thing going, and you couldn't imitate that."

Ethel Waters (1896-1977)

Movie fans remember Ethel Waters as a stout Mammy character. Yet not too long before, she had been "Sweet Mama Stringbean," who, from her background of singing the blues in vaudeville, produced a jazz-pop vocal style that enchanted black and white listeners alike. Born out of wedlock, put to work at eight, miserably married at 13, Waters had every excuse to fail in life. But she could sing. She started out in 1917 singing "St. Louis Blues," but soon evolved what she called "my low, sweet" ballad style. Her elocution was precise; she even rolled her r's.

When Harry Pace's fledgling Black Swan label needed a boost in 1921, he signed Waters up for a promotional tour. The venture was a success, bringing Pace vital funds and Waters fame as a premier blues and jazz singer. She went on to cut an astounding 259 records, either introducing or claiming for her own "Dinah," "Heat Wave," "I'm Coming, Virginia," "Am I Blue?" and "Tell 'Em about Me."

The obituary writers tended to forget most of that when Waters died. Yet even in her racially stereotyped Mammy roles, she infused the characters with such depth that she received an Oscar nomination, for Pinky in 1949.

Clara Smith (1894-1935)

Before they got into a terrible fight in 1925, Clara Smith and Bessie Smith were on friendly terms. Columbia Records' two blues headliners sometimes even pretended to be sisters, singing duets in such songs as "My Man Blues," in which they playfully agree to share the same man "on the cooperation plan."

But after the clash, it was all competition for status—and Clara came off second best. Yet there were those who thought that she was, if not the best, certainly the most underrated of all the female blues singers.

Clara's strength was as "Queen of the Moaners"; she threw herself into wailing, anguished blues about a woman's miseries. She had 120 titles to her credit, songs like "Far Away Blues," "Court House Blues," and, naturally, "Awful Moaning Blues." Wrote one critic: "Her voice is powerful or melancholy by turns. It tears the blood from one's heart."

Sippie Wallace (1898-1986)

"I sings the blues to comfort me on," Sippie Wallace once remarked. And for Wallace, the blues were her life as much as her art. She would be thinking things over, she said, "and it would just come to me to make a song about what was troubling me." The daughter of a Houston deacon, Wallace was married first to a two-timer, then to a gambler—and those woes showed up in her songs: "Adam and Eve Had the Blues," "Up the Country," "Gambler's Dream," "Special Delivery Blues."

She was called the Texas Nightingale, but no bird ever sang her high-C wails and mournful slides. Wallace's first record for Okeh, "Shorty George," sold 100,000 copies; she went on to be one of the label's top artists.

Her star was eclipsed by the Depression. But then a wonderful thing happened: She was rediscovered in the 1960s and spent another 20 years singing in clubs and concerts and making albums, for which she received a Grammy nomination at the grand old age of 85.

THE PRODIGIOUS MR. WALLER

The popular image of Thomas "Fats" Waller has him seated at the piano, derby hat perched jauntily on his head while he delivers a clever lyric. But although he was a superb entertainer, the perception does Waller an injustice, for it obscures his contributions to American music as a great jazz innovator and teacher and as a composer of rare genius.

One of 11 children born to a middle-class couple in New York City, Waller started banging away on a neighbor's piano as soon on he could climb up on the bench. At six, he was also playing a har-

monium, a small, organlike instrument, with street-corner missions for approving passersby.

Harlem, then as now, was alive with music, a magnet for musicians from all over the country. In its cabarets, entire bands of top instrumentalists would battle until dawn in "cutting contests" to see who could outplay whom. At the piano, the king of the cutters was James P. Johnson, composer of the song that touched off a 1920s dance craze, "Charleston," and master of "stride piano." In this boldly imaginative

style, a striding left hand deals with the rhythmic and harmonic structure while the right hand romps through the melody, inventing and enriching at will.

Young Waller was in the thick of it. His huge hands could span 10 notes—do "backwards tenths," in the parlance of pianists—where others could only cover octaves. Johnson, a keen judge of talent, took the fledgling genius under his wing, making him fluent in the language of stride, then carrying him further, into the realm of jazz composition. And Waller in time repaid the master, as one musicologist wrote, "by tak-

In one of his many bits of exuberant musical showmanship, a happy-go-lucky Fats Waller "talks to the keys" of his piano in this 1941 photograph. "All That Meat and No Potatoes," written with his longtime manager, Ed Kirkeby, was a typically sly ditty from the master of double meanings.

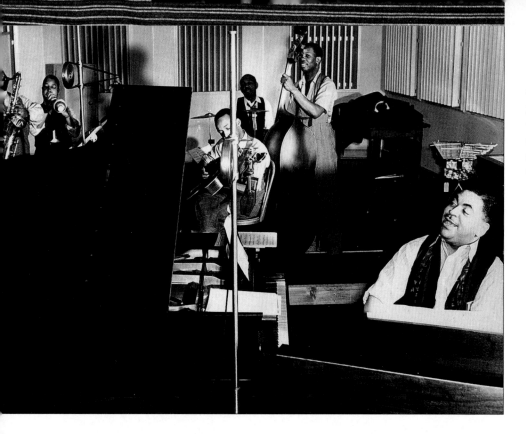

At the studio, "Fats Waller and His Rhythm" cut a side for Victor in 1941. The sextet made hundreds of discs between 1934 and 1942 while maintaining a full schedule of personal engagements. The caricature below was a trademark for Waller's sheet music.

ing the still somewhat disjunct elements of Johnson's style and unifying them into a single cohesive jazz concept."

As leader of what became known as the Harlem School in the 1920s, Fats Waller in his turn profoundly influenced rising young musicians who themselves would achieve immortality. Not only Duke Ellington, but also Art Tatum and Count Basie learned from him. Nor was it just a piano style they absorbed; from his childhood days with the harmonium and a theater organ he had learned to play in accompaniment to silent movies, Waller developed a lifelong love of the organ, and now he brought that instrument into the jazz idiom. Basie, for one, spent years studying jazz organ under Waller.

The 1920s were seeing an explosion of "race records" (*page 90*), and Waller cut his first side, a piano solo called "Muscle Shoals Blues," for the Okeh label in 1922. From then on, he made records virtually every year for the rest of his life.

His output of new music was prodigious. Often the material would literally be created at the recording studio—Waller inventing the melodies and his legendary lyricist, Andy Razafinkeriefo (usually shortened to Razaf), supplying the words. And whereas modern artists often take weeks or months to record a complete album, Waller could lay down as many as a dozen sides at a session.

The hits poured forth in a flood: "Honeysuckle Rose," "Ain't Misbehavin'," "Keeping Out of Mischief Now," "Stealin' Apples," "Blue Turning Gray over You," "It's a Sin to Tell a Lie," "Christopher Columbus." Occasionally, the ebullient Waller would record a more serious, slow-tempo composition, such as his *London Suite.* Sometimes he said that he thought his real artistic success would lie in classical music.

All the while, Waller was the quintessential performer, jovial, witty, having a wonderful time doing radio shows with a band, going on the road for concerts and

nightclub gigs, taking a fling at Broadway and the movies. Hollywood never forgot how he stole the show in 1943's *Stormy Weather* simply by raising an eyebrow in one scene. Or how in that same movie, instead of acting shocked at the sudden demise of a character, he delivered the line that has since become a classic: "One never knows, do one?"

Waller had been called Fats since childhood. With gargantuan appetites, not just for music but also for partying, he hauled around 285 pounds on a frame slightly less than six feet tall. This lifestyle naturally had its effect on his health, and when he developed pneumonia on a train returning from Hollywood to New York in 1943, his constitution could not fight it off. Fats Waller was only 39 when he died, but as a creator of wonderful music he had lived a full lifetime.

SCAT: THE WORDLESS LYRICS OF JAZZ SINGING

Louis Armstrong puts it all into a vocal. The scat singing he popularized in the 1920s has been taken to new heights by some of the most adventurous performers in jazz.

As justly famous as Louis Armstrong is for his brilliant trumpet solos and improvisations, his scat singing—according to many jazz buffs—was even better.

Scat is a distinctive form of jazz singing in which the performer vocalizes nonsense syllables to an improvised melody, often with a free rhythm. The idea is to make the human voice imitate jazz instruments. For example, this scat riff was sung by Armstrong on his famous recording of "Hotter than That" in 1927: "Rip da du da du da du-ya da da dit dip bah!"

Armstrong did more than merely excel at scat singing—he put it on the jazz map. While he was in a studio in 1926 recording a song called "Heebie Jeebies," his sheet music accidentally fell to the floor—although some believe he purposely dropped it so that he would have an excuse to try something new.

In any case, rather than interrupt the recording, he began vocalizing a string of syllables that mimicked the notes of his horn playing. His singing proved to be wonderfully imaginative and musically gratifying. Ever since, "Heebie Jeebies" has been considered one of his finest records.

Considered by many to be the greatest of all jazz—and scat—singers, Ella Fitzgerald lets loose with her glorious voice and joyful aura in this 1959 performance, when she was 41.

Jon Hendricks, of the Lambert, Hendricks, and Ross Trio, made a career of writing and singing lyrics for instrumental bebop solos.

Some students of music believe that the roots of scat can be traced back to western Africa, where singers mimic the sound of percussion instruments. Early New Orleans jazz musicians sometimes vocalized extemporaneously in a similar fashion. The scat that has evolved among African American jazz singers since Armstrong's time, however, is freer in melody and rhythm and richer in sounds than West African vocalizations.

Innovation is the key to scat singing, and no one is more inventive than Ella Fitzgerald. She burst on the music scene in 1934 when, at age 16, her radiant, fluid voice astounded everybody one amateur night at Harlem's Apollo Theater. By 1945, her scat singing of bebop licks, particularly on her legendary rendition of "Flying Home," put her in a class by herself as a scat artist.

A few years later, scatting moved into a new phase when singer and tap-dancer Eddie Jefferson got the idea of writing lyrics to saxophonist Coleman Hawkins's classic improvisation on "Body and Soul." Jefferson's initiative was carried further by Dave Lambert, Jon Hendricks, and Annie Ross. Beginning in 1957, the trio made a reputation vocalizing Count Basie recordings, and ultimately rendered in voice solos by Charlie Parker, Miles Davis, Lester Young, and John Coltrane.

In the 1970s, singer Al Jarreau moved onto the jazz scene. As one writer put it, out of his throat emerged "an entire orchestra of sounds," and a range that made it seem "as if he had a dozen or more different male and female voices at his disposal."

Then in the 1980s came Bobby McFerrin, singing a cappella and beating out the rhythms on his chest. McFerrin's voice sizzled with guitar riffs and "blown" sounds. And he was the first jazz singer ever who could sing while he was drawing in a fresh breath as well as on an exhalation.

Spanning the entire evolution of scat from Ella to McFerrin has been Betty Carter, who sang with Charlie Parker while still a teenager. Carter works such magic in her improvisations that a listener would swear she was inventing a brand new song right on the spot. Now she performs alongside and teaches young musicians, perhaps someday to uncover the genius who will carry scat singing to its next plateau.

After an appearance at the 1978 Newport Jazz Festival, scat innovator Betty Carter rehearses for a Broadway concert.

With his amazing three-octave range, Bobby McFerrin swoops from falsetto to deep bass as he explores the outer limits of scat.

On a rainy evening in 1948, Manhattan's 52d Street, though already in decline, still scintillates with color and music as the jazz capital of the world. Famed pianists Erroll Garner and Art Tatum are among the names on the marquees.

GOING DOWNTOWN TO "THE STREET"

On a Sunday afternoon in February 1936, the great blues singer Bessie Smith walked into the Famous Door nightclub on Manhattan's 52d Street. By tradition, that time of the week was reserved for musicians' jam sessions in nightspots ranged along a short stretch of "The Street"—also called Swing Street—so there was a bit of a stir when Smith, whose career had long been going downhill, appeared.

The "Empress of the Blues" gave the only 52d Street performance of her life that day, and, as one observer recalled, she didn't even take off her fur coat to do it. "She came in and planted those flat feet firmly on the floor. She did not shake her shoulders or snap her fingers. She just opened that great kisser and let the music come out." When she finished singing, she simply walked off the stage and out the door. Nobody who was lucky enough to have been there ever forgot it.

In the decades of the 1930s and 1940s, 52d Street was a place where strange and wonderful things like that could happen. The 20 or so tiny clubs that lined the two blocks between Fifth and Seventh avenues drew the country's top jazz musicians, who played before knowledgeable, appreciative—though white-only—audiences.

The jazz scene made for quite a change in the sedate residential neighborhood 52d Street had been earlier in the century. The upper crust had departed for New York's East Side and suburbs after World War I, and when speakeasies took over the brownstone townhouses during Prohibition, 52d Street's reputation as a place for good times was born.

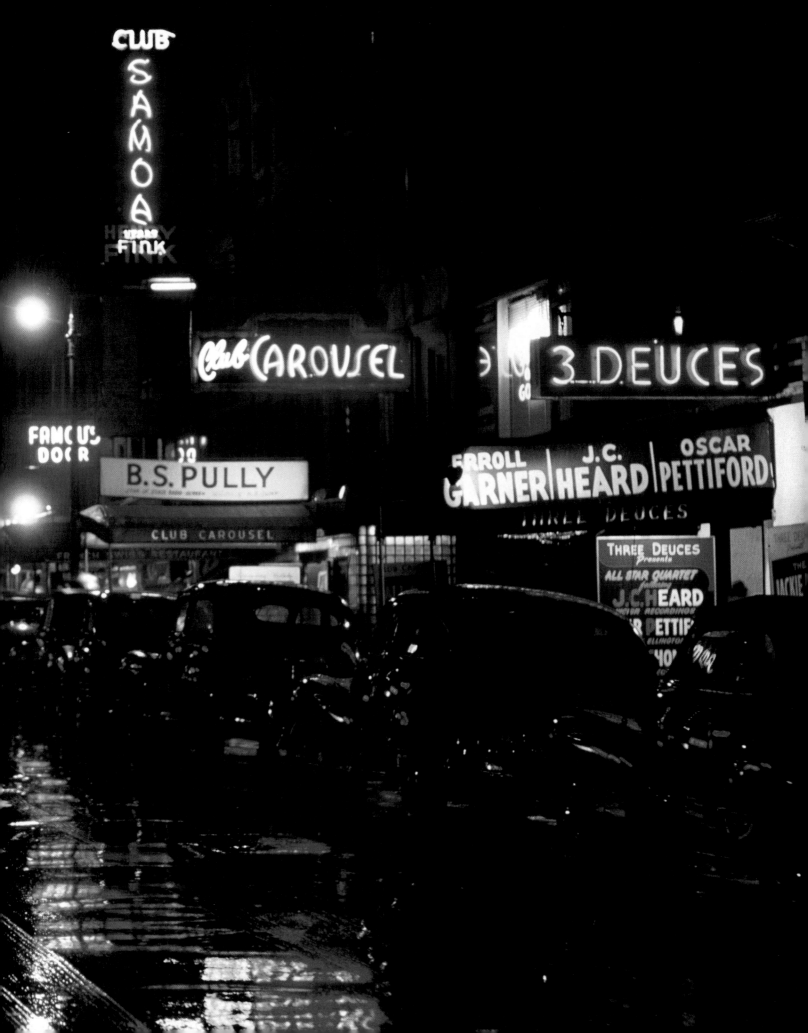

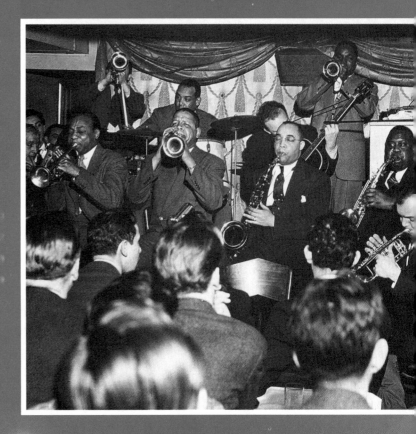

The good times kept right on rolling after Prohibition ended in 1933. The Onyx Club got the jump on everybody by booking a combo from Harlem called the Five Spirits of Rhythm, led by scat singer Leo Watson. As one jazz historian put it: "52d Street came alive because of the Onyx, and the Onyx began booming because of the Spirits of Rhythm."

For black musicians, The Street was a place to earn some money in hard times and a way to spread their music beyond the confines of Harlem. Dizzy Gillespie and Count Basie, Charlie Parker and Coleman Hawkins, Roy Eldridge, Fats Waller, Erroll Garner, Eddie Heywood, Mabel Mercer, Billie Holiday, and Sarah Vaughan were among the host of black headliners who drew crowds to the clubs night after night.

Yet The Street could be a nightmare for black performers. According to Gillespie, playing there was both frustrating and rewarding—a grotesque mixture of racist humiliations behind the scenes and unrestrained adulation from the audiences out front. Appearing on The Street for the first time at the Famous Door in 1935, Billie Holiday was forbidden by the owner to mingle with customers, take a seat at a table, or even sit at the bar. Between sets, she had to take her breaks upstairs, in the hall by the toilets. She later found a less discriminatory management at Kelly's Stable, where she wowed the audiences and settled in for her long, triumphant association with The Street.

More than just a showcase for talent, 52d Street in the mid-1940s became an important venue for a whole new kind of jazz. This was bebop, which, as one musicologist wrote, "brought new resources into the field of jazz, fresh melodic lines, startling rhythms, complex chords and new repertoire." It was hard-edged, aggressive—and exclusively black.

When bebop came downtown from Harlem with groups like that of singer-bandleader Billy Eckstine, with it rode a message of African American anger at continuing racism and inequality. Black musicians took a grim satisfaction in the fact that most white instrumentalists—who were usually better paid than their black counterparts—could neither understand nor play the new music.

On 52d Street, the new form found an early home in four clubs—the Spotlite, the 3 Deuces, Kelly's Stable, and the Onyx. But although bebop would in time dominate the genre and lay a foundation for the jazz of later decades, it also exacted a price for its complexity and exclusivity. By the late 1940s, the music had become so introspective and rarefied that it lost much of The Street's white audience; few except other musicians could appreciate it.

The Street began to slip. The small, noisy clubs with tables clustered right up against the bandstand no longer held their allure. Accelerating the decline was an influx of parasitic drug peddlers, who preyed implacably on the musicians. The bands got messed up, the talent drained away, and the clubs shut down one by one. By the early 1950s, the place had become a hangout for pushers, pimps, and prostitutes.

Today, only the "21" Club—where power, not jazz, is the attraction—remains of the brownstones on what was once The Street; office towers have replaced all the others. A sign reading "Swing Street" reminds knowing visitors that this is the place where jazz once was king.

Musicians from nightclubs up and down 52d Street gather at Jimmy Ryan's for a swinging Sunday afternoon jam session. So infused with music were the jazzmen that they would play until the clubs closed, and then—with aficionados in tow—make their way uptown to Harlem, where the jazz would continue until dawn.

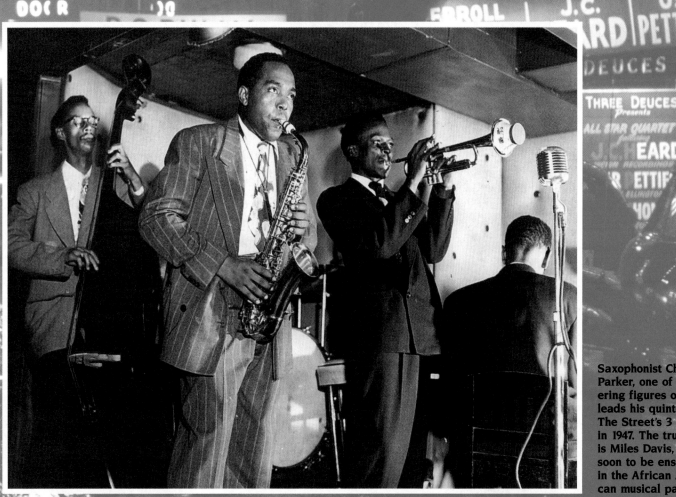

Saxophonist Charlie Parker, one of the towering figures of jazz, leads his quintet at The Street's 3 Deuces in 1947. The trumpeter is Miles Davis, himself soon to be enshrined in the African American musical pantheon.

BREAKTHROUGH BALLADEERS

In an industry where a singer's fame may begin and end with a single hit record, five African American performers have been stable commodities over the years—Billy Eckstine, Nat King Cole, Dinah Washington, Sarah Vaughan, and Johnny Mathis. The first four vocalists were firmly grounded in the black musical traditions of gospel, jazz, and blues, but it was their consummate artistry as balladeers that eventually brought them national and international acclaim. These musical pioneers smoothed the way for the next generation of entertainers, with Johnny Mathis among the first of their grateful heirs.

Eckstine, Cole, Washington, and Vaughan came to prominence in the 1930s and early 1940s, when the black and white entertainment worlds scarcely overlapped. Then, in the rock-and-roll era of the late 1950s and early 1960s, Mathis and his love songs burst on the scene with the brightness of a supernova. His album *Johnny's Greatest Hits* was on the top of the pop charts for 490 weeks—almost nine and a half years!

Billy Eckstine

The first time people took notice of Billy Eckstine's honeyed baritone was when he won first prize in an amateur talent contest in Washington, D.C., in 1931. The 17-year-old student's first love was football, however, not music. He won an athletic scholarship to Saint Paul University, but his days as a football player ended abruptly when he shattered his collarbone. With a football career out of reach, he left college and recast himself as a jazz singer.

In 1939, a spot as a vocalist with Earl "Fatha" Hines's band boosted Eckstine into the big time. Five years later, he organized his own innovative bebop band, which at times included Dizzy Gillespie, Charlie Parker, Miles Davis, Fats Navarro, and Sarah Vaughan.

Besides heading up the band and doubling on trumpet, Eckstine won fans with solo club dates and recordings, exploding onto the pop scene in 1945 with two romantic ballads, "Cottage for Sale" and "Prisoner of Love." Both sold over a million copies—a first for any black male singer. Eckstine went on to win worldwide acclaim for the stylized romantic vocals that sustained his career to the end. He died in 1993.

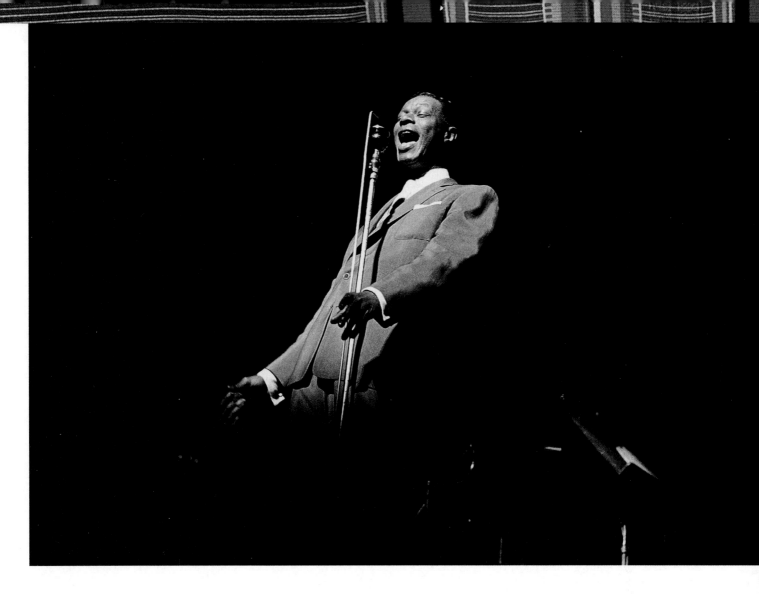

Nat King Cole

If Nat "King" Cole (1917-1965) had never sung a note except in the shower, he would still be revered as a jazz pianist of the highest rank. Indeed, his singing career happened more or less by chance. Born Nathaniel Adams Coles in Alabama, he spent most of his childhood in Chicago, where his father was a pastor and his mother sang in the church choir. He was a budding pianist at five and by age 12 was playing the church organ and singing in the choir.

Cole was hearing other sounds as well, for Chicago was a great town for jazz. After playing piano with various groups there, he formed his own trio in 1937 and went on the road. In performing across the country, he acquired his nickname, dropped the s from Coles, and carved a reputation as a keyboard virtuoso.

Along the way, Cole sang now and again during the trio's gigs "to break the monotony," he said later, "of piano, guitar, and bass." But fans relished his smoky baritone, pristine diction, and effortless delivery. They pressed him for more vocals, and soon record buyers were following suit.

Cole scored his first big hit in 1943 with "Straighten Up and Fly Right," a song he wrote in response to one of his father's sermons. His popularity with white record buyers jumped, and he garnered more and more crossover fans as he expanded his repertoire to include ballads as well as jazz numbers.

Cole got his own radio show in 1946, and during the 1956-57 TV season he was the first black solo star of a weekly network program. But it was mainly concerts, club dates, and recordings that kept Cole fans faithful. Over the years, they put 26 of his songs on Billboard's Top 40 charts.

Nat King Cole's appeal is evergreen. A quarter century after his death, his daughter Natalie Cole, with the aid of high-tech equipment, sang a poignant duet with her late father, blending her voice with the standard-setting rendition of "Unforgettable" he had recorded in 1961. Her album landed at the top of the charts.

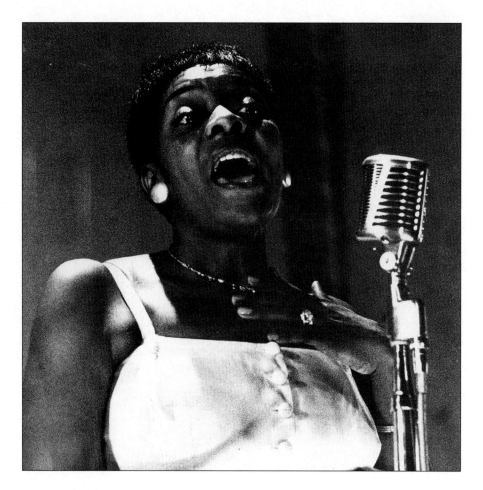

Dinah Washington

Dinah Washington was one of a kind. Equally at home in jazz, gospel, blues, and pop, she blended these strains into a thoroughly original sound.

Washington grew up in Chicago and was 16 when she first stepped into the public eye, performing in 1940 as a singer and piano player with a group led by gospel artist Sallie Martin. But the musical influence of such early blues stars as Bessie Smith and Ethel Waters and the singing and success of Billie Holiday were pushing the youngster in another direction.

By 1942 Washington had left the gospel group, and a Chicago club owner let her try out as a singer. Her throaty alto became the talk of the town, prompting Lionel Hampton to hire her as a

vocalist. After a three-year stint with his band, she launched herself as a solo singer, soon earning the title the Queen of the Blues.

Offstage, Washington became what one admiring critic termed a "living jukebox" for Mercury Records, singing not only rhythm-and-blues but country and pop tunes plucked from the mainstream repertoire, such as "Wheel of Fortune," "Love for Sale," and "Cold, Cold Heart."

Washington's 1959 rendering of the ballad "What a Difference a Day Makes" became a million-seller. In 1963, her career still in high gear, she made no fewer than eight albums. But there would be no more. On December 14 the 39-year-old star inadvertently ingested a fatal combination of alcohol and diet pills.

Sarah Vaughan

As a child growing up in a poor neighborhood in Newark, New Jersey, Sarah Vaughan was shy, serious, and convinced that she was homely—the last person in the world to imagine any special kind of future for herself. Certainly she never dreamed that she would grow up to become the "Divine One" of the entertainment world. Her expectation—common at the time—that people would have small regard for her because her skin was quite dark cast a shadow over her childhood, and she longed for a magical escape to a place where the color of your skin didn't matter.

For all her feelings of inferiority, Vaughan flourished musically. Her parents, a carpenter and a laundress, were musical themselves, and they provided her with eight years of piano lessons and two years of organ lessons. And then there was her lovely voice—a lyric soprano—the jewel in the choir of Newark's Mount Zion Baptist Church. In 1942, eighteen-year-old Vaughan screwed up her courage and entered a contest for amateurs at Harlem's Apollo Theater. Her rendition of "Body and Soul" captured first prize—20 dollars and a week's engagement at the Apollo.

The gig was Sarah Vaughan's open sesame. Among the people enchanted by her singing was Billy Eckstine, then a vocalist with Earl Hines's band. At Eckstine's urging, Hines signed her on as a vocalist and second pianist, and when Eckstine formed his own ensemble in 1944, she sang with him for a year.

In late 1944 Vaughan began cutting records, and it didn't take long for her to cause a stir in jazz circles. The instrumentalists she worked with were the best in the business, including such luminar-

ies of the vanguard of modern jazz as trumpeter Dizzy Gillespie and saxophonist Charlie Parker. Sarah Vaughan soon established beyond a doubt that she was not simply a vocalist but a brilliant musician who could "play" her rich voice as if it were an instrument. In her modern jazz recordings, the words took a backseat to the music itself.

By the late 1940s Sarah Vaughan was recognized as one of the giants of jazz. At the same time, her sophisticated way with popular songs was attracting a different but equally enthusiastic audience, much of it white. The singer's record sales mounted steadily until, in 1959, "Broken-Hearted Melody" put Vaughan into the million-seller league. For the remainder of her career, the versatile Vaughan would move easily between jazz dates and pop sessions. Listeners, whether they heard her in clubs, in concert, or on record, could never get enough of the Divine One.

Johnny Mathis

Johnny Mathis's rise to stardom appeared as effortless as his singing. Blessed with a sweet tenor voice and reared in San Francisco by an ex-vaudevillian who saw to it that his son had singing lessons, Mathis enjoyed performing but had decided to become a schoolteacher. In 1955, however, as a 20-year-old college student and sometime singer at clubs in his hometown, he caught the attention of Columbia Records. A contract followed and, after a false start as a jazz singer, Mathis hit his stride as a master balladeer with "Wonderful! Wonderful!" in 1957. Within a year he had nine Top 40 hits to his credit.

Mathis's tender, caressing delivery of "Chances Are," "Misty," and other romantic songs made him a perennial favorite of lovers of all races. In 1993 a crowd of those romantics sold out Carnegie Hall to hear Mathis's still-sweet tenor run through a repertoire drawn from four decades of entertaining.

THE BLACK PEDIGREE OF WHITE ROCK 'N' ROLL

The Chords, the original R&B victims of the mid-1950s "cover" phenomenon, saw their "Sh-Boom" success dimmed by the Crew Cuts' remake. The Chords never again made the pop chart.

In 1951, Leo Mintz, a white record-store owner in Cleveland, noticed something unusual. White kids were coming in and buying black rhythm-and-blues records. Somehow they had got wind of this music, perhaps by listening to black radio stations, perhaps by word of mouth.

Though few people were yet aware of it, a profound change was brewing. The musical tastes of white adults and teenagers, which had more or less coincided for many decades, were diverging. The trend was in its infancy when Mintz made his observation, but it would soon accelerate, and in just a few years the break would be virtually complete.

Not sure what to make of what he was seeing, Mintz telephoned Alan Freed, a new disc jockey at local white radio station WJW, and told him about the phenomenon. Mintz urged Freed to start giving heavy airplay to R&B recordings —in an age when white-oriented radio stations simply did not broadcast black music. At first Freed was doubtful, but when he spent an evening at Mintz's store, he could not deny the enthusiastic reaction of white kids to the music of black R&B singers like Red Prysock and Big Al Sears and Ivory Joe Hunter.

Freed persuaded the station manager to let him play R&B. He then put on what he called a Rock 'n' Roll Party, an R&B deejay show that quickly became a huge hit.

The phrase *rock 'n' roll* had already been in circulation for some time among blacks—as a euphemism for sex. In the late 1940s it began to work its way into R&B songs: "Rock All Night" by the Ravens, "Good Rockin' Tonight" by Roy Brown, "All She Wants to Do Is Rock" by Wynonie Harris. When the full phrase appeared in the Dominoes' 1951 release, "Sixty Minute Man," there could be no mistaking the meaning of "rockin' and rollin' all night long."

Soon, the young whites who sought out R&B records were calling the music rock 'n' roll. The trend, also breaking out in other cities, became a nationwide phenomenon in 1954, when the Chords, a black R&B group, released "Sh-Boom." Almost immediately it moved to the top of the R&B charts, but even more astonishing, within three weeks it

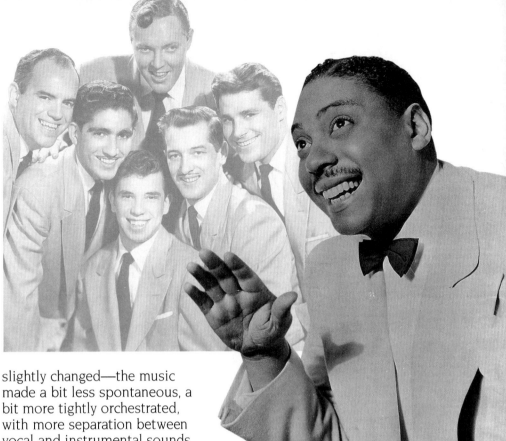

Joe Turner's 1954 hit "Shake, Rattle and Roll" rose to number two on the charts; the version by Bill Haley and the Comets was seventh.

crossed over and made the Top 10 on the pop charts. No previous R&B number had ever scored big in the pop rankings.

The "Sh-Boom" craze got major record companies thinking, and soon the Chords found themselves the target of a record-industry hijacking. It had long been an industry practice for performers to put out their own version of a hit record. Sometimes in the 1920s and 1930s a popular new song might be recorded by a dozen or more performers. The practice was called covering.

Covering took on a more negative meaning in the mid-1950s, however. During this period, when R&B records were becoming popular hits, the target of a cover would often be a black R&B singer or group, and the cover artist would be white.

The white version would be slightly changed—the music made a bit less spontaneous, a bit more tightly orchestrated, with more separation between vocal and instrumental sounds than on a black R&B treatment. Maybe more to the point, any lyrics suspected of having a double meaning, no matter how playful and harmless, were altered.

Harvey and the Moonglows reached the number two spot with "Sincerely" in 1954, but sales of their hit were weakened by the McGuire Sisters' cover, which went to the top of the charts.

Etta James saw her 1955 hit, "Roll with Me Henry," stop at number 12 among the top pops when Georgia Gibbs's cover, renamed "Dance with Me Henry," made number two .

sion of "Ivory Tower" by Otis Williams and the Charms, and Georgia Gibbs's cover of Lavern Baker's "Tweedle Dee."

This covering worked partly because the major record labels had the most efficient manufacturing facilities and the strongest distribution and promotion arrangements. Furthermore, the covers were supported by most white deejays, who either shunned black R&B recordings because of their own racism or were too timid to spin these discs for fear of negative reactions from white listeners. Alan Freed, however, was one white deejay who refused to play covers on his radio show in Cleve-

But the arrangement on the original, which often was as much a part of the record's success as the singing, would simply be expropriated and used in the cover version without apology. (At the time, copyright laws did not protect arrangements, a failing that has since been corrected.)

When a white Canadian group called the Crew Cuts released a cover of "Sh-Boom"—changed slightly to appeal more to a white audience—it quickly outsold the Chords' version. The Crew Cuts' "Sh-Boom" soared to the top of the charts and finished as one of the Top Five pop songs of 1954.

The Crew Cuts' success touched off a string of white covers of R&B recordings, including the McGuire Sisters' version of Al Hibbler's "He," a remake by Pat Boone of Fats Domino's "Ain't That a Shame," Gale Storm's ver-

Little Richard was twice covered by Pat Boone—on "Tutti Frutti" and "Long Tall Sally." Though injured by the lost record sales, Little Richard has remained popular, while Boone long ago slipped from the limelight.

land and, later, in New York.

Of course, as had happened often in the past, anybody might cover any record; there were cases of whites covering white hits, blacks covering black hits, and even blacks covering white hits. But the mid-1950s were a time when many black performers were being exploited by white managers and record companies, and covering only added to the ways they were hurt financially.

As events would show, however, it was just the "different" quality of the R&B sound that appealed to young white audiences. And the covers, while harmful at first, eventually proved a very effective way to spread the R&B sound to a vast new white audience.

Soon, white record buyers were rejecting the covers and insisting on the originals. Voting with their dollars, they showed that record-company executives were out of touch with youthful tastes. As early as 1956, Little Richard's "Long Tall Sally" outsold Pat Boone's cover version—demonstrating the universal appeal of genuine African American music.

When Smiley Lewis's "I Hear You Knockin' " was covered by Gale Storm in 1955, it was one of two remakes of R&B hits by Storm that year; she covered two more in 1956.

Fats Domino's "I'm Walkin' " hit number five on the charts, compared with number seven for Ricky Nelson's cover version. On four other Domino hits between 1955 and 1957, covers outsold the originals twice.

PROPHET OF FREE JAZZ

When Ornette Coleman and his quartet played for the first time at New York's Five Spot Café in November 1959, the audience was stunned. Coleman had liberated himself from the conventions of music theory, conceiving instead a kind of music that he termed "harmolodic"—from the words *harmony*, *motion*, and *melody*. Rather than follow the metronomic beat of drums and bass, or the usual harmonic chord changes, he felt free to improvise on the melody, wherever that might lead.

For much of Coleman's career, many listeners—audiences and performers alike—had decried the wild dissonances, ragged honks, and strained wails coming from his alto sax. "Most musicians didn't take to me," he recalled later. "They said I didn't know the changes and was out of tune." That night at the Five Spot, though, Ornette Coleman finally got through. Soon people like composer-conductor Leonard Bernstein were hailing Coleman as a new genius, producing the most exciting music in a generation.

Coleman paid no mind to praise or criticism but simply pursued his vision. Born to poverty in Fort Worth in 1930, he had no formal music training. At 14, he managed to buy a cheap saxophone and taught himself to play by mimicking songs he heard on the radio. He often played what he pleased, whether it was technically correct or not—a habit that got him kicked off his high-school band.

Around 1950 Coleman joined the band of blues singer and guitarist Pee Wee Crayton and traveled to

Los Angeles. Crayton, however, forced him to stick to the blues, so when the band broke up after all its members but Coleman were drafted, he felt no loss. He tried to sit in with a few other bands, but they wouldn't accept his playing. In 1952 he returned to Texas, where he formed several groups over the next few years. He cut an album, *Something Else*, in 1958 and, after changing drummer and bassist, followed up in 1959 with *Tomorrow Is the Question!* For both albums and his history-making gig at the Five Spot a few months later, Coleman used an inexpensive plastic sax; he felt it gave him a purer tone than brass.

On the heels of his two-week engagement at the Five Spot came a gig at the city's Town Hall. Coleman then went on tour, returning to the Five Spot in April 1960 to begin a triumphant four-month stay.

By this time, Coleman had changed jazz forever. His third album, confidently titled *The Shape of Jazz to Come* and also released in 1959, was a milestone in the jazz world's acceptance of Coleman's music. Critics noted his uncanny ability to express the tonal qualities of the human voice with his saxophone.

In 1960 Coleman assembled a double quartet that recorded an improvisational album called *Free Jazz*. The name soon came to be used for Coleman's music and the movement he inaugurated.

A musician who has always gone his own way, Coleman has performed and made records according to his own schedule. In 1972 he released *Skies of America*, and nothing else until *Dancing in Your Head* in 1977—but then eight new albums over the next 14 years. He has also piled up a number of unreleased tapes, including some experiments with electronic music. Meanwhile, he doesn't worry about success or failure. All he truly thinks about, he says, "is achieving something that I believe is good to do."

BLACK SONGWRITERS: POETS OF MUSICAL NOTE

The entire music industry—with its singers, bands, arrangers, and producers—is built on a single foundation: the song. Ironically, those who write the songs that become hits and standards, and that bring fame and fortune to many in the music business, are seldom known to the public, even as their material catapults performers to stardom. Since the 1950s, many of the biggest rock 'n' roll, soul, and rhythm-and-blues songs to achieve hit status on American popular music charts have been written by black composers, some of whom are profiled here.

Otis Blackwell

Early fans of Elvis Presley and Jerry Lee Lewis who happened to read the labels on the singers' hit records saw the name Otis Blackwell listed as the composer time after time. Blackwell, who was born and raised in Brooklyn, got started performing his own material in Harlem at the Apollo Theater's weekly amateur contest. In 1955 he sold six songs for $25 each, including "Don't Be Cruel," which Presley made into a hit that sat at number one for nine weeks. Among Presley releases, its success was equaled only by "All Shook Up," another Blackwell composition. In addition to Presley's "Return to Sender" and "One Broken Heart for Sale," Blackwell wrote Jerry Lee Lewis's 1957 hits "Great Balls of Fire" and "Breathless," as well as "Handy Man," recorded by Jimmy Jones and, later, by James Taylor. Otis Blackwell's "Fever," which was first released by Little Willie John and then by Peggy Lee, has become a standard. In all, the composer—who is now a wealthy man—has written more than 900 songs.

Smokey Robinson

Perhaps best known as the lead singer of the Miracles, William "Smokey" Robinson is also a prolific songwriter, having written more than 4,000 songs and published more than 1,500 during his career.

Smokey was 11 years old and a delivery boy for the *Detroit Free Press* when he began jotting down melodies and lyrics in 1951. Within a few years, he had progressed from tunes in the "moon-June" mode to those with a more sophisticated appeal. When Berry Gordy, Jr., heard Robinson at an audition in 1957, he helped the teenager and his band—even then named the Miracles—get a deal with End Records.

In 1961, after Gordy had formed Motown, he and Robinson collaborated on a number they titled "Shop Around." Recorded by the Miracles at Motown, it rose to number three

on the pop charts and became the company's first hit. With Gordy, Robinson had worked out a formula that would help launch the Motown sound: a clever story line set to a funky beat.

"The songs just come," Robinson once said when asked about his creative process. Sometimes he begins with a few bars of melody; other times a catchy phrase serves as inspiration. His plays on words abound in such numbers as "The Hunter Gets Captured by the Game," released by the all-female Motown group the Marvelettes, and "I Second That Emotion," a tune he cut himself with the Miracles.

Some of the biggest recording artists in pop history have immortalized the products of Smokey Robinson's muse. "My Girl" and "My Guy"—smash hits by the Temptations and Mary Wells—are Robinson compositions; he has also written for Marvin Gaye, the Supremes, the Four

Tops, Aretha Franklin, the Isley Brothers, and Dionne Warwick.

But, understandably, the composer—pictured at near left in the 1960s with the Temptations—may have kept some of his favorites for himself. During

Holland, Dozier, and Holland
Known in shorthand as H-D-H, Eddie Holland, Lamont Dozier, and Brian Holland came together at Motown soon after Berry Gordy, Jr., formed the company. Dozier (*below, left*) was 20 years old and had been playing in a local band when Gordy brought him on board in 1961. The following year, 23-year-old Eddie Holland (*center*) joined the staff as a singer, and his younger brother Brian (*right*) worked as a producer.

"I first met Brian Holland when Berry suggested I team up with him to write and produce," recalled Dozier in 1988. The pair crafted "Locking Up My Heart," a Top 20 hit for the Marvelettes, but wrote nothing else significant until Eddie decided he was ready for a career change. "He never wanted to be a singer anyway," said Dozier. "So he came in with us as a lyricist and we became Holland-Dozier-Holland."

The chemistry worked. H-D-H scored their first big hit with

his nearly 30-year association with Motown, Robinson recorded one chart-topper after another, including "The Tears of a Clown" with the Miracles, and "Cruisin' " and "Just to See Her" as a solo artist in the 1970s and 1980s.

"Heat Wave," recorded by Martha and the Vandellas—but it was with the Supremes that the three made their biggest mark. Of the phenomenal 14 chart-busters they wrote for the group between 1964 and 1969, seven of them reached number one, including "Where Did Our Love Go?," "You Can't Hurry Love," and "The Happening." During the same period, Holland, Dozier, and Holland also catapulted another Motown group, the Four Tops, to the top of the charts with such hits as "I Can't Help Myself (Sugar Pie, Honey Bunch)" and "Reach Out, I'll Be There."

"Brian was basically the recording engineer, melody man, and producer," said Dozier of the division of labor. "Eddie wrote lyrics, and he would sing the demos for the artists. My function was melody, lyrics. I'd sing backgrounds on the demos, and I produced with Brian."

In 1969 the dream team left Motown to set up its own label, Invictus Records. Their charm unbroken, H-D-H fired off such successes as "Band of Gold," sung by Freda Payne, and Chairman of the Board's "Give Me Just a Little More Time." Five years later, however, Dozier parted company with the Hollands, ending the extraordinary synergy of H-D-H.

Ashford and Simpson

In 1964, a year after they met in Harlem, 18-year-old gospel singer Valerie Simpson and 22-year-old singer and jazz dancer Nickolas Ashford began writing songs together. At first they composed purely for fun, but when a publisher bought some of their material, they realized they had a career in the making.

Scepter Records signed them up as writers in 1965. The next year, Ray Charles hit number one with "Let's Get Stoned," a song Ashford and Simpson crafted with writer Jo Armstead. The pair soon afterward accepted a contract from Motown, where they wrote "Your Precious Love," "Ain't No Mountain High Enough," "Reach Out and Touch (Somebody's Hand)," and "You're All I Need to Get By" for Marvin Gaye and Tammi Terrell. In 1970 Diana Ross also cut "Ain't No Mountain," which soared to number one.

Since then, Ashford and Simpson, who married in 1974, have launched a successful singing career of their own, earning several gold records while continuing to write for Chaka Khan, Gladys Knight and the Pips, and Patti LaBelle.

Pioneers of the Philly Sound

The Sound of Philadelphia—a distinct musical style that combines infectious melodies with a big-band dance beat—was born in the 1970s to a large extent through the labors of three local black writers (*below, left to right*): Thom Bell, Leon Huff, and Kenny Gamble.

Bell was a child prodigy who could play piano, drums, and flügelhorn by the time he was nine years old. As a young adult, he first worked as a performing artist before becoming a producer for such acts as Philadelphia's Delfonics. Around the same time, in 1971, he teamed up with lyricist Linda Creed and began writing a string of what would become Philly classics. Most of the hits of the Stylistics, including "Betcha by Golly Wow" and "I'm Stone in Love with You," are Bell's musical compositions, as are "Could It Be I'm Falling in Love" and "I'll Be Around," recorded by the Spinners.

Kenny Gamble, a musician who happened to be a friend of Bell's, pooled his songwriting talent with keyboardist Leon Huff after they met during a recording session in 1964. In 1971 the composing duo scored their first million-seller when the Intruders recorded their song "Cowboys to Girls." Throughout the 1970s Gamble and Huff helped make stars of the O'Jays, Harold Melvin and the Blue Notes, Peaches and Herb, the Three Degrees, and Billy Paul, writing such Philly hits as "Love Train," "If You Don't Know Me by Now," "Reunited," "When Will I See You Again," and "Me and Mrs. Jones."

Isaac Hayes

"I was always in little bands," Isaac Hayes once said of his years growing up in Tennessee. "I listened hard to the blues and said, 'Yeah, that cat is talkin' about me.'" Hayes teamed up with lyricist David Porter around 1964, when he was 21, and soon afterward went to work as a studio musician for Stax Records, producers of the down-to-earth, soul-based "Memphis Sound." Together Hayes and Porter wrote some 200 songs, including "Soul Man" and "Hold On, I'm Coming," which were big hits for the duo Sam and Dave.

Hayes turned performer of his own material when, on a lark, he and the vice president of Stax went into the studio to see what kind of voice the composer had. In 1967 he released *Presenting Isaac Hayes*, and two years later, his *Hot Buttered Soul* earned him a gold record. Hayes reached the pinnacle of his career with "Theme from Shaft," which won an Oscar and a Grammy in 1971. In 1976 Hayes left Stax and went into what he called a rest-and-reconstruction phase, from which he emerged around 1990 to record with sax-ophonist Kim Waters.

Stevie Wonder

"Music can measure how broad our horizons are," musician-singer-songwriter-producer Stevie Wonder once said. "My mind wants to see to infinity." Blind since shortly after his premature birth on May 13, 1950, Steveland Judkins Morris has never let his impairment stop him or slow him down. Since 1960, when the 11-year-old landed a Motown recording contract and a new stage name, Stevie Wonder has won 17 Grammys and been inducted into the Rock and Roll Hall of Fame. He has written such enduring love songs as "You Are the Sunshine of My Life" and "My Cherie Amour." He wrote the number one hit "I Just Called to Say I Love You" for the 1984 movie *The Woman in Red*, for which he won an Oscar for Best Original Song at the Academy Awards ceremonies the next year.

Wonder's creative genius is ceaseless. He has published over 300 songs and shown huge crossover appeal, having been recorded by everyone from Dionne Warwick and the Jacksons to the Boston Pops and Barbra Streisand. "Every day of my life," Wonder has said, "I thank the Lord I have sound."

Prince

Winner of an Oscar, four Grammys, and three American Music Awards, Prince also claimed five platinum albums before he turned 30. Born Prince Rogers Nelson in Minneapolis in 1958, he was playing piano, guitar, bass, and drums by age 15, and while still a teenager he sent a one-man-band tape to Warner Brothers Records. The demo featured Prince on all instruments, singing and producing his own compositions. He won a contract, and in rapid succession wrote the music for a series of hit albums he recorded, including *For You* (1978), *Prince* (1979), *Dirty Mind* (1980), and *Purple Rain* (1984), which sold 17 million copies. He is in the nearly unique position among songwriters and performers of controlling his own career. In 1987 he launched his label, Paisley Park, where he writes and produces for himself and for such artists as Sheila E, The Family, and Mavis Staples.

SOUL MUSIC'S REIGNING MONARCH—QUEEN ARETHA

In the late 1960s, singer Aretha Franklin took the music scene by storm, unleashing the full force of her incredibly elastic voice and blowing people away with her righteous delivery.

Her name became synonymous with soul; if anyone wanted to know what the word meant, they had only to listen to an Aretha Franklin performance. "Soul to me is a feeling," the singer once reflected. "The song doesn't matter. . . . It's just the emotion, the way it affects other people."

Franklin has been affecting people with her singing since the age of 12, when she gave her first solo performance—in the 4,500-member Detroit church presided over by her father, the Reverend C. L. Franklin. Her first album, *Songs of Faith*, came out in 1956, when she was just 14.

Four years later, after Franklin had decided to follow in the footsteps of Dinah Washington and Sam Cooke, two of her idols, and switch from gospel to popular music, she landed a contract with Columbia Records. The man who signed her, John Hammond, had recorded Bessie Smith and Billie Holiday, and he saw Aretha as the next great jazz singer.

Although Franklin made several fine recordings for Columbia, commercial success eluded her. She said later of her five years with the label: "I was getting a lot of play, but not a lot of sales, and I think that was largely due to the kind of material that I was doing. I was being classified as a jazz singer, and I never, ever felt I was a jazz singer."

Franklin's transformation into a music legend began in 1967, when she moved to Atlantic and was teamed with another industry giant, Jerry Wexler. His vision of her musical future differed from Hammond's. In Wexler's words, he "took her to church, sat her down, and let her be herself." It paid off. The first two songs she released for Atlantic—"I Never Loved a Man (The Way I Love You)," and "Do Right Woman—Do Right Man"—yielded a rare double-sided hit. But it was Franklin's next single that sent her rocketing to the top of the R&B and pop charts and to superstardom. "Respect" was the song, and respect was what she got after her rendering of the Otis Redding composition won her the first of seven straight Grammys for "Best R&B Performance, Female."

A flood of hits followed, including "Baby, I Love You," "A Natural Woman," "Chain of Fools," "Think," and "Spanish Harlem." Then, in the mid-1970s, disco made its appearance, and Franklin, trying to force her powerful, emotional style into the monotonous dance-beat confines of the new music, saw the deluge dry up.

She made a strong comeback in the 1980s, however, signing a new record contract, making a show-stopping appearance in the film *The Blues Brothers*, and scoring hits again with such songs as "Jump to It," "Freeway of Love," and "Who's Zoomin' Who?"

Through it all—stardom and eclipse, good times and bad—Aretha Franklin has shown that she was, is, and always will be the Queen of Soul.

Newly anointed as Soul Sister Number One when this picture was taken in 1967, twenty-five-year-old Aretha Franklin displays the ebullient spirit that, combined with a rich, powerful, gospel-trained voice, fueled her rise to enormous popularity with fans of all races.

At the Lincoln Memorial in Washington, D.C.,
Aretha Franklin—by her own description a
staunch Democrat—takes a bow after perform-
ing during the festivities for the inauguration of
Bill Clinton as president in January 1993.

PRODUCERS OF THE POPULAR SOUNDS

Music producers wear many hats: They typically advise an artist on repertoire and technique, arrange the artist's songs—often composing them as well—and supervise recording sessions. Serving also as impresario, musician, and engineer, the producer is a gatekeeper of quality and style on recordings and in live performances—and, increasingly, the steering force behind music trends. Some of the most accomplished in that role are African Americans whose sensitivity to both performers and the public has shaped popular music into the 1990s.

One of the most familiar names in music production—if not the entire entertainment industry—is Quincy Jones, pictured at right (*center*) surrounded by stars in 1988. Born in 1933 and raised in Seattle, Jones was a musical wunderkind who had mingled with the likes of Charlie Parker, Thelonious Monk, Count Basie, and Ray Charles by the age of 18. "I had such a thirsty mind, I wanted to learn everything," he said in 1990. During the 1950s, he played trumpet and piano with Lionel Hampton while also working in New York studios as an arranger and musician for such luminaries as Duke Ellington and Dinah Washington.

For Jones, 1963 was a banner year. He won his first Grammy for an arrangement of Count Basie's recording of "I Can't Stop Loving You." He became the first African American to score a film by a major Hollywood studio with his work on *The Pawnbroker*. And he made his entrée into pop music, discovering Lesley Gore and producing her smash number one hit "It's My Party."

The key to working with a performer, said Jones nearly 30 years later, is "remembering this per-

QUINCY JONES

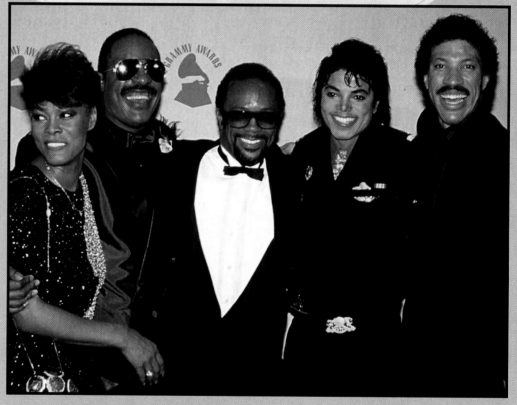

son is a human being and the human being has gifts. Love and respect force you to pay attention to all the intricacies of those gifts." By 1993 that formula had earned 25 Grammys for Jones, who has tapped the "gifts" of Ella Fitzgerald, Bobby McFerrin, George Benson, Al Jarreau, and countless others. His production

JIMMY "JAM" HARRIS AND
TERRY LEWIS

of Michael Jackson's 1982 album *Thriller* led to an all-time sales record of 41 million copies.

Quincy Jones is particularly deft at handling large-scale productions, such as the 1990 Grammy-winning album *Back on the Block*, which merged black musical styles ranging from jazz to funk to rap and was performed by a multigenerational group of artists. He also produced the five-million-selling record "We Are the World," which benefited the hungry in Ethiopia and featured a huge ensemble of stars from every popular music background. In 1992 Jones directed 85 black performers in the spectacular "Hallelujah" chorus for the recording *Handel's Messiah: A Soulful Celebration*, and in January 1993 he produced the inaugural concert at the Lincoln Memorial for President Bill Clinton. Says Jones, "I go for the music that gives me goosebumps."

Quincy Jones has opened doors for African Americans in music production, and many talented blacks have followed him through, including Jimmy "Jam" Harris and Terry Lewis, who won the 1986 Grammy for Best Producers of the

Year. "We like to think of ourselves as tailors," said Harris of the role he and Lewis play. "We look at each artist individually and try to make him or her a suit that's made especially for that artist." Since the mid-1980s, the pair have been virtually synonymous with chart-topping R&B music, working with such major acts as Janet Jackson, Patti Austin, Klymaxx, Cherelle, Johnny Gill, and Gladys Knight.

Harris and Lewis first teamed up in the late 1970s as musicians in a Minneapolis band, and in 1982 they formed Flyte Tyme Productions to write and produce for other artists. Just four years later, in 1986, Harris-Lewis songs sold 15 million records, including four million copies of Janet Jackson's blockbuster first album, *Control*.

The team usually writes, arranges, and plays most of the instruments for their productions. "To do our best work," Lewis notes, "we feel we have to have *control*." Flyte Tyme and its artists have garnered many Grammy nominations for a succession of gold and platinum records. In 1992 Harris and Lewis formed their own label—Perspective Records—and its very first release, *The Evolution of Gospel*, won a Grammy for the group Sounds of Blackness.

Maurice Starr, the original producer of such groups as New Kids on the Block and En Vogue, has taken the idea of artistic control to its furthest extent by actually creating the acts he works with. "I find all my performers on the street," he said in 1990. "I'm an image person." In 1984, after producing the black group New Edition, the composer, singer, musician, producer, and manager recruited five white youths from Boston and transformed them

MAURICE STARR

into the pop idols New Kids on the Block. In the group's first six years, they sold 17 million albums in the United States alone, and in 1991 they earned an estimated $115 million. Starr believes that by crossing the color barrier and producing white acts, black promoters can greatly broaden their opportunities.

Narada Michael Walden, winner of the 1987 Grammy for Producer of the Year, works with some of the most famous names in music. The easy-mannered Walden, who is also a drummer and a songwriter, seems to get the best results with female stars, including Aretha Franklin, Whitney Houston, and Mariah Carey.

Franklin's album *Who's Zoomin' Who?*, produced mostly by Walden and released in 1984, was her first commercial hit in some 15 years. Walden has worked with Houston (*pictured above right with the producer in* 1987) since the beginning of her meteoric career on such up-tempo hits as "How Will I Know?" and 1987's Grammy-winning "I Wanna Dance with Somebody (Who Loves Me)." In 1991 Walden coproduced *Mariah Carey*, the singer's debut album, which sold four million copies in the United States, generated three number one singles, and earned Carey two Grammys.

Native New Yorker Teddy Riley parlayed his own success as a performer into a career producing hit recordings in the "New Jack Swing" style, the fierce brand of R&B music he is credited with inventing in the late 1980s. Riley introduced New Jack with his trio, Guy, whose first album scored five hit singles.

In 1990 Riley created the Future Enterprise label to "do strictly New Jack Swing because New Jack Swing is for everyone," he said. "It's not black or white."

NARADA MICHAEL WALDEN

Riley—who has moved his base of operations to Virginia Beach, Virginia—uses his skills as a songwriter, singer, vocalist, multi-instrumentalist, and engineer when producing recordings. Michael Jackson's album *Dangerous*, Janet Jackson's hit single "It's Alright," and Bobby Brown's album *Don't Be Cruel*, which sold eight million copies, all benefited from the Riley touch.

Kenny "Babyface" Edmonds, a tremendous success as a songwriter and performer himself, with such album credits as *Tender Lover* in 1990 and *For the Cool in You* in 1993, also has a distinguished career in music production. Together with Antonio "L.A." Reid, Edmonds began producing records for their Cincinnati band, the Deele, in the mid-1980s. Since then the

TEDDY RILEY

team has written and produced for Whitney Houston, Bobby Brown, Boyz II Men, Johnny Gill, Paula Abdul, and others—to the tune of more than 40 million records sold.

In 1993 Edmonds and Reid won a Grammy, which they shared with Daryl Simmons, for Producers of the Year and for Best R&B Song, the Boyz II Men's hit "End of the Road." The pair also produced the soundtracks for the movies *Boomerang* and *The Bodyguard*, starring Whitney Houston, and in 1993 Edmonds began working solo as a producer for Aretha Franklin and Mariah Carey. Edmonds says a "return to emotional music" is under way, evidenced by a rise in the charts of the R&B and soul he produces and performs.

KENNY "BABYFACE" EDMONDS

Producing hits from a different point on the popular musical spectrum is Russell Simmons, who was instrumental in bringing rap music into mainstream American culture. Simmons heard rap for the first time in 1978 while he was attending a party in Harlem. The 20-year-old college student was so taken with the sound that he began promoting rap performers, including the duo Run-D.M.C.

In 1983, at the age of 25, he co-founded the recording label Def Jam—meaning "cool music" in the lingo—which has grown to become the best-known rap label in the world. By 1991 Simmons's company, Rush Communications, encompassed six recording labels with 17 platinum albums to their credit, producing LL Cool J, Public Enemy, the Beastie Boys, 3rd Bass, and Jazzy Jeff and the Fresh Prince.

Simmons looks for raw talent in inner-city African American neighborhoods and develops it. "It's okay to leave the ghetto behind," said the Queens, New York, native in 1992. "But don't leave the attitude, the style, the ideas, the culture, the coolness."

Andre Harrell agrees with his friend Simmons. "I'm checking for style, substance, and attitude as well as music," said the 31-year-old producer in 1992. When the "Uptown Sound," a new mix of rap and R&B, caught the ear of urban youth in the mid-1980s, Harrell responded by forming Uptown Records. *Uptown Kicking It,* a multi-artist album, was his company's first release, launching the career of Heavy D. & the Boyz. Since then, Harrell has discovered and produced other big talents, including Jodeci, Al B. Sure!, Christopher Williams, Father MC, and Mary J. Blige.

In 1992 Uptown Records' four number one hits sold more than 10 million albums. Expanded into Uptown Entertainment that year, Harrell's company now produces not only music but also television and film performed exclusively by African Americans. "If you don't feel like you have to conform in your dress or your attitudes, you become a *black* person," says Harrell with emphasis. "And that is the idea behind Uptown. It's a lifestyle."

Sweet Honey in the Rock in 1993 (*left to right*): Ysaye Maria Barnwell, Bernice Johnson Reagon, Carol Maillard, Nitanju Bolade Casel (*bottom*), Aisha Kahlil, and Shirley Childress Johnson.

VOICES SWEET AND STRONG

One Sunday morning in 1948, the Reverend J. J. Johnson of the Mount Early Baptist Church in Worth County, Georgia, called his five-year-old daughter Bernice to the front of the sanctuary to sing. Feeling shaky at first, she relaxed when the congregation began foot-tapping to the rhythm and calling out encouragement. The energy from the congregation, she wrote many years later, "seemed to become a part of the sound of the voice coming out of my throat . . . and it changed my voice."

In 1973 Bernice Johnson Reagon founded Sweet Honey in the Rock, a women's singing group that has amassed a worldwide following, performing in Africa, Japan, Australia, and Europe. The group has recorded some 20 albums and earned many awards, including a Grammy for the 1989 recording *A Vision Shared: Tribute to Woody Guthrie and Leadbelly.*

What perhaps makes the achievement all the more remarkable is that Sweet Honey is an a cappella group. While most of Western music relies on a variety of instruments to create harmony and rhythm, the women of Sweet Honey produce these elements with only their voices, their hands, and sometimes an African *shekere*—a percussion instrument made from a gourd and peas or beads. "My first music is the voice," Reagon has said. "And the bulk of my music is people singing together."

In 1971, two years before Sweet Honey's debut, Reagon had moved to Washington, D.C., and begun working as the vocal director of the D.C. Black Repertory Company. There she discovered that the a cappella style that came naturally to her—a style rooted in Georgia's black churches of the 1800s—was unknown to other black performers. Reagon began to teach it to some of the women at the theater, and in November 1973, Sweet Honey in the Rock gave its first performance at Howard University.

The group's unusual name comes from the Reverend Johnson, who told his daughter that it describes a land so rich that when the rocks are cracked open, honey flows out. Reagon gave the parable a new dimension, seeing the rocks as metaphors for African American women: strong, tough, and stable, yet filled with reserves of sweetness waiting to flow.

Over the years, a total of 20 women have sung with the group, which at any time has five or six members. "Sweet Honey has her own body, her own voice," said Carol Maillard, an original member, in 1993. "She's all of the pieces of all of the women who have been involved."

Since its earliest days, Sweet Honey has sung songs of love, liberation, and social responsibility, structured during their concerts as "a dialogue with the audience—an emotional, spiritual, and intellectual call and response," says Shirley Childress Johnson, who sign-interprets during performances. The group has continually expanded its range of musical styles to include everything from gospel, folk, and blues to rap. Yet it remains profoundly conscious of the vocal legacy it inherited from 19th-century African Americans. "There ought to be some constant way you say thank you," says Reagon, "to acknowledge that you stand on the ground that was laid by other people who came before you."

MY POEM IS LIFE, AND NO
ED. IT SHALL NEVER BE
MY POEM IS LIFE, AND CA
WHEREVER LIFE CAN GRO
LL. I SPRO
AN SO THE
GIVE
HA
N T
OF
VERT
WHICH IS
WHERE I

WITH PEN IN HAND

obody had to explain to young Richard Wright what it meant to be a black person in the South in the 1920s; he was quite capable of observing that for himself. At the whites-only library in Memphis, Tennessee, the teenager was denied access to the books because of the color of his skin. Finally, he approached the matron at the check-out desk with a note presumably written by a white resident of the town: "Dear Madam: Will you please let this nigger boy have some books by H. L. Mencken?" The librarian then handed over the requested volumes—and Wright took them home and read them himself. There was no white book borrower. Wright had dreamed up the crudely phrased note himself, in effect creating his first fictional character.

Richard Wright, who went on to become one of the great American novelists of the 20th century, was born into grinding poverty on a cotton plantation near Natchez, Mississippi, in 1908. His father left when Richard was six, and his mother soon became seriously ill and had to place her two sons in an orphanage. The boys were later sent to live with family in Arkansas, then back to Mississippi. Wright did not attend a full year of school before the age of 12; three years later, his formal education ended at the ninth grade. But he always liked reading and writing, and it was in Memphis, where he moved on his own in 1925, that those interests really took hold. Through literature he carved out an intellectual and emotional identity that transcended the difficult realities of his life.

At the age of 19, Wright moved to Chicago and launched his literary career, publishing poems and short stories in journals of the Communist party. He was also appointed to the Federal Writers' Project, a government program to support indigent writers. In 1937 Wright moved to America's literary capital—New York City. His Communist ties won him the job of Harlem editor of the *Daily Worker*, and he found additional work organizing a literary journal, *New Challenge*, for black writers. Wright also won a $500 prize offered by *Story* magazine for the best book-length manuscript by an author associated with the Federal Writers' Project. The book, a collection of four novellas entitled *Uncle Tom's Children*, was published by Harper in 1938.

Two years later, Wright published his masterpiece, the complex and dramatic *Native Son*. The novel depicted in graphic detail the life and death of Bigger Thomas, a 20-year-old black man who lives in a rat-infested apartment on Chicago's South Side. One day Thomas accidentally kills the daughter of his white employer, setting in motion a series of tragic incidents. Forces beyond his control threaten him with dehumanization and despair, but Thomas does not become a mere victim. Through his

struggle to find meaning in his experiences he ultimately gains a profound understanding of who he is as a black American.

The novel was an immediate and immense success, selling 215,000 copies in three weeks, and it was the first by an African American to be a Book-of-the-Month Club main selection. In 1947, two years after the publication of his autobiographical *Black Boy*, finding himself increasingly frustrated by the limitations and pain of living as a black man in America, Wright moved permanently to Paris.

Native Son launched the modern genre of black protest fiction, but it was only the latest contribution to a stream of black literary achievement dating back to the 1700s. From the poignant work of enslaved poets to the plays and poetry of the early-20th-century Harlem Renaissance and the diverse literary achievements of the 1990s, black writers have sought, among other things, to craft their vision of the African American experience. Their words are integral to the whole American literary tradition, and to global history as well—as was emphatically illustrated in 1993 when author Toni Morrison became the first African American to win the Nobel Prize for literature.

During the 1600s, the institution of slavery took firm hold throughout the British North American colonies. Many brutal codes were directed at African Americans, including laws that did not allow enslaved men and women—and in some jurisdictions, free blacks as well—to learn to read and write. This hostility to black literacy, and a lack of access to education, helps explain why African American literature developed slowly during the first century of the black presence in North America.

The first known published piece of literature by an African American was written in 1746 by an enslaved Massachusetts teenager named Lucy Terry. In the 28 lines of "Bars Fight," 16-year-old Terry vividly described a surprise Indian attack near "the bars" (a colonial word for meadows), in which a man was killed and a woman left for dead. Terry later married a former slave named Abijah Prince, who bought her freedom. She is known to history as Lucy Terry Prince.

Fourteen years after "Bars Fight" was printed, Briton Hammon of Boston added another element to the fledgling tradition of African American literature with his 14-page autobiography, *A Narrative of the Uncommon Sufferings and Surprising Deliverance of Briton Hammon, a Negro Man*. In it, he recounted his adventures in traveling to Jamaica, the British Isles, and back home to New England, during which he survived a shipwreck, was captured by Indians, and was imprisoned by Spaniards. Over the next several decades, black autobiographies came increasingly into the public eye in England and America. One that helped fuel early antislavery sentiment was *The Interesting Narrative of the Life of Olaudah Equiano, or Gustavus Vassa, the African*. Published in 1789, it was written by a one-time plantation slave who had been kidnapped as a child in Africa, brought to the Caribbean and then Virginia, and later sold to a British naval officer.

Slave narratives, as such books were known, not only offered the record of an individual's life but also were evidence in themselves of the intellectual power of black men and women—giving the lie to slaveholders' myths about the mental inferiority of black people. In that sense, perhaps no early black American literary figure was more revolutionary than Phillis Wheatley.

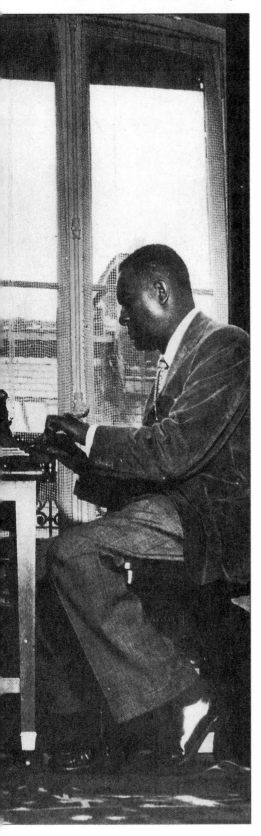

By the early 1950s, author Richard Wright, shown here working at home, was world-famous for his books *Native Son* and *Black Boy*.

Kidnapped from her home in Senegal at the age of seven or eight, the young girl was purchased in a Boston slave market by John Wheatley, a wealthy merchant-tailor, in July 1761; his wife Susannah christened her Phillis. After Phillis showed an early interest in the alphabet, she was tutored by the Wheatleys' daughter Mary. In 16 months, as John Wheatley later boasted, Phillis mastered the English language and learned to read and write. She went on to study Latin, geography, astronomy, ancient history, and the Bible. She also began writing poetry.

In 1770, Wheatley's first published work, "On the Death of the Rev. Mr. George Whitefield," won her international fame. She became known for writing well-crafted verse in the neoclassical style of the day, and was invited to many elite social gatherings—despite the fact she was still a slave. Her health was poor, however, and in 1773, upon medical advice, she took a sea voyage to London, accompanied by the Wheatleys' son Nathaniel. There she was again well received socially. It was in England that her first and only book, *Poems on Various Subjects, Religious and Moral*, was published.

Phillis Wheatley was freed at some point later in the 1770s—certainly by the time John Wheatley died in 1778. She married John Peters, a free black man, and never stopped writing. The couple had three children, but life was not kind, and the family sank into poverty. Peters was in debtors' prison and two of the children were dead by the time the poet, then about 30, died on December 5, 1784. Her last poem had been published that September, and at the time of her death she was at work on a planned second collection of verses.

Wheatley's works usually avoided the subject of slavery. Of her 46 known poems, 18 are elegies, and the six inspired by politics deal with such topics as the repeal of the Stamp Act. Recent scholars have pointed out, however, that some of her works express a sensitivity to slavery's wrongs, show the poet's pride in the black race, and frequently refer to her African origins.

The ideals of the Revolutionary era that Wheatley praised in her few political poems had inspired some black Americans to submit formal petitions and appeals for emancipation, but to no avail. After the Revolutionary War, political writing by black Americans remained a rarity for several decades. The most incendiary work in this vein in the early 1800s was David Walker's 1829 *Appeal, in Four Articles; together with a Preamble, to the Coloured Citizens of the World, but in Particular and Very Expressly, to Those of the United States of America*, often referred to by some abbreviated version of the lengthy title. Walker, himself the son of a slave, drew his arguments from the minutes of an early black political organization to which he belonged, fashioning a passionate case against slavery and encouraging slaves to rise up against their oppressors. It was rumored that southern slaveholders were offering a $1,000 reward for Walker dead and $10,000 for him alive, but Walker refused to flee to Canada as his friends urged, saying only that "somebody must die in this cause." On June 28, 1830, he was found dead, apparently poisoned, near the door of his clothing shop.

Within decades, political writings and speeches by black abolitionists had become far more common, as had a new round of slave narratives by such influential figures as Frederick Douglass. Still, millions of Americans remained enslaved, prey to physical mistreatment and mental cruelties.

Among slavery's many tragic stories is that of George Moses Horton, an enslaved farm laborer who lived near the University of North Carolina at Chapel Hill. Like many slaves in the area, Horton was given Sundays off and used the time to try to earn money. Stationing himself at the campus, he would offer his wares—love poems of his own composition for use by undergraduates in wooing their young ladies. One typical example, later published, suggests his style: "Whilst tracing thy visage I sink in emotion, / For no other damsel so wondrous I see; / Thy looks are so pleasing, thy charms so amazing, / I think of no other, my true-love, but thee."

Horton, who came to be known as the Colored Bard of North Carolina, took orders for new love poems each week, then composed the desired verses while he did chores. The next Sunday, he recited the result and was paid, usually in money or books. As Horton's fame spread, northern abolitionists mounted two campaigns to purchase his freedom, but met with no success. Years later, Horton recalled that his master was offered "$100 more than any person of sound judgment should say I was worth," but simply refused to sell him. Horton continued writing poetry, some of which was published in a prestigious southern literary journal, the *Raleigh Register*. His poems "Slavery" and "On Liberty and Slavery" were printed in the *Lancaster Gazette* in Massachusetts, and "Slavery" was reprinted in William Lloyd Garrison's abolitionist newspaper, the *Liberator*, in 1834. A collection of his verses was published in 1829 and a second in 1845. But while newspapers in Raleigh, Chapel Hill, and other cities celebrated his prowess, Horton remained a slave. Not until the end of the Civil War in 1865 was he finally freed. By then in his late sixties, he published his final book, a collection of 133 poems entitled *Naked Genius*.

George Moses Horton was still 12 years from emancipation when the first known novel by a black American was published. Written by abolitionist William Wells Brown, *Clotel; or, The President's Daughter*, which came out in Britain in 1853, told the tragic story of a light-skinned young slave woman whom the novelist presented as the daughter of Thomas Jefferson. "The bones, muscles, sinews, blood, and nerves of a young lady of sixteen were sold for five hundred dollars," he wrote in one powerful passage about Clotel's sale at a southern slave market. "Her moral character for two hundred; her improved intellect for one hundred, her Christianity for three hundred; and her chastity and virtue for four hundred dollars more. And this, too, in a city thronged with churches."

The book, which is crammed with multiple plots, long-winded speeches, and enough characters for several novels, lacked unity as a piece of fiction. Yet it served Brown's purpose, depicting, in the words of its narrator, how "the present system of chattel slavery in America undermines the entire social condition of man."

Brown knew the horrors of slavery firsthand. Born a slave in Lexington, Kentucky, he escaped at about the age of 20 on New Year's Day, 1834. He eventually landed work on Lake Erie steamers and became a busy and successful "conductor" of fugitive slaves crossing to Canada. In 1847 he moved to Boston, where he began a career as an abolitionist lecturer. During this time he published a widely

Say unto foul oppression, Cease:
 Ye tyrants rage no more,
And let the joyful trump of peace,
 Now bid the vassal soar.

from George Moses Horton, "*On Liberty and Slavery*," 1829

read narrative of his early years. He was still a fugitive slave, however, and so in 1849 he left the country to travel in Europe. During this period he delivered more than a thousand antislavery lectures and got *Clotel* published.

After friends in England purchased his freedom, Brown returned to Boston in 1854. There he kept up his frenetic literary and political pace. Among other works, he wrote one of the earliest travel books by a black American; the first drama to be published by an African American, the 1858 play *The Escape*; and a number of books on aspects of African American history. When the Civil War ended, Brown became active in the temperance movement and also continued his writing with such works as *The Negro in the American Rebellion*, published in 1867, and his memoir *My Southern Home*, published in 1880.

Although Brown was the first African American to publish a novel abroad, the first to publish a novel in the United States was Harriet Wilson, of whom relatively little is known. Her book *Our Nig; or, Sketches from the Life of a Free Black, in a Two-Story White House, North. Showing that Slavery's Shadows Fall Even There* was published in Boston in 1859.

Author and abolitionist William Wells Brown, the first African American known to have published either a novel, travel memoirs, or a play, chose his own name in 1834 after escaping from slavery. William was the name his slave mother had given him, which a slaveholder had forced him to change to Sandford, and Wells Brown was an Ohio Quaker who aided him during his flight.

After the withdrawal of federal troops from the South in 1877, the sweet promise of emancipation began to sour. Racial attitudes were institutionalized in harsh "Jim Crow" laws that enforced segregation of the races in every aspect of life, and violence and discrimination directed against blacks escalated. Black writers responded in different ways; some harked back to rural life and folk values, others explored racial issues of the new postslavery society.

The most popular autobiography of the day was Booker T. Washington's *Up from Slavery*, a book firmly rooted in the slave narrative tradition. In telling his life story, the prominent black educator offered an unabashed message to black readers: Concentrate on acquiring property and wealth if you wish to earn white respect—and, eventually, civil and political rights. Washington's emphasis on black solidarity as a bulwark against white racism made him a hero to many during the segregation era.

Although Washington looked to the future, his work encouraged black Americans to work hard in building a good life where they already were, for the most part in the rural South. A note of nostalgia for the countryside, as well as for a simpler time and traditional values, was sounded by a number of writers of the time, especially in some of the early works of the turn-of-the-century poet Paul Laurence Dunbar. The versatile Dunbar could write a line like "Oh, de grubbin'-hoe's a-rustin' in de co'nah" in his poem "The Deserted Plantation," then publish it together with "Ode to Ethiopia," a paeon to the black race that urges "Be proud, my Race, in mind and soul; / Thy name is writ on Glory's scroll / In characters of fire."

As a young man, Dunbar, who was born in Ohio in 1872, began composing his own verse and short stories, some in dialect. Although he managed to sell a few of his pieces, he could not afford to give up his four-dollar-a-week salary as an elevator man in Dayton. Then, in the early 1890s, Dunbar's high-school classmate Orville Wright (later to become famous as the coinventor of the airplane) encouraged him to publish

an entire book. Dunbar himself paid for the printing of *Oak and Ivy*, a collection of 56 poems, in 1893. *Majors and Minors* followed in 1896, but it was his next collection, published later that year under the title *Lyrics of Lowly Life*, that made Dunbar's reputation.

Lyrics of Lowly Life began with an introduction by one of America's most influential white literary critics, William Dean Howells, who described Dunbar somewhat hyperbolically as the "only man of pure African blood and of American civilization to feel the negro life aesthetically and express it lyrically." Howells specifically praised Dunbar's frequent use of dialect. The words were well intentioned, but Dunbar was troubled. "Mr. Howells has done me irrevocable harm in the dictum he laid down regarding my dialect verse," he later told a friend. Nonetheless, by the turn of the century Dunbar was the favorite black poet of white and black Americans alike. His work, some of it still in dialect, appeared in America's finest periodicals and in books from prestigious publishing houses.

Dunbar went on to write three novels that avoided racial themes, but in 1902 he published *The Sport of the Gods*, a work of fiction in which he attempted to portray black city life in all its harsh reality. This powerful early protest novel begins on a plantation, where a black butler is wrongfully sentenced to 10 years of hard labor. The members of his family, now displaced, migrate north to "cruel and cold and unfeeling" Harlem, where the children go astray. One becomes an alcoholic and a murderer, another is enticed by the glitter of the stage and becomes callous and hardened in the process. Upon his release from prison, the former butler goes in search of his family. But he can rescue only his wife from the demoralizing influences of urban life. Although many critics, both black and white, called *The Sport of the Gods* powerful and poignant, many white readers rejected this new approach to racial issues. Dunbar wrote no more novels, although he continued to produce poems and articles. In 1906, four years after the publication of *The Sport of the Gods*, he died of tuberculosis at the age of 33.

More time was granted to one of Dunbar's many literary contemporaries, Charles Waddell Chesnutt. An Ohio lawyer and successful businessman, Chesnutt became popular in the 1890s for his novels and short stories, some of which were written in dialect. In some of Chesnutt's fiction, the writer satirized light-skinned men and women who snubbed darker-skinned relatives, imitating the same color prejudice that whites practiced. Other stories appeared to use familiar stereotypes: easygoing slaves speaking in thick dialects tell folk tales to bemused white narrators. In no case, however, were the stories sentimental tributes to the bygone days of slavery. Rather, Chesnutt penned what he called conjure tales, stories of metamorphosis and magic that presented black culture as a highly valued resource and slaves as shrewd manipulators.

As the first black author to be pub-

Although his literary career was cut tragically short by tuberculosis, Paul Laurence Dunbar (*below*) was one of America's most popular turn-of-the-century poets. According to his wife Alice, herself a writer, Dunbar's well-known dialect poems were "the side issues of his work." Rather, she said, "it was in the pure English poems that the poet expressed *himself*."

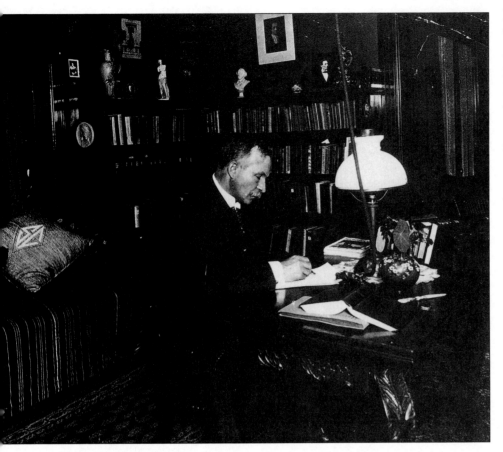

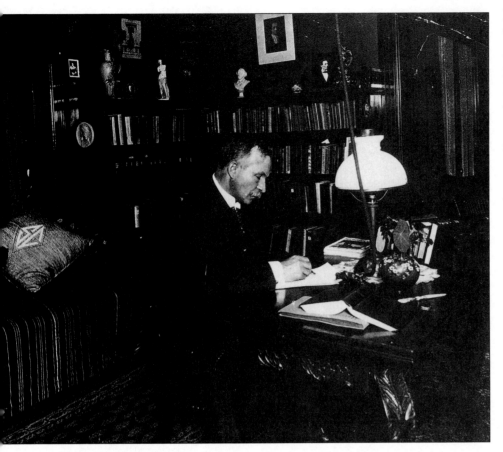

Charles W. Chesnutt (*above*) works at his desk in the comfortably appointed study of his Cleveland home. Chesnutt, who ran a stenography business during the day and composed novels and short stories at night, often evoked in his fiction the people and places of the Cape Fear River area of North Carolina where he grew up.

lished in a major American magazine—"The Goophered Grapevine" ran in the *Atlantic Monthly* in 1887—Chesnutt received much favorable attention in the 1890s for his skillful storytelling and his sensitivity to problems of the color line. Then, in 1900, he struck out in a new direction. His first novel, *The House behind the Cedars*, a story of interracial love in the post-Civil War South, was remarkable for its tolerant attitude toward the heroine's decision to pass for white. A year later, Chesnutt's second novel, *The Marrow of Tradition*, spoke frankly about the violent rise of white supremacy in the late-19th-century South. *The Marrow of Tradition* did not sell well. After one more novel on racial conditions in the South, Chesnutt ceased writing race-problem fiction, convinced that white readers were not ready for his brand of realism.

Two years after the publication of *The Marrow of Tradition*, a new voice burst upon the literary scene: black scholar and historian William Edward Burghardt Du Bois, the first African American to get a PhD from Harvard. Du Bois had already written a number of academic works, but *The Souls of Black Folk* was his first in a more popular vein, and it had a tremendous impact. The book was an intricately compounded verbal symphony of essays about post-Reconstruction America, each headed with a passage from a spiritual or "sorrow song." It spoke in many voices: In addition to giving vent to black rage and alienation, *The Souls of Black Folk* offered dispassionate analyses and evocative prose that explored the dilemma of being black in America, of experiencing daily prejudice and discrimination in a supposedly egalitarian democracy.

Du Bois wove a musical motif of spirituals and other songs throughout the essays, returning to that theme in the book's conclusion. "Even so is the hope that sang in the songs of my fathers well sung," he wrote. "If somewhere in this whirl and chaos of things there dwells Eternal Good, pitiful yet masterful, then anon in His good time America shall rend the Veil and the prisoned shall go free. Free, free as the sunshine trickling down the morning into these high windows of mine, free as yonder fresh young voices welling up to me from the caverns of brick and mortar below—swelling with song, instinct with life, tremulous treble and darkening bass. My children, my little children, are singing to the sunshine." Du Bois went on to publish many other books and articles, some scholarly and others for a more general audience, but *The Souls of Black Folk* remains among his most powerful and best-known works.

The spirit of black confidence that Du Bois evoked was captured by a popular

song of the period. "Lift Every Voice and Sing," often referred to as the Negro national anthem, was an inspirational piece that seemed to beckon toward a new and better day. First performed in 1900 by a chorus of 500 black schoolchildren on the anniversary of Abraham Lincoln's birth, the anthem was the work of two multitalented brothers, John Rosamond Johnson and James Weldon Johnson, who went on to collaborate on a number of Broadway show tunes. James wrote the words and Rosamond, as he was usually called, the music.

James Weldon Johnson, who twice served as an American consul abroad, during the administrations of Theodore Roosevelt and William Howard Taft, was also an author. In 1912, while stationed in Venezuela, he published—anonymously—a highly influential novel, *The Autobiography of an Ex-Colored Man*. Loosely based on the experiences of a friend who had attended a Michigan law school, the novel told the story of a light-skinned black man who passed as white. The point was not so much to discuss "passing" as to question the situation in which racial classification became a person's primary defining characteristic.

Not long after the book came out, Johnson returned to New York. In the years that followed, he wrote editorials for the *New York Age*, served as the first black executive secretary of the NAACP, and became a leading figure in the time of literary, artistic, and political flourishing that is now usually known as the Harlem Renaissance. Although there is no single cause for this outpouring of creativity and activism, it is true that the Harlem Renaissance coincided with the beginning of the Great Migration of southern rural blacks to the big cities of the North. Johnson, who later described the era in his nostalgic 1930 book *Black Manhattan*, spent the Renaissance period writing songs, poems, and articles, as well as writing and editing essays on black poetry, music, and theater. His book *God's Trombones: Seven Negro Sermons in Verse*, published in 1927, used the rhythmic rhetoric and images of black preachers while abandoning the exaggerated dialect misspellings of the past. Johnson's clear, deceptively simple verses included the famous line, "Your arm's too short to box with God."

Perhaps the most influential commentator on the era's bustling literary scene was black critic Alain Locke. Born in 1886, Locke grew up in a comfortable Philadelphia home. A gifted scholar and an amateur musician, he enrolled as a student of philosophy at Harvard in 1904 and graduated in three years rather than the customary four. He then became the nation's first black Rhodes Scholar, an honor that took him to Oxford University. (In fact, in a shameful sign of the racial climate of the times, at the time of his death in 1954 Locke was still the only African American to have been made a Rhodes Scholar.)

In 1912, Locke took a six-month tour of the American South and was appalled by the discrimination he witnessed there. Searching for an answer, he turned to the arts—painting, sculpture, literature—as a way of building race pride and fighting prejudice. Although he wrote extensively on this theme, it was his 1925 book, *The New Negro: An Interpretation*, that had the greatest impact on writers. In this anthology of es-

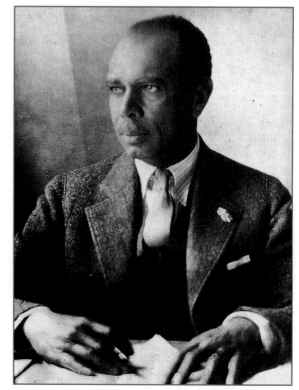

Lyricist, novelist, literary critic, American consul, and NAACP leader James Weldon Johnson (*above*) is perhaps best remembered as a poet: On his death in 1938 he was buried holding a copy of his 1927 collection of verse, *God's Trombones*.

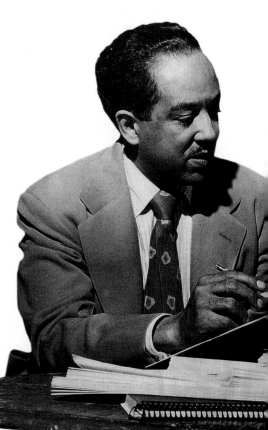

says, stories, and poems by African American authors, Locke announced that the apologetic "Old Negro" of white imagination was dead; the "New Negro," sophisticated in the complexities of urban life, was more than willing to be assertive. As evidence of this change, he wrote, "we have, as the heralding sign, an unusual outburst of creative expression." What would later be called the Harlem Renaissance he dubbed the New Negro Movement—a term some scholars still prefer today. The book drew together African American writers who had been working in near isolation and profoundly influenced the next generation as well.

Despite the literary and artistic excitement of the period, it was still a time of severe and sometimes violent oppression for black Americans. Jamaican immigrant poet Claude McKay reflected such concerns in many of his poems. "If we must die, let it not be like hogs / Hunted and penned in an inglorious spot," he wrote in one famous passage. "Like men we'll face the murderous, cowardly pack, / Pressed to the wall, dying, but fighting back!"

McKay, like many of the literary figures of the day, made his base in New York, but the Renaissance was alive in other cities as well. Jean Toomer of Washington, D.C., for example, sought to preserve the folk material and speech of the South in a 1923 work, Cane, which contrasted life in rural Georgia with that in cosmopolitan Washington through a mélange of seven stories, six prose vignettes, 15 poems, and a play.

And perhaps no single writer of the Renaissance period was more prolific than Langston Hughes, who first made his mark at the age of 19 with an eloquent poem, "The Negro Speaks of Rivers," published in the NAACP publication The Crisis in 1921. Hughes said he wrote it on a train to Mexico while watching a river roll by outside. The poem, which called the Mississippi River "ancient as the world and older than the flow of human blood in human veins," concluded that the poet's own soul had "grown deep like the rivers." In the decades that followed, both during and after the Renaissance, Hughes wrote novels, plays, collections of short stories, a newspaper column, essays, nine children's books, 16 volumes of verse, and two autobiographies—The Big Sea, published in 1940, and I Wonder as I Wander, published in 1956.

Although he traveled the world, Hughes found his inspiration at home. He took pleasure in writing about black people's dignity and strength, filling his work with "people up today and down tomorrow," as he once wrote. His work was openly influenced by the newly popular music forms of jazz and the blues, which affected his use of rhythm and dialect.

At first, although white critics gave Hughes high marks, many black critics didn't consider his poems sufficiently literary. Because he wrote of ordinary urban life, the black press accused him of parading "racial defects" before the public. In New York City, an Amsterdam News headline read, "Langston Hughes—The Sewer Dweller"; the Pittsburgh Courier called his poems trash. Countee Cullen, a Renaissance poet who worked for a short time as an assistant editor of the Urban League periodical Opportunity, advised Hughes—in friendlier fashion—to drop jazz rhythms from his poems and

At a table strewn with manuscripts, author Langston Hughes (*below, left*) confers with composer Jan Meyerowitz in 1950. The two men collaborated on the musical drama *The Barrier,* inspired by a Hughes story, "Father and Son." Active in the theater since the 1930s, Hughes continued to work on plays well into the 1960s.

avoid becoming a "racial artist." The black reading public, however, liked Hughes's work from the beginning, and as tastes changed his achievements gained respect in literary salons as well.

The energy of the Harlem Renaissance began to wane after the stock market crash of 1929, and by 1931 the era was over. "That spring for me (and, I guess, all of us) was the end of the Harlem Renaissance," Hughes later wrote. "We were no longer in vogue." Many of the era's literary lights dimmed and vanished, but others, like Hughes, went on to lengthy, productive careers. Hughes, for example, wrote extremely popular stories about an inimitable folk philosopher named Jesse B. Semple. He also wrote a number of plays and established the Suitcase Theatre in Harlem, the Negro Art Theatre in Los Angeles, and the Skyloft Players in Chicago. His 1935 play *Mulatto* was Broadway's longest-running drama by an African American up to that time, and he remained active as a playwright until his death in 1967.

In the last days of the Renaissance, Hughes had collaborated with fellow writer Zora Neale Hurston in writing *Mule Bone: A Comedy of Negro Life*, a drama that was not produced until many years later. Hurston, like Hughes, affirmed day-to-day black life, but from her own perspective. Her best-known novel, *Their Eyes Were Watching God*, celebrates the zest for life and the pursuit of self-fulfillment by a young black woman growing up in small Florida towns, much as Hurston herself had. Hurston was a folklorist and trained anthropologist as well as a playwright and novelist, and she traveled to Jamaica, Haiti, Bermuda, Honduras, Florida, and Louisiana in search of African American folk tales. She remained popular with publishers through the 1930s, then suffered a sad and puzzling decline both professionally and personally. By the time of her death in 1960 at the age of 69, this glowing star of the Renaissance was living in a home for indigents.

During the Great Depression, some of the more experienced black American writers left for Europe (*pages 152-155*). Those who remained in the United States included many just beginning their careers, some of whom found support through the Federal Writers' Project of the Depression era. Frank Yerby, for one, got his start with the project and went on to write 32 adventure novels, mostly about white characters, that sold more than 62 million copies worldwide. Another Writers' Project participant was Willard Motley, who later wrote the 1947 novel *Knock on Any Door*, the story of a church helper who becomes a cold-blooded killer. Among other participants who made their mark within the next several years were Richard Wright with his 1940 publication of *Native Son*, Margaret Walker Alexander with her award-winning poetry, and Ralph Ellison with the 1952 novel *Invisible Man* (*pages 156-159*).

Wright's novel offered a new model of protest fiction for black novelists in the 1940s, many of whom went on to depict in unsparing detail the indignities and injustice of black life in America. Ann Petry's 1946 novel *The Street* told the story of Lutie Johnson, a newcomer to New York City who murders a man sent to pressure her into becoming her employer's mistress. The novel was the first by an African American woman to sell more than a million copies.

Black poet and professor Sterling Brown, best known for his regular literary col-

Packing a pistol in case of trouble, author Zora Neale Hurston pauses during a 1927 trip into the backwoods regions of the American South, one of many solo expeditions she undertook to gather folklore from rural blacks. She published the stories in two collections, *Mules and Men* and *Tell My Horse*, as well as incorporating them into some of her fiction.

umn for *Opportunity*, became so noteworthy a literary commentator by the 1940s that, as one scholar commented, "all trails led, at some point, to Sterling Brown." Brown, a Howard University professor who wrote a great deal about the work of the Harlem Renaissance writers, was also among the first to analyze the role of folk themes and idioms in African American literature—as well as the way in which white writers tended to misuse similar material to the point of caricature. In his own poems, Brown tried to replace stereotypic characters with authentic black folk heroes in new poetic forms that embodied the spirit of work songs, ballads, blues, and spirituals.

Other African American poets were exploring different paths. Missouri-born Melvin B. Tolson, who wrote verses about international brotherhood, was appointed poet laureate of Liberia in 1947, an honor that some years later led to his composing the epic poem *Libretto for the Republic of Liberia*. In 1950, Gwendolyn Brooks became the first African American writer to win a Pulitzer Prize. The award recognized her second volume of poems, *Annie Allen*, which traces the coming of age of a young black woman. Brooks, who has spent most of her life in Chicago, began saving her own poems at age 11. She has been writing poetry, often on the everyday lives of urban blacks, ever since. In one of many honors, in 1990 she was appointed to Chicago State University's newly created Gwendolyn Brooks Distinguished Chair of Creative Writing.

Outside the realm of poetry, black protest fiction—which was implicitly addressed to the conscience of white readers—began to share the literary limelight with a more introspective approach typified by Ellison's *Invisible Man*. Many new works of black literature probed the dual heritage of African Americans and analyzed racial alienation in a society fraught with tension and rebellion.

An intriguing example of this shift was Chester Himes, who wrote a number of short stories and five novels in the protest tradition in the 1940s. In 1953, Himes left the United States for good and settled in France. There an editor suggested that Himes's spare, gritty writing style was better suited to literary crime novels crafted in the tradition of Dashiell Hammett and Raymond Chandler. Himes tried the genre and found, to his surprise, that he liked it.

In 1958 France awarded Himes its highest prize for mystery writers, Le Grand Prix de la Littérature Policière, for his crime novel *For Love of Imabelle*, which he retitled *A Rage in Harlem* some years later. By the time his novel

African American author Chester Himes (*below*) **joins writer Fred Kassak in a book signing shortly after Himes received France's most prestigious mystery-writers' award at a televised cocktail party in November 1958. Himes wrote a total of 10 detective novels set in Harlem, each featuring the characters "Coffin" Ed Jones and "Grave Digger" Johnson.**

Cotton Comes to Harlem was printed in 1964, the author's face had appeared on magazines at newsstands across Paris. "After that everybody knew me by sight," Himes later said. "I was the best-known black in Paris." Three of his crime novels were later made into popular films: *Cotton Comes to Harlem*; *A Rage in Harlem*; and *The Heat's On*, renamed *Come Back, Charleston Blue* for the screen.

Another writer to move on from the "protest" era was Himes's fellow expatriate James Baldwin, whose story appears on pages 160-161. Baldwin's work, like Ellison's *Invisible Man* and other new books, espoused integration but not accommodation. Presenting black people as American in their own terms, Baldwin affirmed a rich African American cultural heritage.

Back home in New York, a number of black authors formed the Harlem Writers Guild, a professional association dedicated to achieving publication for its members. The first Writers Guild member to have a novel published was John O. Killens, whose 1954 book *Youngblood* launched his long and successful literary career.

Black playwriting, largely dormant since the Harlem Renaissance, had something of a rebirth at the end of the 1950s. On March 11, 1959, Lorraine Hansberry's *A Raisin in the Sun* became the first play by a black writer to be produced on Broadway since Langston Hughes's *Mulatto* a quarter century before. It was, in fact, a line from the book-length Hughes poem, *Montage of a Dream Deferred*, that gave Hansberry her title. In his verse, the poet asks what happens to dreams of equal opportunity that are not fulfilled, answering at one point that they may "dry up like a raisin in the sun."

The play, which drew an unusual number of African American playgoers to Broadway, unfolded the saga of a black Chicago family moving into a previously all-white neighborhood. The plot was loosely autobiographical; Hansberry had grown up in a well-to-do Chicago family that integrated a neighborhood despite local real-estate laws, winning a historic Supreme Court decision on the matter in 1940.

A Raisin in the Sun was a triumph for Hansberry. New York City's dailies gave the play good reviews, and it ran for 538 consecutive performances, making Hansberry the darling of Broadway. Not only was she Broadway's first black woman playwright, but she was also the first black American, and the youngest American, to win a New York Drama Critics Circle Award for the best new play of the year. *A Raisin in the Sun*, which was later made into a movie with many of the same performers, established itself as a classic of the black theater movement.

In the early 1960s, Hansberry wrote more dramas, including *The Sign in Sidney Brustein's Window*, which ran for 101 performances, and *Les Blancs*, a play about Africans battling the effects of colonialism. But Hansberry did not live to see *Les Blancs* performed. She died of cancer in 1965 at age 34, leaving behind two other plays that were later brought to the stage.

The themes of Hansberry's plays mirrored the growing civil rights movement of the 1950s and early 1960s. As

Playwright Lorraine Hansberry (*below*), who won a New York Drama Critics Circle Award for 1959's *A Raisin in the Sun*, based the play in part on her own experiences when her parents integrated a Chicago suburb. She wrote—but later cut—a scene in which the fictional mother nervously patrols her home with a shotgun; her own mother had done the same.

An experienced newspaper reporter and magazine editor, Georgia-born Hoyt Fuller (*above*) nurtured black writing talents in his role as executive editor of Chicago-based Johnson Publishing Company's magazine *Negro Digest*, retitled *Black World* in 1970. In 1976, Fuller launched a new magazine, *First World*, in Atlanta, and continued as editor there until his death in May 1981.

that era's focus on desegregation and nonviolent protest shifted to the more assertive black nationalism, much of the African American literary community reflected that reality. For example, author John A. Williams—whose first novel, *The Angry Ones*, won critical acclaim in 1960—secured his international reputation in 1967 with *The Man Who Cried I Am*, a novel in which the protagonist, a reporter, learns of a global white conspiracy aimed at black genocide and joins forces with a militant named Minister Q. It was also in 1967 that Gwendolyn Brooks made the "conversion" from integrationism to Black Power in her poetry. A year later, African American poet Amiri Baraka (*pages 162-163*), the former LeRoi Jones, and writer Larry Neal produced *Black Fire: An Anthology of Afro-American Writing*.

In *Black Fire*, an important collection of writings by many authors, Neal first defined the goals of what he called the Black Arts Movement, which over time came to include creating a new mode of expression, defining the role of the black artist in his community, and making art more meaningful by taking it to the black masses. As part of the Black Arts Movement, a number of African Americans produced a burst of poetry in inventive formats, often incorporating elements of popular culture and black English (*pages 164-169*).

Neal worked tirelessly to defend and promote the new aesthetic. With Baraka, he co-wrote *Trippin': A Need for Change*. Neal himself published two collections of poetry and wrote plays, television scripts, and screenplays. He also wrote *Analytical Study of Afro-American Culture*. Neal taught at six universities in 13 years, including the City College of New York and Yale University, before dying of a heart attack at age 43 in 1981.

At the height of the Black Arts Movement, new writers turned not to mainstream publications but to black periodicals, including *Journal of Black Poetry*, *Black Dialogue*, *Soulbook*, *Freedomways*, *Umbra*, and *Liberator*. This development freed them from vying for sanction by white editors and critics and enabled them to "blacken the language," as Dudley Randall, publisher of the Broadside Press, put it, enlarging the black literary idiom with expressions derived from jazz musicians and the street corner.

Perhaps the most influential black literary outlet was the Chicago-based *Negro Digest*, which in 1970 changed its name to *Black World*. Under editor Hoyt Fuller the magazine welcomed both established and new black voices. Fuller's work didn't end in the pages of his magazine; he also acted as guiding light for a Chicago-based artistic workshop, the Organization of Black American Culture. Usually called OBAC, the group included in its early days such black poets as Don L. Lee (later known as Haki Madhubuti), Carolyn Rodgers, and Johari Amini.

African American novelist Ishmael Reed—who called the sixties "the decade that

screamed"—wrote his fiction in a stinging, irreverent tone that mixed standard English with vernacular from the street, television, and popular music. The ferment of the period also witnessed the emergence of a new commercially popular voice—that of Malcolm X as rendered by black journalist Alex Haley in *The Autobiography of Malcolm X*. The life story of the Muslim activist, told to Haley in a series of interviews, was rushed to print after Malcolm X was assassinated in 1965.

The book made Haley's reputation, and the author went on to have a powerful impact with his bestseller, *Roots*. This multigenerational saga of an African American family's journey from life in an African village through the torment of the Middle Passage and more than a century in slavery to the years of emancipation also formed the basis of the first television miniseries. Broadcast in 1977, *Roots* attracted huge audiences of Americans of all races; each episode was watched by an estimated 130 million viewers. The success of *Roots* established the miniseries as a permanent television form.

As in every age, however, black writers were listening to their own voices; not every author dealt with the civil rights and Black Power movements as directly as LeRoi Jones or Alex Haley. Louisiana-born Ernest J. Gaines, whose first book, *Catherine Carmier*, was published in 1964, never stopped writing books about American racial relations from the perspective of rural black Louisianans. Perhaps his best-known creation was the title character of his 1971 novel *The Autobiography of Miss Jane Pittman*, in which Gaines told the story of southern blacks from Reconstruction to the civil rights movement through the eyes of one very old black woman. "A lot happened in those 350 years between the time we left Africa and the fifties and sixties when we started writing novels about the big city ghettos," Gaines later said about his books. "We cannot ignore that rural past or those older people in it. Their stories are the kind I want to write about. I am what I am today because of them."

As the decade of the 1970s began, a variety of new black authors began to explore very individual directions in their works, much as Gaines was already doing. Alice Walker, the eighth child of a Georgia sharecropping family and a former student at Spelman and Sarah Lawrence colleges, wrote *The Third Life of Grange Copeland* in 1970. The novel told how three generations of one family were affected by their move from the South to the North. Among Walker's many subsequent works was the 1982 novel *The Color Purple*, for which she won the American Book Award and the Pulitzer Prize. Maya Angelou—actress, singer, dancer, poet, playwright, novelist, and ed-

A SCIENCE-FICTION STAR

Samuel Delany was 24 when he won science fiction's coveted Nebula Award in 1967 for his futuristic spy novel **Babel-17**, but he had already published five other books in the genre. Born in 1942 to a well-to-do Harlem family, Delany attended New York's predominantly white Bronx High School of Science. It was one of many experiences that left him feeling as if he were, as he put it, "living in several worlds"—a phrase that also aptly describes the process of writing science fiction. Delany, a professor of comparative literature at the University of Massachusetts at Amherst since 1988, is among the relatively few black authors who specialize in science fiction. Language and myth—and how they influence reality—are a central theme of his works. In *Babel-17*, for example, he invented an artificial language without such personal pronouns as "I" or "me." As a result, those who speak the language lack any sense of personal responsibility. In 1968 Delany won two Nebula awards, one for the story "Aye and Gomorrah" and a second for his novel **The Einstein Intersection**. He won both a Nebula and a Hugo Award in 1970 for his novelette **Time Considered as a Helix of Semi-Precious Stones**. By the early 1990s, Delany had published more than 20 novels, two story collections, and several works of criticism.

itor—published I *Know Why the Caged Bird Sings* in 1970, telling the story of her youth in Arkansas; St. Louis, Missouri; and California. In this and later autobiographical works and poetry collections, Angelou showed her commitment to speaking out on behalf of black women who, like herself, were determined to assert their own independent voices. Toni Morrison (*pages 174-175*) also emerged in 1970 with her first novel, *The Bluest Eye*. In 1976, a "choreopoem" by Ntozake Shange, *for colored girls who have considered suicide / when the rainbow is enuf*, became the first play by a black woman to be staged on Broadway since A *Raisin in the Sun*. Two years later, James Alan McPherson received the Pulitzer Prize for fiction with his short-story collection *Elbow Room*.

Black men and women continued to triumph through the written word in the 1980s and 1990s with achievements in a number of arenas. Gloria Naylor made a strong emotional impact with her 1982 novel *The Women of Brewster Place* (later a television movie), which told the stories of seven African American women living on the same city street. In 1984, John Edgar Wideman, a former college basketball player and Rhodes Scholar, won the PEN Faulkner Award for his lyrical fifth novel *Sent for You Yesterday*. The same year marked African American playwright August Wilson's Broadway debut with the successful play *Ma Rainey's Black Bottom*—the first in a cycle of historical dramas he continued to write into the 1990s (*pages 170-173*). Rita Dove, noted for her book-length character portraits in verse, in 1987 became the second black woman to be awarded the Pulitzer Prize for poetry; she was later named the national poet laureate. And Charles Johnson revived the fundamental literary form of the slave narrative in his novel *Middle Passage*, which won the 1990 National Book Award for fiction.

Veteran science-fiction author Samuel Delany (*opposite*) continued to push the frontiers of that genre during the 1980s and 1990s, as did Octavia Butler, who won the coveted Hugo Award for her 1984 short story "Speech Sounds," and both the Hugo and Nebula awards for her 1985 novella *Bloodchild*. In the mystery field, novelist Walter Mosley produced a number of highly regarded books featuring a black detective working in Los Angeles in the years just after World War II. Terry McMillan's book *Waiting to Exhale* nearly set a record in 1992 when the paperback rights sold for $2.64 million. Meanwhile, the novels of still other black authors explored an increasingly diverse array of topics and story lines.

In 1993, Maya Angelou served as the inaugural poet for President Clinton's inauguration, the first American poet to be so honored since Robert Frost read his work at John F. Kennedy's swearing-in ceremony 32 years before. The year's auspicious beginning was matched by a stunning end when Toni Morrison was awarded the Nobel Prize for literature. Although these and other honors rightly acknowledged African American literary achievements, perhaps the best news, as in other years, was the appearance of still more works—poems, plays, literary criticism, novels, and stories—by gifted black writers. Through their words, the centuries-long story of African American literature continues to unfold.

Alice Walker, shown below in 1988, has said she began taking note of people and their feelings at age eight, after she was accidentally blinded in one eye. Her memories of the Georgia farm country where she grew up shape many of her books, including her 1982 novel *The Color Purple*.

WAGING WAR WITH WORDS

In about 1853 a free black man traveled to Maryland, unaware of a state law that barred entry to free African Americans. He was arrested and sold as a slave, but managed to escape, only to be recaptured; he died not much later. With four million black Americans still enslaved, the incident was one of countless tragedies. But it shocked many observers, among them a 28-year-old black schoolteacher and poet named Frances Ellen Watkins. "Upon that grave," she later wrote, "I pledged myself to the Anti-Slavery cause."

For her fight against slavery Watkins's weapons were poems and speeches meant to shape public opinion. The battle was one for which this orphaned niece of a Baltimore educator was well armed. Although she had gone to work as a domestic in 1838 when she was about 13, her employers recognized her abilities and urged her to write. Two years later, Watkins published her first article, and by the age of 21, she had assembled her poems and essays into a collection she called *Forest Leaves*, of which no copies survive.

Frances Ellen Watkins Harper was the best-known black poet of the abolitionist era. This portrait of her appeared as the frontispiece to her novel *Iola Leroy*, published in 1892.

Watkins became the first woman faculty member of Ohio's Union Seminary in 1850, moving on two years later to teach in Little York, Pennsylvania. It was there she met escaped slaves on the Underground Railroad and also learned of the tragic Maryland incident.

In 1854 Watkins won a job as speaker for the State Anti-Slavery Society of Maine and also published what would become her most frequently reprinted collection, *Poems on Miscellaneous Subjects*, which included some antislavery verse.

She went on to lecture not only in Maine but in Massachusetts, Pennsylvania, New Jersey, New York, Ohio, and Canada, always including poetry about the horrors of slavery. Her verse was rhymed and emotionally charged—written to be read aloud; perhaps her best-known poem in this vein was "Bury Me in a Free Land" (*excerpt, above right*). In 1859 she wrote "The Two

I would sleep, dear friends, where bloated Might
 can rob no man of his dearest right;
My rest shall be calm in any grave
 Where none can call his brother a slave.

I ask no monument, proud and high,
 To arrest the gaze of the passers by;
All that my yearning spirit craves
 Is — *Bury me not in a land of slaves*!

from "Bury Me in a Free Land," 1864

Let me make the songs for the people,
 Songs for the old and young;
Songs to stir like a battle-cry
 Wherever they are sung.

Not for the clashing of sabres,
 For carnage nor for strife;
But songs to thrill the hearts of men
 With more abundant life.

from "Songs for the People," 1895

Offers," which is thought to be the first published short story by an African American woman.

Watkins largely withdrew from the lecture circuit in 1860, when she married Fenton Harper of Cincinnati and settled down on a small farm near Columbus, Ohio. As the Civil War raged elsewhere, the couple celebrated the birth of a child, Mary. Then, in 1864, Fenton Harper died.

After the war, Frances Harper resumed her speaking tours, this time in the South. For the next several years she lectured as often as four times a day on such subjects as temperance, civil rights, strengthening the family, and equality for women. She made her home with newly freed people in each place she visited.

Harper also kept writing, producing numerous essays, several serialized novels, and seven volumes of poetry. Many of her highly sentimental poems no longer suit today's tastes, although verses written in the voice of fictional ex-slave "Aunt Chloe Fleet" effectively comment on the Reconstruction era.

For modern readers, her 1869 epic, *Moses: A Story of the Nile*, is more successful. Apparently inspired by the death of Abraham Lincoln, whom she and others compared to Moses in his role as liberator, the poem presents its familiar Bible story in blank verse. Describing one of the 10 plagues in Egypt, Harper wrote: "That lengthened night lay like a burden / On the air,—a darkness one might almost gather / In his hand, it was so gross and thick." In the poem's final section, Moses "stood upon the highest peak of Nebo, / And saw the Jordan chafing through its gorges," but dies before he can cross the river to the promised land. In 1892, three years after rewriting and expanding *Moses*, Harper published *Iola Leroy*, the bestselling African American novel of the 19th century, and an inspiring call to black female leadership in the post-Reconstruction era.

Frances Harper died of heart failure in 1911 at 85, having devoted her life to a mixture of poetry and progressive politics. Almost two decades before, in the poem "Songs for the People" (*excerpt, above*), she wrote what some consider her poetic epitaph, including a line particularly appropriate to her career: "Let me make the songs for the people."

A TRADITION OF CRUSADING NEWSPAPERS

In 1846 Willis A. Hodges, a free black man who worked as a house painter in New York City, appeared at the offices of the *New York Sun* with a letter responding to the newspaper's editorials against equal voting rights for blacks. The editors grudgingly agreed to print Hodges's letter as a paid advertisement, but toned it down and buried it on the back pages. When the painter protested, he was told "the *Sun* shines for all white people, and not for colored men."

The attitude underlying that rebuff had already led some blacks to start their own papers. The earliest, *Freedom's Journal*, was founded in New York in 1827 by John Russwurm and the Reverend Samuel Cornish. It was followed by others—including the *Ram's Horn*, established by Hodges and a partner, Thomas Van Rens-selaer, in 1847. The *North Star*, edited by abolitionist Frederick Douglass, debuted some months later.

After the Civil War, hundreds of black newspapers sprang up to inform, instruct, and agitate on behalf of African Americans. By the early 1900s papers like the ones profiled here and on pages 146-151 circulated nationally to hundreds of thousands of readers, reporting on everything from landmark legal cases to black society events. During World War II, total circulation for the black press topped one million. In recent years, the influence of the black press, like that of newspapers generally, has declined somewhat. Yet, in giving voice to persistent demands for justice and equality, the black press carries on a long tradition of crusading American journalism.

Christopher J. Perry

Philadelphia Tribune (founded 1884)

The oldest continuously published black newspaper in America, the *Philadelphia Tribune* was founded by editor Christopher J. Perry, who had moved to Philadelphia from Baltimore as a child. Before founding the paper, Perry worked as a journalist, writing short pieces for the city's white dailies, and served as editor of the *Philadelphia Sunday Mercury*'s "colored department."

When the *Mercury* folded, Perry launched the *Philadelphia Tribune* in rented quarters using second-hand equipment.

His editorial talent and shrewd business sense helped make the paper an immediate success despite its modest beginnings.

Perry early on set a courageous editorial policy of identifying and exposing social injustice, attacking discrimination in Philadelphia and calling for better housing and education for blacks. After Perry's death in 1921, one of his sons-in-law, E. Washington Rhodes, became the editor and led the paper through the triumphs of the civil rights era.

BE 100% WITH YOUR WAR BONDS

The Philadelphia Tribune

FOR 57 YEARS PHILADELPHIA'S HOME NEWSPAPER

"The Constructive Newspaper"

PHILADELPHIA, PA. SATURDAY, JULY 18, 1942

TEN CENTS

VOLUME 58—NUMBER 31

WE SEEK FULL OPPORTUNITY AS AMERICANS

Dear Congressman:
The American Negro is in a bad and awkward spot: Bad because of his mass disfranchisement; awkward because of his inability to obtain redress except through the Congress of the United ... "not mere exis-

Hold Lawyer In 'Riot' Case

A charge of inciting to riot was laid against the lawyer who defended Walter Stafford, 21, of 814 North Holly street, central figure in the "riot" case of that street and Ha-verford avenue. Wednesday.

At the continued hearing before Magistrate Roberts at 20th and Lancaster avenue, Max Cohen, representative of the National Lawyers Guild and affiliated with the police ...

Patient Dragged From Hospital By Lynch Mob

TEXARKANA—Just a few days after Tuskegee Institute's president, Dr. F. D. Patterson, had released the information that there had been only one lynching in the first half of the year with this year's second lynching. A ... this small community started the second half of 1942 and hanged by a mob year-old man was dragged from his bed in a hospital ...

Local Soldiers Win Officer's Bars In Corps Of Engineers

Among the 17 successful Negro officers graduated as second candidates in the Corps of Engi-

John H. Murphy, Sr.

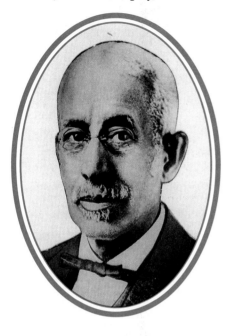

Baltimore Afro-American (founded 1892)

What would become one of the largest black weeklies began with the separate efforts of three Baltimoreans. In the early 1890s, the Reverend George F. Bragg began printing a church circular called the *Ledger*. About the same time, John H. Murphy, the owner of a house-decorating firm and the unpaid superintendent of a local Sunday school, started putting out a small paper in his cellar called the *Sunday School Helper*. Meanwhile, the Reverend William M. Alexander started a church newsletter called the *Afro-American*. When Alexander decided to sell his paper, Murphy borrowed $200 from his wife to buy it, and later joined with Bragg to merge the *Ledger* into the *Afro*, as the paper came to be known. Eventually, Murphy bought out Bragg and assumed sole control of the *Afro-American*.

The new owner insisted that to be truly independent, a black newspaper had to be self-sufficient. He recruited talented young people, trained them in every aspect of the business, and bought his own building and presses. "How can our own people ever expect to operate complicated machinery," Murphy asked, "unless they get a chance at it in our own plants?"

Upon Murphy's death in 1922, his son Carl assumed the editorship. The younger Murphy crusaded against lynchings in the South and expanded the paper's national coverage with vivid reports of the trials of the Scottsboro Boys and of the Midwest floods of the 1930s. He also brought his readers foreign news, hiring reporters to cover the coronation of King George VI in London, the 1936 Olympic Games in Berlin, the Italian invasion of Ethiopia, and the Spanish civil war.

When World War II began, the *Afro-American* was outspoken in demanding equal treatment of black servicemen in the armed forces. *Afro* editorials, joined by the voices of other African American newspapers, helped force the army to commission black officers and accept black cadets for flight training. So vigorous was their advocacy that only intervention by President Roosevelt and his attorney general prevented the federal government from charging the editors of the papers with sedition.

Readers rewarded the *Afro*'s fierce partisanship by making it one of the most successful black newspapers in history, with a peak circulation of over 300,000. Today the *Afro*, though far smaller than in its heyday, is still a family-run paper that remains dedicated to the words of its founder: "I have faith in myself, in the ability of my people to succeed in this civilization and in the ultimate justice which will secure them full citizenship in the nation."

Robert Sengstacke Abbott

Chicago Defender
(founded 1905)

The paper that set the standard for the modern black press as an advocate for the African American community was started by a failed attorney with a total capital of 25 cents. Robert Abbott, who was born on Saint Simons Island off the coast of Georgia in 1870, came to Chicago in the 1890s to study law, having learned the printer's trade at Hampton Institute in Virginia. He practiced briefly in Gary, Indiana, and in

Topeka, Kansas, before returning to Chicago in 1903. When his efforts to practice law there failed, he took up journalism. He spent a quarter on paper and pencils, arranged for printing on credit, and put out the *Defender* in his landlady's kitchen. In the early years, Abbott also hawked the paper door-to-door and in barbershops, churches, and poolrooms.

In an inspired marketing ploy, he abandoned the moralizing tone common in black papers of the era and instead patterned the *Defender* after publisher William Randolph Hearst's sensationalist tabloids, plastering his front page with lurid tales of crime and scandal. An early campaign against prostitution ran under a headline that screamed "Mother Takes Innocent Daughter to Houses of Ill Fame," only to add in much smaller type, "to play the piano." Abbott also saw a world of economic possibilities for black workers in northern industry, and his paper editorialized accordingly, with banner headlines urging southern blacks to "Come North!" So successful was this formula that by 1915 the *Defender*'s circulation grew to some 230,000, with a readership

spreading far beyond Chicago. It became the most widely read black newspaper in the South, and its influence was credited with fueling the great migration of southern blacks to northern cities during and after World War I.

Abbott believed that a black newspaper had to champion the cause of African Americans in every field. His early editorials supported America's entry into World War I while opposing segregation in the armed forces. The *Defender* campaigned against lynchings in the South, covered the 1919 race riots in Chicago, and denounced white trade unions that tried to keep blacks out of the booming war industries.

Upon Abbott's death in 1940, the paper was taken over by his nephew and chosen successor, John Herman Henry Sengstacke. That same year, Sengstacke helped found the Negro Newspaper Publishers Association. He later made the *Defender* the cornerstone of Sengstacke Newspapers, which is still the largest chain of black newspapers in the country.

SEVERAL ARE SHOT FOLLOWING BASEBALL GAME

THE *Chicago Defender*
WORLD'S GREATEST WEEKLY

PRICE 5 CENTS

VOL. XII. NO. 21

SATURDAY

CHICAGO, MAY 26, 1917.

TUCKER DIVORCE CASE FULL OF SCANDAL

HORRIBLE MEMPHIS LYNCHING ASTOUNDS CIVILIZED WORLD

TENTH CAVALRY TO FRANCE

FUTURE AMERICAN CITIZENS

HEROES OF CARRIZAL MAY GO WITH GEN. PERSHING

By a Staff Reporter
Washington, D. C., May 25.—President Wilson has put his signature to the bill which sends 560,000 men to France and

Clilan Bethany Powell

Amsterdam News (founded 1909)

The *Amsterdam News*—the name refers to New York City's 17th-century name, New Amsterdam—began in 1909 as a one-man operation run out of the New York apartment of founder James H. Anderson. In 1936 the paper was purchased by two local physicians, Philip M. H. Savory and Clilan Bethany Powell. Fourteen years earlier Powell had become the city's first African American radiologist; now, despite a lack of journalistic experience, he became an editor in chief.

Powell aimed the *Amsterdam News* primarily at New York's black community in Harlem, packing its pages with scandalous accounts of murders, rapes, raids on love nests, and interracial conflict. And although the paper ran uplifting accounts of black accomplishments as well, it was blunt in its coverage of racial discord. For example, the

News gave perhaps more thorough treatment of the 1935 Harlem race riots than any other paper. The *News* was also the first black newspaper to sign a contract with the Newspaper Guild and to pay union wages.

Racial issues dominated reporting and editorial policies at the *News*, but Powell avoided the activist stance of many African American papers. He criticized the Black Power movement of the late 1960s, for instance, and ran regular columns by moderate civil rights leaders such as Roy Wilkins. In terms of circulation, his approach was effective: The *Amsterdam News* became the largest black newspaper of the civil rights era. In 1989, having outlived nearly all its competitors in New York City, the paper celebrated its 80th birthday.

Plummer Bernard Young, Sr.

Journal and Guide (founded 1910)

Acclaimed by media critics for many years as the best-edited black newspaper in America, the Norfolk *Journal and Guide* was founded by Plummer Bernard Young in 1910, when he was just 26. During the 1890s, Young's father had started a temperance newspaper in Littleton, North Carolina. The son learned the printing trade working with his father before enrolling at Saint Augustine's College in Raleigh, North Carolina, in 1903.

Young left after only two years, however, and by 1907 was working as plant foreman for the *Lodge Journal and Guide*, a publication of a black fraternal order known as the Knights of Gideon, which was based in Norfolk, Virginia. One day the editor failed to show up, and Young took it upon himself to write the scheduled editorial. The lodge officers were so impressed they made him associate editor on the spot; soon he was made editor in chief.

In 1910 Young bought the paper, dropped the word *Lodge* from the masthead, and launched the new *Journal and Guide* as an independent weekly. The paper grew rapidly and by 1927 had reached a circulation of 10,000.

In establishing a reputation for excellence, Young rejected crime and scandal stories, favoring balanced news accounts and thoughtful commentary. He campaigned against saloons in black neighborhoods and fought for better schools, housing, and jobs for blacks. Although a college dropout, he remained interested in education and served as a trustee of several black Virginia colleges as well as chairman of the board of Howard University in Washington, D.C.

In 1946 the *Journal and Guide* won the first of three Wendell L. Willkie Awards for Negro Journalism. The National Newspaper Publishers Association named Young its Man of the Year in 1960. At the time of Young's death two years later, his paper was among the largest weekly newspapers in the South, and Young was universally acknowledged as the dean of the black press.

Robert Lee Vann

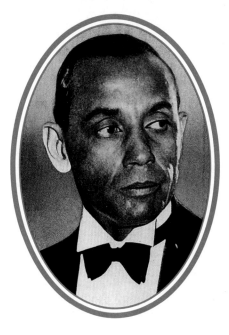

Pittsburgh Courier
(founded 1910)

In the 1930s, the *Pittsburgh Courier* was one of the largest and most influential black newspapers in America. It achieved that rank in spite of—or perhaps because of—the mercurial temperament of its editor, Robert Vann, who was apt to change his position on issues from year to year and sometimes from week to week.

Vann was born in 1879 in Ahoskie, North Carolina, the son of a cook. With the aid of a scholarship, he attended Western University of Pennsylvania, where he became editor of the campus newspaper. In 1909 he earned a law degree from the same school.

In 1910, Vann was approached by a group of Pittsburgh blacks who had started a struggling newspaper and wanted him to join the venture as general counsel. Within months, he had also become the paper's editor, launching one crusade after another as Pittsburgh's black population swelled during World War I.

In the rough-and-tumble reporting of the 1920s, newspaper editors were often inconsistent in their positions, and Vann was no exception. He opposed, then supported, a boycott of one of the city's department stores. He blew hot and cold on the labor movement, criticizing AFL strikers from 1919 to 1922 but supporting A. Philip Randolph's efforts to organize a porters union in 1925. Then, in 1928, he turned against Randolph because of his socialist ties. Even as Vann's editorial positions shifted, however, the paper's circulation grew, reaching 250,000 in 1938. The growth was at least partly a result of beefed-up sports coverage, titillating pictures of beauty queens, and the luster added by hiring a Washington reporter.

Vann also held numerous appointive offices in Pittsburgh and on the national political scene. He started out a Republican, but backed Roosevelt for president in 1932. His pro-Roosevelt columns were credited with helping wean blacks away from the Republican party. Then, characteristically, he soured on the Democrats, too.

Vann was preparing to endorse Republican Wendell Willkie for president in 1940 when he became terminally ill with stomach cancer. The paper was taken over by his widow, Jessie Vann. In 1965 it was acquired by John H. Sengstacke of the *Chicago Defender*, and Vann's paper joined the Sengstacke chain.

ROOSEVELT LANDSLIDE WRECKS HILL MACHINE, G. O. P. FORCES LOSE OUT IN COUNTY VOTE DRIVE

Oscar DePriest Wins; Another Pro-Parker Senator Beaten

GUARDING OUR BALLOT

OUR NEXT PRESIDENT

Pittsburgh Courier

AMERICA'S BEST WEEKLY

Clean and Progressive

Live Features, Latest News

Leader In Advertising, Circulation and News

PITTSBURGH, PA., SATURDAY, NOVEMBER 12, 1932

VOL. XXIII—No. 45

PRICE TEN CENTS

ELECTION EXTRA

SEVEN SCOTTSBORO BOYS WILL BE GIVEN NEW TRIAL

HIGHEST COURT

Chester A. Franklin

The Call
(founded 1918)

The journalist who launched the *Call* of Kansas City learned his trade at an early age, through the efforts of two powerful role models: his parents. Chester A. Franklin was born in Denison, Texas, in 1880, the only child of George F. Franklin, a barber, and Clara Belle Williams Franklin, a schoolteacher. The family moved to Omaha, Nebraska, when Chester was seven, and there the little boy made it known that barbering wasn't for him. To encourage their son in a new profession, the Franklins started a small newspaper, the *Omaha Enterprise*.

Young Chester learned the mechanics of newspaper publishing before he graduated from high school, whereupon he enrolled at the University of Nebraska. When his father became ill two years later, the son returned home and took over the *Enterprise*. In 1898 the family moved to Denver, Colorado, where they bought another paper they named the *Star*. George Franklin died three years later.

Franklin continued to publish the *Star* until 1913, when he and his mother moved to Kansas City, Missouri, hoping to start yet another new paper to serve the town's expanding black population. In Missouri, they opened a job printing shop and established a reputation for reliability. Finally, in 1919, they launched the *Call*. One of the paper's earliest editorial campaigns was influential in deciding the Kansas City courts to seat blacks on local juries for the first time. The paper developed into the leading black weekly of the Midwest, distinguished by its optimistic tone, sober presentation, and emphasis on the gains blacks had made in the community.

THE CALL
Southwest's Leading Weekly

THE CALL, KANSAS CITY, MO. WEEK OF JUNE 29 TO JULY 5, 1990

40 Cents

Vol. 70, No. 49

Nelson Mandela Electrifies Crowds Wherever He Goes

He Has One Message: 'Apartheid Must Go And Must Go Now!'

By L.H. Bluford

WASHINGTON, D.C.—Wherever he went or was scheduled to go, Nelson Mandela, the South African anti-apartheid leader who was imprisoned for 27 years because of his democratic beliefs, drew crowds of enormous proportions and electrified audiences and crowds wherever he spoke or passed by during his three-day visit to the nation's capital.

Mandela, 71-year-old deputy president of the African National Congress, was the "man of the hour" all week long on the East Coast, speaking to thousands in New York and Boston before coming to Washington before he met with President

where he captivated members of Congress when he addressed a Joint Session of the House and Senate Tuesday morning before an unprecedented "standing room only" crowd and received at least four standing ovations.

His message to Congress and to every other American audience he addressed was "Apartheid Must Go and It Must Go Now." Mandela and his wife, Winnie, came to the United States to ask for financial aid for his struggle against apartheid and to urge this country and others to keep their economic sanctions against the white minority government of South Africa in place until apartheid is brought to an end, until all people in South Africa can vote and be

elected to public office, an independent judiciary is established and there is a non-racial economy in the country. The African national Congress and the F.W. de Klerk government are on the verge of negotiating toward the elimination of the apartheid system. De Klerk's release of Mandela from prison in February was but one step toward reformation in South Africa, leader of the ANC aver.

Mandela told the Congress that the economic sanctions, passed in 1986 over then President Reagan's veto, should remain in place because "the purpose for which they were invoked has not been achieved." "We are encouraged," said Man-

MANDELA AND OFFICIAL CONGRESSIONAL ESCORT PARTY ... Just before Nelson Mandela of South Africa made his historic address before the Joint Meeting of Congress in Washington Tuesday morning, June 26, four members of the House escorted the distinguished visitor from the rear of the House of Representatives to the podium of the Speaker's rostrum amid thunderous applause. Left to right: Rep. Bill Gray, Rep. Alan Wheat, Nelson Mandela, Rep. Ron Dellums and Rep. Steny Hoyer.

People From All Over Country Attend Breakfast For Mandela

It was learned later that the hosts of the breakfast, the members of African delegation had expected a warm welcome in the United States, having a deep sense of the support the American people gave to his cause, but

Mandela said that he and his South

William Alexander Scott II

Atlanta Daily World (founded 1928)

William Alexander Scott II had been publishing the *Atlanta World* for nearly four years when he stunned readers with an announcement in the February 26, 1932, edition of the paper. Declaring his intention to "go the world one better," he vowed to transform the thrice-weekly publication into a full-fledged daily newspaper—one of the first black papers to publish so frequently. (The bilingual French-English *New Orleans Tribune*, founded in 1864, was the first black American daily.)

Scott had laid the groundwork carefully for his historic venture. Before going into the newspaper business, the young publisher and his brother Cornelius had put out a series of black business directories in Atlanta and Jacksonville, Florida. Armed with this experience, they purchased the Service Printing Company in 1928 and launched the *Atlanta World* as a weekly. Two years later they started a sister publication, the *Birmingham World*, and opened still another weekly *World* newspaper in Memphis in 1931.

When Scott decided to convert the *Atlanta World* to the *Atlanta Daily World* he had already acquired a considerable publishing empire and was able to economize by publishing newspapers intended for different markets in a single plant. His papers featured the first regularly published comic strips drawn by a black cartoonist as well as a pictorial insert, the *Gravure Weekly*, which became the first nationally circu- lated black picture magazine.

Scott's pioneering efforts were cut short when he was mysteriously shot dead in 1934 at the age of 31. With considerable courage, his brother Cornelius took the helm, launching a vigorous editorial campaign in memory of his brother to secure voting rights for blacks. The paper also campaigned for repeal of the poll tax.

Following Cornelius Scott's own inclinations, however, the *World* became staunchly Republican in 1952. During the civil rights era, it adopted a moderate, even conservative, stance. The paper once criticized a proposed boycott of white businesses in black neighborhoods that refused to hire black employees—and was sharply rebuked by its younger readers. Today, the *World* continues to follow the vision announced by its founder in the first daily edition: To print the news "then, not later," and to cover "any and everything that happens of consequence to Negroes here and elsewhere."

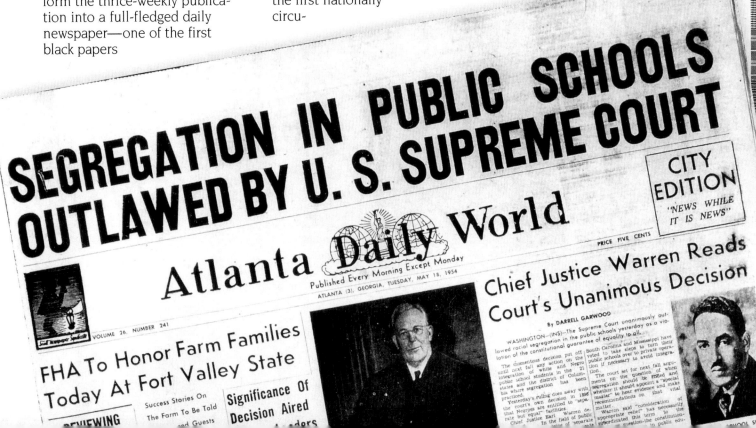

THE LURE OF FRANCE

Some of black America's foremost intellectuals once considered France—and Paris in particular—to be a haven of liberty and grand culture. In the 19th century, W. E. B. Du Bois and Booker T. Washington visited to observe, firsthand, the workings of a comparatively egalitarian society, and during the 1920s, when the Harlem Renaissance was flourishing, several of the movement's most prominent members went in search of the inspiration that had fueled any number of writers, artists, and musicians—both black and white—before them.

In February 1924, twenty-two-year-old Langston Hughes, who had long equated Paris with literary accomplishment and personal liberty, worked his way across the Atlantic by freighter and arrived in the City of Light with just seven dollars in his pocket. "I guess dreams do

come true," he wrote in his first autobiography, *The Big Sea*, "and sometimes life makes its own books, because here I am living in a Paris garret, writing poems and having champagne for breakfast." Hughes quickly met his immediate need to earn money by securing a job as a doorman, and then as a dishwasher at Le Grand Duc, a club in Montmartre. There he experienced none of the condescension white Americans often evinced toward anyone employed in similar occupations back home. "A great many celebrities and millionaires came to the Grand Duc in those days," he wrote, "drawn by the fame of Florence Embry—known simply as Florence—the beautiful brown-skin girl from Harlem who sang there."

Hughes reveled in the social acceptance the French accorded blacks, and in their special regard for blacks in creative enterprises. Without censure, he could bring in enough to pay the rent and concen-

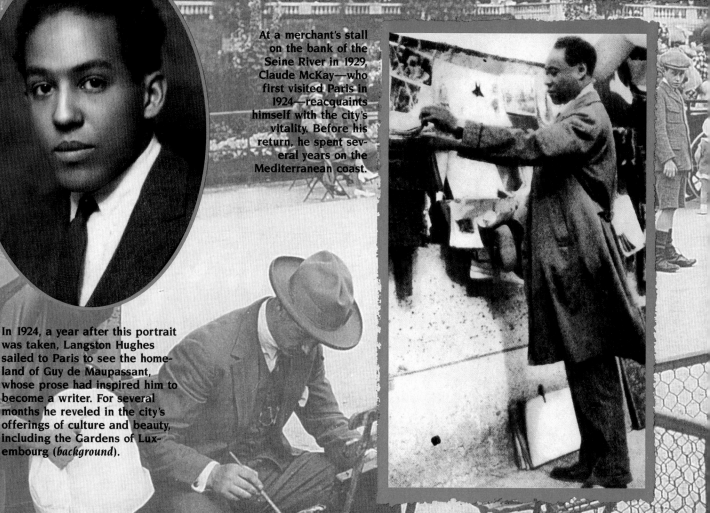

At a merchant's stall on the bank of the Seine River in 1929, Claude McKay—who first visited Paris in 1924—reacquaints himself with the city's vitality. Before his return, he spent several years on the Mediterranean coast.

In 1924, a year after this portrait was taken, Langston Hughes sailed to Paris to see the homeland of Guy de Maupassant, whose prose had inspired him to become a writer. For several months he reveled in the city's offerings of culture and beauty, including the Gardens of Luxembourg (*background*).

152

trate on the task at hand: to study the culture and stimulate his writer's soul. In August, he left France and eventually returned home to Washington, D.C., but he came back to Paris in 1937 and 1938.

While Hughes was still enjoying his first visit, he received a letter from black novelist and editor Jessie Fauset, who had first been to Paris more than a decade before. "I cannot think of anything lovelier," Fauset wrote, "than being young, healthy, and a poet in Paris." So said, the refined Phi Beta Kappa scholar traveled there herself in October and spent the next few months studying, frequenting literary teas and cafés, and working on her next book, *Plum Bun*. Ironically, though, she found that the social freedom she experienced caused her writing to suffer. "My book progresses so slowly, because I'm away from the pressure," she wrote to Hughes.

During the first months of 1925, Fauset toured other cities of France—Marseilles, Nîmes, Avignon—relishing the landscapes and cathedrals while sharpening her perceptions of the French people, whom she came to view with some skepticism. She preferred to spend her time with her American friends, and once remarked, "Whatever may be said against American whites, there is no question that American Negroes are the best there are."

The poet Countee Cullen, an ardent Francophile, had none of Fauset's reservations about the French. Cullen had planned to sail to Europe with Langston Hughes in 1924 but then decided to attend Harvard instead. However, Cullen spent two weeks in France in 1926 and returned in 1928 for the first of many extended stays, immersing himself in the culture and attending the University of Paris, the Alliance Française, and the Sorbonne. Of Paris he wrote: "I find everything that appeals to me: lights, noises in the night, places where one has fun according to one's liking, a sympathetic and tolerant world, in sum, a true civilization."

Cullen's facility with the language and uncritical admiration of the French gained him entrée into very exclusive venues, where he consorted with nobles,

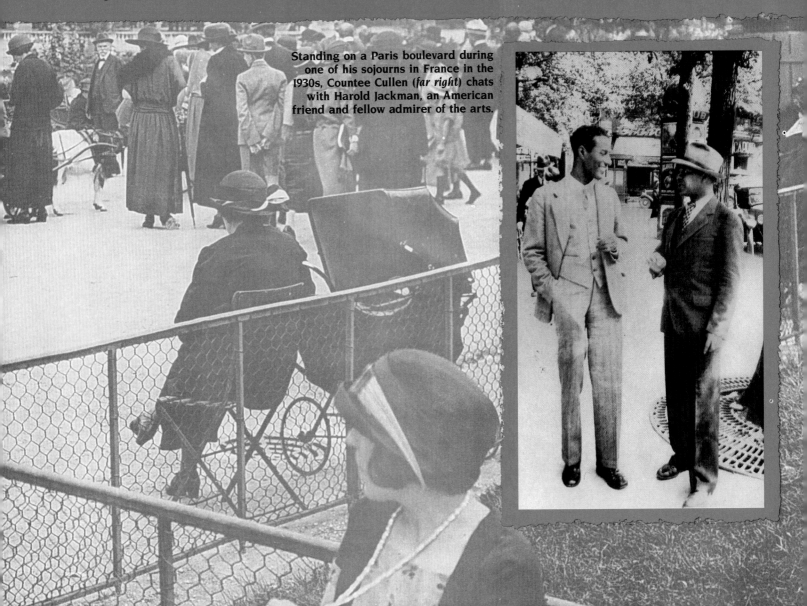

Standing on a Paris boulevard during one of his sojourns in France in the 1930s, Countee Cullen (*far right*) chats with Harold Jackman, an American friend and fellow admirer of the arts.

other literati, musicians, and patrons of the arts—enjoying a way of life unavailable to a black writer in the United States. He was nonetheless seriously devoted to his art and to study, publishing many original works as well as translations of French poets. World War II drove him back to America for the last time, and he died there in 1946.

Poet, novelist, and essayist Claude McKay also preferred Europe to the United States, but he saw France in a less rosy light than did Cullen. "Paris has never stormed my stubborn heart / And rushed like champagne sparkling to my head," he wrote in the late 1920s. Before World War II, McKay spent 11 years in Europe as a self-proclaimed "fellow-traveller in the expatriate caravan," and he grew to believe that the seeming lack of French prejudice toward black writers and artists existed in part because of a national admiration for the creative spirit, but also because the presence of blacks was too limited to be threatening. McKay concluded that beneath the Gallic tolerance lurked an element of racial prejudice, which showed itself in the treatment of Africans in French colonial holdings such as Algeria and Senegal.

Nevertheless, after the war many African Americans decided that life in France was far preferable to the one that awaited them back home. By this time, black writers arriving in France were coming less from a desire to sample Europe and more from a need to escape America's racial hostility. Even so well known an author as Richard Wright was subjected to constant indignities: His neighbors protested the presence of a black family in Greenwich Village; a Fifth Avenue department store barred his young daughter from the restroom; he was forced to take the stairs rather than an elevator to visit his friend Sinclair Lewis at a New York apartment. As a result, what had once been a French vacation became for many African Americans a self-imposed exile.

Wright visited Paris in 1946 and moved his family there permanently in 1947. "It is so good to be somewhere where your color is the least important thing about you," he wrote after his introduction to the

city. Once established in France, he reigned for many years as the dean of an expatriate black writers' community, holding court regularly at Café Tournon on the Left Bank or at Deux Magots (*below, far left*) on the Boulevard Saint-Germain. In contrast to his life in New York, Wright was a celebrated person in his new land, officially named a citizen of honor.

The growing coterie of African American writers abroad also included Wright's protégé James Baldwin (*pages* 160-161) and novelist Chester Himes. Himes left the States in 1953, fed up with Jim Crow employment and devastated by negative reviews—and in 1958 on foreign soil he won a prestigious award for his detective fiction. Novelist Frank Yerby first exiled himself to the French Riviera in 1957 and eventually settled in Spain, as did Himes, although Yerby continued to set his plots in France. And William Gardner Smith, whose *Last of the Conquerors* earned him enough to venture overseas in 1951, worked for decades as a journalist for Agence France Presse. While abroad he wrote, among other works, *The Stone Face*, which took up the cause of liberation for Algeria.

In the second half of the 1950s, as the civil rights movement gained momentum in the United States, France's own race problems flared. Algeria and other French-held colonies in Africa demanded independence, while Africans living in France took a firm stand in favor of a separate black community—a stand not shared by the black American expatriates. After 1960, the century-old allure of France began to fade for African Americans, although many in voluntary exile—such as Wright and Himes—stayed in Europe until their deaths. Despite the changing social climate, young black American writers continued to visit the Land of Liberty, but now they came to pay homage to their predecessors as much as to sample the culture. Also, because of the country's proximity to Africa, France was viewed by many as a gateway to that continent. For them, the writer's pilgrimage had become not only an escape from American intolerance and a search for inspiration but also a journey of self-discovery into their African roots.

Detective novelist Chester Himes stands beside his 1934 Fiat, "Jemima," outside the ground-floor Paris apartment where he lived in 1963. The writer spent 15 years in France—seven of them in Paris—before retiring to Spain, where he died in 1984.

Author of *Native Son* and other fiction protesting the plight of black Americans, Richard Wright—shown in front of a bookstore on the Rue de Seine—moved to Paris in 1947 and was buried there 13 years later.

THE INVISIBLE MAN

"I am an invisible man," announces the hero of Ralph Ellison's novel of race and identity on the very first page of what has become one of the classic works of American literature. "I am a man of substance, of flesh and bone, fiber and liquids—and I might even be said to possess a mind. I am invisible, understand, simply because people refuse to see me."

The nameless narrator of *Invisible Man* has fallen down a manhole while trying to escape angry whites giving chase during a riot in Harlem. Next to him, tumbled onto a pile of coal, is a briefcase he has been carrying that contains the symbols of who he has become in his lifetime: a high-school diploma, a slip of paper bearing his underground name in a revolutionary group called the Brotherhood, a black Sambo doll. For a moment his anonymous pursuers shine a match down the hole, then cover up the opening, plunging the Invisible Man into darkness. In that blind state he begins to recount the misadventures that brought him there—the often sad, often funny incidents that form the body of the book—and in the process he comes to understand his experiences as a young black man coming of age in a white world.

Published in 1952, *Invisible Man* was immediately recognized as a work of genius. In 1953, it won the National Book Award as well as a Russwurm Award and the *Chicago Defender*'s accolade for a work "symbolizing the best in American democracy." More than a decade later, in 1965, *Book Week* published the results of a poll of 200 writers and critics, who judged Ellison's novel to be "the most distinguished single work" written in the past 20 years.

As it happened, *Invisible Man* was not the story Ellison set out to write, nor had he set out to be a writer. In 1935, while he was a student of music at Tuskegee Institute, the 21-year-old aspiring composer traveled to New York, hunting for a summer job that would earn him the tuition to continue his education. He was unable to save enough money to return to Alabama, but in Harlem he met poet Langston Hughes and author Richard Wright—and found a new direction.

In 1937, Wright encouraged Ellison to try his hand first with a review essay and then a short story for a magazine Wright was then editing. Between 1938 and 1944, Ellison wrote a number of articles and stories, which appeared in such publications as *New Masses*, and he formed his ideas of what fiction—particularly black fiction—should be.

Ellison felt that the current protest fiction, represented by such works as Wright's *Native Son*, sometimes missed the full complexity of black life. "I think that the mixture of the marvelous and the terrible is a

basic condition of human life," he wrote in an essay some years later, "and that the persistence of human ideals represents the marvelous pulling itself up out of the chaos of the universe."

In 1945 Ellison began work on what he envisioned as a wartime novel set in a German POW camp, but that idea did not progress as planned. Writing about the creation of *Invisible Man* for a 30th-anniversary edition, Ellison told a fablelike account of an odd presence that had insinuated itself into his consciousness—"nothing more substantial than a taunting, disembodied voice" that urged, "I am an invisible man." At first, the author wrote, he dismissed it as a troublesome distraction, but soon the artist in him sensed that this "voice of invisibility issued from deep within our complex American underground."

Trying to imagine what sort of character might lie behind the insistent apparition, Ellison decided it must belong to a black man, "young, powerless (reflecting the difficulties of Negro leaders of the period) and ambitious for a leadership role." He considered incorporating the character into the scheme of his war novel but eventually gave up the original project altogether and devoted himself to unraveling the mystery of his uninvited muse. "Although *Invisible Man* is my novel," Ellison wrote, "it is really his memoir."

Ellison worked on *Invisible Man* for seven years, dividing his time between his home in a ground-floor Harlem apartment and a donated office at a jeweler's on Manhattan's Fifth Avenue. To support what he called the "desperate gamble" of becoming a novelist, he wrote reviews and short stories, took freelance photography assignments, and even built and installed sound equipment, while his wife brought in the steady income of a full-time job. The fruits of his long labor amply justified Ellison's faith and persistence. Upon its publication, the *Hudson Review* hailed *Invisible*

Man as the quintessential 20th-century American novel: "For if there is an American fiction it is this."

Ellison had created a work that spoke to the deepest concerns of people everywhere. Blending Dixie and Harlem, jazz and the blues, and African folklore with the classical journeys of Dante and Homer, he showed how the African American experience, for all its historical uniqueness, is nevertheless inextricably bound to the common human enterprise. "I had no doubt that I could do something, but what? and how? I had no contacts and I believed in nothing," says the book's narrator. "Who was I, how had I come to be?"

From his darkness in the manhole, the Invisible Man realizes that his only source of illumination is the vestiges of his life in the briefcase. Setting fire to them one by one, he lights up the darkness—and starts to see who he is, becoming no longer invisible to himself. "I was my experiences and my experiences were me," he proclaims at the end of the book, "and no blind men, no matter how powerful they became, even if they conquered the world, could take that, or change one single itch, taunt, laugh, cry, scar, ache, rage or pain of it." As the journey concludes, Invisible Man is sitting in a room blazing with the light of more than a thousand bulbs.

It was Ellison's genius to give voice to a universal human quest for self-knowledge and self-acceptance. As the Invisible Man himself asks on the final page of the novel, after undergoing countless setbacks in the course of forging an authentic identity, "Who knows but that, on the lower frequencies, I speak for you?"

A TIRELESS VOICE FOR CHANGE

Although he spent much of his adult life in France, James Baldwin considered himself a commuter rather than an expatriate. He never relinquished his American citizenship, and while he was consistently critical of the United States for its inability to come to terms with its racial problems, he maintained that his often searing commentaries were made with the highest intentions: "I love America more than any other country in the world," he wrote in *Notes of a Native Son*, "and, exactly for this reason, I insist on the right to criticize her perpetually."

James Arthur Baldwin was born in Harlem in 1924. The oldest in a household of nine children, he was close to his mother but terrified of his sometimes violent stepfather. To escape the gloomy atmosphere at home, young Jimmy—a voracious reader—haunted Manhattan's public libraries and the theater, and at 14 he turned to religion, preaching as a junior minister at the Fireside Pentecostal Assembly. For the next three years Baldwin kept congregations spellbound with his inspired speechmaking—until he came to view the Christian church as yet another means of oppressing blacks.

In 1942, after graduation from high school, Baldwin decided to make writing his life's work. He juggled several odd jobs during the day and wrote in the evening, surviving on only four hours of sleep a night. In 1944 he met Richard Wright, who recommended him for a coveted writer's scholarship, the Saxton Memorial

Trust Award, and in 1948 he also won a Rosenwald Fellowship.

By age 24, Baldwin had garnered some success, but he was all too aware of America's stifling "Negro problem"—a problem he saw to be even worse in real life than in the growing body of protest literature. He decided to leave the United States, choosing Paris as his destination almost at random. "Once I found myself on the other side of the ocean, I could see where I came from very clearly," he said years later.

While in France Baldwin completed his first major work, the autobiographical novel *Go Tell It on the Mountain*, in which he por-

In 1963, during one of his trips back to the United States from France, Baldwin strolls along a street in Harlem, his childhood home.

James Baldwin talks in 1957 with the New Orleans boy whose experiences in a newly integrated school he would describe in a 1958 essay, "The Hard Kind of Courage."

160

trays the church's inability to solve the difficulties faced by black Americans. *Notes of a Native Son*—a collection of essays published two years later, in 1955—examines Baldwin's own identity as both an American and a black American. The books—both of them published first in the United States—established Baldwin as a writer of note, and even in his adopted city, the black *écrivain* became something of a celebrity.

But as the civil rights movement evolved in America, Baldwin felt the tug to return home to "bear witness to the truth." Back in the United States, he marched, lectured, and generally acted as America's conscience in matters of race. In *The Fire Next Time*, published in 1963, Baldwin's essays address blacks and whites alike about the necessity of putting love before color for the very survival of the nation. Love, for Baldwin, was not "anything pas-

sive," as he said in 1965. "I mean something active, something more like a fire, like the wind, something which can change you. I mean energy."

The advent of the Black Power movement in the late 1960s somewhat marginalized Baldwin—an integrationist—in his home country. His insistence that humanity was redeemable with love fell on increasingly impatient ears: The black arts community, on the one hand, rejected him for refusing to claim a specifically black vantage, yet white literary circles found his keenly analytical works too dire for their taste. Being popular, though, was not Baldwin's goal. "An artist is a sort of emotional or spiritual historian," he told an interviewer. "His

role is to make you realize the doom and glory of knowing who you are and what you are. He has to tell, because nobody else *can* tell, what it is like to be alive."

And Baldwin told: In his lifetime, he produced a vast body of fiction that includes novels, short stories, and plays, although he is most highly regarded for his nonfiction. Baldwin, considered a national treasure by the French, spent his last years in the south of France, where he died of cancer in 1987. But true to his roots, he was returned home for a funeral under the soaring arches of the Cathedral of Saint John the Divine at the edge of Harlem.

Speaking for civil rights, Baldwin addresses a meeting of CORE—the Congress of Racial Equality—in Los Angeles in June 1963.

James Baldwin was living in a 300-year-old farmhouse in Saint Paul de Vence, France, near Nice, when this photograph was made shortly before his death at age 63.

BRIDGING ART AND POLITICS

Amiri Baraka, one of the most passionate writers in African American history, has turned out a prodigious body of work during the four decades of his career. He has penned not only several volumes of poetry but also some three dozen plays, an autobiography, screenplays, nonfiction essays, music criticism, short stories, and a novel—all expressing a continually evolving political viewpoint. Perhaps more than any other black writer, Baraka has defined the relationship between politics and art.

Baraka was born Everett LeRoi Jones in Newark, New Jersey, in 1934. The son of a middle-income family, Jones graduated with honors from high school, and after a brief stint at Rutgers University transferred to Howard University to study English and philosophy. After two years, though, he left Howard in 1954, failing in his coursework and feeling socially adrift. Without knowing it, he was embarking on a long search for his true identity.

Immediately after leaving school, Jones joined the air force and began writing poetry regularly—"straining for big words and deep emotional registration, as abstract as my understanding of my life," he wrote in 1984 in *The Autobiography of LeRoi Jones*. On leave, he would sometimes visit Greenwich Village, the bohemian enclave of New York City, and was so taken with the lifestyle that when the military dismissed him in 1957—for attempting to publish poetry in allegedly Communist magazines—he moved to Manhattan himself.

In New York, Jones immersed himself in the mostly white literary world of Allen Ginsberg and other avant-garde poets of the "Beat," a term that refers to the sophisticated rhythms of the jazz music they listened to. For Jones, this marked the first of three transitional periods that have defined his evolution.

During this time, Leroi Jones published *Preface to a Twenty Volume Suicide Note*, a collection of experimental poetry. Although his early verse did contain references to African American culture, his greatest impact, along with other Beat poets, was to break the confines of the American poetic tradition. "I now knew poetry

In 1967 Amiri Baraka—pictured outside the Newark, New Jersey, courthouse with his wife and infant son (*above*)—was arrested for illegal arms possession during a Newark riot and later acquitted. At right, he speaks at a rally held in Newark that September to protest police brutality during recent political events.

could be about some things that I was familiar with," he later recalled, "that it did not have to be about suburban birdbaths and Greek mythology."

In 1960 Jones traveled to Cuba in the immediate aftermath of its revolution. There he realized that art could be used as an agent of change, and he began producing work more focused on race issues. Branching into other genres, he wrote *Blues People: Negro Music in America*, a seminal and highly acclaimed study of black music from slavery to the 1960s, and *The Dutchman*, a heavily symbolic drama of racial tension that won the 1964 Obie Award for best off-Broadway play.

The following year Malcolm X was assassinated, and LeRoi Jones turned his back completely on the white world. Disillusioned with the apolitical stance of the Greenwich Village literati, he moved to Harlem—and into a period of cultural nationalism. A principal architect of the new Black Arts movement, Jones established the Black Arts Repertory Theatre/School, on which black theaters across the country would model themselves. He also wrote politically charged poetry, drama, and essays that would greatly influence the black literary world as well as a generation of young writers. "The Black Artist's role in America is to aid in the destruction of America as he knows it," he said at the time. "We want poems that kill."

In 1967 Jones returned to his hometown, Newark, and devoted himself to political expression through his writing and community activism. That same year he also decided to make a profound declaration of his black identity by taking the African name Imamu (which means "spiritual leader") Ameer ("blessed") Baraka ("prince"), which he later amended to Amiri Baraka.

Yet for all his passion, Amiri Baraka chose to abandon cultural nationalism in 1974, having come to believe that the enemy of black Americans—and indeed of all oppressed persons—is not white society but capitalism. As a socialist, Baraka has continued to write poetry, drama, and nonfiction, offering his reconsidered views to African Americans and encouraging the fight for justice and equality. "I think fundamentally my intentions are similar to those I had when I was a Nationalist," Baraka explained in 1985. "I see art as a weapon, and a weapon of revolution. It's just now that I define revolution in Marxist terms."

Baraka, shown here at age 59 in 1993, wrote the Marxist play *What Was the Relationship of the Lone Ranger to the Means of Production?* in 1978. "The analysis of our condition," he has said of the African American community, "*must* be made in terms of class and an international struggle."

Poetry

Scores of writers, musicians, and visual and performing artists who championed the ideology and goals of the Black Power movement of the 1960s and 1970s found direction and strength in the Black Arts Movement (BAM). Dubbing the BAM the "spiritual sister" of Black Power, poet and theorist Larry Neal characterized the arts as "primarily concerned with the cultural and spiritual liberation of Black America."

Poets of the movement created a body of work that abandoned traditional conventions and forms. Instead, New Black Poets such as LeRoi Jones (now Amiri Baraka, *pages* 162-163), Don L. Lee (now Haki Madhubuti), Nikki Giovanni, Sonia Sanchez, Mari Evans, and Gil Scott-Heron crafted verse infused with the idioms and idiosyncracies of black music and speech. Together their voices rallied black Americans to celebrate their African heritage, to be Black and Proud, and to know that Black Is Beautiful.

STIRLING STREET SEPTEMBER

(for Sylvia)

I CAN BE THE BEAUTIFUL BLACK MAN
because I am
the beautiful black man, and you, girl, child nightlove,
you are beautiful
too.
We are something, the two of us
the people love us for being
though they may call us out our
name, they love our strength
in the midst of, quiet, at the peak of,
violence, for the sake of, at the lust of
pure life. WE WORSHIP THE SUN.

We are strange in a way because we know
who we are. Black beings passing through
a tortured passage of flesh.

LeRoi Jones (Amiri Baraka), 1967

For the

But He Was Cool
or: he even stopped for green lights

super-cool
ultrablack
a tan/purple
had a beautiful shade.

he had a double-natural
that wd put the sisters to shame.
his dashikis were tailor made
& his beads were imported sea shells
 (from some blk/country i never heard of)
he was triple-hip

his tikis were hand carved
out of ivory
& came express from the motherland.
he would greet u in swahili
& say good-by in yoruba.
woooooooooooo-jim he bes so cool & ill tel li gent
 cool-cool is so cool he was un-cooled by
 other niggers' cool
 cool-cool ultracool was bop-cool/ice box
 cool so cool cold cool

 his wine didn't have to be cooled, him was
 air conditioned cool
 cool-cool/real cool made me cool—now
 ain't that cool
 cool-cool so cool him nick-named refrig-
 erator.

cool-cool so cool
he didn't know,
after detroit, newark, chicago &c.,
we had to hip

 cool-cool/super-cool/real cool

 that
to be black
is
to be
very-hot. Don L. Lee (Haki Madhubuti), 1969

P E O P L E

EGO TRIPPING
(there may be
a reason why)

I was born in the congo
I walked to the fertile crescent and built
 the sphinx
I designed a pyramid so tough that a star
 that only glows every one hundred years falls
 into the center giving divine perfect light
I am bad

I sat on the throne
 drinking nectar with allah
I got hot and sent an ice age to europe
 to cool my thirst
My oldest daughter is nefertiti
 the tears from my birth pains
 created the nile
I am a beautiful woman

I gazed on the forest and burned
 out the sahara desert
 with a packet of goat's meat
 and a change of clothes

I crossed it in two hours
I am a gazelle so swift
 so swift you can't catch me

 For a birthday present when he was three
I gave my son hannibal an elephant
 He gave me rome for mother's day
My strength flows ever on

My son noah built new/ark and
I stood proudly at the helm
 as we sailed on a soft summer day
I turned myself into myself and was
 jesus
 men intone my loving name
 All praises All praises
I am the one who would save

I sowed diamonds in my back yard
My bowels deliver uranium
 the filings from my fingernails are
 semi-precious jewels
 On a trip north
I caught a cold and blew
My nose giving oil to the arab world
I am so hip even my errors are correct
I sailed west to reach east and had to round off
 the earth as I went
 The hair from my head thinned and gold was laid
 across three continents

I am so perfect so divine so ethereal so surreal
I cannot be comprehended
 except by my permission

I mean . . . I . . . can fly
 like a bird in the sky . . .

Nikki Giovanni, 1970

166

right on: white america

this country might have
been a pio
 neer land
once.
but. there ain't
no mo
 indians blowing
custer's mind

 with a different
image of america.
 this country
might have
 needed shoot/
outs/daily/
 once.
 but. there ain't
no mo real/white/ allamerican
 bad/guys.
just.
 u & me.
 blk/and un/armed.
this country might have
been a pion
 eer land. once.
 and it still is.
check out
 the fallling
gun/shells on our blk/tomorrows.

 Sonia Sanchez, 1970

I Am A Black Woman

I am a black woman
the music of my song
some sweet arpeggio of tears
is written in a minor key
and I
can be heard humming in the night
Can be heard
 humming
in the night

I saw my mate leap screaming to the sea
and I/with these hands/cupped the lifebreath
from my issue in the canebrake
I lost Nat's swinging body in a rain of tears
and heard my son scream all the way from Anzio
for Peace he never knew. . . . I
earned Da Nang and Pork Chop Hill
in anguish
Now my nostrils know the gas
and these trigger tire/d fingers
seek the softness in my warrior's beard

I am a black woman
tall as a cypress
strong
beyond all definition still
defying place
and time
and circumstance
 assailed
 impervious
 indestructible
Look
 on me and be
renewed

Mari Evans, 1970

The Revolution Will Not Be Televised

You will not be able to stay home, brother.
You will not be able to plug in, turn on and cop
 out.
You will not be able to lose yourself on scag and
skip out for beer during commericals because
The revolution will not be televised.

The revolution will not be televised.
The revolution will not be brought to you
 by Xerox in four parts without commercial
 interruption.
The revolution will not show you pictures of
 Nixon blowing a bugle and leading a charge by
 John Mitchell, General Abramson and Spiro
 Agnew to eat hog maws confiscated from a
 Harlem sanctuary.
The revolution will not be televised.

The revolution will not be brought to you by
The Schaeffer Award Theatre and will not star
Natalie Wood and Steve McQueen or Bullwinkle
 and Julia.
The revolution will not give your mouth sex
 appeal.
The revolution will not get rid of the nubs.
The revolution will not make you look five
 pounds thinner.
The revolution will not be televised, brother.

There will be no pictures of you and Willie Mae
pushing that shopping cart down the block on
 the dead run
or trying to slide that color t.v. in a stolen
 ambulance.
NBC will not be able to predict the winner at
 8:32 on reports from twenty-nine districts.
The revolution will not be televised.

There will be no pictures of pigs shooting down
 brothers
on the instant replay.
There will be no pictures of pigs shooting down
 brothers
on the instant replay.

There will be no slow motion or still lifes of Roy
 Wilkins strolling through Watts in a red, black
 and green liberation jumpsuit that he has been
 saving for just the proper occasion.

Green Acres, Beverly Hillbillies and Hooterville
 Junction
will no longer be so damned relevant
and women will not care if Dick finally got down
 with Jane
on Search for Tomorrow
 because black people will be in the streets
 looking for
 A Brighter Day.
 The revolution will not be televised.

 There will be no highlights on the Eleven
 O'Clock News
 and no pictures of hairy armed women
 liberationists
 and Jackie Onassis blowing her nose.
 The theme song will not be written by Jim
 Webb or Francis Scott Key
 nor sung by Glen Campbell, Tom Jones, Johnny
 Cash,
 Englebert Humperdink or Rare Earth.
 The revolution will not be televised.

 The revolution will not be right back after a
 message about a white tornado, white lightning
 or white people.
 You will not have to worry about a dove in your
 bedroom,
 the tiger in your tank or the giant in your toilet
 bowl.
 The revolution will not go better with coke.
 The revolution will not fight germs that may
 cause bad breath.
 The revolution *will* put you in the driver's seat.
 The revolution will not be televised
 will not be televised
 not be televised
 be televised
 The revolution will be no re-run, brothers.
 The revolution will be LIVE.

 Gil Scott-Heron, 1974

A PLAYWRIGHT AND HIS CENTURY

"My work is about how the past must inform your future," playwright August Wilson declared in 1988. The winner of two Pulitzer Prizes, a Tony award for Best Play, and five New York Drama Critics Circle Awards, he has not forgotten his own past growing up on the "Hill," a poor black neighborhood of Pittsburgh, Pennsylvania. As a writer, Wilson gives voice exclusively to the dreams, strengths, and fears of the black community.

Wilson dropped out of school in the ninth grade after a teacher falsely accused him of plagiarizing a term paper the teacher thought too well written for a black boy. Young Wilson took on menial jobs but at the same time pursued his own education in the public libraries. Just before his 20th birthday, in 1965, he bought a typewriter and began writing and publishing poetry. Three years later, during the Black Power movement, he started a theater company called Black Horizons. "I considered myself a cultural nationalist," Wilson has said, "trying to raise consciousness through theater."

In 1978, Wilson moved to St. Paul, Minnesota, where he began work on a cycle of 10 dramas about the African American experience—one play for each decade of the 20th century. The first, *Jitney*, is set in a Pittsburgh cab station during the 1970s. With his second piece, *Ma Rainey's Black Bottom*, Wilson made it to Broadway after the play's debut at the Yale Repertory Theater in New Haven, Connecticut.

By 1993 Wilson had completed six plays—including the five Broadway productions profiled here—and all are praised for their colloquial, poetic dialogue, reflecting the influence of the cadences and street sensibilities of poet Amiri Baraka. Wilson has also noted the profound effect of artist Romare Bearden on his writing process. "He's a collagist," the playwright once pointed out. "I piece it all together, and, hopefully, have it make sense, the way a collage would."

Perhaps Wilson's greatest influence, though, is the blues, which he has termed the wellspring of his art. Listening to singer Bessie Smith, he has said, he learned that "as Black Americans we all had a song that was in us."

Ma Rainey's Black Bottom
Named for a song about a shimmylike dance sung by the real-

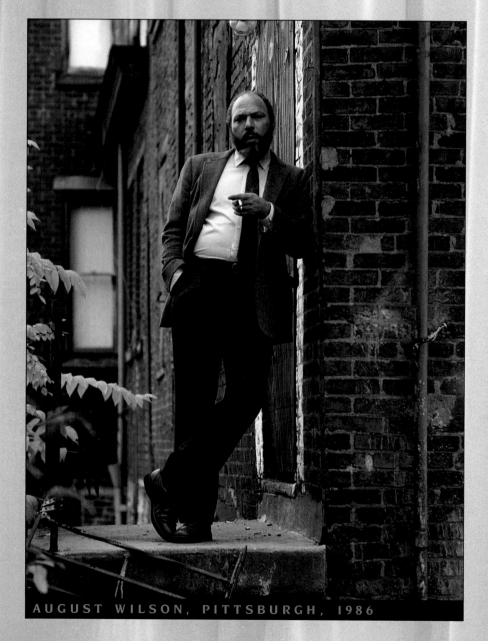

AUGUST WILSON, PITTSBURGH, 1986

life blues singer Gertrude "Ma" Rainey, *Ma Rainey's Black Bottom* marked Wilson's Broadway debut. A smash hit, it opened in 1984, ran more than 10 months, and won the New York Drama Critics Circle Award.

Ma Rainey is set in 1927 in a Chicago music studio, where the singer and her four musicians meet for a recording session. Wilson got the idea for the play after listening to Rainey's albums. "I decided to examine the meaning of the lives of the musicians to show where the music came from," he said of the fictional quartet, whose members have different histories, aspirations, and musical ideas. The drama also depicts Rainey's life as well as, in a broader sense, the economic exploitation of all African American performers of her era.

Even as they dislike following Rainey's orders, the musicians admire her for the outspokenness with which she makes demands on her manager and the owner of the recording studio, both white men. But despite her courage, Wilson suggests, Rai-

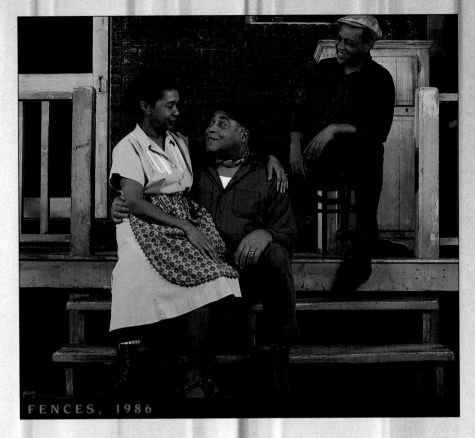

FENCES, 1986

ney's relationship with the bosses is much like the position of blacks in society at large—in the control of white hands. Ultimately, Wilson shows the terrible consequences of anger born of futility and frustration.

Fences
Set in the 1950s, before the civil rights movement brought greater opportunities for blacks, *Fences*

symbolizes the bitter confines of the African American experience.

The drama unfolds in a black neighborhood in a northern industrial city. Troy Maxson, now a sanitation worker, had been in his younger years an enormously talented baseball player. But because of his race, he was denied entrance to the major leagues.

When a college offers Troy's son Cory a football scholarship,

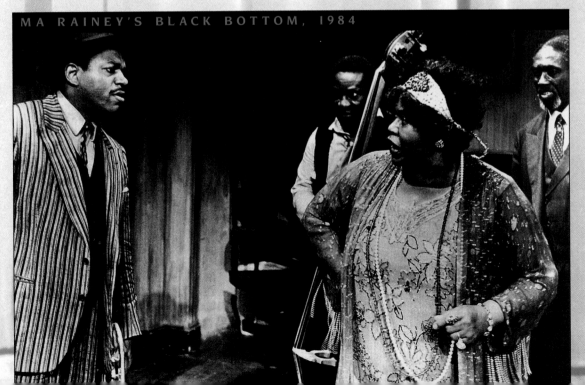

MA RAINEY'S BLACK BOTTOM, 1984

Troy refuses to let him accept. Wanting to spare his son the bitter disappointment he had known, Troy is also overwhelmed with jealousy—and he attempts to put up the same blockade for his son that society had built against him. The story reveals both the external and the internal restrictions that torture Troy and finally lead to the quiet collapse of the entire Maxson family.

The Broadway production of *Fences* garnered the theatrical Triple Crown: the 1987 Tony for Best Play, a Pulitzer, and the New York Drama Critics Circle Award.

Joe Turner's Come and Gone

The title of Wilson's fourth major work, *Joe Turner's Come and Gone*, draws upon a blues song that tells of a bounty hunter by that name who tricked black Americans into servitude after emancipation. "I knew from the song that Joe Turner would take off 40 men at a time and would keep them for seven years," said Wilson. "What happened to the women left behind? What about

those men? Joe Turner became a symbol to me of 400 years of slavery." The rest of the story came to Wilson after he saw a Bearden painting of a boardinghouse scene in which an abject man is surrounded by characters on the verge of departure.

Named the best play of the 1987-88 season by the New York Drama Critics Circle, *Joe Turner* is set in 1911 in a Pittsburgh boardinghouse. Freed after his years of Turner's forced labor, Herald Loomis now searches the country for his missing wife, convinced that he will be able to make peace with his past once he finds her. After they are reunited, however, he finds he is still haunted and trapped by the past.

Loomis is Wilson's symbol for America's black population, which the playwright envisions as being technically freed from slavery but still living in a state of emotional and spiritual bondage. The character Bynum Walker, a wise conjurer who offers advice to the boardinghouse tenants, speaks for August Wilson when

he declares that every person has a "song," a uniqueness that when recognized by oneself is the source of true liberation.

The Piano Lesson

Fifth in the cycle, *The Piano Lesson* earned Wilson his second Pulitzer. Set in 1936 Pittsburgh, the work examines a subject the playwright considers of utmost importance: the migration from south to north that began in earnest around 1915, when black Americans went in search of better social acceptance and economic opportunities.

Wilson believes that by abandoning the culture they knew and had been evolving for more than 200 years, black Americans paid a heavy price. "I think if we had stayed in the South, we would have been a stronger people," he contends. Further, because the connection was broken, "it's very difficult to understand who we are."

The drama pits Boy Willie Charles against his sister Berniece over the possible sale

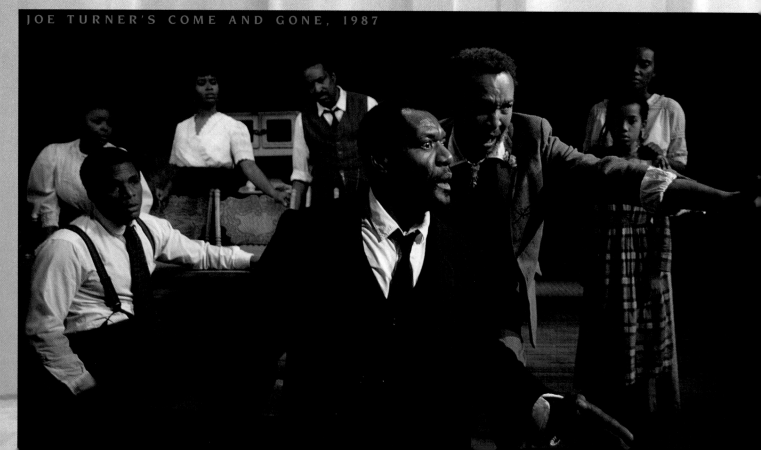

JOE TURNER'S COME AND GONE, 1987

of a piano that has been in the family since slaveholders traded away their relatives for it. Boy Willie plans to use his half of the proceeds to buy a piece of the Mississippi acreage their ancestors worked as slaves. For him, the land promises dignity and equality. Berniece, however, has no intention of selling the piano—or of playing it. For her it is a mute monument to her ancestors' suffering.

After experimenting with several different endings, Wilson settled on one that he felt offered both characters true liberation. "I wasn't so much concerned with who ended up with the piano," he said.

Two Trains Running
Wilson set *Two Trains Running* in 1969, a time of social conflict and activism; yet the mood of this play is comparatively calm. Rather than the excitement of a civil rights rally or a planned bombing, it offers a slice of life in a Pittsburgh luncheonette.

The drama spans a week in the lives of the various patrons and personnel at Memphis Lee's

Home Style Restaurant. Among the players are a young and eager ex-convict named Sterling; Risa, the only waitress, whose body shows the scars of self-inflicted wounds; Memphis himself, the owner, who moved to Pittsburgh after whites ran him off his farm in Mississippi; and Holloway, a counter-stool philosopher and the play's interpretive voice.

Instead of developing a linear plot or using explosive scenes as in several of his earlier plays, in *Two Trains* Wilson relies on the more delicate medium of words—monologue and dialogue—to put across his ideas. Prompting much of the conversation are the deaths of two prophets: black separatist leader Malcolm X, and a local black evangelist who had basked in material riches and the adoration of his many followers. The messages of these two men to African Americans are as different from each other as the separate legacies of Africa itself and the Old South.

Each of the characters has a story to tell, and through their stories—both tragic and funny—Wilson subtly covers a wide range of black political, social, and philosophical issues. Ironically, considering the decade portrayed, *Two Trains* is the most benevolent of Wilson's plays. "You got love and you got death," says one of the characters. "Death will find you . . . it's up to you to find love."

A NOBEL LAUREATE IN LITERATURE

Toni Morrison is that rare phenomenon in the literary world: an author who has achieved both popular success and great critical acclaim. In 1978, her novel *Song of Solomon* not only became a bestseller but also won a National Book Critics Circle Award and was a Book-of-the-Month Club main selection, the first offering by an African American since Richard Wright's *Native Son* in 1940. In 1988, the partly supernatural tale *Beloved*, her fifth novel, was awarded the Pulitzer Prize. And in 1993, a year after the publication of her novel *Jazz*, Morrison became the first black American to receive the most prestigious honor that can be given to any writer worldwide: the Nobel Prize for literature.

Born Chloe Anthony Wofford in 1931, she grew up during the Depression in the small steel-mill town of Lorain, Ohio. Her father, a shipyard welder who held down three jobs simultaneously, took such pride in his work that when he welded a perfect seam, he wrote his name in the side of the ship. Years later his daughter would comment on her own craft: "The seams must not show," and "the language must not sweat." No matter how hardworking they may be, the words must flow smoothly and effortlessly.

Even from an early age, Morrison seemed destined for success. When she entered the first grade, she was the only student in the class who could read, and by the time she graduated from high school—with honors—she had worked her way through many of the classics. "Those books were not written for a little black girl in Lorain, Ohio," she has observed, but she found them "so magnificently done" that she understood them anyway.

Although none of Morrison's books are autobiographical, she writes about the kind of environment she knew as a child, in which people "took the sense of community for granted." After the publication of *Beloved*, which follows an escaped slave woman to the home of a free black relative in Ohio, Morrison compared the world of her own youth to that of the characters in the book, noting that "those were the days of Black people who really loved the company of other Black people."

Morrison began calling herself Toni (derived from her middle name, Anthony) in college. She earned degrees from Howard and Cornell universities and began to write seriously when she returned to Howard in 1957 as an instructor. The following year she married an architect, Harold Morrison. By the mid-1960s, she was a divorced mother working as an editor for Random House and pursuing her own writing after hours.

At the time, Morrison has remarked, she took up her pen "under duress, and in a state of siege and with a lot of compulsion."

In 1970, Morrison published her first novel, *The Bluest Eye*, the stream-of-consciousness story of a black girl in Lorain who believes she would be beautiful if only she had blue eyes. The book introduced the public to its creator's poetic voice, psychological insight, and complex black perspective. "My stories come to me as clichés," she said of the genesis of her ideas. "A good cliché can never be overwritten; it's still mysterious. The concepts of beauty and ugliness are mysterious to me."

In each of her novels, Morrison confronts ugliness in all its dimensions: physical, moral, and spiritual. Beyond simply depicting violent events and disturbing emotions, she creates whole characters who embody the shadow side of humanity. Sula, in the book of the same name, published in 1973, is a self-centered, amoral presence, and a ghost daughter in *Beloved* is a virtual force of destruction. Yet out of tragedy the author distills "epiphany and triumph," as she calls it. Sula's death inspires good in those closest to her; even Sethe, who murders her child Beloved to save her from slavery and later endures a tortured haunting, comes to know self-forgiveness and self-love and to free herself from guilt.

The search for self is another thread running through Morrison's novels. Both *Song of Solomon* and the 1981 book *Tar Baby* chronicle the identity struggles of young 20th-century African Americans. *Beloved*, according to the author, is the first volume of a planned trilogy whose theme is "the search for the beloved—the part of the self that is you, and loves you, and is always there for you." The second, *Jazz*, set in 1920s Harlem, is populated with characters who, as Morrison put it in 1993, are "very busy reclaiming their bodies—bodies which have been owned by other people." The third volume will be set in the 1970s, when, she contends, Americans—black, white, women, men—were trying to reach out to one another.

Morrison gives the individual the last word over political forces and history. Individual imagination, she believes, is what "makes life human, and humane." Critics have lauded her novels for their universality, but she insists that universality is not her purpose when she turns her creative mind to the black world. Instead, she proclaims, her books are meant to celebrate those things that specifically make being black in America "the most dynamic existence possible."

CONTINUING THE ORAL TRADITION

"I was amazed the first time I saw them doing storytelling on a stage," remembers Diane Ferlatte, a modern-day African American griot living in Oakland, California. "I was used to seeing it done on a porch."

In fact, Ferlatte traces her own storytelling roots to her grandparents' porch. Born in New Orleans in 1945, she grew up listening to her relatives weave tales about themselves, her ancestors, and an assortment of characters from African American folklore. "If I had known then that I would become a storyteller," Ferlatte remarked in 1993, "I would have listened more carefully to those stories. I just took them for granted." Now she pulls out a pencil every time her father says, "I remember the time . . ."

A clerical worker for many years, Ferlatte's career transformation to professional bard began at home around 1980. While reading to her three-year-old son in an effort to woo him away from television, she would metamorphose into the characters in the storybooks. "I would add a witch voice," she recalled in an interview several years later, "and he would pause and listen. After a while, I knew I had him." Enjoying the performance as much as her son, Ferlatte began playing to audiences outside her home—and by 1992 she was enthralling audiences in places as far-flung as Austria, New Zealand,

A long, long time ago, the Creator, He was traveling, His face was shining so bright, no one could see His face. And as He was traveling, in his hands he carried a gourd. And inside the gourd there were many, many languages. And everywhere he went, he would give each group a very special language....

In this series of photos, Diane Ferlatte performs "The Changer," a story in which mythical Africans pull together to cope with extraordinary circumstances: a confusing surplus of languages and a sinking sky. Ferlatte adapted the tale from a story that originated among the Skagit Indian tribe of the Pacific Northwest.

When He came to Africa, he stopped. And He said, "Whoa! This is a beautiful place! The trees! The animals! The people! I need go no further! I'll stay right here!" And so he did. He went no further. But the gourd, it was still full of languages!...

and Australia with her stories.

Diane Ferlatte's favorite pieces are fables that take place in Africa—such as the one recorded below and on the following two pages—and African American folk tales with titles like "Little Eight John" and "The Knee-High Man."

"Little Eight John" tells of a boy who refuses to obey his mother and the dire consequences he suffers as a result. Because slaves were usually forced to leave their children unattended while they worked in the fields, they often told such parental-obedience stories to their young sons and daughters in an attempt to keep them out of harm's way.

"The Knee-High Man," about a short man who asks the large animals he meets for tips on growing big, encourages listeners to believe that they possess all they need in their own resourcefulness. The tiny man eventually meets an owl, who informs him that he doesn't need height to see as far as the horizon or to defend himself in a fight; his wits will see him through.

As she talks and sings her characters to life, Ferlatte is often accompanied by an African drum or a thumb piano—a musical instrument of Bantu origin, also called a *mbira*. Although she derives great pleasure from her acting and staging, she also regards her craft with a seriousness of purpose. More than entertainment, it is a way to pass on African American history, culture, and values, and Ferlatte hopes her stories give her listeners— particularly schoolchildren—the sense of identity and personal strength she derives from them herself. "I didn't see myself in

So the Creator began tossing them in every direction. "Well. It is done." And the Creator disappeared....

Oh, but now there were so many languages, the people couldn't understand one another. And the Creator, he left the sky too low. And the tall people began bumping into the sky. And some even climbed up into the Sky World....

books," she has said of her youth. "I think all of my teachers were white. And I wasn't told my own history." That history came only from her family.

As a modern-day griot, Ferlatte perpetuates a longstanding African American tradition. The first African captives to arrive in what would become the United States brought a rich grounding in storytelling that they passed on to their descendants. In slave communities throughout the South, storytelling became a means of expressing dreams and desires, articulating strategies for survival, and nurturing a uniquely African American world-view. Storytelling also provided an outlet for laughter—strong medicine for the cruelties of slavery.

Anonymous authors—and most likely multiple anonymous authors—composed the black folk tales of the 19th century. A good storyteller knew how to embellish an existing tale, adding new twists and turns as he or she progressed through the plot. Listeners might respond as if in conversation with the narrator, and in this way new stories were created with each telling.

The eclectic body of black folk tales includes creation myths, legends about Old Africa, how and why tales, moral fables, and ghost stories. But the most popular tales, both in Africa and among African Americans, are those that relate the exploits of cunning animal figures like the devilish Brer Rabbit.

Most of these "trickster" tales stress a theme critically important to blacks both before and after emancipation: the need to understand the ways of the powerful, even if only to manipulate those ways to one's advantage.

How can we fix the problem if we don't have a common language? What if we learned one word, just one word, *u-jima*, which means "collective work and responsibility"? Yes, we can all work together and prepare these long, long poles and point them toward the sky. Then, when I pull down my pole very slowly, you say "U!" When I push up, you say "Jima!"...

Come on, get your poles ready.
Uuuuuu...

JIMA!!...

Typically, such tricksters find themselves—often because of their own mischief—at the mercy of a more powerful adversary and must use their wits to outsmart their foe and escape. Time and again, as the story unfolds, brains prove more valuable than brawn in the game of survival.

Another version of the African American trickster tale features a slave, often named Jack. A common story line begins with Jack eavesdropping beneath his master's window, where he learns the white man's plans. Jack then anticipates the master's every need in order to win favor. Such deception promises reward but also courts danger. If caught in his deceit, Jack must rely on quick thinking and a silvery tongue. Typically the story ends with Jack escaping punishment and the master looking foolish.

Word spinners like Diane Ferlatte ensure that these folk tales will be passed on from one generation to the next. But the art of storytelling is also preserved in written literature. Black folk tales embody a cultural style that celebrates the spoken word, poeticizes folk language, and rewards the imagination. This style profoundly influenced African American literature written after the Civil War, and continues to be felt in the works of such modern writers as Toni Morrison (*pages* 174-175) and August Wilson (*pages* 170-173).

Like many of the finest African American writers, Ferlatte believes that the values passed on by her black community are the source of her strength. "My parents knew what they were doing—the front porch, the swing, the neighborhood store," she says. "Those were roots."

We have to push harder. Four times, that's the magic number. Four. Use a big, big voice!...

Yes! We did it! Because we used one heart, and one mind, to accomplish one goal. And that way we can do anything. With just one word. Ready?

U-JIMA!

THE VISUAL ARTS:
BOUNTY FROM GIFTED HANDS

Evolving from cartoonist to painter to collagist, Romare Bearden, here at work on Captivity and Resistance in 1975, echoed in the increasing complexity of his art the history of black American artistic achievement.

he scene was ordinary enough, on the face of it: The time was the late 1890s, and a little black girl was playing in the dirt outside her north Florida home. But this was no ordinary little girl. This six-year-old was already plunging deft hands into the area's red clay to shape ducks and then showing her playmates how to make them. Recalling those times much later, she wrote, "At the mud pie age, I began to make 'things' instead of mud pies."

The child grew up to be Augusta Savage, a gifted sculptor whose struggle to make progress as an artist typified the battle against racism that aspiring African American artists have had to wage since the days of slavery.

In high school, young Augusta Fells—her maiden name—showed so much talent that she was hired to teach clay modeling to her classmates. Though her years directly after high school were given over mainly to marriage and domestic life, she never stopped working the clay, and in 1919 she won a sculpture prize at the Palm Beach County Fair. The following year, at the age of 28, Savage moved to New York City with a heart full of hope, $4.60 in her pocket, and a letter of introduction that helped her get into the Cooper Union, a tuition-free art school. Life wasn't easy for her. During the four-year course, which she completed in three, Savage met her expenses with small scholarships and a series of menial jobs. She began her art career in earnest during this period, receiving several commissions and sculpting busts of W. E. B. Du Bois and Marcus Garvey that were well received and gave her considerable encouragement. She was going to need it.

In 1923, the French government announced the opening of a summer art school outside Paris that would admit 100 American women tuition free. A committee of eminent American artists and scholars would choose the candidates. Savage eagerly sent in the $35 application fee.

Her application was turned down flat. When she pressed for a reason, the committee dissembled at first but then came clean: White students from the South, the chairman said, might object to traveling and studying with a black woman. Trying to regain the high ground, he then asserted that Savage herself might find the experience "embarrassing."

Savage instantly saw through the sham expression of concern for her and decided to fight. She wrote a letter of protest, published in the *New York World*. A flood of letters and editorials supported her, to no avail. Savage was left behind, sore at heart, when the group sailed for France.

But talent is hard to suppress. She continued to sculpt while scratching out a living, and in 1929 she received a Julius Rosenwald Fund fellowship to study abroad. Her jubilant supporters threw parties to raise money for her expenses, and Augusta Savage finally made it to Paris.

The years in France were productive and successful. Savage studied sculpture, woodcarving, and portraiture at the Académie de la Grande Chaumière. She won citations for her works and was exhibited in top Paris salons. Returning to New York in 1932, she had an exhibit at the Anderson Art Galleries. But by then the Depression had the country in its grip, and it cast a pall over her prospects for making a living from selling her works. She decided instead to establish the Savage Studio of Arts and Crafts in Harlem in 1932, where she channeled her energies into teaching young black artists such as William Artis, Norman Lewis, and Ernest Crichlow.

Perhaps the most important role Savage played in nurturing black artistic progress was to demand fair treatment for African Americans in the Depression-era work programs the Roosevelt administration had created to keep people in the arts from starving. She became head of the Harlem Community Art Center, one of the largest government-funded art programs in the country. Subsequently she was appointed assistant supervisor of the Federal Arts Project for New York City and fought for the inclusion of black artists in its programs.

Savage's activism came at a high price. Although she lived to the age of 70—she died in 1962—her career as a sculptor lasted less than two decades, sacrificed as it was to the needs of the next generation of African American artists. But she did much to ensure that the great tradition of black American artistic achievement, begun by the skilled hands of slaves from Africa, would not be snuffed out in the desperate times in which she lived.

The artworks produced by those skilled African hands came in the form of crafts (*pages* 196-199). The first slaves brought not only the age-old artisanship they had acquired in their African villages but also the tradition of making objects beautiful as well as functional. Before long, talented slaves were also being apprenticed to white craftsmen and learning additional skills, to which they applied their African-inflected artistry. By the time of the Civil War, blacks made up most of the artisan labor force of the South.

Among the crafts African Americans picked up was one called limning. Limners originally were itinerant sign painters and house painters who, over time, also began to paint pictures—including portraits. Since colonial times, portraits had been universally popular among white Americans who could afford them, and the paintings were often done by artisans who worked in the limner tradition. Although artistic talent in blacks was held to be an aberration by many whites—who claimed that blacks lacked the intellectual capacity for high culture—portraiture by limners was considered not an art but a trade. As such, it was open to black artisans.

In the 18th century and much of the 19th, however, limning was as far as most African American painters were able to go.

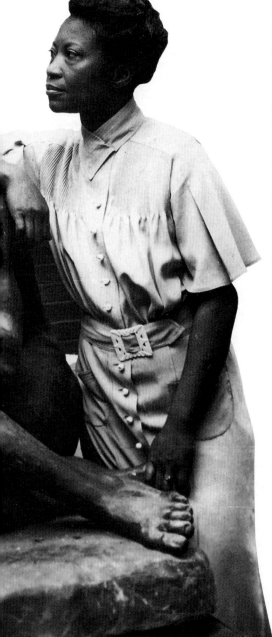

Sculptor and Harlem art instructor Augusta Savage, shown here in 1936, leans on one of the shoulders of her sculpture *Realization*, completed two years earlier. Harlem residents helped preserve the work by raising the money needed to cast it in bronze.

Those who aimed higher and aspired to study art were usually denied entry to academies or professional groups. The few who managed in spite of all obstacles to become artists keenly felt the need to win acceptance in the white art world, which meant that they had to follow prevailing European art trends. Yet some eventually began working on black subjects and themes, relying on sympathetic whites, generally abolitionists, to provide them with both instruction and patronage.

As early as the 1770s, slave and free black artists were being advertised in newspapers. One such artist, a slave named Scipio Moorhead, is believed to have painted a portrait of the celebrated ex-slave poet Phillis Wheatley that was later reproduced as a copperplate engraving. Wheatley apparently remembered him in a 1773 dedication of one of her poems: "To S.M., a Young African Painter, on Seeing His Works."

Another early black portraitist of note was Joshua Johnston. This limner was the first free black to gain professional recognition as a portrait painter. Yet little is known for certain about who he was, where he came from, and how he learned to paint. Johnston began his art career in Baltimore, where, in 1796, the city directory listed a Joshua Johnston as a portrait painter. Between that year and 1824, the leading families of Maryland sat for him. Johnston apparently attracted his elite clientele mostly by word of mouth, although in 1798 he placed an ad in the *Baltimore Intelligencer* in which he referred to himself as "a self-taught genius."

Although black subjects are largely absent from Johnston's work, he did make three paintings of blacks. No known image of the artist himself exists, but at least 120 of his portraits are in the hands of private collectors and museums today.

Nineteenth-century painter Julien Hudson is the first black portraitist whose own likeness survives. He painted the earliest known self-portrait by a black artist (*overleaf*), a work that is perhaps more revealing than the scant records documenting his life. From those, all one learns is that Hudson, who opened a studio in New Orleans in 1831, had studied in Paris, liked to paint miniatures, and gave drawing lessons. His portrait, done in the 1830s, shows a poised man with an aquiline nose and piercing eyes who clearly lived a comfortable life in tolerant New Orleans.

In the North, abolitionists were seen as natural allies by black artists. A Philadelphia freeman named Robert M. Douglass, Jr., used his art in support of abolition, producing portraits of leading figures in the movement. Stymied by racism at home, Douglass spent much of his life abroad. He died in 1887, at age 78. One of his cousins, David Bustill Bowser, was also an artist, although not full-time. He made a living by turning out emblems and banners for fire companies and fraternal organizations. In 1852, the *New York Herald* praised him for his paintings of ships. He also did two portraits of Abraham Lincoln, for one of which it is believed the president sat.

Another artist who made common cause with abolitionists was Patrick Reason, a New York City engraver and lithographer. Born in 1817, Reason attended the city's African Free School and, through abolitionist connections, was apprenticed to a white engraver, first achieving recognition at age 13 by designing the frontispiece of a history of the African Free School. Reason's connection with the antislavery movement grew stronger when he went into business as an engraver and began making portraits of leading abolitionists. He gained renown by engraving a copy of the em-

blem of the British antislavery movement, which was then widely used in the United States.

In 1839, a Frenchman named Louis J. M. Daguerre invented a practical photographic process; soon the images called daguerreotypes were all the rage in the United States. One of the American pioneers of the new medium was Jules Lion, a black man who was born in 1810 in France. Little is known of his early life, but at 21 he was the youngest artist to be exhibited in the annual show in Paris called the Salon des Artistes Français. In about 1836, he emigrated to New Orleans and opened an art studio, where he painted portraits of the city's leaders and produced lithographs of its architecture. Lion had a sharp eye for new opportunities, and within a year after the daguerreotype had been perfected the young artist was being praised in the *New Orleans Bee* for producing "the first specimens of drawings by the Daguerreotype we have seen. Nothing," the paper rhapsodized, "can be more truly beautiful." Unfortunately, financial setbacks in 1844 and 1845 forced Lion to sell his possessions. Today, only a few of his lithographs and a single portrait exist.

New Orleans painter Julien Hudson looks out with cool assurance in this 1839 work, the first known African American self-portrait. Largely known for his miniatures, Hudson also painted *Battle of New Orleans* in 1815, which focuses on the commander of a corps of free black militiamen who fought on the American side.

As more African Americans became photographers, they also received support and patronage from abolitionists, who were always eager to call attention to cultural or scientific achievement by blacks. One such photographer was Cincinnati-based James P. Ball, who in 1855 assembled a 600-yard-long panorama of photos and paintings grandly titled "Ball's Splendid Mammoth Pictorial Tour of the United States Comprising Views of the African Slave Trade; of Northern and Southern Cities; of Cotton and Sugar Plantations; of the Mississippi, Ohio, and Susquehanna Rivers, Niagara Falls, and Canada." Ball arranged for the panorama to tour around the country; it is believed to be the first photodocumentary on a social issue.

Another first was scored by Glenalvin Goodridge, the oldest of three brothers who made a lifetime's work of photography (*pages 202-205*). In 1856, Glenalvin Goodridge became the first African American to win a photographic competition.

But most black photographers in the latter half of the 19th century did not aspire to produce art with their cameras; they simply attempted to earn a living, following mainstream trends of shooting studio portraits and local scenes. Yet the everyday work of these photographers had a beauty and eloquence of its own, capturing and preserving precious glimpses of black life of the period.

According to the U.S. census of 1900, 247 African Americans—230 men and 17 women—were professional photographers. By that time, five centers of African American photographic excellence had emerged—New York City, Chicago, Houston, Washington, D.C., and

One winter day in 1932, Prentice Herman Polk, the best known of the Tuskegee School of photographers, became intrigued by the striking appearance of the anonymous woman below. The photo he took, titled *The Pipe Smoker*, is typical of Polk in its sensitive revelation of character etched in the woman's face.

Operatic soprano Lillian Evanti wears a stage costume in this striking portrait made around 1924 by Addison Scurlock of Washington, D.C. Though justly famous for his studio portraits, Scurlock also photographed many civic events and in the 1930s even produced weekly newsreels that were shown at black movie theaters in Washington.

Tuskegee, Alabama. The latter two were centered on two black universities, Howard and Tuskegee Institute.

At these institutions and elsewhere in the early years of the 20th century, African American students saw an expansion of opportunities to study photography in an academic setting. For example, Cornelius Marion Battey, an accomplished New York portraitist, opened Tuskegee Institute's Photography Division in 1916. Battey became a fixture at the school, establishing what has been called the Tuskegee School of photography, which emphasized the dignity and importance of work, a central element of the institute's philosophy.

Battey's greatest legacy turned out to be not his own photographs, or even the Photography Division, but the work of his first student, Prentice H. Polk, who graduated from Tuskegee in 1920 and returned to work there in 1927. The native Alabaman brought what critic Valencia Hollins Coar called a "transcendent esthetic vision" to his work. Another commentator praised the pictorial quality of Polk's portrait style, with its moody, atmospheric backgrounds.

Another master photographer of the time was Addison N. Scurlock of Washington, D.C. For more than 50 years, beginning in 1911, Scurlock, later joined by his sons George and Robert, ran one of the most successful black portrait studios in the country. Known for producing photos rich in detail and tone that showed subjects in dignified poses, the Scurlocks counted poet Paul Laurence Dunbar, diplomat Ralph Bunche, and Judge Robert H. Terrell among the scores of African American dignitaries who became their clients. Addison Scurlock also was named the official photographer of Howard University in the early 1920s, a post he held until his death in 1964.

While black photographers were quick off the mark in adopting the new medium and developing individual styles, African American painters took a different path. Black painters seeking to stretch beyond the limning style to a more developed, mature form of painting were drawn, whether by inclination or by instruction, toward the European academic tradition that dominated American artistic taste.

During the second quarter of the 19th century, landscape painting became an increasingly popular form of art in America, and by midcentury some African American artists were working in this style. One of the best of these was Robert Scott Duncanson (*pages* 200-201), who painted from the 1840s until shortly before his death in 1872. Another was Edward M. Bannister. Over a long career, the force and appeal of Bannister's personality and his obvious talent helped him sidestep some of the effects of racism and participate successfully in the white art world.

Born in New Brunswick, Canada, in 1828, Bannister credited his mother with "encouraging and fostering my childish propensities for drawing and coloring." At age 20, Bannister moved to Boston, where, after a series of menial jobs, he became a barber and married a hairdresser, Christiana Carteaux. He apparently continued to paint during this period, subsidized by his wife's business success. By the early 1850s he

was receiving commissions, and in 1855 he was accepted for evening drawing classes at the Lowell Institute. There he had the chance—unusual at that time for any American student and practically unheard of for a black—to learn the details of anatomy and to practice drawing the human form by working with live models.

Few of Bannister's Boston paintings remain, but he is known to have produced portraits, religious scenes, seascapes, and landscapes. In 1871 the Bannisters moved to Providence, Rhode Island, where he began three decades of richly gratifying professional activity and accomplishment. He became a familiar and welcome part of the city's cultural life, described by a contemporary as one whose conversation "was more than ordinarily intelligent, so that it was a privilege to be in his company."

In 1876 Bannister made history. He entered a landscape, *Under the Oaks*, in competition at the Philadelphia Centennial Exposition. The oil painting, which was described in a contemporary account as "quite a startling representation of a grove of old gnarled oaks, beneath which a shepherd watches a small flock of sheep," won a medal. No one involved with the award knew that Bannister was black.

They found out when he showed up in the room where the medals were being distributed. He was treated initially with the rude curtness African Americans often faced upon entering a setting that whites considered to be theirs alone. Later he recounted the incident: He had inquired of an official whether *Under the Oaks* had won. "The official replied, 'What's that to you?' In an instant," said Bannister, "my blood was up. The looks that passed between that official and the others were unmistakable in their meaning. To them I was not an artist; simply an inquisitive colored man. Controlling myself I said with deliberation, 'I am interested in the report that *Under the Oaks* has received a prize. I painted that picture.'"

"The explosion of a bomb," Bannister recalled, "could not have created more of a sensation in that room. Without hesitation the official apologized to me, and soon all

New England landscape artist Edward Mitchell Bannister (*inset*) conveyed his romantic perception of nature in works like *Oak Trees* (*top*). The painting, completed in 1876, was similar in title to another Bannister piece, a prizewinning landscape—now lost—that also incorporated oak trees.

were bowing and scraping." Bannister had become the first African American to win a national art award.

The prize was a huge boost to Bannister's reputation in Providence. In February 1880, he met with two white artists at his studio to consider ways to advance their mutual profession by providing the city's artists with instruction and help in exhibiting and selling their work. The result was the Providence Art Club; Bannister signed its charter and became an active member and regular exhibitor until his death in 1901.

Unfortunately, Bannister's rewarding career was an exception; for most 19th-century African American artists, the brief indignity Bannister had suffered in Philadelphia was more likely to be an everyday reality. But those unwilling to endure it had another option: They could go to Europe. The humiliations and dangers of life common in America were rare on the Continent, and African Americans could enjoy creative freedom with much greater access to patronage. The European alternative was especially attractive to black female artists, who—in that mid-Victorian time—encountered even more difficulties than their male colleagues. As a result, black women who wanted to study art and to work as artists were strongly drawn to Europe and particularly to Rome, where they found reverence for art and a society relatively free not only of racism but of Anglo-American social constraints on women.

One of the most remarkable expatriates was Edmonia Lewis, the first African American professional sculptor. Her exact birthdate is unknown and details of her childhood are few, but what is known about her is colorful. She was apparently born in 1843 of a black father and a Chippewa mother, both of whom died when she was still a toddler. Wildfire, as the Chippewa called her, lived with the tribe in New York State until she was 12. In the meantime, her brother, Sunrise, had had some success in the California gold rush, and he encouraged her to leave her Chippewa home and acquire an education. In 1859 she enrolled in the preparatory school at Ohio's Oberlin College, her tuition paid by Sunrise.

While there, Wildfire became Mary Edmonia Lewis—the source of the name is unknown—and began making drawings. Although Oberlin had accepted black students since 1835 and Lewis was one of about 30 then enrolled, the place was not without racism. During her stay, Lewis was once beaten by vigilantes after two white students said she tried to poison them. In 1863, she was accused of stealing art supplies, and although exonerated, she was barred from graduating.

The same year, Lewis moved to Boston to study sculpture. She met famed abolitionist William Lloyd Garrison, who introduced her in turn to sculptor Edmond Brackett. She studied briefly under Brackett but in 1864 opened her own studio, where she sculpted a number of busts of abolitionist leaders and Civil War heroes.

Lewis walked a tightrope in Boston's cultural world. She needed the support of the city's liberal whites, but she was constantly offended by their patronizing attitude toward her. She soon saved enough money—from the sales of reproductions of her busts and portrait

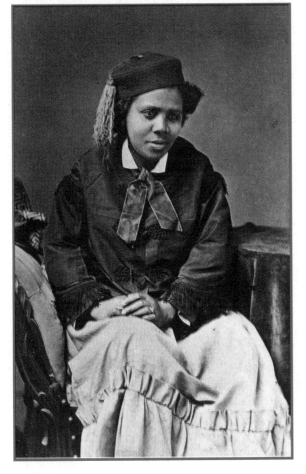

Dressed with characteristic flair, sculptor Edmonia Lewis had settled in Rome by the time this photo was taken in the 1870s. She financed her sojourn through sales of her busts and reliefs of celebrities such as Colonel Robert Shaw, the white commander of the all-black 54th Massachusetts Infantry who was killed in the Civil War.

medallions—to buy passage to Europe. After touring London, Paris, and Florence, she set up a studio in Rome in the winter of 1865-66.

In Rome, Lewis did things her own way. For example, it was common practice for foreign sculptors to hire local workers to enlarge their models or do the final carving. In addition, most artists expected to critique each other's work in progress. In both matters Lewis declined to go along, preferring to do all of her own sculpting and avoiding the company, and opinions, of her colleagues. She reasoned that if critics thought she had received assistance on her sculptures, they might say the work was not strictly of her making. Of all the ways Lewis defied convention, however, the most significant was her willingness to delve into African American and Native American subjects. While her formally trained black colleagues largely confined themselves to subjects that would appeal to white buyers, Lewis sometimes portrayed blacks and Indians in her sculpture.

Many of Lewis's works have disappeared, but those that survive, such as *Forever Free*, which depicts a black man and woman at the moment of emancipation, and a bust of Henry Wadsworth Longfellow, carved from life during a visit he made to Rome in 1869, demonstrate the sculptor's intensity and grace.

Lewis's last years, like much of her work, are untraceable. She is believed to have died in California in 1911, but the precise date and place are unknown.

There are no doubts about the birth, life, and death of African American artist extraordinaire Henry Ossawa Tanner. Born in Pittsburgh in 1859, Tanner was the son of a mother who had escaped from slavery and a free black father who was a college-educated minister. In 1868 the family moved to Philadelphia, and a few years later the 13-year-old youth found his calling when he encountered a landscape artist at work one day. Tanner watched the man, enthralled. "From this time forward," he wrote later, "I was all aglow with enthusiasm. . . . I was going to be an artist."

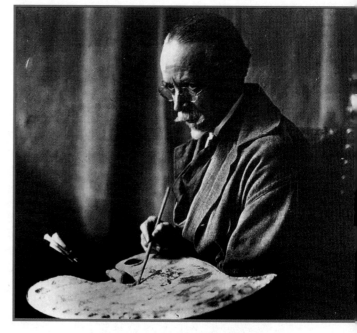

Henry Ossawa Tanner, shown at the easel in his adopted city of Paris in about 1935, was the son of an African Methodist Episcopal bishop. Tanner's middle name is from the town of Osawatomie, Kansas, home of John Brown, the radical abolitionist who in 1856 killed five local proslavery men.

In 1879, when he was 20 years old and had been sketching on his own for years, Tanner enrolled in the Pennsylvannia Academy of the Fine Arts as the sole African American among 230 students. His primary instructor was Thomas Eakins, who had studied at the Ecole des Beaux-Arts in Paris and emphasized drawing and painting from life. Eakins passed on wisdom to Tanner that the younger artist invoked over a lifetime. From Eakins, Tanner learned the importance, for example, of searching for a subject's inner life and of creating mood through use of shadow and light.

In 1881 Tanner began an eight-year struggle to establish himself as a painter. He sold a few works, but by 1889 he was so discouraged by his lack of success that he moved to Atlanta. Here, he opened a small photography studio, but it, too, soon failed. Later that year, his luck changed. With the help of a white benefactor—Bishop Joseph Crane Hartzell, a trustee of Clark College—he was hired to teach drawing at the school. Around the same time he received his first portrait commission. In December 1890, Hartzell and his wife persuaded Tanner to hold his first one-man show,

from whose proceeds, they thought, he could travel to Europe and further his training. When not one of the exhibited paintings sold, the Hartzells bought them all for about $300. In January 1891, Tanner embarked for Europe.

Soon after arriving in Paris, Tanner enrolled in the Académie Julien. His principal instructors were Benjamin Constant and Jean Paul Laurens, known for their large-scale biblical and historical paintings. Tanner loved Paris. He had found his home.

During the next few years, Tanner produced several black-genre paintings, such as *The Thankful Poor* and *The Banjo Lesson*, which were both cultural and artistic breakthroughs in the sensitivity and sympathy they reflected. And for the first time, he tasted critical success. In 1894, *The Banjo Lesson* was selected for exhibition at the Salon des Artistes Français. Over the next 20 years, Tanner's work appeared regularly at the Salon. At the 1896 Salon he exhibited a painting that represented an important departure from his previous work. *Daniel in the Lion's Den* signaled his decision to devote himself to biblical subjects. The painting was one of 85 pieces to earn an honorable mention from among the thousands of works exhibited at the Salon each year.

In 1897, Rodman Wanamaker, a scion of the Wanamaker department-store family, saw Tanner's second—and ultimately most famous—religious painting, *The Resurrection of Lazarus*. Wanamaker gave the artist a grant to make a six-week tour of Egypt and the Holy Land. Tanner was on his way back to France when he received the thrilling news that the French government wanted to buy the *The Resurrection of Lazarus* for its Luxembourg Museum. The Luxembourg held works by living artists that would be transferred to the Louvre after their deaths. Only a few Americans, such as John Singer Sargent and James A. McNeill Whistler, had ever been chosen for the honor.

Overnight, Tanner became an artist of world renown. He also became a beacon to black artists: Many made pilgrimages to his Paris studio, where he was generous with his time in receiving and instructing them. His works now met with praise in the United States as well. In 1909, he was elected an associate member of the American National Academy of Design, and in 1923 the French government made him a Chevalier of the Legion of Honor. In 1911, a French critic assessed Tanner's standing in the art world thus: "Many claim that he is the greatest artist that America has produced."

By the time of his death in 1937, Tanner's active career had been in abeyance for several years, but his works were hanging in major museums, and his place in the art pantheon was firmly established.

Tanner's life as an expatriate coincided with the Great Migration, when vast numbers of blacks left the South and moved to northern cities. This social revolution, which was in full force around 1920, laid the groundwork for a cultural revolution of equal magnitude. Called then the New Negro Movement, it was later commonly known as the Harlem Renaissance—although it occurred in many other places as well. By either name, it was an unprecedented upwelling of literature, music, and visual arts grounded in a newfound awareness among blacks of their African American heritage.

The visual artists of the Harlem Renaissance were a varied lot. Perhaps foremost among them was Aaron Douglas, who relocated to New York from Kansas in 1925, when he was 26. Douglas created a wealth of paintings, book and magazine illustra-

tions, murals, and portraits that conveyed the dignity and pride of black Americans. Another artist of the movement was Archibald Motley, Jr. Born in New Orleans in 1891, Motley moved north and studied painting after working as a laborer. His realistic paintings of ordinary African Americans were noted for their energy and activity. Muralist Hale Woodruff, sculptors Richmond Barthé and Selma Burke, and painter-art historian James Porter were important contemporaries of these two pioneers, although their most significant work came after the Harlem Renaissance.

Even as the New Negro Movement flowered, a number of white art schools and academies once shut to blacks began opening their doors. But more than mere access was needed; higher education was expensive. White philanthropic institutions offered help, especially the Harmon Foundation. Created in 1922 by a New York real-estate tycoon to promote self-help among worthy individuals of any race in any field, the foundation by 1926 was granting funds primarily to blacks for distinguished achievement in the arts. In 1928 the Harmon Foundation sponsored a juried exhibit of African American art in New York, the first of an annual series of shows that were elegantly presented and grew to be major events in the art world.

Despite these indications of enlightened tolerance and generosity, racism was a constant presence. In 1927, Lois Mailou Jones graduated with honors from the School of the Boston Museum of Fine Arts. She thought that after graduation she would like to teach and asked the school's director for an assistantship. Despite her superb record, he rejected her application, saying that she should go help "her own people." Wounded by the snub, Jones eventually decided—but for her own reasons—to do what he had said. In 1930, she joined Howard University's art faculty as professor of design and watercolor. She stayed there for 47 years, until her retirement in 1977, playing a major role in the lives of aspiring black art students while continuing to evolve as a highly acclaimed painter herself.

As the economic crisis that began with the stock market crash of 1929 worsened into the Great Depression of the 1930s, the federal government became a leading source of funds for struggling artists. In 1935 a New Deal agency called the Works Progress Administration (WPA) was created to relieve unemployment. The WPA soon established the Federal Arts Project (FAP) for people in the fine arts, literature, and theater. The program, which lasted till 1943, employed at its peak 5,000 artists, many of them black.

Among the notable FAP beneficiaries was a young African American painter named Jacob Lawrence (*pages 218-225*). Another whose career thrived under the largesse of both the Harmon Foundation and the FAP was Sargent Claude Johnson. One of the luminaries of the Harlem Renaissance, Johnson,

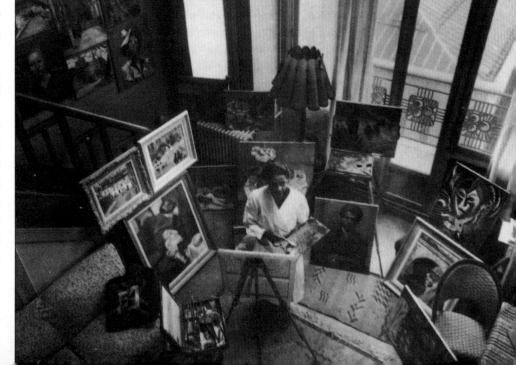

Howard University professor Lois Mailou Jones is shown surrounded by her own works in a Paris studio during a sabbatical year that began in 1937. Jones later recalled that in Paris she felt "shackle free" as an artist because race was much less of an issue there than in the United States.

Enitled simply *Copper Mask*, this 1933 work by Sargent Johnson reflects his interest in the traditions of the Baule people of western Africa. Johnson was among the earliest modern black American artists to make use of African imagery.

who was born in 1887, exhibited at the annual Harmon show every year from 1926 to 1935. An artist of great versatility, he was primarily a sculptor who worked in stone, terra cotta, black clay, copper, wood, and cast ceramics. But he also was a painter and enamelist.

Johnson was exposed to art at an early age while staying in Washington, D.C., with an aunt, May Howard Jackson, a respected sculptor who specialized in busts of African Americans. He studied both art and music for a time, but settled on an art career and in 1915 moved to the San Francisco area, where he continued to study and create. Johnson's busts and portraits of Bay-area subjects brought him recognition in local exhibits as early as 1925. The following year he began his string of entries in the Harmon Foundation's annual show, where he won awards in 1927, 1929, and 1933.

Though he looked Caucasian, Johnson elected to live as an African American and to celebrate his African heritage in his work, often making copper masks in the Nigerian tradition and portraits and mother-and-child scenes of black subjects. In his final two decades—he died in 1967—Johnson produced more than a hundred pieces, applying all the techniques he had studied during his long career.

The FAP also came to the rescue of photographers. The 1930 census had reported the existence of 4,735 black professional photographers, all but 85 of them men. The spurt in their numbers from the relative handful of the 1900 census was given great impetus by the New Negro Movement, during which black photographers documented African American life as never before. In Harlem alone, there were half a dozen or more photo studios, some of them run by talented camera artists like James VanDerZee (*pages* 212-217), whose career spanned six decades.

Since the development in the mid-1920s of small, high-speed cameras with improved optics and interchangeable lenses, photographers had been able to take to the streets to record city life as it happened. Twin brothers Morgan and Marvin Smith, prolific Harlem cameramen of the 1930s and 1940s, opened a photo agency that assembled picture essays of Harlem for national black publications like E*bony* and C*risis*.

One black camera artist chose his career after viewing dramatic photos of rural poverty taken by photographers working for another New Deal agency, the Farm Security Administration. Gordon Parks, born and reared in Kansas, bought his first camera in 1937 and was soon in Chicago studying photography and working with other artists at the city's South Side Community Art Center to record neighborhood life. After his photographs were exhibited at the center, he became a full-fledged professional, landing a job with the Farm Security Administration and going on to several other jobs before joining the staff of L*ife* magazine in 1948 as its first African American photographer. He stayed for nearly 23 years, covering a vast range of subjects.

In the late 1930s and 1940s, African American painters, like their photographer colleagues, continued to affirm their ethnic heritage, using a variety of styles. One of the most striking of these was social realism, which expressed protest against social injustice. Painter Jacob Lawrence and sculptor Elizabeth Catlett (*pages* 226-229) were two highly acclaimed black artists who had their roots in social realism. Art also began appearing from the hands of African Americans who, like the limners of the 18th

Stoic faces tell the story in *Unemployment, Philadelphia, April 2, 1959,* photographed by Gordon Parks. Often called the father of urban photojournalism, Parks has also directed films, written books, and composed musical scores.

William H. Johnson, looking every inch the artist in this 1930s photograph (*inset*), depicted a dying man awaiting 11 angels in *Swing Low, Sweet Chariot* (*bottom*), painted in about 1944. Johnson broke new ground in showing biblical figures as black.

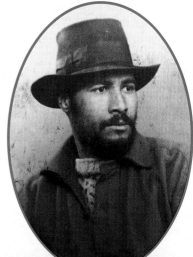

century, had no training. Their work, the product of their own instincts and personal vision, was often characterized as neo-primitive, though today such artists are more accurately and objectively referred to as intuitive or self-taught (*pages* 206-211).

Some African American artists, although schooled in the Western tradition, saw the intuitive mode of art as a way to capture more faithfully than academic styles could the spirit of ordinary black lives. William H. Johnson, for one, turned away from a life of delving into Impressionism, Cubism, Fauvism, and German Expressionism to embrace the intuitive style. Born in Florence, South Carolina, in 1901, Johnson developed an interest in art by copying newspaper cartoons as a child. At 17, he moved to New York City and worked at low-paying jobs for three years before saving enough to enroll in the School of the National Academy of Design. There he eventually came under the influence of white artist Charles Hawthorne and blossomed into one of the school's most promising students. In 1926, Johnson went to study art in Paris.

For the next three years, Johnson traveled and painted throughout Europe, steeping himself in impressionist and expressionist styles. In 1929 he returned to New York and submitted a number of his paintings to the Harmon Foundation, winning a gold medal and $400.

Returning to Europe in 1930, he married a Danish ceramist and textile artist 16 years his senior and resumed his traveling and painting. As the Depression deepened, however, he began to struggle financially. In 1938, the Swedish National Gallery in Stockholm did purchase his *Girl in a Red Dress*—but it was the only purchase by a major museum during Johnson's working life.

On the eve of World War II, Johnson and his wife returned to the United States, where he intensified his work in a style he had begun trying out in Scandinavia— a more simplified, flat, geometric, "primitive" technique

with a palette of only four or five colors. He began to use it to paint urban and rural black folk life. In May 1941 Johnson had his first major one-man show in New York, a critical success that should have jump-started a long and illustrious career. But the last 26 years of Johnson's life were tragic. In 1944, his wife died of cancer. Two years later, he returned, disconsolate, to Denmark, where his behavior became erratic, finally reaching the point that he had to be institutionalized, never to paint again.

During and after World War II, new opportunities for African American photographers were slow to emerge. Photographers like Gordon Parks remained the exception rather than the rule; African Americans seeking to break into big-time photojournalism as staff or freelance photographers knew that their best chances lay with black-owned magazines such as *Ebony*, *Jet*, *Our World*, and *Sepia*.

Moneta Sleet, Jr., who began shooting pictures for *Ebony* in 1955, became in 1969 the first African American to win a Pulitzer Prize for a photograph. Sleet, who gained fame as a recorder of the civil rights movement, received the honor for his shot of Coretta Scott King comforting her daughter at the funeral of Martin Luther King, Jr.

The work of another prizewinning black photographer, Roy DeCarava, showed not only a sensitive eye but also an artist's insight. Trained as a painter, DeCarava started taking pictures in 1946, at age 27. His work began to attract notice, and in 1952 he became the first African American to win a Guggenheim Fellowship in photography, enabling him to devote an entire year to a specific photographic subject. He chose Harlem as his project. Three years later, these photographs were combined with Langston Hughes's poetry to produce *Sweet Flypaper of Life*, which won a New York Times award as one of the 50 best books of the year. In 1958, DeCarava quit his job in the commercial art field to devote himself exclusively to photography.

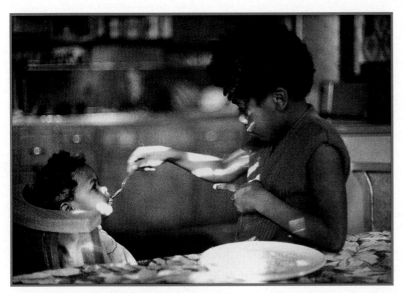

In a 1974 image by Roy DeCarava, eight-year-old Clarence McIntyre, Jr., of Brooklyn feeds his sister Tasha. DeCarava has said that his work is "intended to be accessible, to relate to people's lives."

While the emphasis in American photography in the postwar years was on photojournalism, the dominant force in the fine arts was abstract art, expressed in numerous styles that proliferated from the 1950s onward. The black painter who focused the attention of the African American art world on abstraction was Norman Lewis. In the mid-1940s, he began painting abstract expressionist works based on jazz. Lewis was followed by Sam Middleton, Richard Mayhew, and other African American artists working in the same style. By then, many black artists were using either abstract or representational styles to express a new ethnic vision, one shaped by the growing movement for independence among African and Caribbean countries and by the civil rights movement at home. Artists explored their African roots and reinterpreted them with intensity and raw energy.

The creation of informal black photographers' collectives in New York and Chicago epitomized this trend. The collectives provided their members with intellectual support and professional guidance and reinforced a commitment to developing a black aesthetic, or consciousness, in their work. For example, members of the

Kamoinge Workshop in New York City met regularly to critique each other's work and to debate the role of the black photographer. The Chicago School of photographers, a group with volunteer mentors but no designated meeting place, had more of an emphasis on documentary work than Kamoinge and focused on social concerns.

Just as black photographers were drawing inspiration from the community around them, black artists began using its colors for their palette and its walls to extend their canvas. In 1967 several painters, under the leadership of William Walker and Jeff Donaldson, took their art to the streets when they painted a mural on the side of an abandoned building in a black neighborhood of Chicago. Called the *Wall of Respect*, the work depicted African American cultural and political heroes, and inspired hundreds of other such works across America.

African American cultural and artistic influences connected strongly in Romare Bearden (1913-88), who became a presence in American art from the 1940s through the 1980s. As a boy, Bearden had nothing to do with art until he started cartooning in his senior year of high school. At New York University in the early 1930s he majored in mathematics but also was art editor and political cartoonist for the school's humor magazine and sold several cartoons. He decided to become a professional artist.

In 1936 Bearden enrolled in classes at the Art Students League, where he studied with German Expressionist George Grosz. Before he entered the army in 1942, he had taken a job as a social caseworker to make ends meet but had also held his first show, where he exhibited colorful Cubist-type images with stylized African heads painted on brown wrapping paper. Back from the army in 1945, Bearden got a break when the *New York Times* lauded his first major gallery show. Eighteen of his paintings were sold, one to the Museum of Modern Art. In 1950, he took a break from painting, working instead as a songwriter until he started painting again in 1954.

As the 1960s dawned, Bearden was working on photomontages and stood on the threshhold of the most significant period of his life as a painter. During a casual conversation in 1963, a fellow artist suggested to Bearden that he use photography to enlarge his works. From experiments with this technique, he moved to collage, a form he stayed with for the rest of his life. In 1964, he presented a selection of collages—enlarged monochromatic photomontages in which single images of heads and hands were arranged in skillful designs with distinct black themes, from Sunday churchgoers to children in Harlem—in a one-man show titled *Projections*. It was so successful that a year later the Corcoran Gallery of Art in Washington, D.C., organized a second show. By the late 1960s, Bearden, finally able to support himself as an artist, was making his collages from bits of fabric, colored paper, and paint.

In 1971, New York's Museum of Modern Art held a one-man show of 56 of Bearden's works, which then traveled to several other cities. Other honors came his way, including membership in the American Academy of Arts and Letters and the National Institute of Arts and Letters. In 1987, a year before his death, he received the President's National Medal of the Arts.

Today, black artists and photographers are exploring a variety of fields, and new opportunities have opened up for them. For example, abstract artist Sam Gilliam of Washington, D.C., has won renown for his folded, draped works vibrating with bright

Hanging on an exterior wall of the Philadelphia Museum of Art, *Seahorses (below)*, a 1975 work by Washington, D.C., artist Sam Gilliam, was one of the last of his much-imitated draped canvases. In a continuing quest for new avenues of artistic expression, Gilliam switched to collages influenced by jazz, then to paintings mostly in subtle shades of black, then to thickly textured acrylics.

Artist Faith Ringgold shows her granddaughter how to paint stories on quilts in 1989—a technique she perfected in the 1980s. Ringgold has also created and acted in performance art, including the descriptively named *Faith Ringgold's Over 100 Pound Weight Loss Story Quilt.*

colors and designs. Richard Hunt is another well-established African American artist who has gained national recognition. Hunt's medium is cast or welded metal, which he shapes into powerful abstract sculptures.

One art form that has continued to inspire many artists has been black music, especially jazz. Photographer Anthony Barboza says jazz is "fully integrated" into his work. Frank Smith creates abstract paintings that are interpretations of jazz themes in designs made up of scintillating colors and lines representing sound waves.

Betye Saar is a southern California artist who creates mixed-media assemblages and installations, which are groupings of objects in a defined space (*pages* 234-235). Clarissa Sligh, a New York City photographer, combines and re-creates old and new family photographs, using 19th-century film processes or silkscreening methods to develop them. Another New Yorker, Lorna Simpson, makes photographs in a postmodern, image-as-metaphor style. Using photographs with text, she reexamines race and gender issues, especially those affecting African American women.

The quintessential combiner of art forms, including painting, soft sculpture, quiltmaking, and performance art, is Faith Ringgold. Born in 1930, the Harlem native became a full-time artist at age 29. During the past several decades, she has explored various media. From early impressionist landscapes she moved into a more strident, politically motivated, abstract style in the 1960s, working mainly in tones of black. She then painted for a while on thin, unstretched canvas, before turning in the early 1970s to sewing soft-sculpture figures with faces resembling African masks. In 1982 she and her daughter, Michelle, acted together in Ringgold's *No Name Performance #1*, which, she said, "was a form of mourning for us since both my mother and my sister had recently died." At the same time, Ringgold began to stitch and paint on quilts to tell "little bitty short stories." Today, Faith Ringgold, an artist for more than three decades, is, as she puts it, "beginning to reap the benefits of just being there" that long. Among them are an award from the National Endowment for the Arts and a Guggenheim grant.

An unbreakable thread of African American creative impulse reaches from the days of the first slaves, with their African-born crafts, through the 19th-century sculptures of Edmonia Lewis, to the performance art of Faith Ringgold. Since 1619, Africans in America have crafted, drawn, sculpted, painted, and photographed in ways that reflect themselves and the world they lived in. Yet black artists have never lived for art alone. The taut canvas created by black life in America has required not only that they use their emotions, intellect, and vision to enrich and redefine African American existence but also that they put a triumphantly black imprint on art in America.

Using skills originally brought from Africa, slaves made baskets like this one, sewn in North Carolina around 1840, from cornhusks, reeds, and pine needles. As they had done in their villages back home, the first slaves taught their descendants to make objects as pleasing to the eye as they were useful.

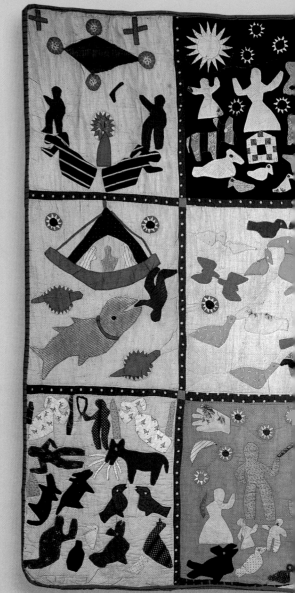

EARLY AFRICAN AMERICAN CRAFTS: A LEGACY OF SKILL

Because the earliest blacks to arrive in the Atlantic seaboard colonies had come from African cultures rich in artisanship, the first art to be produced by blacks in America took the form of fine handicrafts. For several decades or so after Africans first landed on North American shores in 1619, some worked side by side with white artisans, trading techniques with their European-trained colleagues and using time-tested skills in metal- and woodworking, textile making and dyeing, leatherwork, pottery, and basketry to produce objects of beauty and utility, some echoing African styles.

But as slavery became the norm for African arrivals after

about 1650, many skilled black artisans were barred from exercising the sort of enterprise inherent in craftwork, and much of this ancient heritage was lost. Most of the blacks who survived the ordeal of the Middle Passage were put to backbreaking labor in the fields, with little consideration for their talents. Capabilities that had been acquired through a lifetime of training and experience were allowed to atrophy.

Even so, skills essential to the slaves' everyday lives, such as basket weaving, sewing, and woodcarving, survived. And as the white population in the colonies grew in the 18th century, so did the need for skilled artisans. Slave owners came to realize that

a slave with a natural talent for some craft was worth far more as an artisan than as a field hand.

Thus began the practice of apprenticing slaves to white craftsmen, with the result that African Americans acquired proficiency in a wide range of crafts and became an important source of skilled labor in the South. In 1796, for example, a British traveler reported that all the iron forges in Maryland were operated by blacks.

Slaves from the African "Rice Coast" of Gambia and Senegal were highly valued by plantation

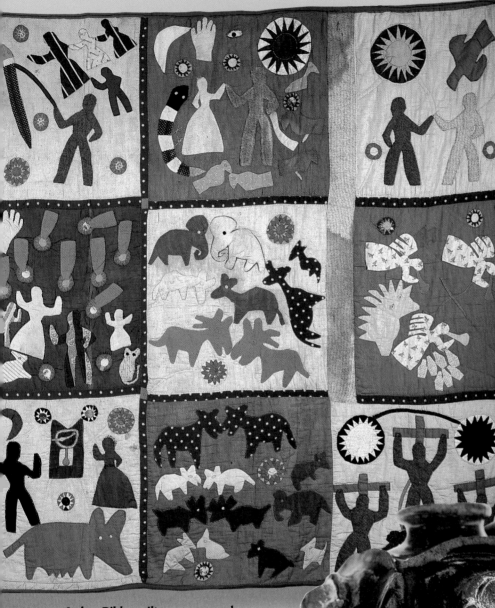

owners along the marshy coastal regions of South Carolina for their knowledge of rice cultivation. These slaves were also skilled in the crafts associated with rice growing, such as the carving of wooden mortars and pestles to hull the rice and the weaving of winnowing baskets of remarkable beauty and symmetry.

Slaves produced virtually all textiles on some plantations. They wove linen for their masters and homespun for themselves, and they stitched everything from elegant dresses and intricately patterned quilts for the whites to "crazy quilts"—patchwork quilts with no fixed design—for themselves. Harriet Powers, born into slavery in Georgia in 1837, was one of the very few of these talented seamstresses whose work has survived. She transformed pieces of cloth into colorful quilts with appliqué pictures illustrating Bible stories, local legends, and astronomical events.

Pottery was another slave craft that produced beautiful work—but not in the traditional African way. In Africa, where most pottery was made by coiling and pinching clay, women were the potters. In America, pottery was men's work because pots were shaped on a potter's wheel, and men had the strength to turn the heavy wheel.

Out of slave-manned pottery factories in South Carolina

In her Bible quilt, sewn around 1886, Harriet Powers portrayed such scenes as Jonah and the big fish (*second row, far left*) and "the falling of the stars" (*second row, third from left*), as well as what she termed "God's merciful hand" (*top row, fourth from left*).

Slave potters in Edgefield, South Carolina, produced arresting "face vessels" like the one at right, probably working on them during their few precious moments of free time. It stands only six and a half inches tall.

This unusual 19th-century table, with a human figure carved into each leg, is owned by the descendants of an overseer but is believed to have been made by a slave craftsman in Franklin County, North Carolina.

Attributed to master cabinetmaker Thomas Day, this newel post adorns a stairwell in Caswell County, North Carolina.

in the early to mid 19th century came a class of stoneware containers called face vessels, which were molded with boldly stylized human features. Historians are not sure what face vessels were used for. Ranging in height from one to 12 inches, they may have been associated with traditional African religious beliefs.

Clearly the product of highly skilled hands, these mugs com-bined European and African styles of decorating pottery. A similar kind of container, called a toby, was in widespread use in 18th-century England and was exported to western Africa, where it may have influenced the adornment of face vessels produced there. The hybrid form is believed to have then found its way to American shores.

Slaves also excelled in the art of cabinetmaking. Plantation slaves who had been apprenticed to white cabinetmakers returned to produce fine furniture for the master's house as well as rough but functional pieces for slave quarters.

Thomas Day, a free black man born around 1801 in Virginia, is thought to have acquired skills through an apprenticeship that enabled him to become a highly

Slave smiths created wrought-iron gates and fences like this one, designed by white blacksmith Christopher Werner and executed by his crew of five slave and three white craftsmen in Charleston, South Carolina.

Some slaves were provided with their own shops and were permitted to keep part of their earnings.

Many African American blacksmiths, slave and free, worked in forges turning out wrought-iron fences of marvelous intricacy, sometimes following the design of a white employer, sometimes executing their own conceptions.

So skilled and so prevalent throughout the South were these African American craftsmen that their white counterparts often objected vociferously to the competition. In Charleston, South Carolina, white craftsmen managed to get an ordinance passed as early as 1756 decreeing that an owner who allowed a slave artisan to work alone would be subject to a fine, and that at least one white artisan must be employed for every two slaves.

Despite competing with white artisans and occasionally affronting the sensibilities of white society by making too much of a success of business, African American artisans continued to be an economic necessity in the South, up to and even after the Civil War. In the totality of their efforts, they established beyond any question that within the collective consciousness of the African American community nested a treasure trove of aesthetic inspiration.

Though American-born, ex-slave Henry Gudgell used a distinctly African motif in carving this walking stick around 1867. He is thought to have seen such canes carved by slaves from Africa during his youth in Kentucky.

successful cabinetmaker. After moving to Milton, North Carolina, in about 1823, Day practiced his craft for almost 40 years, building up the largest furniture-making business in the state and employing 12 workers.

Day also became a large property owner and a valued member of the community. When he married Aquilla Wilson, a free black Virginian, citizens of Milton successfully petitioned the state to grant his bride an exemption from an 1827 law that prohibited free blacks from entering the state.

Woodworking and blacksmithing were the two crafts most commonly practiced by African Americans. Besides working on plantations, slave craftsmen in these occupations also worked in cities, where they were owned by and worked for white artisans.

MASTER OF THE LANDSCAPE GENRE

Robert Scott Duncanson, the first African American artist to receive national and international acclaim, started out as a house painter. Born in 1821 in Fayette, New York, he grew up in the town of Monroe on Lake Erie as part of an extended family of painters and interior decorators. In his late teens, he tried unsuccessfully to establish a partnership in the family trade. Then, in about 1840, he moved to Cincinnati, the economic and cultural center of the western United States, to seek wider opportunities.

Still earning his way as a house painter, Duncanson trained himself in the fine arts by copying paintings. His first original paintings included compositions like the one below and portraits of white Cincinnati abolitionists, and his work began to be reported in the antislavery press as another proof of black ability. Then, in 1848, Rev. Charles Avery, an abolitionist and mining-company owner, commissioned a painting of the first profitable copper mine in North America. The resulting landscape, *Cliff Mine, Lake Superior*, marked a turning point in Duncanson's career. Two years later the city's wealthiest resident, Nicholas Longworth, commissioned Duncanson to paint eight landscape murals for his mansion. Duncanson carried off the assignment with panache, combining his artistic skills with his experience in interior decorating.

Duncanson's work began to flourish. By 1850 he had taken a studio next to William Sonntag, an artist of what was called the Hudson River school. Painters in this movement viewed the wilderness as the symbol of America's promise, and they painted it in bold contrasts of light and dark and meticulous detail. Duncanson adopted the style enthusiastically. In 1853, with the financial assistance of Longworth, he joined Sonntag in studying landscape paintings and natural scenery in England, Italy, and France. The trip bolstered Duncanson's confi-

Called "the best landscape painter in the West" by one Cincinnati newspaper, Robert Scott Duncanson (*above*) poses for a portrait in 1864, midway through a two-year stay in Canada.

Duncanson had already begun to turn toward his real love, landscapes, when he produced this still life in 1849. A Detroit newspaper said his paintings of fruit elicited "universal admiration."

dence in his talent. "Of all the landscapes I saw in Europe, and I saw thousands," he wrote to a friend, "I do not feel discouraged."

Back in Cincinnati, Duncanson found work retouching and coloring portraits by James Presley Ball, a black Cincinnati daguerreotyper whose studio was the best known in the Ohio Valley. Duncanson continued to refine his landscape-painting style, and he exhibited paintings of ancient ruins, based on his travels, in Ball's gallery. Reports about Ball and Duncanson attracted a number of aspiring black artists and artisans to Cincinnati.

Soon after the beginning of the Civil War in 1861, Duncanson completed his most artistically ambitious work to date, a picture titled *Land of the Lotus Eaters*. In the painting, dark-skinned people serve the Greek hero Odysseus with the narcotic lotus plant, a scene that some have called a veiled comment on the decadence of the South's slave society. In 1863 Duncanson moved to Canada, where he contributed to the beginnings of Canadian landscape painting, and two years later he exhibited his works in Great Britain. When Duncanson returned to the United States in 1866, he began producing a new series of Scottish landscapes.

By 1870, however, Duncanson was obviously mentally ill. Newspapers reported that he believed he was possessed by the spirit of a woman master artist, and his moods swung from despair to euphoria. Some paintings from this period depict his most luminous, tranquil scenes. But he also painted his only seascapes during this time—works that featured violent seas below angry skies.

Finally, in the summer of 1872, Duncanson collapsed while hanging an exhibit of his own work in Detroit. He was committed to an asylum and died that December. Some have since speculated that his illness came from the lead-based paints he had used as an apprentice house painter.

Mourned at his death, he nevertheless was largely forgotten as the Hudson River school fell out of favor. Nearly 60 years later, in 1931, his murals in the Longworth mansion were rediscovered under layers of wallpaper and restored. Not until the revival of interest in the Hudson River school in the 1950s, however, was interest in Duncanson's work renewed.

1857's *Western Forest* (*left*) depicts the aftermath of a tornado by contrasting torn trees with a tranquil stream and sky. Considered one of Duncanson's best works, it drew international praise.

THE PIONEERING GOODRIDGE BROTHERS

In the late 1840s, a young black man named Glenalvin Goodridge established a photography studio in York, Pennsylvania, thereby launching a family enterprise that involved his younger brothers, Wallace and William, and that was to thrive for nearly 70 years. The Goodridge Brothers studio would be noted not only for its commercial success but also for the artistic quality of its photographs.

Perhaps more remarkable even than the longevity of the Goodridge brothers' career is the fact that the brothers were able to pursue such a specialized profession at all, considering the times in which they lived. Paving the way for this accomplishment was their father, William Goodridge, who had been born a slave in Baltimore in 1805 and apprenticed at age six to a minister from York, Pennsylvania.

In time the minister put young Goodridge to work in his tannery, and then, in 1821, granted the 16-year-old his freedom, along with a Bible and a suit of clothes. William struck out on his own, married, and in 1840 returned with his family to York. There he earned his fortune in a variety of business ventures, including a small railroad known as the Reliance Line. Goodridge's considerable success enabled him to construct Centre Hall, a five-story building that was the highest in York at that time. He also built a spacious townhouse for his family at a fashionable address, which soon became the social hub of the town's black community.

Their father's affluence enabled Glenalvin and his brothers to indulge their interest in photography, an art that had been introduced in Paris in 1839. Glenalvin, who appears to have inherited his father's flair for business, soon capitalized on his newly acquired camera skills. He opened a studio in the family office building around 1847 and was quick-

Photographers William and Wallace Goodridge pose for their New Year's greeting more than a century ago. The brothers were shrewd entrepreneurs who not only marketed their work across the state of Michigan but also reportedly drove two competitors out of business.

After a fire destroyed their first studio in 1872, the Goodridge brothers built this one according to their own design, complete with a huge ground floor gallery—the largest in the state.

ly turning a profit by recording individuals and families for posterity. In 1856 his artistic talents won him the prize for "best ambrotypes"—an early type of photographic image—at the York County Fair.

The Goodridges' pleasant life was a casualty of the Civil War, however, for William Goodridge was not merely a prominent businessman: He and his family were also key figures in the Underground Railroad. Both their home and Centre Hall concealed specially designed hiding places for runaway slaves. In addition, the Reliance Line was said to be an integral part of the escape route through Pennsylvania. When the Confederate army approached York in June of 1863, the family had to flee the city.

With Confederate agents at his heels, the elder Goodridge made his way to safety, joining his daughter Emily in the Minnesota Territory, where he died 10 years later. Meanwhile, his three sons and his daughter Mary settled in East Saginaw, Michigan.

The pine-studded valley was a booming lumber region—and a wide-open opportunity for enterprising photographers. Within a year of the brothers' arrival, the tenacious trio had reestablished the family studio. Glenalvin is believed to have died shortly there-

Viewed side by side through a stereoscope, these two Goodridge photos create a three-dimensional image of the fire-ravaged ruins of a popular vaudeville theater. The brothers took the photograph from the three-story Bancroft Hotel.

203

In the tradition of the Goodridge brothers, who often captured subjects in their own settings, Wallace Goodridge made this 1913 portrait of Edward and George Morley in the private office of their hardware business. The photographers also recorded groups of schoolchildren and such objects of civic pride as buildings and bridges.

after, in 1867, but Wallace and William carried on a thriving business founded on portrait and landscape photography and cartes de visites—two-and-a-half-by-four-inch photos of people and interesting sites. In addition, the brothers shrewdly developed several specialty sale items. Among these were wallet-size folding photographs that marked significant community events, such as the opening of a bridge.

The brothers' artistic bent was readily apparent in their work. Their original studio had a huge skylight—advertised as the "Largest and Best Sky-light in the State"—and the natural lighting turned routine photographs of local citizens and business bigwigs into character portraits.

The sensitive handling of light and shadow carried over into the brothers' outdoor photography as well. Over the years, they produced a remarkable photographic record of their region, often in the form of stereoscopic views, or stereos. These consisted of two nearly identical photos mounted side by side and viewed through a special optical instrument called a stereoscope, which made the scene appear three-dimensional. Stereo views were all the rage in the late 19th century, both in the United States and abroad. The brothers catered to this demand by producing several different series, which they advertised in local papers. The first, "Saginaw Valley Views," featured scenes from East Saginaw and Sagi-

naw City. "Michigan State Views" appealed to an even larger audience, focusing on picturesque landscapes and scenes of the rough-and-ready lumber industry.

Modern critics have remarked that the Goodridge brothers' stereoscopic views, along with some of their landscape work, reveal the photographers' skill and creativity. The images, one reviewer has noted, reflect the brothers' "acute sense of detail, their awareness of the impact of perspective, their sense of the unity of man and nature."

In their own day, the Goodridge brothers' aesthetic talents were well recognized. At Michigan State Fairs, where they competed against photographers from such comparatively sophisticated cities as Detroit and Ann Arbor, the Goodridges often took home awards. And in 1889, at the invitation of the U.S. Department of Forestry, the Goodridge Brothers studio exhibited several of their stereo views of Michigan lumber scenes at the Paris World Exposition. Such achievements earned them the reputation of being one of the finest studios in their part of the nation.

After the death of William in 1891, Wallace maintained the Saginaw studio until 1922, when he died at the age of 81. Today the Goodridges' work is valued for its historic and artistic qualities. Not only were the brothers among the first black professional photographers in America, but their work captured a way of life now past and a region forever changed.

RAIL ROAD.
CAMPS of GRAYWICK SMITH & FRYER
LUMBER CO. OTSEGO County. MICH.

DRIDGE BROS.

Strong lines and striking composition characterize this photograph of the Warner and Eastman Mill in East Saginaw, evidence that the Goodridge brothers took as much pride in their creative talents as in their business acumen.

Balancing on massive logs, lumbermen on the Tittabawassee River take time out for a photograph during the dangerous drive downriver to the mills. Between 1866 and 1892, the Goodridges recorded scenes like this at dozens of sites in the Saginaw Valley.

MARVELS OF THE UNTRAINED EYE

"It got so if I had something in my head I had to paint it," Clementine Hunter (*below*) told E*bony* magazine in 1969. Then, she said, "people would worry me so for paintin's that I'd sell them." By the time of her death in 1988, the Louisiana painter had created more than 4,000 works, some of which are now valued at as much as $75,000.

The work of untrained artists like Hunter used to be labeled "naive" or "primitive," or, more recently, "folk art." But the most accurate term for the men and women who craft such works, more of which appear on pages 207-211, is simply "self-taught." Without the aid of formal art training, these gifted people—often elderly and often from rural backgrounds—produce highly original works of art from the materials at hand, sometimes using methods they themselves invent.

As outsiders to the world of museums and galleries, self-taught artists may labor in obscurity for years—or forever. And even those who do make a name for themselves may not make the money that can go with artistic success. But for many the art itself remains the goal; as Hunter told E*bony*, she painted not for others, but for herself.

Clementine Hunter

When Clementine Hunter took up painting she was in her mid-fifties. She created images on any available surface, from canvas and cardboard to paper bags, skillets, and snuff bottles. Always, her paintings depicted Louisiana plantation life—something the artist knew intimately.

Born around 1887, Hunter spent most of her life at Melrose Plantation near Natchitoches. Melrose was both a working farm and a historical and artistic center, and in time Hunter moved from the fields to the kitchen, quilting and making dolls in her spare time. She first tried painting in about 1940, when, as she remembered later, she told the plantation curator, François Mignon, that she could make a picture "if she sot her mind to it." Mignon provided some discarded brushes and paints and a torn window shade, and Hunter made good her boast.

Encouraged and financially assisted by Mignon and others, Hunter painted for nearly four decades, exhibiting some of her works in a small "gallery" in her cabin (*right*). By the time she died in 1988, her paintings had also been shown at major museums throughout the United States.

In Hunter's *Wedding* (*near right*), painted on cardboard in about 1955, the bride's mother looms larger than either bride or groom—perhaps a comment on her importance in the family. At far right, smoke from a wood stove follows the shape of the cutting board on which it was painted.

Painted in 1979 on canvas board, an inexpensive material used by artists, *Plantation Harvest* (*below*) depicts Melrose Plantation, where Hunter lived.

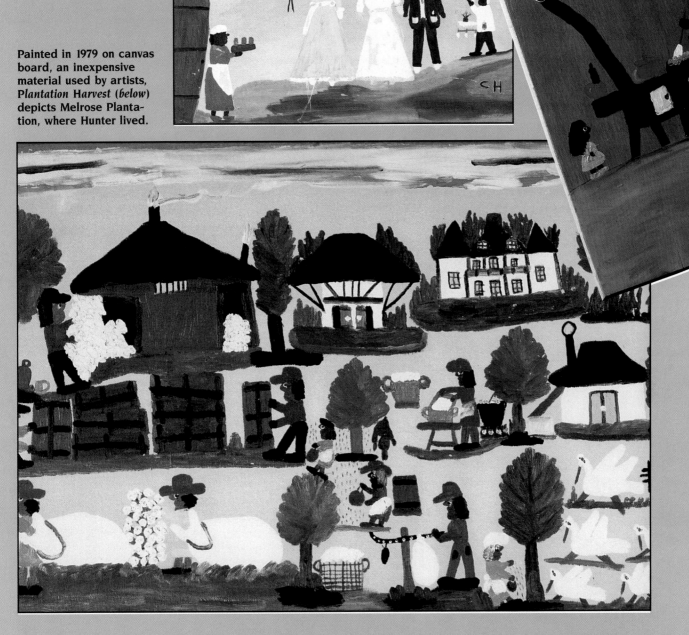

Bill Traylor

Born into slavery in 1854 on a plantation near Benton, Alabama, Bill Traylor remained there as a free man until after the deaths of his wife and the plantation owners. In 1938, at the age of 84, he moved to Montgomery, where he subsisted on charity and welfare relief. Illiterate and homeless, he slept in the back rooms of shops, and the city's busy Monroe Street was his living room.

One spring morning in 1939, a young white artist named Charles Shannon observed Traylor on Monroe Street—seated on a box and drawing. "He had a little straight-edge stick and was ruling lines with the stub of a pencil on a small piece of cardboard," Shannon later recalled. Shannon struck up an acquaintance with Traylor and bought some of his paintings, in effect becoming the elderly artist's first patron.

Over the next three years, still occupying his place on Monroe Street, Traylor created between 1,000 and 1,500 works, four of which are shown at right. In 1942 he moved north to live with some of his children. While there he lost a leg to gangrene and apparently lost interest in painting, too. Traylor returned to Alabama in 1946, where he died about a year later in a squalid nursing home. One of his last visitors was Charles Shannon.

Traylor's work has received international acclaim and now commands a good price; some of the paintings by the former Alabama slave have been purchased for more than $10,000.

Among Bill Traylor's favorite subjects were snakes like the one at left and dancing figures such as his *Blue Man Arching* (*below*). Like most of his work, both images shown here are painted on cardboard.

A strutting bird dominates Traylor's painting *Yellow Chicken*, which, like all his known work, was created between 1939 and 1942. Traylor's animals often combine simple geometric shapes.

Like many of Traylor's human figures, the *Man in Black and Blue with Cigar and Suitcase* (*below*) has a hat and is carrying something. These motifs stemmed from observation: Sitting near a hotel, a bus station, and a train station, the artist saw a lot of travelers.

Horace Pippin

Horace Pippin, one of the best-known self-taught American artists of any color, was also among the most atypical. Unlike other artists without formal training, who tend to specialize in a particular subject, Pippin painted portraits and still-life compositions, personal memories and biblical scenes, and more.

Pippin was born in 1888 in West Chester, Pennsylvania, and grew up in Goshen, New York, working at odd jobs as a laborer. When the United States entered World War I in 1917, he joined the all-black 369th Infantry Regiment and saw combat in France, keeping a diary and making sketches of his experiences. In 1918, a bullet crippled his right shoulder. Pippin returned to West Chester and in 1920 married a widow with a young son.

Some five years later, he turned to art as physical therapy, burning images into wood with a hot poker. The technique strengthened his arm and his spirits. He began adding paint to his burnt-wood panels and also began painting on canvas. "Pictures just come to my mind," he later said, "and I tell my heart to go ahead."

Unlike most self-taught artists, Pippin "discovered" himself. It was he, not a white sponsor, who first put his paintings on display in local shops, where in 1937 they were noticed by art critic and collector Christian Brinton and illustrator N. C. Wyeth. As leaders of the Chester County Art Association, they entered two of Pippin's works in the group's annual art exhibition. Pippin soon won acclaim for his arresting use of color and sense of design, and four of his works were included in a 1938 show at the Museum of Modern Art in New York. His paintings were bought by museums, collectors, socialites, and Hollywood stars.

But then tragedy struck: Pippin's wife became mentally ill. He committed her to an institution in March 1946, and four months later he died of a stroke at age 58. Horace Pippin left behind 137 works of art, which have been exhibited around the world.

Self-taught artist Horace Pippin, shown at left in about 1941, used his left hand to support his weakened right arm, injured at the shoulder during the First World War.

Pippin once described his 1943 oil painting *Domino Players* (*above*) as a "pleasant memory" of his own childhood—clay pipes and all.

Pippin carved tanks, guns, grenades, and bombs into the frame of his dramatic 1930 painting *The End of the War: Starting Home* (*left*).

Holy Mountain III (*below*) is one of three works by Pippin that show the influence of Edward Hicks's famous *Peaceable Kingdom* paintings.

The seated man in Horace Pippin's last work, the 1946 painting *Man on a Bench* (*right*), is thought by many to be a self-portrait.

James VanDerZee was still an amateur when he took this photo of his first wife, Kate, and their daughter, Rachel, in 1909, but it reveals the beginnings of his style—subjects carefully posed in an idyllic setting.

By the time he made this self-portrait in 1922, VanDerZee had become a successful photographer whose work attracted Harlem's humble and famous alike.

CREATIVE CHRONICLER OF HARLEM LIFE

A client once returned to James VanDerZee's Harlem photography studio with a complaint about her portrait. "Everybody says, 'Daisy, that's a good picture, but you don't look like that,' " she said. "Can't you make no picture that looks like me?"

"Sure," VanDerZee said. "Don't the proofs look like you?"

"Yes," the woman answered, "but they look so bad."

VanDerZee wanted his subjects to look good, even if that meant retouching to erase the evidence of poor health, bad teeth, or shabby clothes. Everyone who stepped into VanDerZee's studio was guaranteed a flattering photograph that conveyed grace, dignity, and strength of character.

James VanDerZee was born on June 29, 1886, in Lenox, Massachusetts. His parents encouraged their six children in artistic pursuits such as painting and drawing. But VanDerZee preferred photographs to fine art, and when he was around 13, he saw an advertisement that promised a camera kit to anyone who sold 20 packets of a sachet. He signed up, made the sales, and waited eagerly for his camera.

What arrived was nothing but a box with a broken bit of eyeglass for a lens. VanDerZee never managed to produce a picture from the thing, but the disappointment did not dampen his enthusiasm for photography.

As official photographer of the Universal Negro Improvement Association (UNIA), VanDerZee used a direct photojournalistic approach to document such activities as this 1924 UNIA parade.

VanDerZee "ghosted in" the image of this woman's husband or sweetheart and named the photo "Daydreams." "I wanted to make the camera take what I thought should be there," he said of his multiple-image photos.

At 19, VanDerZee moved to New York, where he met and married a woman named Kate Brown. He earned a living as a waiter and an elevator operator while taking photographs for a hobby. On a trip to visit Kate's family in Phoebus, Virginia, he took one of his most famous early photographs—the interior of a blacksmith's shop. Critics have praised the work for its sensitive play of light and shadow.

VanDerZee wanted to open a studio, but Kate objected. "You better get a job," she told him. "At least you'll know where your

Despite the Great Depression, affairs like this elaborate 1932 wedding uniting two prosperous Harlem families kept VanDerZee busy. The names of the families have been lost.

VanDerZee and Gaynella, his second wife, opened their 135th Street studio in 1917. Thirteen years later, as this interior shot reveals, the VanDerZees were enjoying a comfortable life.

money's coming from." So he took a darkroom job in the photography studio of a department store in Newark, New Jersey.

The photographer did hack work—"three pictures for 25 cents, finish while you wait." But once, when he took a few days off, VanDerZee operated the camera. He spent time with clients, observing them to discover their natural expressions. He also experimented with lighting and poses. When the boss returned, he found that customers now preferred to be photographed by his darkroom man.

Meanwhile, VanDerZee's marriage was coming apart, and as it headed for divorce, another woman, Gaynella Greenlee, entered his life. They married in 1918, a year after opening the Guarantee Photo Studio on West 135th Street. Their timing was propitious, for Harlem was about to enter the golden age later dubbed the Harlem Renaissance. This cultural boom of the 1920s and early 1930s inspired many African Americans with a new sense of self-respect. For his part, VanDerZee used every device at his command to make his

subjects look dignified and comely. His street photographs captured the nobility of everyday people in evocative Harlem scenes. For his studio work he posed his subjects amid classical columns, rich draperies, and beautifully painted backdrops.

Soon, all roads in Harlem led to VanDerZee's studio, as the nation's African American elite showed up at his door to be photographed: World War I heroes Henry Johnson and Needham Roberts, the first Americans to receive France's Croix de Guerre; dancer and movie star Bill "Bo-

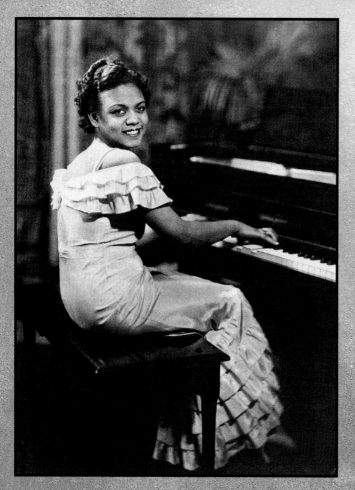

Singer-pianist Hazel Scott, future wife of Congressman Adam Clayton Powell, Jr., sat for this VanDerZee portrait in 1936, when she was 16 years old.

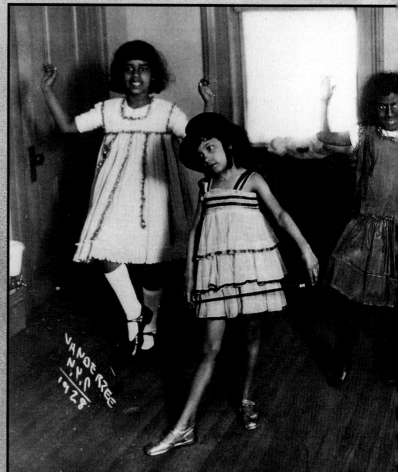

jangles" Robinson; poet Countee Cullen; boxing champ Joe Louis; religious leaders Adam Clayton Powell, Sr., and Father Divine.

One of the most important elements in VanDerZee's work was his affiliation with Marcus Garvey and the Universal Negro Improvement Association (UNIA). VanDerZee's determination to make his subjects look prosperous and happy dovetailed with Garvey's own efforts to cultivate what he termed a "success mentality" among African Americans. The photographs VanDerZee took of UNIA activities, recording powerful images of a vibrant African American community in Harlem, were seen by hundreds of thousands in the black press.

In the 1940s and 1950s, however, changing tastes in portraiture and the advent of simple, inexpensive cameras dealt a blow to professional photography. Now anyone could take pictures, and the demand for studio portraits declined sharply. VanDerZee was reduced to taking passport and identification-card photos. Eventually, he and Gaynella lost both home and studio.

Then, in 1969, New York's Met-ropolitan Museum of Art presented a multimedia exhibit entitled *Harlem on My Mind*, with VanDerZee's work making up the largest part of the show. Thus, decades after his genius had been recognized by African Americans, the mainstream art world "discovered" VanDerZee.

Gaynella's health was failing during this period, and VanDerZee devoted his own waning energies to caring for her until her death in 1976, when she was 84 and he was 90. He later met a young gallery director, Donna Mussenden, who began

This 1928 photograph of students of a Harlem dance school was one of thousands VanDerZee made of Harlem's flourishing social clubs, athletic teams, and cultural organizations.

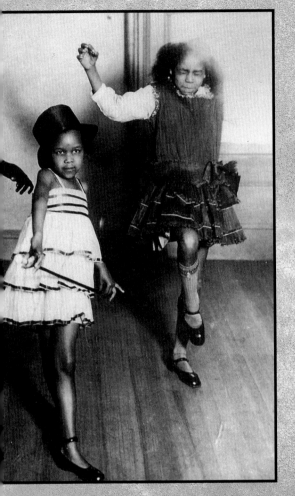

After his pictures were exhibited at a 1969 Metropolitan Museum of Art show, VanDerZee gained renown in the photography world and eventually returned to active work, beginning with this 1980 portrait of Bill Cosby.

concerning herself with his well-being. They married in 1978, after which she was instrumental in orchestrating his successful return to active photography.

Now recognized for his genius, VanDerZee received medals and honors and invitations to speak before distinguished audiences. But what must have pleased him most was seeing his career as a creative camera artist begin again—at age 93—as celebrities such as Bill Cosby, Lou Rawls, and Eubie Blake came to him for portraits. He died in his sleep on May 15, 1983, at the age of 96.

THE ENDURING VISION OF JACOB LAWRENCE

In November 1941, a leading New York art gallery opened an exhibit entitled *The Migration of the Negro*, a series of paintings by a 24-year-old African American artist, Jacob Lawrence. The paintings, featured earlier that month in *Fortune* magazine, depicted the mass movement of southern blacks to the North in a vivid style influenced by cubism. The show marked Lawrence, a sampling of whose work appears on pages 220-224, as a major American artist.

Although white art connoisseurs may have thought Lawrence was an overnight success, his paintings had been admired in Harlem for years. As he later put it, "I must attribute my motivation and my desire to be an artist to the people of the black community."

Lawrence came to Harlem when he was about 13. He had spent his early childhood in Pennsylvania, until his parents separated and economic hardship forced his mother to place him and his brother and sister in foster care. She moved to Harlem, where the children rejoined her about three years later. By then the literary and artistic Harlem Renaissance of the 1920s was winding down and the Great Depression had begun. But to young Jacob Lawrence, the new neighborhood still seemed wonderful. As he later recalled, "For the younger people coming along like myself, there was a real vitality in the community."

Lawrence's mother enrolled her children in an after-school program that emphasized arts and crafts. There Lawrence was taught by Charles Alston, a black painter who became his first mentor. Almost at once, the youngster showed an interest in vivid, contrasting colors and patterns. "Like other poor people in Harlem, we used a lot of color to decorate our houses," Lawrence later explained. "This was a part of my cultural experience, so it was reflected in my paintings." In 1932, with Lawrence in tow, Alston moved on to become director of the Harlem Art Workshop, based in a community library. Two years later, Alston set up a federally funded arts workshop in his own studio; Lawrence again followed along.

Times were hard, and Lawrence worked at odd jobs to help his family. But he continued to go to Alston's studio, where he got to know an extraordinary cross section of gifted African Americans, including poet Claude McKay, authors Richard Wright and Ralph Ellison, sculptor Augusta Savage, scholar and critic Alain Locke, and painter Romare Bearden. Lawrence also became friends with a painter named Gwendolyn Knight (*right*), whom he later married Outside the studio, he absorbed whatever information about painting he could find, studying books on the Mexican muralists, for example, and walking 60 blocks to the Metropolitan Museum of Art to examine everything from Egyptian wall paintings to early European works.

The effort began to pay off in 1937, when some Harlem street scenes Lawrence had painted were exhibited locally. Then, the following year, he had his first one-man show, at the Harlem YMCA. By that time, Lawrence was enrolled at the American Artists School on a scholarship. He wanted to paint Toussaint L'Ouverture, the 18th-century slave who had led the revolt that liberated Haiti from French rule, but he felt that one image could not do the man justice So he decided to create a series of paintings—a solution to which he would return again and again.

Lawrence was finding his artistic vision, but the family still needed his earnings, and it was getting harder for him to justify the long hours he spent painting and studying. He later said his artistic career would have ended in 1938 if Augusta Savage had not secured him an 18-month position with the government employment program of the Depression called the Federal Arts Project. Lawrence was paid to produce two paintings every six weeks. He also created two more series: 32 paintings on the life of Frederick Douglass and 31 on Harriet Tubman.

Next came the *Migration* series, which he began to research in 1939. The new topic reflected Lawrence's own knowledge of family and friends: His mother had moved north from Virginia, his father had come from South Carolina, and many people he knew in Harlem were also from the South. In 1940, he obtained a Rosenwald Fellowship, the first of three such grants enabling him to set up his own studio. There Gwendolyn Knight, a frequent visitor, helped him write the captions for the images in the *Migration* project.

In July 1941, with *The Migration of the Negro* complete Lawrence and Knight married and left for an extended painting honeymoon in New Orleans. They were still there when Alain Locke, who had seen the work persuaded a white gallery owner, Edith Halpert, to exhibit it—making the artist's reputation and starting a partnership between Halpert and Lawrence that would last into the 1950s. The newlyweds remained

continued on page 225

Another cause was lynching. It was found that where there had been a lynching, the people who were reluctant to leave at first left immediately after this.

Lawrence often used lengthy titles like this one to describe his works. The powerful composition below, one of 60 panels in the 1940-41 *Migration* series, evokes the outrage of lynching with very few elements: a noose, a tree bough, and a mourning woman.

This Is Harlem
Bustling with life and full of huge billboards representing neighborhood businesses, the first image (above) in Lawrence's 1942-43 Harlem series offers a rooftop perspective in a cubist style. Lawrence drew on his teenage memories of Harlem for the series, which ranks among his most personal works.

Going Home
The painting at right, part of the War series of 1946 and 1947, recalls Lawrence's wartime service aboard a troop transport. "We would go overseas carrying 5,000 troops and we would come back a hospital ship," he later said. "I'll always remember the physical and psychological damage."

Depression
Painted during the time Lawrence spent in a sanatorium in 1949 and 1950, this image from the *Hospital* series juxtaposes depressed patients with symbols of hope—a flower and a Jewish man reading a sacred text. A psychiatrist later commented that it was the healthy part of Lawrence's mind that created the paintings.

The Ordeal of Alice
In a surrealistic 1963 painting, a young black student trying to attend a whites-only school is surrounded by menacing figures suggestive of witches and goblins. Her white dress and stockings are pierced with arrows, a reference to Renaissance images of the martyr Saint Sebastian. The image reflected reality; at the height of school desegregation, black students often faced jeers, threats, and violence.

Canada Bound
In a scene from the 1967 book *Harriet and the Promised Land*, one of Lawrence's few works for children, Underground Railroad conductor Harriet Tubman leads fugitive slaves to freedom across a snowfield. The exaggerated perspective and the large hands and feet reflect an African influence from Lawrence's 1964 stay in Nigeria.

Builders, No.1
One of Lawrence's many *Builders* images, the 1972 painting above contrasts the large, simple shapes of a woman and a window with intricately detailed carpentry tools. Lawrence uses craftsmanship as a metaphor for working toward a goal, but he also likes carpentry itself and collects old tools.

Munich Olympic Games 1972
Three relay runners approach the finish line in a painting Lawrence created for a poster celebrating the 1972 Olympic Games. From the 1970s onward, Lawrence was frequently commissioned to do posters, murals, and other special pieces. He was, for example, one of five American artists asked to create a piece for President Jimmy Carter's inauguration.

Fellowship and began to capture his Coast Guard experiences in the 14-image War series.

Lawrence had weathered the storms of poverty and war, was happily married, and had an assured career. Yet by 1949 the pressure of fame became unbearable for him, and the artist committed himself to a psychiatric hospital. During the nine months he spent there, he painted his fellow patients in what has come to be known as his Hospital series.

Back home again, he experimented with fanciful images for the next few years, often calling on themes related to the theater. Then, in 1955, he composed another historical series, Struggle: From the History of the American People, a 30-panel work that covered the period from 1775 to 1817 in scenes that included black Americans as well as white.

During the civil rights movement in the 1960s, Lawrence created images of racial oppression in a surrealistic style suffused with anger, while at the same time producing countless illustrations for black periodicals. A trip to Nigeria, also in the 1960s, added a subtle African influence to his style.

In 1970, Lawrence became the first black artist to receive the NAACP's highest honor, the Spingarn Medal. The same year, he took a post as a visiting professor at the University of Washington in Seattle. Jacob and his wife Gwendolyn, New Yorkers to the bone, never imagined the arrangement could become permanent, but they liked the Pacific Northwest, and Lawrence accepted an appointment as full professor. By the early 1990s, the Lawrences were still happily settled in Seattle. The city's Kingdome Stadium brought Lawrence his first mural commission, in 1978, and he continued to create small historical series—including five paintings of the black explorer and pioneer of the Oregon Territory, George Washington Bush. His main focus during the decades in Seattle, however, has been a sequence of paintings on what he calls the builders theme, scenes of skilled workers and their tools that often show people of different races working together.

in New Orleans, where Lawrence painted a series on white abolitionist John Brown.

By the end of the year, the United States had entered World War II, and two years later Lawrence was drafted into the Coast Guard, then a branch of the navy. He was first stationed in Florida as a steward's mate, the standard assignment for black navy inductees in that segregated era. Against all expectations, his commanding officer, a Captain J. S. Rosenthal, encouraged him to keep painting—a piece of good fortune that stayed with him through his next assignment, to the USS Sea Cloud. The Sea Cloud was the first ship in the modern navy to be racially integrated in duties other than food service, and here Lawrence came under the command of a white captain who not only urged him to paint but also got him a public-relations berth that enabled him to obtain paints and materials. Several months later, Captain Rosenthal—now in command of his own ship—asked for Lawrence as a full-time combat artist, in which capacity he served out the war. The Museum of Modern Art sponsored an exhibit of some of Lawrence's Coast Guard paintings in 1944.

Lawrence was discharged in late 1945, and the following summer he served as an instructor at North Carolina's Black Mountain College—the first in a number of teaching positions he would hold. On his return to New York, Lawrence took up a Guggenheim

ART IN THE SERVICE OF HER PEOPLE

"I want to do large, public works," said sculptor and printer Elizabeth Catlett in 1976. "I want public art to have meaning for Black people, so that they will have some art they can identify with." That year—the nation's bicentennial—the 57-year-old artist presented the city of New Orleans with a monument to the contributions of African Americans: a massive, 10-foot bronze sculpture of jazzman Louis Armstrong (*right*). "I have always wanted my art to service Black people," she said, "to reflect us, to relate to us, to stimulate us, to make us aware of our potential."

Catlett was born in Washington, D.C., in 1919, shortly after the death of her father—a mathematician, musician, and teacher with an artistic sense that he apparently bequeathed to his daughter. Growing up, young Elizabeth demonstrated an interest in carving soap sculpture and drawing paper dolls for neighborhood girls, but she was in high school before she "first became aware of art as art," as she put it.

Following high school, Catlett attempted to enroll at the Carnegie Institute of Technology in Pittsburgh to study art, but she was turned down because of her race. Undaunted, she applied to Howard University, and in 1937, at the age of 18, she graduated cum laude with a bachelor's degree in art. Two years later she started graduate school at the University of Iowa. When one of her professors encouraged her to "paint what you know most about," she began to find her creative niche.

Recalls Catlett, "I knew most about Black people—that was when I began to focus seriously on Black subject matter."

Catlett became interested in sculpture while studying at Iowa, and in 1940 she became the first student in the university's history to earn a master's degree in the field. Her thesis project—a marble figure of a mother holding her child—went on to win first prize at the 1941 American Negro Exposition in Chicago.

As soon as she finished her de-

gree, Catlett moved to New Orleans to head the art department at Dillard University. Two years later, she relocated to Hampton, Virginia, and taught briefly at the Hampton Institute before moving on to New York City and joining its glittering art scene. When she arrived there, Catlett found herself in the company of other black artists, including Gwendolyn Knight and Jacob Lawrence (*pages 218-219*), as well as such Harlem Renaissance legends as the writer Langston Hughes and actor and

Mother and child is a recurring theme in Catlett's artwork. This marble sculpture served as her master's thesis project in 1940.

Catlett's dedication to honoring the beauty and dignity of black women is demonstrated in her 1968 cedar sculpture *Homage to My Young Black Sisters*.

singer Paul Robeson, who had lectured at Dillard on Catlett's invitation in 1942.

By this time, Catlett had become a dedicated political activist. She had demonstrated in front of the Supreme Court while still a student at Howard and, as a teacher in New Orleans, had fought against segregation and for human rights. In New York in 1944, during what she fondly remembers as "one of the greatest experiences of my life," she taught dressmaking and sculpture to maids, cooks, janitors, and other working people at the George Washington Carver School, an experimental community school in Harlem. "That's where I first realized that I had to work for people," she says. "Up until then I guess I didn't have any artist's philosophy about what I was doing and why."

In 1945 Catlett received a Julius Rosenwald fellowship and began working on *The Negro Woman*, a series of paintings and prints about the unique experiences of black

women in various roles, including farm workers, laborers, and artists. The following year, before she finished that project, the venturesome artist pulled up stakes once again, this time to study wood and pre-Columbian ceramic sculpture at the Taller de Gráfica Popular in Mexico. While at the Taller, Catlett met artist Francisco Mora, whom she married in 1947. They settled in Mexico City, had three children, and continued their association with the Taller.

For nearly 10 years Catlett worked exclusively in printmaking, then produced a series of wood carvings on the theme of mothers and children. In 1958 she became the first woman professor at the National University of Mexico, where she taught until her retirement from education in 1976.

In Mexico, Catlett was inspired by the way activists often used art for political purposes. "We were involved in the problems of the Mexican people," she remembers of her years at the Taller. "If students were on strike, or if trade unions had labor disputes, or if peasants had problems about their land, they would come into the workshop and ask for something to express their concerns."

At the same time, Catlett continued to use art to reach out to blacks in the United States. Creations representing such subjects as Malcolm X, activist Angela Davis, Underground Railroad "conductor" Harriet Tubman, and many other images of everyday black women, men, and children in a wide variety of situations convey her pride in—and concern for—African Americans.

Although Catlett became a Mexican citizen in 1962, she is still considered by many to be the greatest African American sculptor. Because she believes that art needs to be taken to the people

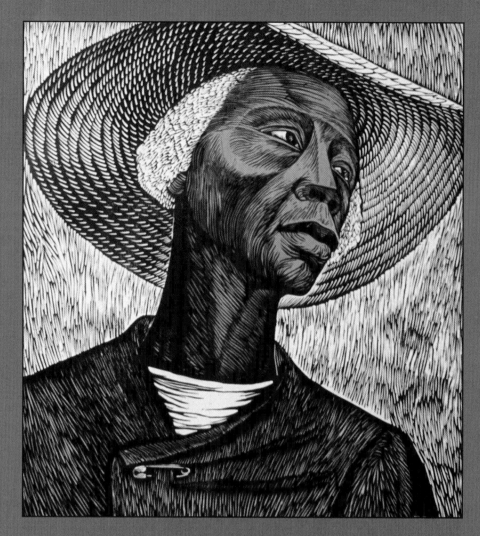

instead of locked away in museums, she has concentrated much of her effort—especially since the 1970s—on such works as the Louis Armstrong sculpture in New Orleans. Other artwork includes *Olmec Bather*, a nine-foot bronze statue that graces the cultural center of Mexico's National Polytechnic Institute, and a life-size bust of 18th-century black poet Phillis Wheatley, which she produced for Jackson State College in Mississippi.

"I learned that my sculpture and my prints had to be based on the needs of people," Elizabeth Catlett has said of her purpose. "These needs determine what I do. We have to create an art for liberation and for life."

The 1968 print *Sharecropper* exemplifies the type of work Catlett produced at the Taller de Gráfica Popular to represent the Mexican people.

Malcolm X Speaks for Us, created in 1969, vividly reflects the artist's interest in African American history and her determination to make it more accessible through art.

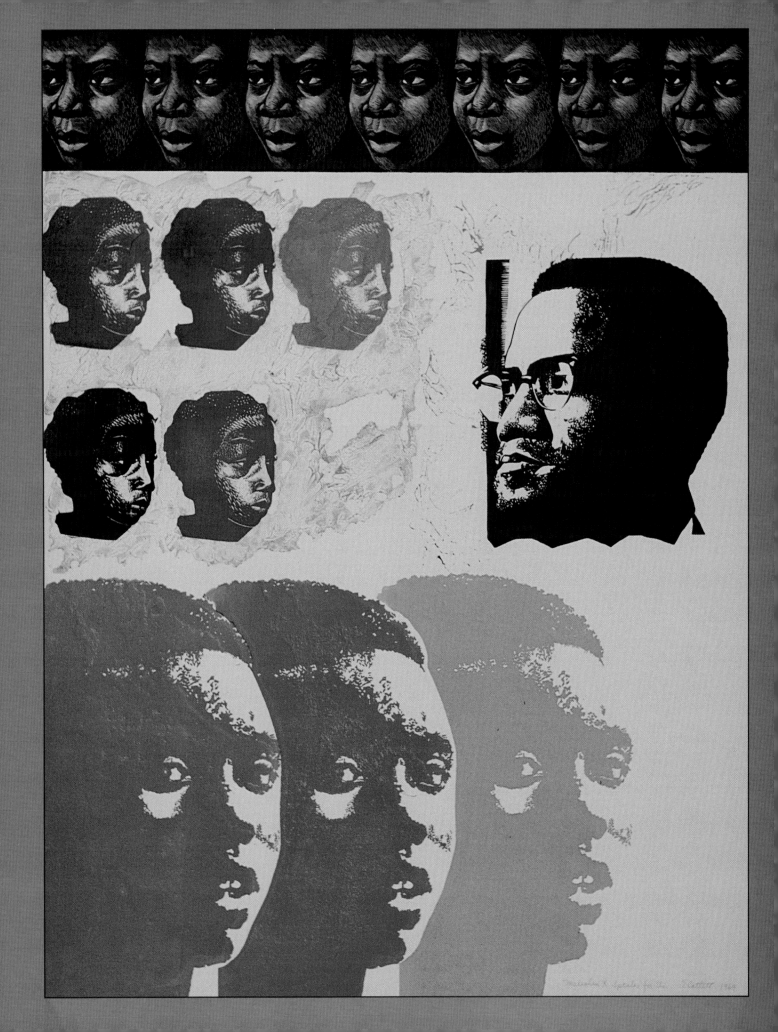

Robert Blackburn worked on his 1962 lithograph *Blue Windows* (*left*) for almost three months before it took this final form.

Making fine adjustments to a so-called American French Tool Press, Robert Blackburn operates the driving wheel of the press during a demonstration.

ROBERT BLACKBURN'S LABOR OF LOVE

For some 40 years artist, teacher, and printmaker extraordinaire Robert Blackburn has been a bridge between artists who render their original works on printmaking media and printers who reproduce those works. In 1948 Blackburn founded the Printmaking Workshop in Manhattan to provide a place where students, artists, and printers of all races could work together, share knowhow and experience, and revel in artistic freedom.

"I grew up in a situation where people helped me," says Blackburn. "When I got the opportunity, I wanted to help too." Born in New Jersey in 1920, Blackburn lived in Harlem from the age of six, when he was already drawing pictures nonstop. He received his first art training in junior high and at DeWitt Clinton High became the art director of what was then one of the nation's leading school magazines, the *Magpie*.

Blackburn developed his talent at neighborhood art centers funded by Roosevelt's New Deal.

At the Harlem Community Art Center on 125th Street, he fell in love with printmaking.

In this process, artists create images on stones (lithography), metal plates (engraving or etching), or woodblocks (relief), seeking the particular effect the chosen medium can produce. Then, the artist or a skilled printer runs the medium through a press to print the work on paper.

At the 125th Street Center Blackburn learned how to create art in the various media and how to operate the presses. His mentors were some of the leading lights of the Harlem Renaissance, Augusta Savage and Gwendolyn Bennett, and members of the 1930s white art scene—particularly Riva Helfond. He also gravitated to another artistic haven, the Uptown Community Workshop, and met artists Romare Bearden and Aaron Douglas.

In 1941 Blackburn won a scholarship to study at the New York Art Students League and then apprenticed in the studio of Will

Barnet—an artist who saw printmaking as high art. Blackburn studied with several other artists before opening the Printmaking Workshop in an 8,000-square-foot loft on West 17th Street.

The workshop offers a full schedule of printmaking classes. Blackburn no longer teaches regularly, but six instructors conduct six-to-eight-week evening courses. Many artists and painters attend, paying tuition, but needy students can barter services for instruction and printing time and space. Since 1948 some 1,500 students have taken classes there.

The workshop also operates a variety of programs that engage the community at large. Its Guest Artist Program invites six to eight exceptional artists to spend a semester at the facility, exchanging ideas and techniques with resident artists and printers.

The workshop's Fellowship Program chooses 10 minority fellows and gives them free print time and reduced prices on courses for nine months or more.

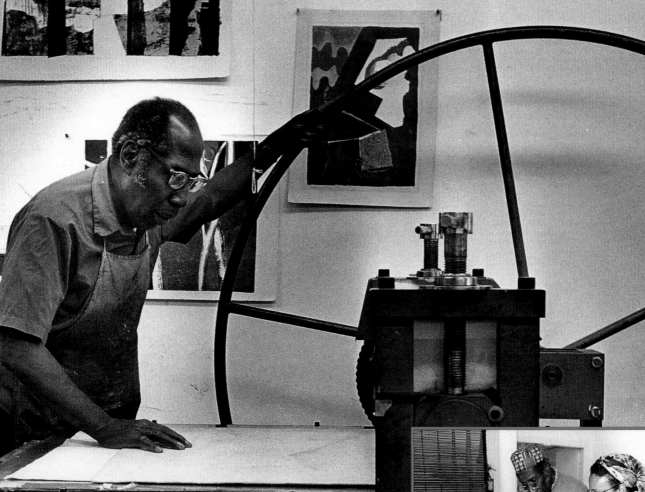

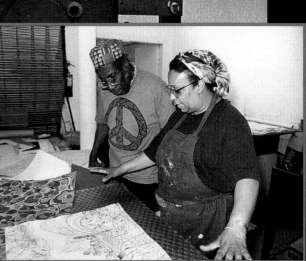

Blackburn also developed the Invited Minority Artist Program to offer six experienced, midcareer artists creative time at the workshop for a total of six weeks.

The workshop's Outreach Program takes teachers and presses into schools, senior homes, and community centers in the city's toughest areas to give children and elders alike what Blackburn calls "a sense of attachment, of being connected to art."

Within its first decade, the workshop almost shut down for lack of funds, and Blackburn taught university courses to keep it afloat. In 1956 it was reorganized into a cooperative of seven artists, each of whom paid a fee that collectively made up its operating budget.

In 1971 the workshop became a nonprofit corporation that could receive individual, corporate, and government grants. Funding from the National Endowment for the Arts, the New York State Council on the Arts, the New York Department of Cultural Affairs, and private foundations help the workshop thrive.

In 1992 Robert Blackburn received a MacArthur Foundation "genius grant" for his achievements as a master artist and founder of the workshop. The same year he received the New York City Mayor's Award for Art and Culture. He has also accept-

Blackburn examines a highly textured silk collagraph made by guest artist Margo Humphrey at the workshop in 1992. Humphrey now teaches printmaking at the University of Maryland.

ed the New York State Governor's Art Award and many honorary doctorates. Said Blackburn of his effort: "It was always a labor of love. We never made much money at it. Our job was to serve the artists, young and old."

A SHOWCASE FOR BLACK ARTISTS

Without dispute, the Studio Museum in Harlem is the world's premier museum dedicated to the works of black artists from America, the Caribbean, and Africa. Its collection includes examples of the artistry of such African American masters as Sam Gilliam, Romare Bearden, Jacob Lawrence, and Elizabeth Catlett. As its name suggests, however, the museum was once intended primarily as a studio—a workspace for black artists, with limited room for exhibition.

Founded in 1967 by Museum of Modern Art volunteers and black community leaders—including lawyer Eleanor Holmes Norton, who later became a congressional delegate for Washington, D.C.—the Studio Museum began in a loft above a luncheonette and a liquor store on upper Fifth Avenue. Almost at once, it established an artists-in-residence program—still in operation today—that offered studio room to emerging black artists.

Within a year, the museum expanded this somewhat narrow mission. Black poet and filmmaker Edward Spriggs, who became director in 1969, reached out aggressively to local residents, promoting the museum's exhibits and other activities to local black churches, schools, and civic groups. "Art in the black community should be inseparable from the reality of the black community," he later said.

The Studio Museum's first exhibit under Spriggs's direction displayed 100 works by modern Harlem artists. It went on to mount a number of ambitious shows, including one in 1970 that demonstrated the influence of African culture on white artists and musicians such as Picasso, Matisse, and Stravinsky. By the early 1970s, Studio Museum exhibits were touring black colleges and black-oriented galleries across the country. In 1974 the museum established its Cooperative School Program, which sends professional artists into Harlem's public schools, and during the 1970s it also began offering printmaking classes, lectures, dances, poetry readings, concerts, and film programs.

As the museum entered its second decade, Mary Schmidt Campbell, a black art historian with a doctorate from Syracuse University, became executive director. Under her leadership, the museum

To celebrate its 25th anniversary in 1993, the Studio Museum in Harlem showcased selected works of art from its permanent collection, many of which are shown above in the main exhibition hall.

Figures like this wooden and brass ritual object, used by the Kota people of Gabon to guard the bones of ancestors from evil forces, make up a powerful Studio Museum collection that includes African American and Caribbean as well as African art.

232

The Studio Museum's programs of concerts and other events include performances by such figures as South African singer, actress, and dancer Thuli Dumakude (*left, in red dress*), shown here performing with her dance troupe in 1990.

first assembled a permanent collection, acquiring African artifacts, paintings and sculptures by 20th-century black artists, and other works—most notably a vast archive of images by photographer James VanDerZee (*pages* 212-217).

When the gallery threatened to outgrow its loft, the New York Bank for Savings donated a five-story building on West 125th Street. Fitted out with two levels of galleries, artists' studios, and storage space, the museum reopened with a flourish in 1982, holding three simultaneous exhibits: one on VanDerZee, another on painter and graphic artist Charles White, and one on the theme of ritual and myth in African American art.

Five years later, in 1987, the museum became the first arts institution featuring the work of blacks and Latinos to be accredited by the American Association of Museums, a sign it had satisfied the association's standards as an organized and professionally staffed nonprofit institution. The year brought another triumph when the museum organized a three-year national tour for an exhibit of works from the Harlem Renaissance.

At this point, Campbell left to become New York City's Commissioner of Cultural Affairs. She was replaced by her deputy Kinshasha Conwill, who has continued to push for more acquisitions. Indeed, Conwill has dubbed the 1990s the Decade of Collecting.

In 1993 the museum celebrated its 25th anniversary by displaying a selection of its treasures in a triumphant exhibit. With an estimated 100,000 visitors a year, the gallery that started above a liquor store has clearly established itself as a permanent institution.

THE ART OF THE EVERYDAY

A number of black artists, some of whose works appear here and on the following pages, create large, sometimes sprawling pieces that may defy conventional notions of art. Assemblages, as such works are known, are collections of diverse objects in a wide range of sizes and materials—from shoes to household appliances, from wood to metal or rubber—that together become more meaningful than the objects taken separately.

As demonstrated here, assemblages come in all sizes. Large ones are often called installations because they are, in effect, whole environments rather than simply random objects being displayed in isolation.

Betye Saar

At a young age, Los Angeles-born Betye Saar watched the construction of the nearby Watts Towers— 100-foot-high concrete and steel-framed monuments of shattered glass, tile, and other urban junk. By the late 1960s, when Saar was in her forties and a divorced mother raising three daughters (all of whom are also artists), she was gaining a reputation for her own assemblages.

At first Saar's works were often ironic, like the gun-toting figure in *The Liberation of Aunt Jemima* (1972). Later pieces, she says, deal with "humankind's need for some kind of ritual," often involving the four elements: water, earth, air, and fire. The canoe in *Ritual Journey* (*far right*), for example, embodies this mystical theme. After teaching nearly 15 years at Los Angeles's Otis Art Institute, Saar resigned in the early 1990s to pursue her art full-time.

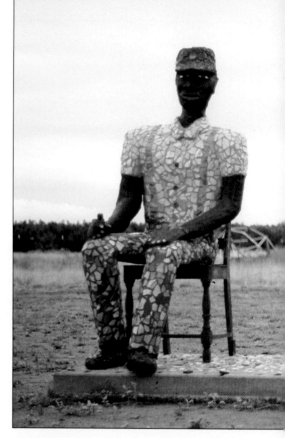

Alison Saar

In 1981, three months before exhibiting work required for her master's degree at the Otis Art Institute, Alison Saar scrapped the series of brightly colored paper objects she had been working on and began carving figures out of wood. "I decided to make a piece that I wanted to own," she said later. The carvings—in a style influenced by black folk art—were finished in time to meet the show deadline.

The decision marked the emergence of Saar's own vision. Rather than using the more symbolic style favored by her mother, Betye Saar—who incorporated her daughter's discarded pieces in her own work—Alison aims for a grittier quality through the use of urban debris.

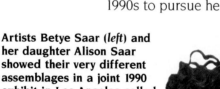

Artists Betye Saar (*left*) and her daughter Alison Saar showed their very different assemblages in a joint 1990 exhibit in Los Angeles called *Secrets, Dialogues, Revelations*.

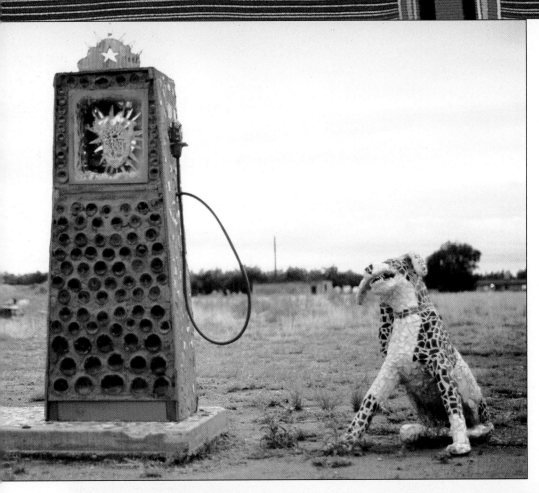

In Alison Saar's 1986 installation *Soul Service Station* (*left*), the figures of a man, a gas pump, and a dog are studded with bright shards and set outdoors near Roswell, New Mexico. According to the artist, the piece is "an invitation for weary travelers, or simply the routine commuter, to pause and think."

Branches and brambles fill the camouflage netting and suspended canoe that make up Betye Saar's 1992 *Ritual Journey*, an installation in a Connecticut museum. The Egyptian eyes on the sides of the canoe represent guardians for the spiritual journey.

Howard's Tap: *Investigation of Memory* consists of a shoeshine stand, tap shoes, and taps set into the wall and floor. Visitors walking up to the stand hear their comments played back on tape.

Mildred Howard

Born in Berkeley, California, in 1945, Mildred Howard started out as a dancer, beginning ballet classes when she was just five years old and later studying modern dance. But in 1966, her life changed forever when she fell through a glass door and suffered severe nerve damage in her legs. No longer able to pursue dance, she channeled her creativity into the visual arts, and eventually earned a master of fine arts degree in 1985.

For Howard, who had grown up on stories about black life back in Texas, where her parents and older brothers and sisters had lived, the new medium was a way to explore the African American past suggested by her family history. One of the artist's early works was a collage series entitled *Last Train from Dixie and* $1.25—a reference to the amount of money her parents had between them when the family arrived in California from Texas. Recollections of family members who tap-danced and shined shoes were also an inspiration for *Tap: Investigation of Memory* (*above*), which Howard created in 1989.

Remembrance is the theme as well in the 1990 work *Memory Garden*, a sunlit structure of 4,000 colored glass bottles that was inspired by the folk tradition of bottle-trees—twigs covered in glassware to ward off evil. The next year Howard fashioned a grimmer assemblage—78 copper hands on raised poles against a wall of bullets—a memorial to the Soweto schoolchildren in South Africa killed in 1976.

Such powerful works have earned Howard a number of awards and one-woman shows. In the end, however, she says, "it's the going beyond yourself that remains with you."

David Hammons

Despite having won a Guggenheim Fellowship and a MacArthur Foundation award, and despite an art-school education, New York artist David Hammons claims that his work is not really art at all. "I can't stand art actually," he says. "I've never ever liked art, ever."

Certainly, Hammons's work does not take conventional forms. Born in 1943 in Springfield, Illinois, he literally first made his mark by imprinting the image of his body on American flags and other surfaces, a comment on failed promises and violence toward black America.

Hammons continued to address racism with a series of "spade" assemblages, in which shovels became masks or were shown in chains or even turned up playing a saxophone. "I remembered being called a spade once and I didn't know what it meant," Hammons explained. "So I took the shape and started painting it."

Perhaps nothing so exemplifies his artistic perspective as his towering mockeries of basketball (*right*). "Basketball has become a problem in the black community," he says, "because kids aren't getting an education, they're pawns in someone else's game." In smaller pieces, he often finds beauty in urban refuse. "We've been depending on someone else's sight," Hammons has said. "We need to look again."

In an "anti-basketball" Harlem installation titled *Higher Goals*, David Hammons decorated 20- to 30-foot-tall telephone poles with bottle caps and topped them with basketball hoops. Of the installation's title, he says, "It means you should have higher goals in life than basketball."

ACKNOWLEDGMENTS

This project was made possible by the generous support of Time Warner.

The editors thank the following for their valuable assistance in the preparation of this volume: Dr. Russell L. Adams, Chairman, Department of Afro-American Studies, Howard University, Washington, D.C.; Don Anderson, Senior Adviser to the Chairman and CEO, Time Warner Inc., New York City; Amiri Baraka, Newark, New Jersey; Danny Baror, Bedford Hills, New York; Dr. Thomas Battle, Director, Janet Sims-Wood, Joellen El Bashir, Moorland-Spingarn Research Center, Washington, D.C.; Cyndi Bemel, Glendale, California; Dr. Tritobia Benjamin, Howard University Art Gallery, Washington, D.C.; Rodger Birt, Humanities Department, San Francisco State University, San Francisco, California; Robert Blackburn, Printmaking Shop, New York City; Carol Ann Bowers, Historical Charleston Foundation, Charleston, South Carolina; Reginald K. Brack, Jr., Chairman and CEO, Time Inc., New York City; Marie Brown, President, Kubari K. Jordan, Marie Brown Associates, New York City; Charles Burnett, Los Angeles, California; Ruth Carter, Beverly Hills, California; Françoise Chassagnac, Paris, France; Ayoka Chenzira, New York City; Barbara Chirinos, New York City; Ralph Clayton, Supervisor of Microfilm Division, Enoch Pratt Free Library, Baltimore, Maryland; Kinshasha Holman Conwill, Director, Pat Cruz, Deputy Director, Yalieth Simpson, Studio Museum in Harlem, New York City; Samuel Delany, Bedford Hills, New York; Ernest Dickerson, Brooklyn, New York; Trish Eden, Francine Seders Gallery Ltd., Seattle, Washington; Mari Evans, Indianapolis, Indiana; Toni Fay, Vice President, Community Relations, Time Warner Inc., New York City; Federation of Commercial Audiovisual Libraries, London, England; Diane Ferlatte, Oakland, California; Charles Fleischmann, Cincinnati, Ohio; Haile Gerima, Negod Gwad Productions, Washington, D.C.; Nikki Giovanni, Christianburg, Virginia; Lynn Goldberg, President, Pat Follert, Jennifer Swihart, Lynn Goldberg Communications, New York City; William Greaves, New York City; Ada Griffin, Third World Newsreel, New York City; Lucy Ann Hurston, Bloomfield, Connecticut; Juanita James, Senior Vice President, Book-of-the-Month Club, New York City; Brian V. Jones, Columbia, Maryland; Quincy Jones, Los Angeles, California; Dr. Joseph D. Ketner, Washington University, St. Louis, Missouri; Jacob Lawrence and Gwendolyn Knight, Seattle, Washington; Gerald Levin, Chairman and CEO, Time Warner Inc., New York City; Dolores Littles, Falls Church, Virginia; Don Logan, President and COO, Time Inc., New York City; Paul McLaughlin, Time Inc., New York City; Haki Madhubuti, Third World Press, Chicago, Illinois; Warren Mantooth, New York City; E. Ethelbert Miller, Afro-American Resource Center, Howard University, Washington, D.C.; Earl Mills, Palm Springs, California; Cynthia Mitchell, University of Illinois Press, Champaign, Illinois; Makneeka Moss, Washington, D.C.; Colleen Murphy, Director of Corporate Communications, Time Inc., New York City; Donna Mussenden-VanDerZee, New York City; Beverly Nelson, Special Projects Consultant, Chevy Chase, Maryland; Floyd Norman, Altadena, California; Donald L. Polk, East Bridgewater, Massachusetts; Rick Powell, Durham, North Carolina; Alfred Prettyman, Upper Nyack, New York; Suzanne Robertson, Santa Monica, California; Sonia Sanchez, Philadelphia, Pennsylvania; Schomburg Center for Research in Black Culture, New York City; Lynne Scott, Director of Public Relations, Uniworld Group, New York City; Gil Scott-Heron, Brooklyn, New York; Frank Stewart, Brooklyn, New York; Wynn Thomas, New York City; John Vlach, American Studies, George Washington University, Washington, D.C.; Evelyn Ward, Librarian, Cleveland Public Library, Cleveland, Ohio; Russell Williams, Los Angeles, California; Terrie Williams, President, Jim Murray, Jae Ja Simmons, Karen Taylor, The Terrie Williams Agency, New York City; Dr. Clint Wilson, Department of Print Journalism, School of Communications, Howard University, Washington, D.C.; James Woods, Baltimore, Maryland; Mark Wright, Research Assistant, National African-American Museum Project, Smithsonian Institution, Washington, D.C.; Sylvia Wright, Director of Library Media, University of Maryland, Baltimore County.

PICTURE CREDITS

The sources for the illustrations in this volume are listed below. Credits from left to right are separated by semicolons; from top to bottom they are separated by dashes.

Kente cloth borders, courtesy the British Museum, London. **Cover, 2, 3:** Princess Asie Ocansey and Dayo B. Babalola, ABC International, New York, photo by Fil Hunter. **8, 9:** Courtesy Dr. Henry Louis Gates, Jr.; courtesy Maya Angelou; Austin Hansen, New York; courtesy Johns Hopkins Hospital, Baltimore, Md.; courtesy United Negro College Fund, New York— © Scurlock Studio, Washington, D.C.; Robert L. Earles Photography, Oakland, Calif.; Toni Parks; © Steve Goodman 1993. **10:** Photofest, New York—AP/Wide World Photos, New York. **11:** © Brian Lanker 1989—Frank Stewart. **12-21:** Artwork by Ron Hemmings. **22, 23:** Photofest, New York. **24:** Library of Congress (LC# 84504). **25:** Tuskegee University Archives, Tuskegee, Ala. **26, 27:** Photofest/Kisch, New York—UCLA Special Collections Department, George P. Johnson Collection, Los Angeles, Calif. **28:** UPI/Bettmann Archive, New York. **29:** Photofest/Jagarts, New York. **30:** UPI/Bettmann Archive, New York. **31:** Photofest, New York. **32:** John Kisch Separate Cinema Collection/John Kisch, Hyde Park, N.Y. **33-36:** Culver Pictures, New York. **37:** Springer/Bettmann Film Archive, New York. **38:** Peter Sorel/Photofest, New York. **39:** © Sandra Johnson/Retna, New York. **40, 41:** Anthony Barboza. **42-45:** Background art by Time-Life Books; UCLA Special Collections Department, George P. Johnson Collection, Los Angeles, Calif. **46:** American Museum of the Moving Image, Astoria, N.Y. **47, 48:** Courtesy Harryette Barton. **49:** John Kisch/Mapp, Separate Cinema Collection, Hyde Park, N.Y.—courtesy Academy of Motion Picture Arts and Sciences, Beverly Hills, Calif. **50, 51:** Earl Mills except bottom right, from Jean Howard's Hollywood. **52:** Ronnie Finley, Midnight Matinee, Los Angeles, Calif.; UPI/Bettmann Archive, New York. **53:** Earl Mills. **54:**

Courtesy Time Inc. Picture Collection. **55:** Bettmann Archive, New York; Jim Wilson/*New York Times*. **56, 57:** Background, Gary Buss © 1988/FPG International, New York; courtesy Suzanne Robertson; © The Walt Disney Company (4). **58, 59:** Background, Gary Buss © 1988/FPG International, New York; Bobby Holland, Holland Productions, Los Angeles, Calif.; artwork by Ruth Cantor (3)—photo © Elena Seibert. **60, 61:** Background, Gary Buss © 1988/FPG International, New York; Adgar W. Cowans/Paramount Pictures, Los Angeles, Calif; artwork by Wynn Thomas—Phil Caruso. **62:** William Greaves Productions, Inc. **63:** Alfred Prettyman. **64:** Floyd Webb, Chicago, Ill. **65:** © Sharon Farmer. **66:** Myphenduh Productions/WDR, Washington, D.C. **67:** Barbara Chininos. **68:** Photofest, New York. **69:** © 1992 Kino International Corporation, New York. **70, 71:** AP/Wide World Photos, New York. **72, 73:** ASCAP, New York—Library of Congress (LC#31419). **74, 75:** Archive Photos/Frank Driggs Collection, New York. **75:** Michael Ochs Archives, Venice, Calif. **76, 77:** Frank Driggs Collection, New York—© Leonard, New Orleans, La. (2). **78, 79:** Culver Pictures, Inc., New York—© Leonard, New Orleans, La. (3). **80:** BMI Photo Archives/Michael Ochs Archives, Venice, Calif. **81:** © Leonard, New Orleans, La. **82, 83:** Michael Ochs Archives, Venice, Calif., except bottom right, © 1993 Ray Flerlage/Michael Ochs Archives, Venice, Calif. **84:** Michael Ochs Archives, Venice, Calif. **85:** David Magnus/REX Features, New York. **86, 87:** Cathrine Wessel. **88, 89:** Harvard Theater Collection, Cambridge, Mass. **90, 91:** Frank Driggs Collection, New York (3), except center, Bettmann Archive, New York. **92, 93:** Frank Driggs Collection, New York. **94, 95:** Frank Driggs Collection, New York (3), except bottom right, UPI/Bettmann, New York. **96:** Courtesy Thomas Morgan—Frank Driggs Collection, New York. **97:** Bettmann Archive, New York; Thomas Morgan. **98, 99:** Culver Pictures, Inc., New York—UPI/Bettmann, New York; Frank Driggs Collection, New York; UPI/Bettmann, New York; © 1993 Craig Harris. **100, 101:** © William P. Gottlieb. **102, 103:** Background, © William P. Gottlieb; Frank Driggs Collection, New York (2). **104, 105:** Frank Driggs Collection, New York. **106:** Bettmann Archive, New York. **107:** Frank Driggs Collection, New

York; Michael Ochs Archives, Venice, Calif. **108, 109:** Michael Ochs Archives, Venice, Calif. (5), except bottom center, Frank Driggs Collection, New York. **110, 111:** Michael Ochs Archives, Venice, Calif. (7), except bottom center left, © 1984 Frank Driggs/Michael Ochs Archives, Venice, Calif. **112, 113:** Bill Claxton/Visages, New York. **114, 115:** BMI Photo Archives/Michael Ochs Archives, Venice, Calif., except center, © 1993 Don Paulsen/Michael Ochs Archives, Venice, Calif. **116:** Michael Ochs Archives, Venice, Calif. **117:** Michael Ochs Archives, Venice, Calif.; © Jay Blakesberg/Retna, New York—© Neil Zlozower/Michael Ochs Archives, Venice, Calif. **118:** Michael Ochs Archives, Venice, Calif. **119:** © Patsy Lynch/LGI, New York. **120, 121:** Background, Uniphoto, Inc., Washington, D.C.; Alan Berlinger; © Todd Gray—Scott Weiner/Retna Ltd., New York. **122, 123:** Background, Uniphoto, Inc., Washington, D.C.; Dick Halstead/TIME—LOR Records, Virginia Beach, Va.; courtesy Hervey & Company, Los Angeles, Calif. **124, 125:** © Chris Carroll/Onyx, Los Angeles, Calif. **126, 127:** © Brian Lanker 1989. **128, 129:** UPI/Bettmann, New York. **131, 132:** Moorland-Spingarn Research Center, Howard University, Washington, D.C. **133:** Cleveland Public Library, Cleveland, Ohio. **134, 135:** Doris Ulmann Photographer—Warman/Columbia University, New York. **136, 137:** Beinecke Rare Book and Manuscript Library, Yale University, New Haven, Conn.—Keystone, Paris. **138, 139:** *Herald Tribune Magazine*; Carey Winfrey. **140:** Renée Comet, courtesy Danny Baror. **141:** © George Steinmetz. **142, 143:** Portrait, courtesy Moorland-Spingarn Research Center, Neg. #61, Howard University, Washington, D.C., composite photo by Renée Comet. **144:** Moorland-Spingarn Research Center, Neg. #2813, Howard University, Washington, D.C.—Library of Congress. **145:** Moorland-Spingarn Research Center, Neg. #2814, Howard University, Washington, D.C., photographer: Afro-American Newspapers—courtesy Pratt Library, photo by *Baltimore Afro-American*. **146:** Moorland-Spingarn Research Center, Neg. #1087, Howard University, Washington, D.C., Associated Publishers Collection—*Chicago Defender*. **147:** Moorland-Spingarn Research Center, Neg. #1380, Howard University, Washington D.C.—Moorland-Spingarn Research Center, Howard Uni-

versity, Washington, D.C. **148:** © 1927 Associated Publishers, Inc.—Moorland-Spingarn Research Center, Howard University, Washington, D.C. **149:** Moorland-Spingarn Research Center, Neg. #1356, Howard University, Washington, D.C., photographer: Afro-American Newspapers—Library of Congress. **150:** *The Call*, Kansas City, Mo.—Moorland-Spingarn Research Center, Howard University, Washington, D.C. **151:** *Atlanta Daily World* photo, Atlanta, Ga.—Library of Congress. **152, 153:** Background, Roger-Viollet, Paris; Nickolas Muray/George Eastman House, Rochester, N.Y.; *From Harlem to Paris: Black American Writers in France, 1840-1980* by Michael Fabre, University of Illinois Press, Champaign, 1991, hand-tinted by Christine Rodin (2). **154, 155:** Background, Roger-Viollet, Paris; from *The Unfinished Quest of Richard Wright* by Michael Fabre, University of Illinois Press, Champaign, 1991, hand-tinted by Christine Rodin—courtesy E. M. Lesley Himes, hand-tinted by Christine Rodin. **156-159:** Artwork by Anthony Woolridge. **160, 161:** AP/Wide World Photos, New York—Steve Schapiro/Black Star, New York; AP/Wide World Photos, New York; Gastaud/Sipa Press, New York. **162, 163:** AP/Wide World Photos, New York (2); Warren Mantooth. **164:** Granger Collection, New York. **165:** From *Don't Cry Scream* by Don L. Lee (Haki Madhubuti), Third World Press, Chicago, Ill., 1969. **166:** Chester Higgins, Jr. **167:** Courtesy Sonia Sanchez, photograph from *Homecoming* by Sonia Sanchez, Broadside Press, Detroit, Mich., 1969. **168:** B & L Photo, Indianapolis, Ind. **169:** © Martin Benjamen/Retna, New York. **170, 171:** Background, Alan Pitts; David Burnett/Contact, New York; © Ron Scherl 1987—Bert Andrews/Bert Andrews Estate. **172, 173:** Background, Alan Pitts; Peter Cunningham; Gerry Goodstein—Schwartz/Thompson. **174:** James Hamilton. **176-179:** Richard Morgenstein. **180, 181:** Frank Stewart. **182, 183:** Photographs and Prints Division, Schomburg Center for Research in Black Culture, New York Public Library, Astor, Lenox, and Tilden Foundations. **184:** From the collection of the Louisiana State Museum, New Orleans, La.—the P. H. Polk family, courtesy Gary Lee Super. **185:** Scurlock Studio, Washington, D.C. **186:** National Museum of American Art, Washington, D.C./Art Resource, New York—Providence Art Club, Providence, R.I. **187:** Boston

Athenaeum, Boston, Mass. **188:** Henry Ossawa Tanner Papers, photo by H. & H. Jacobsen, Kertminde, Denmark, Archives of American Art, Smithsonian Institution, Washington, D.C. **190:** Courtesy Lois Mailou Jones. **191:** San Francisco Museum of Modern Art, Albert M. Bender Collection, gift of Albert M. Bender. **192, 193:** Gordon Parks/LIFE—Henry Ossawa Tanner Papers, Archives of American Art, Smithsonian Institution, Washington, D.C.—National Museum of American Art/Art Resource, New York; Roy DeCarava/LIFE. **194, 195:** Gianfranco Gorgoni/Contact Press Images, New York—Annie Gawlak. **196, 197:** Acacia Historical Arts International, Savannah, Ga., photo by R. T. Fuller (2); center, Museum of Fine Arts, Boston, Mass. **198, 199:** North Carolina Museum of History Division of Archives and History, Department of Cultural Resources, Raleigh, N.C.; courtesy North Carolina Division of Archives and History, Raleigh, N.C.; © Terry Richardson—Yale University Art Gallery, Director's Fund, New Haven, Conn. **200:** McCord Museum of Canadian History, Notman Photographic Archives, Montreal—gift of Mr. and Mrs. Robert B. Honeyman, Los Angeles County Museum of Art, Los Angeles, Calif. **201:** Private collection, Cincinnati, Ohio. **202-204:** Historical Society of Saginaw Co. Inc., Saginaw, Mich. **205:** *Saginaw News*, Saginaw, Mich. **206:** Guillet Photography, Natchitoches, La. **207:** From the collection of Jack and Ann Brittain and their children; collection of Thomas N. Whitehead—private collection, New York. **208:** Courtesy Ricco/Maresca Gallery, New York—collection of Charles and Eugenia Shannon—courtesy Janet Fleisher Gallery, Philadelphia, Pa., private collection. **209:** Collection of Eugenia Shannon—courtesy Carl Hammer Gallery, Chicago, Ill., private collection. **210, 211:** Reprinted from Selden Rodman's *Horace Pippin: A Negro Artist in America*, Quadrangle Press, 1947, the first book about the artist, and from its sequel, *Horace Pippin: The Artist as a Black American* by Selden Rodman and Carole Cleaver, Doubleday, New York, 1971; © Phillips Collection, Washington, D.C.; Philadelphia Museum of Art, given by Robert Carlen; Hirshhorn Museum and Sculpture Garden, Smithsonian Institution, gift of Joseph H. Hirshhorn, 1966—Mr. and Mrs. Daniel W. Dietrich II. **212, 213:** Background photo by Renée Comet; © 1993 Donna Mussenden-VanDerZee, photo by James VanDerZee; James VanDerZee, © Donna Mussenden-VanDerZee; © 1993 Donna Mussenden-VanDerZee, photo by James VanDerZee. **214, 215:** Background photo by Renée Comet, © James VanDerZee; © 1980 by James VanDerZee; © by Donna Mussenden-VanDerZee, photo by James VanDerZee. **216, 217:** Background photo by Renée Comet, © 1969 by James VanDerZee; © 1980 by James VanDerZee; James VanDerZee © Donna Mussenden-VanDerZee. **219:** Estate of Beaumont Newhall, courtesy Scheinbaum and Russek, Ltd., Santa Fe, N.Mex., photo courtesy Francine Seders Gallery Ltd., Seattle, Wash. **220:** © Dennis R. Whitehead, Amistad Research Center, Tulane University, New Orleans, La.—© Phillips Collection, Washington, D.C. **221:** Hirshhorn Museum and Sculpture Garden, Smithsonian Insitution, gift of Joseph H. Hirshhorn, 1966, photo by Lee Stalsworth—collection Whitney Museum of American Art, New York, gift of Mr. and Mrs. Roy R. Neuberger, photo by Bill Jacobson. **222, 223:** Collection Whitney Museum of American Art, gift of David M. Solinger—painting by Jacob Lawrence, courtesy Dr. Gabrielle Reem Kayden and Dr. Herbert Kayden, photo by Henry Groskinsky; courtesy James L. Curtis. **224, 225:** St. Louis Art Museum, purchase: Eliza McMillan Fund, St. Louis, Mo.—Paul Macapia/Seattle Art Museum, Seattle, Wash.; photo by Armando Solis. **226:** From *The Art of Elizabeth Catlett* by Samella Lewis, Handcraft Studios, Claremont, Calif., 1982. **227-229:** Samella Lewis. **230, 231:** Lithograph by Robert Blackburn; Neal Boenzi/New York Times Pictures—courtesy Robert Blackburn Printmaking Workshop, New York. **232, 233:** Collection The Studio Museum in Harlem, New York, gift of Armand P. and Corice Arman, photo by Becket Logan; courtesy The Studio Museum in Harlem, photo by Becket Logan; courtesy The Studio Museum in Harlem, photo by Sherman Bryce (2). **234, 235:** Anthony Barboza (2); Alison Saar—*The Ritual Journey*, 1992, Betye Saar mixed-media site installation at University of Hartford, Conn., photo by Robert Calafiore. **236:** Courtesy Gallery Paule Anglim, San Francisco, Calif.—Lewis Watts. **237:** Jack Tilton Gallery, New York—Coreen Simpson.

BIBLIOGRAPHY

ANCIENT FIRES

BOOKS

Burton, W. F. P. *The Magic Drum: Tales from Central Africa.* New York: Criterion Books, 1961.

Dietz, Betty Warner, and Michael Babtunde Olatunji. *Musical Instruments of Africa.* New York: John Day, 1965.

Graham-White, Anthony. *The Drama of Black Africa.* New York: Samuel French, 1974.

Huet, Michael. *The Dance, Art, and Ritual of Africa.* New York: Pantheon Books, 1978.

Meyer, Laure. *Black Africa: Masks, Sculpture, Jewelry.* Paris: Terrail, 1992.

Newman, Thelma R. *Contemporary African Arts and Crafts.* New York: Crown Publishers, 1974.

Warren, Fred, and Lee Warren. *The Music of Africa.* Englewood Cliffs, N.J.: Prentice-Hall, 1970.

1

TO CAPTURE THE FLICKERING IMAGE

BOOKS

Bogle, Donald: *Blacks in American Films and Television: An Encyclopedia.* New York: Simon & Schuster, 1989.

Brown Sugar: Eighty Years of America's Black Female Superstars. New York: Harmony Books, 1980.

Toms, Coons, Mulattoes, Mammies, and Bucks. New York: Continuum Publishing Company, 1989.

Cham, Mybe, and Claire Andrade-Watkins (eds.). *Blackframes: Critical Perspectives on Black Independent Cinema.* Cambridge, Mass.: MIT Press, 1988.

Cripps, Thomas: *Black Film as Genre.* Bloomington: Indiana University Press, 1978.

Making Movies Black: The Hollywood Message Movie from World War II to the Civil Rights Era. New York: Oxford University Press, 1993.

Slow Fade to Black: The Negro in American Film, 1900-1942. New York: Oxford University Press, 1993.

Dandridge, Dorothy, and Earl Conrad. Everything and Nothing. New York: Abelard-Schuman, 1970.

Dash, Julie. Daughters of the Dust: The Making of an African American Woman's Film. New York: New Press, 1992.

Draigh, David. American Museum of the Moving Image: Guide to Who Does What in Motion Pictures and Television. New York: Abbeville Press, 1988.

Jones, G. William. Black Cinema Treasures: Lost and Found. Denton: University of North Texas Press, 1991.

Kisch, John, and Edward Mapp. A Separate Cinema: Fifty Years of Black-Cast Posters. New York: Noonday Press, 1992.

Klotman, Phyllis Rauch (ed.). Screenplays of the African American Experience. Bloomington: Indiana University Press, 1991.

Leab, Daniel J. From Sambo to Superspade: The Black Experience in Motion Pictures. Boston: Houghton Mifflin, 1976.

Mapp, Edward. Blacks in American Films: Today and Yesterday. Metuchen, N.J.: Scarecrow Press, 1972.

Maynard, Richard A. The Black Man on Film: Racial Stereotyping. Rochelle, N.J.: Hayden Book Company, 1974.

Murray, James P. To Find an Image: Black Films from Uncle Tom to Super Fly. Indianapolis: Bobbs-Merrill, 1973.

Nesteby, James R. Black Images in American Films, 1896-1954. Washington, D.C.: University Press of America, 1982.

Noble, Peter. The Negro in Films. New York: Arno Press, 1970.

Norman, Floyd. Faster! Cheaper! Burbank, Calif.: Get Animated!, 1992.

Null, Gary. Black Hollywood: The Negro in Motion Pictures. Secaucus, N.J.: Citadel Press, 1975.

Pfaff, Françoise. Twenty-Five Black African Filmmakers: A Critical Study, with Filmography and Bio-Bibliography. Westport, Conn.: Greenwood Press, 1988.

Pines, Jim. Blacks in Films: A Survey of Racial Themes and Images in the American Film. London: Studio Vista, 1975.

Ploski, Harry A., and James Williams (eds.). The Negro Almanac: A Reference Work on the African American (5th ed.). Detroit: Gale Research, 1989.

Reid, Mark A. Redefining Black Film. Berkeley: University of California Press, 1993.

Sampson, Henry T. Blacks in Black and White: A Source Book on Black Films. Metuchen, N.J.: Scarecrow Press, 1977.

Tyler, Bruce M. From Harlem to Hollywood: The Struggle for Racial and Cultural Democracy, 1920-1943 (Vol. 26 of Critical Studies of Black Life and Culture). New York: Garland Press, 1992.

Wiley, Mason, and Damien Bona. Inside Oscar: The Unofficial History of the Academy Awards. New York: Ballantine Books, 1986.

Yearwood, Gladstone L. (ed.). Black Cinema Aesthetics: Issues in Independent Black Filmmaking. Athens, Ohio: Center for Afro-American Studies, Ohio University, 1993.

PERIODICALS

Ansen, David. "A Superstar Returns to the Screen." Newsweek, February 22, 1988.

Baker, Houston A., Jr. "Not without My Daughters." Transition: An International Review (Oxford University Press), Issue 57, 1992.

Bates, Karen Grigsby. "They've Gotta Have Us." New York Times Magazine, July 14, 1991.

Beale, Lewis. "Reelin' and Dealin'." Daily News, October 5, 1993.

"Behind Cameras: The Technicians Are Consistently Proving Their Capabilities and Talents." Business of Film, June/July 1991.

Bennett, Lerone, Jr. "Sweetback in Wonderland." Ebony Magazine, September 1971.

Britt, Donna. "The Noisy World of Russell Williams." Washington Post, April 14, 1991.

Buckley, Gail Lumet. "Dorothy's Surrender." Premiere (special issue, Women in Hollywood), 1993.

Canby, Vincent. "Spike Lee Raises the Movies' Black Voice." New York Times, May 28, 1989.

Collier, Aldore. "Fighting the Power in Hollywood." Ebony, August 1990.

Corliss, Richard. "Boyz of New Black City." Time, June 17, 1991.

Darden, Norma Jean. "Oh, Sister!: Fredi and Isabel Washington Relive '30's Razzmatazz." Essence, September 1978.

Davis, Zeinabu Irene. "Daughters of the Dust." Black Film Review, Vol. 6, no. 1, 1990.

di Perna, Alan. "Tricks of the Trade: Oscar-Winner Russell Williams II Offers His Tips on Capturing High-Quality

Sound while Shooting Feature Films on Location." Film & Video, November 1991.

Flanagan, Sylvia P. "Blacks in Film Tell why Their Movies Are So Popular Today." Jet, March 9, 1992.

French, Mary Ann. "Haile Gerima, Menace II the Status Quo." Washington Post, October 24, 1993.

Gerima, Haile. "Thoughts and Concepts: The Making of Ashes and Embers." Black American Literature Forum, Vol. 25, no. 2, Summer 1991.

" 'GWTW' Pickets Face Trial Tomorrow in Brooklyn Court." Daily Worker (New York), February 5, 1940.

"Hugh A. Robertson: Black Film Editor." Los Angeles Times, January 28, 1988.

"Hugh A. Robertson, Film Maker, 55." Obituary. New York Times, January 14, 1988.

Johnson, Albert: "Moods Indigo: A Long View." Part 1. Film Quarterly, Vol. 44, no. 2, Winter 1990-91.

"Moods Indigo: A Long View." Part 2. Film Quarterly, Vol. 44, no. 3, Spring 1991.

"Kathleen Collins, A Film Maker, Dies at 46." Obituary. New York Times, September 24, 1988.

Knee, Adam. "Symbiopsychotaxiplasm: Take One: Film History Revisited." Sightlines: The Journal of the American Film & Video Association, Fall 1992.

Knee, Adam, and Charles Musser. "William Greaves, Documentary Film-Making, and the African-American Experience." Film Quarterly, Vol. 45, no. 3, Spring 1992.

Leland, John, with Donna Foote. "A Bad Omen for Black Movies?" Newsweek, July 29, 1991.

Little, Benilde. "Brooklyn's Baby Mogul, Spike Lee, Finds the Freedom He's Gotta Have." People, October 13, 1986.

McBride, Joseph. "Costner Western Tallies 7 Wins; Irons, Bates, Pesci, Goldberg Take Acting Nods." Daily Variety, March 26, 1991.

MacDonald, Scott. "Sunday in the Park with Bill: William Greaves' Symbiopsychotaxiplasm: Take One." Independent, May 1992.

McDowell, Jeanne. "He's Got to Have It His Way." Time, July 17, 1989.

"A New Beauty for Bizet." Life, November 1, 1954.

Nicholson, David: "Conflict and Complexity: Filmmaker Kathleen Collins." Black Film Review, Vol. 2, no. 3, 1986.

"Independent and Liking It." American Visions, July/August 1986.

"Power to the Peebles." *Time*, August 16, 1971.

"Producer to Make Dignified Pictures." *Los Angeles Sentinel*, May 9, 1946.

Rein, Richard K. "Broadway's Baadasssss, Melvin Van Peebles, Won't Fold His Play and Just Go Away." *People*, February 15, 1982.

Richardson, Charles V. "Blaxploitation, Phase Two." *American Visions*, April 1991.

Rollins, William. "Stepin Fetchit Looks Back." *Los Angeles Times*, November 16, 1969.

Shah, Diane K. "Soldier, Healer, Seller." *Gentlemen's Quarterly*, October 1988.

Sharp, Saundra. "Charles Burnett." *Black Film Review*, Vol. 6, no. 1, 1990.

Simpson, Janice C. "Not Just One of The Boyz." *Time*, March 23, 1992.

Smith, Liz. " 'Ghost' Gives New Life to Whoopi." *New York Daily News*, September 19, 1990.

Soria, Lorenzo. "L'Espresso: A Rage in Hollywood." *World Press Review*, October 1991.

"Stepin Fetchit Comes Back." *Ebony*, February 1952.

Sterritt, David. "Film Fest Honors Black Pioneer." *Christian Science Monitor*, April 24, 1991.

Tate, Greg. "Cinematic Sisterhood." *Voice Film Special*, June 1991.

Wali, Monona. "L.A. Black Filmmakers Thrive despite Hollywood's Monopoly." *Black Film Review*, Vol. 2, no. 2, 1986.

Wheeler, Robyn E. "News for All Americans." *American Visions*, February/March 1993.

Whitaker, Charles. "Doing the Spike Thing." *Ebony*, November 1991.

"William Alexander, Producer Featuring Blacks, Dies at 75." Obituary. *New York Times*, December 6, 1991.

Young, Al. "Charles Burnett Spellbinds Viewers with His Personal Vision." *American Visions*, December 1990.

OTHER SOURCES

"Excerpts from the Oral History of George P. Johnson." Los Angeles: Collection of Negro Film History, UCLA Library, n.d.

Greaves, William. "Greaves on the Future of U.S. Filmmaking." Speech delivered to a New York City Council hearing, May 9, 1991.

"Hugh Robertson." Speech delivered at the Ninth Annual Oscar Micheaux Awards Ceremony, Black Filmmakers Hall of Fame, February 14, 1982.

"Memories of William Alexander." Speech delivered at the 19th Annual Oscar Micheaux Awards Ceremony, Black Filmmakers Hall of Fame, 1992.

Noel, Angela. "Retrospective Tribute: Dorothy Dandridge." Speech delivered at the 19th Annual Oscar Micheaux Awards Ceremony, Black Filmmakers Hall of Fame, 1992.

Parkerson, Michelle. "Persistence of Vision: Contemporary Perspectives on African-American Women Filmmakers." The Van Zeit Lecture in Communication delivered at the Northwestern University School of Speech, Evanston, Illinois, May 14, 1992.

"William Greaves: Chronicler of the African-American Experience." Brooklyn Museum, 1991.

2

THE ROOTS OF AMERICAN MUSIC

BOOKS

Basie, Count. *Good Morning Blues: The Autobiography of Count Basie, as Told to Albert Murray*. New York: Random House, 1986.

Bego, Mark. *Aretha Franklin: The Queen of Soul*. New York: St. Martin's Press, 1989.

Berendt, Joachim E. *The Jazz Book: From Ragtime to Fusion and Beyond* (6th ed.). Brooklyn, N.Y.: Lawrence Hill Books, 1992.

Blesh, Rudi. *Shining Trumpets: A History of Jazz*. New York: Da Capo Press, 1976.

Blesh, Rudi, and Harriet Janis. *They All Played Ragtime*. New York: Oak Publications, 1971.

Brown, James, with Bruce Tucker. *James Brown, the Godfather of Soul*. New York: Thunder's Mouth Press, 1990.

Charles, Ray, and David Ritz. *Brother Ray: Ray Charles' Own Story* (rev. ed.). New York: Da Capo Press, 1992.

Charters, Samuel. *Robert Johnson*. New York: Oak Publications, 1973.

Chilton, John: *Billie's Blues: Billie Holiday's Story, 1933-1959*. New York: Stein and Day, 1978.

Who's Who of Jazz: Storyville of Swing Streets. London: Bloomsbury Book Shop, 1970.

Collier, James Lincoln: *Duke Ellington*. New York: Oxford University Press, 1987.

Louis Armstrong: An American Genius. New York: Oxford University Press, 1983.

The Making of Jazz: A Comprehensive History. New York: Dell Publishing, 1978.

Courlander, Harold. *Negro Folk Music, U.S.A.* New York: Columbia University Press, 1963.

Crow, Bill (ed.). *Jazz Anecdotes*. New York: Oxford University Press, 1990.

Davis, Miles, and Quincy Troupe. *Miles: The Autobiography*. New York: Simon & Schuster, 1989.

Ellington, Mercer, and Stanley Dance. *Duke Ellington in Person: An Intimate Memoir*. New York: Da Capo Press, 1979.

Ewen, David. *All the Years of American Popular Music: A Comprehensive History*. Englewood Cliffs, N.J.: Prentice-Hall, 1977.

Feather, Leonard. *The Book of Jazz: From Then till Now*. New York: Horizon, 1965.

Feinstein, Elaine. *Bessie Smith*. New York: Viking Press, 1985.

Friedwald, Will. *Jazz Singing: America's Great Voices from Bessie Smith to Bebop and Beyond*. New York: Charles Scribner's Sons, 1990.

George, Nelson: *The Death of Rhythm and Blues*. New York: Pantheon Books, 1988.

Where Did Our Love Go?: The Rise and Fall of the Motown Sound. New York: St. Martin's Press, 1987.

Gitler, Ira. *Jazz Masters of the Forties*. New York: Da Capo Press, 1983.

Gottlieb, William. *The Golden Age of Jazz*. New York: Da Capo Press, 1979.

Guralnick, Peter: *Feel like Going Home*. New York: Outerbridge and Dienstfrey, 1971.

Searching for Robert Johnson. New York: Dutton, 1989.

Sweet Soul Music: Rhythm and Blues and the Southern Dream of Freedom. New York: Harper & Row, 1986.

Hardy, Phil, and Dave Laing. *The Faber Companion to 20th Century Popular Music*. London: Faber & Faber, 1990.

Haskins, James: *Nat King Cole*. Chelsea, Mich.: Scarborough House, 1990.

Scott Joplin. New York: Doubleday, 1978.

Hemming, Roy. *Discovering Great Singers of Classic Pop*. New York: New Market Press, 1991.

Hentoff, Nat. *Jazz Is*. New York: Limelight Editions, 1991.

Hentoff, Nat, and Albert J. McCarthy (eds.). *Jazz*. New York: Da Capo Press, 1982.

Hershey, Gerri. *Nowhere to Run: The Story of Soul Music*. New York: Penguin Books, 1985.

Hobsbawm, Eric. *The Jazz Scene*. New York: Pantheon Books, 1993.

Hughes, Langston, and Milton Meltzer. *Black Magic: A Pictorial History of the Negro in*

American Entertainment. Englewood Cliffs, N.J.: Prentice-Hall, 1970.

Jones, LeRoi. *Blues People.* New York: William Morrow, 1963.

Keepnews, Orrin. *The View from Within: Jazz Writings, 1948-1987.* New York: Oxford University Press, 1987.

Kofsky, Frank. *Black Nationalism and the Revolution in Music.* New York: Pathfinder Press, 1978.

Kunstadt, Leonard. *Jazz: A History of the New York Scene.* New York: Da Capo Press, 1981.

Lieb, Sandra. *Mother of the Blues: A Study of Ma Rainey.* Amherst: University of Massachusetts Press, 1981.

Litweiler, John: *The Freedom Principle: Jazz after 1958.* New York: Da Capo Press, 1984.

Ornette Coleman: A Life in Harmolodics. New York: William Morrow, 1993.

Lyons, Len, and Don Perlo. *Jazz Portraits.* New York: William Morrow, 1989.

Murray, Albert. *Stomping the Blues.* New York: Da Capo Press, 1976.

Murrells, Joseph. *The Book of Golden Discs.* London: Barry & Jenkins, 1978.

Nelson, Havelock, and Michael A. Gonzales. *Bring the Noise: A Guide to Rap Music and Hip-Hop Culture.* New York: Harmony Books, 1991.

Oliver, Paul. *The New Grove Gospel, Blues, and Jazz.* New York: W. W. Norton, 1986.

Pleasants, Henry. *The Great American Popular Singers.* New York: Simon & Schuster, 1974.

Pruter, Robert. *Chicago Soul.* Chicago: University of Illinois Press, 1991.

Ramsey, Frederick, and Charles Edward Smith (eds.). *Jazzmen.* New York: Limelight Editions, 1985.

Reagon, Bernice Johnson, and Sweet Honey in the Rock. *We Who Believe in Freedom: Sweet Honey in the Rock . . . Still on the Journey.* New York: Anchor, 1993.

Rosenthal, David H. *Hard Bop: Jazz and Black Music, 1955-1965.* New York: Oxford University Press, 1992.

Russell, Ross. *Jazz Style in Kansas City and the Southwest.* Berkeley: University of California Press, 1971.

Sales, Grover. *Jazz: America's Classical Music.* Englewood Cliffs, N.J.: Prentice-Hall, 1984.

Schuller, Gunther: *Early Jazz.* New York: Oxford University Press, 1968.

The Swing Era: The Development of Jazz, 1930-1945. New York: Oxford University Press, 1989.

Shannon, Bob, and John Javna. *Behind the Hits.* New York: Warner Books, 1986.

Shapiro, Nat, and Nat Hentoff. *Hear Me Talkin' to Ya: The Story of Jazz as Told by the Men Who Made It.* New York: Dover Publications, 1955.

Shaw, Arnold: *Black Popular Music in America: From the Spirituals, Minstrels, and Ragtime to Soul, Disco, and Hip Hop.* New York: Schirmer Books, 1986.

52nd Street: The Street of Jazz. New York: Da Capo Press, 1977.

The Rockin' Fifties. New York: Da Capo Press, 1987.

Simon, George T. *The Big Bands* (4th ed.). New York: Schirmer Books, 1981.

Smith, Joe. *Off the Record: An Oral History of Popular Music.* New York: Warner Books, 1989.

The Smithsonian Collection of Classic Jazz. Washington, D.C.: Smithsonian Institution, 1987.

Southern, Eileen. *The Music of Black Americans.* New York: W. W. Norton, 1983.

Spellman, A. B. *Four Lives in the Bebop Business.* New York: Limelight Editions, 1988.

Stewart, Rex. *Jazz Masters of the Thirties.* New York: Da Capo Press, 1985.

Swenson, John. *Stevie Wonder.* New York: Harper & Row, 1986.

Tate, Greg. *Flyboy in the Buttermilk.* New York: Simon & Schuster, 1992.

Tee, Ralph. *Soul Music Who's Who.* Roseville, Calif.: Prima Publishing & Communications, 1992.

Toll, Robert C. *Blacking Up: The Minstrel Show in Nineteenth Century America.* New York: Oxford University Press, 1974.

Tucker, Mark. *Ellington: The Early Years.* Chicago: University of Illinois Press, 1991.

Waller, Maurice. *Fats Waller.* New York: Schirmer Books, 1977.

Williams, Martin. *The Jazz Tradition* (rev. ed.). New York: Oxford University Press, 1983.

PERIODICALS

Berman, Eric. "The Godfathers of Rap." *Rolling Stone,* December 23, 1993-January 6, 1994.

Blades, Lynn. "Andre the Giant." *Hits,* October 5, 1992.

Boehm, Mike. "Sweet Honey of a Concert at Chapman." *Los Angeles Times,* April 22, 1991.

Buffalo, Audreen. "Sweet Honey: A Cappella Activists." *Ms.,* March/April 1993.

Carmody, Dierdre. "Hip-Hop Dances to the Newsstands." *New York Times,* September 14, 1992.

Cocks, Jay. "Pop Stardom for Fun and Profit." *Time,* July 30, 1990.

Dennis, Reginald C. "25 Old School Turning Points." *Source,* November 1993.

DiGiacomo, Frank. "Bad Kid Moved In on His Block." *New York Post,* March 20, 1992.

George, Nelson. "Hip-Hop's Founding Fathers Speak the Truth." *Source,* November 1993.

Hirschberg, Lynn. "Living Large." *Vanity Fair,* September 1993.

"Introducing: Producers of the Year—Jimmy (Jam) Harris and Terry Lewis." *Ebony,* July 1987.

"Jimmy Jam and Terry Lewis Celebrate 10 years of Writing-Producing Hits for Top Music Makers." *Jet,* May 24, 1993.

Katzeff, Paul. "The Man Who Spawned New Kids on the Block." *Wall Street Journal,* August 16, 1990.

Kohanov, Linda. "Solid as a Rock." *CD Review,* June 1990.

McAdams, Janine: "Flyte Tyme Turns Ten." *Billboard,* February 22, 1992.

"Going Uptown: Label Plans New Acts, Soundtrack." *Billboard,* May 11, 1991.

"Jam and Lewis Expand Their Perspective." *Billboard,* February 22, 1992.

" 'Mo' Money': Major Push." *Billboard,* May 23, 1992.

"Uptown, MCA Seal Multimedia Deal." *Billboard,* June 20, 1992.

"MCA and Uptown Records Will Form New Company." *Wall Street Journal,* June 12, 1992.

Meyer, Marianne. "The Soul of Handel's 'Messiah'." *Washington Post,* November 29, 1993.

Miller, Jim. "Packaging Quincy Jones." *Newsweek,* January 8, 1990.

Morrison, Allan. "Sarah Vaughan Adopts a Baby." *Ebony,* September 1961.

"New Jack Swing King Teddy Riley Talks about 'The Future'." *Sun Reporter,* June 17, 1992.

Pareles, Jon: "Grammys Turn into Quincy Jones Show." *New York Times,* February 21, 1991.

"2 Concerts Gel Sounds of America." *New York Times,* January 19, 1993.

Perry, Steve. "Flyte Tyme: Piloting Hits from South Minneapolis." *Minneapolis/St. Paul,* November 1986.

Rosen, Craig. "Labels, MTV Keep Plugging Away." *Billboard,* May 8, 1993.

Rule, Sheila: "Charge of Musical Fakery

Retracted." *New York Times*, April 22, 1992.
"New Kids Sue Ex-Director over Charges of Fakery." *New York Times*, February 2, 1992.

Shah, Diane K. "For 40 years, Quincy Jones Has Been Where the Music Is." *New York Times*, November 18, 1990.

Simpson, Janice. "Getting Down to Their Roots." *Time*, April 13, 1992.

Vaughn, Christopher. "Urban Empire Launched." *Black Enterprise*, January 1993.

Watrous, Peter. "White Singer + Black Style = Pop Bonanza." *New York Times*, March 11, 1990.

Wright, Barnett. "Riley and Guy Popularizing New Jack Swing." *Philadelphia Tribune*, November 1, 1991.

Wright, Mickey. "The Future Is Now." *Virginian-Pilot and Ledger Star*, September 19, 1993.

3

WITH PEN IN HAND

BOOKS

African American Literature: Voices in a Tradition. New York: Harcourt Brace, 1992.

Baker, Houston A., Jr. *Singers of Daybreak: Studies in Black American Literature.* Washington, D.C.: Howard University Press, 1983.

Bell, Bernard W. *Modern and Contemporary Afro-American Poetry.* Boston: Allyn & Bacon, 1972.

Bellegarde, Ida R.: *Paul Laurence Dunbar* (Book 3 of Black Heroes and Heroines series). Pine Bluff, Ark.: Bell Enterprises, 1983.

Phillis Wheatley (Book 4 of Black Heroes and Heroines series). Pine Bluff, Ark.: Bell Enterprises, 1984.

Branch, William B. *Black Thunder: An Anthology of Contemporary African American Drama.* New York: Penguin Books, 1992.

Collier, Eugenia W., and Richard A. Long (eds.). *Afro-American Writing: An Anthology of Prose and Poetry* (2d ed.). University Park: Pennsylvania State University Press, 1985.

Davis, Arthur P. *From the Dark Tower: Afro-American Writers, 1900-1960.* Washington, D.C.: Howard University Press, 1982.

Davis, Arthur P., Saunders Redding, and Joyce Ann Joyce (eds.): *The New Cavalcade: African American Writing from 1760 to the Present* (Vol. 1). Washington, D.C.: Howard University Press, 1991.

The New Cavalcade: African American Writing from 1760 to the Present (Vol. 2). Washing-

ton, D.C.: Howard University Press, 1992.

Du Bois, W. E. B. *The Souls of Black Folk.* New York: Bantam Doubleday Publishing, 1989.

Dunbar, Paul Laurence: *Lyrics of Lowly Life.* New York: Citadel Press, 1984.

The Sport of the Gods. New York: Macmillan, 1970.

Ellison, Ralph. *Invisible Man.* New York: Vintage Books, 1990.

Emanuel, James A., and Theodore L. Gross (eds.). *Dark Symphony: Negro Literature in America.* New York: Free Press, 1968.

Fabre, Michel. *From Harlem to Paris: Black American Writers in France, 1840-1980.* Chicago: University of Illinois Press, 1991.

Harris, Trudier (ed.): *Afro-American Writers after 1955: Dramatists and Prose Writers* (Vol. 38 of *Dictionary of Literary Biography*). Detroit: Gale Research, 1985.

Afro-American Writers before the Harlem Renaissance (Vol. 50 of *Dictionary of Literary Biography*). Detroit: Gale Research, 1986.

Harris, Trudier, and Thadious M. Harris (eds.). *Afro-American Fiction Writers after 1955* (Vol. 33 of *Dictionary of Literary Biography*). Detroit: Gale Research, 1984.

Himes, Chester. *My Life of Absurdity: The Later Years.* New York: Paragon House, 1990.

Huggins, Nathan Irvin. *Harlem Renaissance.* New York: Oxford University Press, 1971.

Hughes, Langston. *The Big Sea.* New York: Thunder's Mouth Press, 1986.

Johnson, James Weldon. *Black Manhattan.* New York: Atheneum, 1977.

Killens, John Oliver, and Jerry W. Ward, Jr. (eds.). *Black Southern Voices.* New York: Penguin Books, 1992.

King, Woodie, Jr. (ed.). *The Forerunners: Black Poets in America.* Washington, D.C.: Howard University Press, 1981.

Locke, Alain Leroy (ed.). *The New Negro: An Interpretation.* New York: Arno Publishers, 1968.

Logan, Rayford W., and Michael R. Winston (eds.). *Dictionary of American Negro Biography.* New York: W. W. Norton, 1982.

McMillan, Terry. *Breaking Ice: An Anthology of Contemporary African-American Fiction.* New York: Penguin Books, 1990.

McPherson, James A. *Ordeal by Fire: The Civil War and Reconstruction.* New York: Alfred A. Knopf, 1982.

Magill, Frank N. *Masterpieces of African American Literature.* New York: Harper

Collins, 1992.

Mencken, H. L. *The Vintage Mencken: Gathered by Alistair Cooke.* New York: Vintage Books, 1956.

Metzger, Linda (ed.). *Black Writers: A Selection of Sketches from Contemporary Authors.* Detroit: Gale Research, 1989.

Naylor, Gloria. *The Women of Brewster Place.* New York: Penguin Books, 1980.

Petry, Ann. *The Street.* Boston: Beacon Press, 1985.

Ploski, Harry A., and James Williams (eds.). *The Negro Almanac: A Reference Work on the African American* (5th ed.). Detroit: Gale Research, 1989.

Randall, Dudley (ed.). *The Black Poets.* New York: Bantam Books, 1971.

Richmond, M. A. *Bid the Vassal Soar: Essays on the Life and Poetry of Phillis Wheatley and George Moses Horton.* Washington, D.C.: Howard University Press, 1974.

Shockley, Ann Allen. *Afro-American Women Writers, 1746-1933.* New York: Penguin Books, 1989.

Smith, Jessie Carney (ed.). *Notable Black American Women.* Detroit: Gale Research, 1992.

Still, William Grant. *The Underground Railroad.* New York: Arno Press and New York Times, 1968.

Wilson, Harriet E. *Our Nig; or, Sketches from the Life of a Free Black.* New York: Random House, 1983 (reprint).

Wilson, M. L. *Chester Himes, Author.* New York: Chelsea House, 1988.

Wright, Richard. *Black Boy.* New York: Harper & Row, 1966.

PERIODICALS

"**Better Times for Black Writers?**" *Publishers Weekly*, February 17, 1989.

"**Blacks and the Book World.**" *Publishers Weekly*, January 20, 1992.

"**Black Writers Debate Being Human in 20th Century.**" *Publishers Weekly*, February 17, 1989.

"**Ernest Gaines: Writing about the Past.**" *Essence*, August 1993.

"**Inaugural Poem in Angelou's Mind.**" *Winston-Salem Journal*, December 5, 1992.

McCarthy, Mary. "A Memory of James Baldwin." *New York Review of Books*, April 27, 1989.

Max, Daniel. "McMillan's Millions." *New York Times*, August 9, 1992.

Nixon, Will. "Black Male Writers: Endangered Species?" *American Visions*, February 1990.

"**Poet of South for Clinton's Big Day.**"

New York Times, December 5, 1993.

"A Southern Road to Freedom." *Washington Post*, July 20, 1993.

"The Stories That Cry to Be Read." *Washington Post*, n.d.

Summer, Bob. "Ernest J. Gaines." *Publishers Weekly*, May 24, 1993.

" 'These Yet-to-Be United States'." *Los Angeles Times*, December 6, 1992.

"Thrills, Chills, and Diversity." *Washington Post*, January 5, 1994.

4
THE VISUAL ARTS: BOUNTY FROM GIFTED HANDS

BOOKS

Adams, Russell L. *Great Negroes: Past and Present*. Chicago: Afro-Am Publishing, 1991.

Bearden, Romare, and Harry Henderson. *Six Black Masters of American Art*. New York: Zenith/Doubleday, 1972.

Bontemps, Arna Alexander (ed.). *Art by African-American Women, 1862-1980*. Normal: Illinois State University, 1980.

Campbell, Mary Schmidt, et al. *Harlem Renaissance: Art of Black America*. New York: Harry N. Abrams, 1987.

Chase, Judith Wragg. *Afro-American Art Craft*. New York: Van Nostrand Reinhold, 1971.

Driskell, David C.: *Contemporary Visual Expressions: Inaugural Exhibition, Anacostia Museum—The Art of Sam Gilliam, Martha Jackson-Jarvis, Keith Morrison, William T. Williams*. Washington, D.C.: Smithsonian Institution, 1987.

Hidden Heritage: Afro-American Art, 1800-1987. San Francisco: Art Museum Association of America, 1985.

Two Centuries of Black American Art. New York: Alfred A. Knopf in association with Los Angeles County Museum of Art, 1976.

Fax, Elton C. *Seventeen Black Artists*. New York: Dodd, Mead, 1971.

Fry, Gladys-Marie. *Stitched from the Soul*. New York: Dutton Studio Books, 1990.

Green, Samuel. *American Art: A Historical Survey*. New York: Ronald Press, 1966.

Hartigan, Lynda Roscoe. *Sharing Traditions: Five Black Artists in Nineteenth-Century America*. Washington, D.C.: Smithsonian Institution Press, 1985.

Haskins, Jim. *James VanDerZee: The Picture-Takin' Man*. Trenton: Africa World Press, 1991.

Ketner, Joseph D. *The Emergence of the African-American Artist: Robert S. Duncanson, 1821-1872*. Columbia: University of Missouri Press, 1993.

Kismaric, Carole (ed.). *David Hammond: Rousing the Rubble*. Cambridge, Mass.: MIT Press, 1991.

Lewis, Samella: *Art: African American*. New York: Harcourt Brace Jovanovich, 1978.

The Art of Elizabeth Catlett. Claremont, Calif.: Hancraft Studios, 1984.

Logan, Rayford, and Michael R. Winston (eds.). *Dictionary of American Negro Biography*. New York: W. W. Norton, 1982.

Low, Augustus W. (ed.). *Encyclopedia of Black America*. New York: Da Capo Press, 1981.

McGhee, Reginald. *The World of James VanDerZee: A Visual Record of Black Americans*. New York: Grove Press, 1969.

Mendelowitz, Daniel M. *A History of American Art*. New York: Holt, Rinehart & Winston.

Mosby, Dewey F., and Darrel Sewell. *Henry Ossawa Tanner*. New York: Rizzoli, 1991.

Moutoussamy-Ashe, Jeanne. *Viewfinders: Black Women Photographers*. New York: Dodd, Mead, 1986.

Perry, Regenia A.: "African Art and African-American Folk Art." In *Black Art, Ancestral Legacy*. Dallas: Dallas Museum of Art, 1989.

Free within Ourselves: African-American Artists in the Collection of the National Museum of American Art. Washington, D.C.: Smithsonian Institution, 1992.

Ploski, Harry A., and James Williams (eds.). *The Negro Almanac: A Reference Work on the African American* (5th ed.). Detroit: Gale Research, 1989.

Porter, James A. *Modern Negro Art*. Washington, D.C.: Howard University Press, 1992.

Richardson, E. P. *A Short History of Painting in America*. New York: Thomas Crowell, 1963.

Rubinstein, Charlotte Streifer. *American Women Artists: From Early Indian Times to the Present*. Boston: Avon Books, 1982.

Schwartzman, Myron. *Romare Bearden: His Life and Art*. New York: Harry N. Abrams, 1990.

Vlack, John Michael. *The Afro-American Tradition in Decorative Art*. Cleveland: Cleveland Museum of Art, 1978.

Wheat, Ellen Harkins. *Jacob Lawrence, American Painter*. Seattle: University of Washington Press in association with the Seattle Art Museum, 1986.

Willis-Braithwaite, Deborah, and Rodger C. Birt. *VanDerZee: Photographer, 1886-1983*. New York: Harry N. Abrams in association with the National Portrait Gallery, Smithsonian Institution, 1993.

Willis-Thomas, Deborah: *Black Photographers: An Illustrated Bio-Bibliography* (Vol. 1). New York: Garland, 1985.

Black Photographers: An Illustrated Bio-Bibliography (Vol. 2). New York: Garland, 1989.

PERIODICALS

"The Art of Heading the Studio Museum." *New York Times*, August 27, 1987.

Blodgett, Geoffrey. "John Mercer Langston and the Case of Edmonia Lewis: Oberlin, 1862." *Journal of Negro History*, July 1968.

Brenson, Michael. "New Home and Life for Studio Museum in Harlem." *New York Times*, June 7, 1982.

Douglas, Robert L. "From Blues to Protest/Assertiveness: The Art of Romare Bearden and John Coltrane." *International Review of African American Art*, 1988.

"Elizabeth Catlett: Portrait of a Master Sculptor." *Essence*, June 1985.

Fraser, C. Gerald. "Museum in Harlem Celebrates 3 Ways." *New York Times*, January 30, 1988.

Glueck, Grace. "Art People." *New York Times*, November 6, 1981.

Grillo, Jean Bergantino. "A Home for the Evolving Black Esthetic." *Art News*, October 1973.

"A Harlem Showcase for Black Art." *New York Times*, August 27, 1987.

Hewitt, Mary Jane: "Betye Saar: An Interview." *International Review of African American Art*, 1992.

"Elizabeth Catlett." *International Review of African American Art*, 1987.

James, Curtia. "Elizabeth Catlett: Pulling against the Grain." *American Visions*, February/March 1994.

Jezierski, John V. "Photographing the Lumber Boom: The Goodridge Brothers of Saginaw, Michigan (1863-1922)." *Michigan History*, November/December 1980.

LaDuke, Betty. "The Grande Dame of Afro-American Art: Lois Mailou Jones." *Sage*, Spring 1987.

Montgomery, Evangeline J. "Sargent Johnson." *International Review of African American Art*, 1984.

Skeel, Sharon Kay. "A Black American in the Paris Salon." *American Heritage*, February/March 1991.

Tate, Mae. "John Biggers: The Man and His Art." *International Review of African American Art*, 1987.

Walker, Shawn. "Preserving Our History: The Kamoinge Workshop and Beyond." *Ten*:8, Issue 24, 1987.

Weaver, William. "Harlem Renaissance/Studio Museum, New York." *Financial Times of London*, March 24, 1987.

White, David O. "Augustus Washington, Black Daguerreotypist of Hartford." *Connecticut Historical Society Bulletin*, January 1974.

Wolf, Theodore F. "Black Art Thrives at Harlem's Studio Museum." *Christian Science Monitor*, August 14, 1980.

OTHER SOURCES

"About the Studio Museum in Harlem." Brochure. New York: Studio Museum in Harlem, 1993.

"AFRICOBRA: The First Twenty Years." Catalog. Atlanta: Nexus Contemporary Art Center, 1990.

BlackWoman Collaborative. "The Black Photographer: An American View." Catalog. Chicago: Chicago Public Library Cultural Center, 1985.

Coar, Valencia Hollins. "A Century of Black Photographers: 1840-1960." Catalog. Providence: Museum of Art/Rhode Island School of Design, 1983.

"The Goodridge Brothers: Saginaw's Pioneer Photographers." Catalog. Saginaw, Mich.: Saginaw Art Museum, 1982.

McElroy, Guy. "Robert S. Duncanson: A Centennial Exhibition." Catalog. Cincin-

nati: Cincinnati Art Museum, 1972.

"Mildred Howard—Tap: Investigation of Memory." Catalog. New York: Intar Latin American Gallery, 1992.

"1992 Adaline Kent Award Exhibition: Mildred Howard—Ten Little Children Standing in a Line." Catalog. San Francisco: Walter/McBean Gallery, San Francisco Art Institute, 1991.

Olander, William, and Deba P. Patnaik. "Contemporary Afro-American Photography." Catalog. Oberlin, Ohio: Allen Memorial Art Museum, Oberlin College, 1983.

O'Neill, Charles Edwards S. J. "Fine Arts and Literature: 19th Century Louisiana Black Artists and Authors." In *Louisiana's Black Heritage*, edited by Robert R. MacDonald, John R. Kemp, and Edward F. Haas. New Orleans: Louisiana State Museum, 1977.

The Permanent Collection of the Studio Museum in Harlem (Vol. 1). New York: Studio Museum in Harlem, 1993.

"The Photogram." Newsletter of the Michigan Photographic Historical Society, September/October 1987.

Reynolds, Gary A., and Beryl J. Wright. "Against the Odds: African-American Artists and the Harmon Foundation." Catalog. Newark, N.J.: Newark Museum, 1989.

"Robert S. Duncanson: A Centennial Exhibition." Catalog. Cincinnati: Cincinnati Art Museum, 1972.

Rozelle, Robert V., Alvia Wardlaw, and Maureen A. McKenna, eds. "Black Art—Ancestral Legacy: The African Impulse in African-American Art." Catalog. Dallas: Dallas Museum of Art, 1989.

"Secrets, Dialogues, Revelations: The Art of Betye and Alison Saar." Catalog. Los Angeles: Wight Art Gallery, 1990.

"Since the Harlem Renaissance: 50 Years of Afro-American Art." Catalog. Lewisburg, Pa.: Center Gallery of Bucknell University, 1985.

"The Studio Museum in Harlem." Brochure. New York: Studio Museum in Harlem, 1993.

"Studio Museum in Harlem Quarterly Bulletin." New York: Studio Museum in Harlem, Winter 1980.

"Thomas Day, Cabinetmaker." Catalog. Raleigh: North Carolina Museum of History, 1975.

"Traditions and Transformations: Contemporary Afro-American Sculpture." Catalog. New York: Bronx Museum of the Arts, 1989.

"Two Schools—New York and Chicago: Contemporary African-American Photography of the '60s and '70s." Catalog. New York: Kenkeleba Gallery, 1986.

Weekley, Carolyn J., et al. "Joshua Johnson: Freeman and Early American Portrait Painter." Catalog. Williamsburg, Va.: Abby Aldrich Rockefeller Folk Art Center of Colonial Williamsburg in association with the Maryland Historical Society, 1987.

Willis, Deborah, and Howard Dodson. "Black Photographers Bear Witness: 100 Years of Social Protest." Catalog. Williams, Mass.: Williams College Museum of Art, 1989.

"The World of Lois Mailou Jones." Catalog. Washington, D.C.: Meridian House International, 1990.

INDEX